Contents

This book offers an unusual and exciting way of looking at art. A perfect introduction for those who are new to the subject, as well as an indispensable resource for those who have been studying art for years, *10,000 Years of Art* presents 500 masterworks from different countries, cultures and civilizations in simple chronological order. From the end of the last Ice Age to conceptual art of the twentieth century, this book includes acknowledged masterpieces, some lesser-known, and many surprises. With descriptive texts that shed light on why each work is important, what makes it typical of the culture in which it was created and its place in the development of art history, the book offers a brand new perspective on world art.

Only here can you easily find what was being created in Japan, Iraq, Peru or Nigeria when the *Venus de Milo* was being carved in Greece. Only here will you discover that while Diego Velázquez was painting the monumental royal family portrait *Las Meninas*, an unnamed artist in India was creating a delicate jade wine cup for the Shah who built the Taj Mahal. *10,000 Years of Art* celebrates this rich diversity and shows how art created across the millennia, and from around the world, fits together.

Hand Stencils, Artist unknown
Pigments on rock, H (hands): c.15 cm / 6 in, In situ, Cueva de las Manos,
Rio de las Pinturas

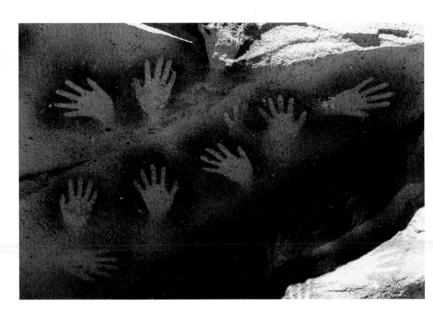

The hand stencils in the Cuevas de las Manos (Cave of the Hands), dating to c.11,000–7500 BC, are critical in demonstrating the artistic heritage of the late Pleistocene/early Holocene hunter-gatherers of Argentina, who comprise some of the earliest human societies in the Americas. Here, a cloud of several dozen stencils created using red, black and white pigments appears to be generally directed at a fissure in the cave wall. Left and right hands are represented, and there is presumably some meaning in the differing orientation of some of them. Paintings of animals such as guanacos, hunting scenes, and enigmatic abstract forms, also present in the cave, are much more recent than the hand stencils.

Negative hand stencils and positive handprints are a common theme in the rock art of small-scale societies, characteristic, for example, in the Upper Palaeolithic art of France and Spain, in Australian aboriginal art, and throughout the Americas. Hands may be painted and then applied to the rock surface (prints) or created as negatives when the hand is placed on the rock surface and paint is blown – usually through a hollow tube – in a diffuse cloud around them (stencils).

Coldstream Burial Stone, Artist unknown
Pigment on quartzite cobble, L (max): c.30 cm / c.12 in, South African Museum,
Cape Town

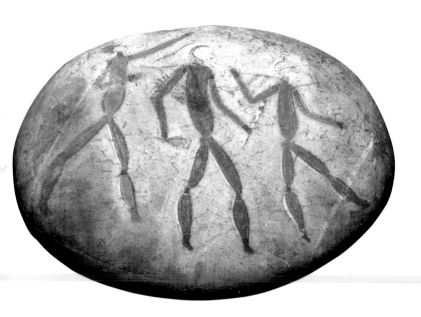

The three figures on this painted cobble are painted
in black, white and red pigments. The work is similar
to other examples of San rock art painted by southern
African hunter-gatherers for thousands of years to
as late as the nineteenth century, which obey specific
stylistic conventions. The back and top of the head is
painted in red, the face in white. The red bodies have
an elongated torso and lower limbs, while joints are
pinched and the overall effect of the limbs is insect-
like. The painted horizontal lines on the face of the
figure on the right may indicate that he is a medicine
man, as this convention is known at other sites for
which a San interpretation is available. The central
figure carries what may be a quill and palette for

producing art, making this image possibly the first
depiction of an artist in human art.

The stone was found in 1911 above a Late Stone Age
(c.40,000–6000 BC) burial in the Coldstream Cave,
in southern South Africa. Standards of excavation
were poor at the time, and existing records are not
sufficient to ascertain whether the stone dates to the
time of burial (in which case it would be of Late Stone
Age date) or whether its association is fortuitous (in
which case it could be much later); it probably dates to
earlier than c.2000 BC, whatever the circumstances of
its deposition.

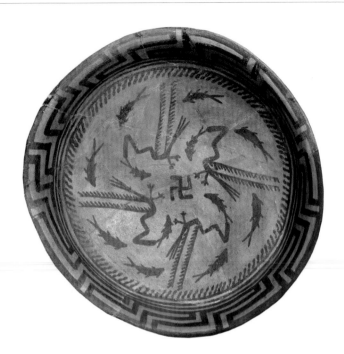

Samarra ware is some of the earliest pottery made using a slow-turned potter's wheel, and the brown-on-buff colouring is characteristic. Many of the figurative motifs in this early Mesopotamian pottery are reduced to geometric patterning in later prehistoric styles, culminating in polychrome Halaf ceramics.

The site of Samarra lies around 96 kilometres (60 miles) north of modern Baghdad. As well as the area's importance to prehistoric archaeology, the city can lay claim to some of the world's most important early Islamic art and architecture (see for example the Glass Beaker, p.197).

Although more common in Indian art, the ancient symbol of the swastika is occasionally attested in ancient Mesopotamia (modern Iraq). Here it gives direction to the swirling arrangement of fish and birds on this decorated plate, dating to the late sixth or fifth millennium BC. These animal forms, particularly the wings of the birds, relate closely to the more abstract geometric patterning towards the rim. The bold outer ring of decoration appears to reverse the direction of the swirl begun by the swastika in the centre, balancing and lending a sense of depth to the composition.

Samarra Ware

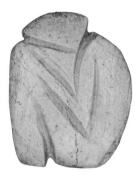

This Early Neolithic (c.6000–5000 BC) figurine, from Magoula Karamourla in Magnesia, the region of Mount Pelion, is carved from a yellow pebble shot with grey veins, with traces of the deliberate smoothing common to many Greek Neolithic figurines. Unlike many carvings in the round, this piece is highly stylized, representing a crouching figure in a strongly contracted position. The simple lines, which convey the impression of legs drawn up to meet the head and arms resting atop the knees, is a masterful example of the confidence of Neolithic sculptors, harmonious and unique for its time.

Such miniature human figurines are a common artistic product of the Greek Neolithic period (c.6000–3000 BC), in standing, seated or reclining poses; the seated images have occasionally been referred to as 'thinkers' in the style of Rodin (for a Palaeolithic 'thinker' see the Thinker of Cernavoda, p.8). Although male depictions exist, images are most frequently either female or without obvious gender. There has been much discussion as to why gender-ambiguous images were common; it could reflect sexual politics or simply the fact that gender was inappropriate or irrelevant to the use of the figurines. Whatever their precise function, the figurines most probably had some ritual purpose and were never merely toys.

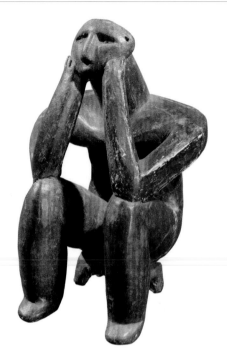

This terracotta figure, known as the Thinker ('Ganditorul'), was discovered in 1956 in settlement debris along with a female figurine, and although it is traditionally interpreted as male, it is interesting that its gender is ambiguous, as with many Neolithic figurines from southeast Europe. In general, it shares with this wider Neolithic world the small, angular, mask-like head placed atop a thick columnar neck, but here the head has a prism-like depth and oval outline. The eyes are large for the face, although unlike the convex 'coffee-bean' eyes typical of figurines from surrounding areas, the eyes on this piece are carved concavities. While the broad-hipped body in seated posture is shared with many other Neolithic figurines, the lack of engraved or painted detail on the body (as on the Cucuteni Figurine, opposite) is striking.

The Hamangia culture of southeast Europe was a society of Neolithic agriculturalists who began to adopt the art of copper metallurgy from early in the fifth millennium BC. The youngest (c.5000 BC) of several Hamangia settlement sites at Cernavoda, Romania, included a large necropolis containing more than 300 graves, and Cernavoda figurines were found in both the burials and in domestic contexts. Although in some respects they are typical of Balkan Neolithic sculptures of the sixth and fifth millennia BC, in others they are stylistically distinct.

Hamangia Culture

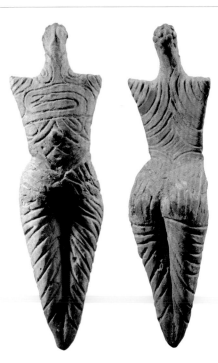

The Neolithic Cucuteni culture of Romania (c.4500–3000 BC) was a society of small-scale agriculturalists, like the Hamangia (see the Thinker of Cernavoda, opposite), who shared many characteristics of the Balkan Neolithic cultures. Most Cucuteni settlement sites have produced clusters of human figurines such as the one shown here, which seem to have had importance in the wider symbolic realm of sculpted figures of animals and houses.

Many Cucuteni sculptures are stylistically standardized and simply executed. This figure, from the settlement site Cucuteni A, is representative of a rarer group of highly stylized figurines that share similar proportions and elaborately incised

decoration. The figure is depicted standing, and in a manner surprisingly analogous to much earlier Palaeolithic 'venus' figurines it lacks lower legs, feet and arms, with little attention paid to the head. Even the face (seen on the left) has been rendered simply, with a beak-like pinch of clay. Concern instead seems to have been with a general shape of the piece, and its surface decoration. The degree of detail of engraved decoration on front and back is notable, and may depict clothing or other body ornamentation: tattooing, scarification, even jewellery. As with many prehistoric human figurines the status of this piece as a human depiction is clear, yet its precise function and form are ambiguous.

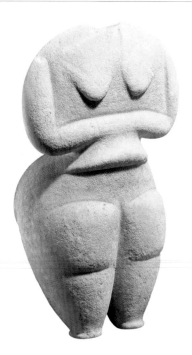

Although male figurines are known from the Greek Neolithic period (c.6000–3000 BC), females are far more numerous. The generous, fleshy proportions of this figure (c.4500–4000 BC), with exaggerated buttocks and thighs, are typical, and her slim waist further emphasizes the jutting belly, pendant breasts and wide hips. She may represent a fertility goddess, or have acted as a charm to encourage pregnancy. Such figurines have been found largely in settlement contexts rather than burials, in which grave gifts are rare; the location of the finds in domestic settings may reflect their function as living talismans.

Carved from marble, the lush, swollen curves and smoothness of the figurine are appealingly tactile.

Symmetrical from front and back views, body parts such as knees and hip joints are delineated with incised lines. Her pose, with arms folded across the chest, anticipates that of the more elongated Early Bronze Age Cycladic marble figurines (see the Cycladic Figurine, p.25). Similar figurines are known in clay, usually highly burnished. This marble example was carved using tools of obsidian (a volcanic glass from the Cycladic island of Melos) with pumice, another volcanic material, as an abrasive.

Dabous Giraffes, Artist unknown
Engraving on rock, H (max): 600 cm / 19 ft 6 in, In situ, Dabous, near Agadez

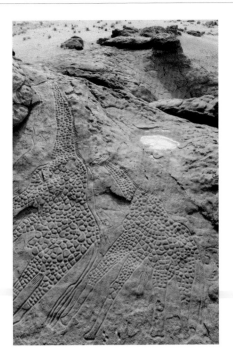

The Dabous giraffes, located north of Agadez in Niger, are some of the most striking examples of Saharan rock art known. It is not known who carved the figures, but they may have been created by the Tuareg people. Rock engravings spanning several thousands of years are common in the Dabous area; over 300 are known, varying in size from quite small to the life-sized depictions shown here. Probably dating to c.5000–3000 BC, each giraffe is engraved into a gently sloping rock face, the choice of location possibly a deliberate attempt to capture the slanting rays of the sun so that the shallow engravings were visible at certain times of the day; human figures representing local hunter-gatherers are drawn to scale below the giraffes. The naturalism, perspective and attention to detail are striking.

Africa's climate was much wetter during the period in which the engravings were made than it is at present, and the Saharan region was verdant grassland that supported a rich wildlife. Other examples of broadly contemporary rock art in the region depict elephants, gazelles, zebu cattle, crocodiles and other large animals of the grasslands, although giraffes appear to have been especially important to regional hunter-gatherer groups.

Possibly Tuareg Culture

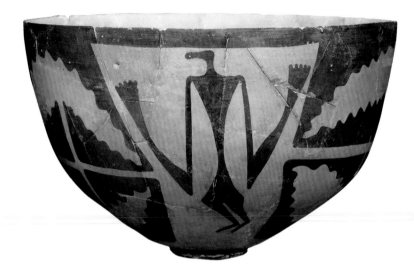

In south and southwest Iran during the fifth
millennium BC, vivid and well-balanced compositions
that integrated abstract and figurative elements
were produced in several painted ceramic traditions.
Valuable in their own right, these painted designs
reflect a comparable richness and variety in textile
production at a date from which no textiles survive.

While the majority of figurative motifs in these
ceramics depict animal, bird and plant forms, those
human figures that do appear are of great interest. In
Chalcolithic (c.5000–3500 BC) Iranian pottery, human
bodies are often portrayed with bird-like heads, as on
this bowl from Tall-i-Bakun in southern Iran. In this
case it is tempting to interpret the greatly elongated

arms and shortened legs as a depiction of the figure
in a transitory state between human and bird. The
ritual and religious implications of this interpretation
are tantalizing, but no later tradition sheds light on
the figure's identity. What is clear is that the human
figure's strange proportions are also related to the
composition of the scene, where the distortion of
body and limbs allows them to complement the bold
patterning of the bowl.

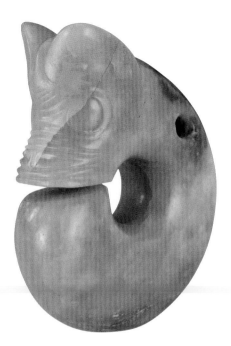

This jade pendant comes from Tomb 4 at Niuheliang, near Jianping, Liaoning Province, in the far northeast of China. The tomb was that of an evidently important male, and the object appears to have been placed on his chest; it has been drilled with a hole, which suggests it might once have been hung on a cord.

Among Chinese Neolithic peoples, those of the Hongshan culture (c.4700–2900 BC), stretching from Inner Mongolia to Liaoning, placed particular value on jade and achieved great skill in working it. The stone identified a social elite and probably played a part in religious rites. Several types of jade were used, ranging from light green to cream or blackish green in colour. Among a variety of artefacts and

figurines, some two dozen examples have been found depicting creatures with the head of a pig or bear and the body of what has traditionally been identified with the dragon, curled in a foetus-like shape. Bears were valuable to these hunting communities, and the ubiquity of pigs' bones in Neolithic sites indicates that besides being eaten, the animals were also sacrificed for ritual use. Chinese archaeologists believe that imaginary creatures such as the pig-dragon were invested with supernatural powers, and that the dragon itself may already have been worshipped by this time.

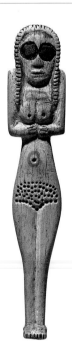

Female figures such as this, usually modelled in clay or carved in hippopotamus ivory or bone, were frequently placed in tombs during the Egyptian Predynastic period (c.5500–2972 BC), although so few come from legitimate excavations that their exact context remains unclear. It is thought that they may have served as an aid to rebirth in the afterlife.

This figure, dating to the middle of the Naqada I period (c.4000–3500 BC), shares many of the characteristics of the group: the narrow waist swelling to broad hips, with a very large and clearly defined pubic triangle. The belly is very slightly rounded, with a pierced belly button. Her arms fold under the breasts, another typical feature. The legs are pressed together, as in contemporary clay figures, but unlike most of those (see the Mourning Figure, p.17), the feet are indicated. The lack of a neck, the generally hunched appearance and the large circular eyes give the rather bizarre appearance of a woman sunbathing on a chilly day. The eyes are inlaid in lapis lazuli, which was imported from Badakhashan in Afghanistan and was always highly prized; its use here, even on such a small scale, indicates both the high value placed on this object and the existence of long-distance trade at a very early period.

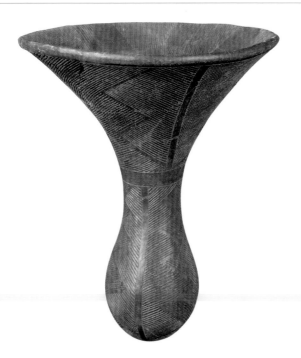

This libation vessel, dating to c.3600–3400 BC, was found at cemetery T.3, el-Kadada, in Sudan. It was coil-made, the inner and outer surfaces then slipped and burnished. The decoration with incised lines is a style that continued throughout the cultures of the Middle Nile valley to Christian times; in the earliest examples the design was made using a rocker stamp, giving a broken, dotted line.

The decorated field is divided into two main areas by a burnished rim and a narrow horizontal band around the waist. The upper and lower sections are further subdivided by vertical bands. Incised parallel lines create overlapping triangular and chevron designs, the incisions highlighted with a white pigment, a technique also characteristic of later vessels with similar decoration. The interior of the flaring mouth has five triangles similarly distinguished with incised parallel lines. The subtlety of the decoration emphasizes the elegance of the vessel's floral form.

The vessel is one of a number of vases of similar type and decoration from cemeteries at el-Kadada and Kadruka in Sudan, spanning a period of over a thousand years. The vessels were used only for funerary purposes, probably for pouring libations, and they were found only with what appears to have been the most important burial in a grave, whether it was that of a male or female.

Female Figurine, Artist unknown
Marble, H: 42.2 cm / 1 ft 4 in, Museo Archeologico Nazionale, Cagliari

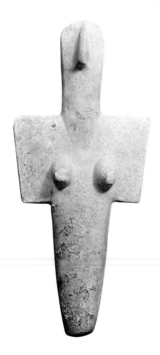

This white stone figurine from Turriga, Senorbì, was originally inserted upright into a stone base, which was set in the ground in an open-air *stazione*, probably a cult place, created by the Ozieri culture of Late Neolithic Sardinia (c.4000–3200 BC). Carved from the local Oriani marble, it represents a standing woman or goddess and is essentially a flat, abstract slab with no modelling other than small hemispherical breasts and an incised V at the base of the neck. The chest is a broad rectangle with sharp 'shoulders' above a tapered, triangular lower body; there is no indication of legs or garment. The front of a long, cylindrical neck is flattened to form a disc-face with a protruding triangular nose.

The distinctive angular sculptures of the Ozieri culture of northwestern Sardinia are loosely paralleled in the marble figurines of the Early Bronze Age Cyclades (see the Cycladic Figurine, p.25) and Crete. They are found in tombs and at cult sites along with other figurines that, in contrast to this piece, are modelled in an exaggerated, voluptuous design like the 'venus' figures of Paleolithic Europe; both types have been interpreted as fertility goddesses. As with the Cycladic idols, the graceful abstraction of these figures has made them popular with modern tomb robbers and art collectors.

Mourning Figure, Artist unknown
Painted terracotta, H (to hands): 29.3 cm / 11½ in, Brooklyn Museum of Art, New York

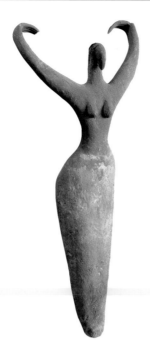

Simplified to the point of abstraction, this elegant and expressive figure raises her arms over her head, the hands folded back. Typically for figures of this date (Naqada II period, c.3500–3100 BC), the torso is triangular, although this is somewhat masked by the raised arms, and the pendant breasts are attached. A very narrow waist swells to broad hips and large buttocks; the whole of the lower part tapers, with the legs only lightly marked. Like so many early figures (cf. the Female Figurine, p.14), the feet are not modelled. The arms sweep upwards and bend slightly backwards, taper, and are then flattened into hands, the fingers carefully incised on both sides, emphasizing their importance. The head, usually described as 'birdlike', is a simple bent and pinched extension of the long neck; hair may once have been attached.

The whole figure was originally covered with red ochre, and a full-length white skirt was painted below the waist. The posture, also found in the painted decoration of a wide range of pottery vessels, suggests that this is a dancing or mourning figure, or that it has some association with resurrection. This example is one of two found in Burial 2 at el-Mamariya, the only figurines of this type from an excavated context.

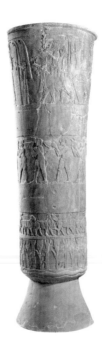

Technically superb and of unique archaeological importance, the Warka Vase may represent the earliest known example of narrative art in the world. Manufactured from a single block of alabaster, this massive vase is decorated with three registers of carved reliefs. Although it is contemporary with the very earliest writing and comes from Uruk (modern Warka), the city in which the first texts appeared, these texts were purely economic in nature and shed no light on the scenes on the vase. We can understand the vase's meaning only by means of comparison with much later Mesopotamian texts, although the iconographic continuity between the earlier and later traditions is strong.

The scenes almost certainly relate to a sacred marriage ceremony and are intended to be read from bottom to top. In the lowest register can be seen water, plants and livestock, representing the fertility and abundance of the land. Above them, a procession of naked men carry jars and baskets, presumably towards the top register, which shows a complex presentation scene in which a priest-king presents gifts either to the goddess Inanna, goddess of sexual love and of war, or to a priestess acting as her representative. In the sacred marriage, the king became the young shepherd god Dumuzid, while the priestess of Inanna became the goddess. This union renewed both the land's fertility and the connection between mortals and their gods.

Cruciform Figurine, Artist unknown
Picrolite, H: 5.5 cm / 2 in, District Museum, Paphos

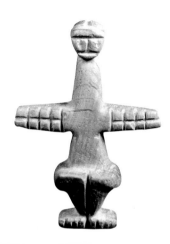

Cruciform figurines made of picrolite (a grey-green stone) are typical of the Chalcolithic (Copper Age) period in Cyprus (c.3800–2300 BC). Their form ranges from freestanding figurines to pendants like this one, the majority no more than 6 centimetres (2½ in) tall. Although many of the known examples were illegally looted and are thus without known context, the large number found in burials at the Souskiou cemetery near Paphos, whence this one may have come, reveals their great popularity as grave goods during the Cypriot Chalcolithic.

This figurine has a short body, elongated neck, outstretched arms, small head slightly tilted back, and legs bent in a squatting position. The segmented arms and schematic facial features are rendered with incised lines. In some figurines, the arms are replaced by a second figurine held horizontally; in other examples the figurine is smooth, with no facial features.

These cruciform figurines are often assumed to have had ritual functions, but an alternative interpretation sees them as fertility amulets, representing a woman in the act of giving birth. Found in settlements as well as burials, some may have been worn as pendants by the living as well as being offered as gifts to the dead.

Sleeping Lady, Artist unknown
Painted terracotta, L: 12.2 cm / 4¾ in, National Museum of Archaeology, Valletta

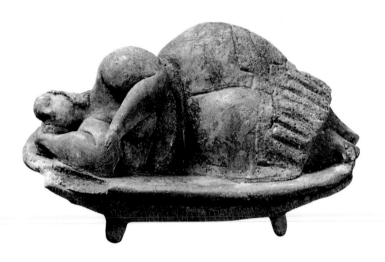

The Sleeping Lady of Malta is arguably the most famous symbol of the islands' prehistoric Temple Period (c.4100–2500 BC). This highly accomplished and evocative figurine has the delicate feet (assumed from similar figures – they are here broken away), massive thighs and pleated skirt typical of Malta's more monumental statuary; but unlike the asexual form of many of those sculptures, the figure is clearly female, with ample breasts. The complex pose is realistically observed, even if the proportions of the body are exaggerated, and the figure imparts an astonishing sense of liveliness in repose.

The figurine was found in what has been interpreted as a votive pit on the main level of the Hypogeum of Hal Saflieni (c.3300–3000 BC), a unique subterranean necropolis and cult centre carved out of solid rock; the pit also contained numerous amulets, beads, and animal and human figurines. The Sleeping Lady's similarity in features and dress to much larger statues found within the nearby Tarxien temple and elsewhere suggest that it may represent a deity, perhaps a form of mother goddess. Female obesity appears to have been an indication of fertility from earliest times. Another interpretation suggests that the figurine represents the rite of incubation, whereby a worshipper sleeps in a sanctuary in the expectation of receiving either physical healing or divine understanding through the medium of dreaming.

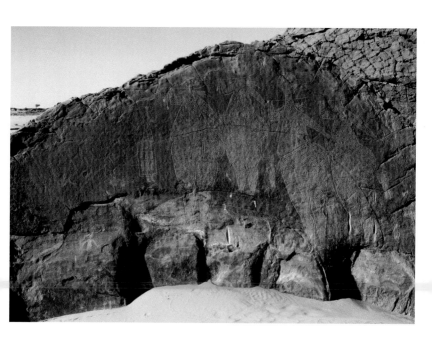

This series of colossal figures, from Niola Doa on the Ennedi Plateau in northeast Chad, is among the most exceptional of those produced some five or six thousand years ago. The contours of the so-called Niola Doa (Beautiful Ladies) suggest voluptuous female curves, while the dense abstract designs may depict body painting.

Images inscribed on rock surfaces in the Sahara chronicle the radical changes wrought by climatic shifts that have historically transformed the region: over hundreds of millennia, the Sahara's landscape has swung from verdant pasture to extreme aridity. Enormous naturalistic petroglyphs carved between 12,000 and 8000 years ago attest to the astonishing range of animal life that populated the region during that period, including elephant, rhinoceros, buffalo, giraffe, antelope, hippopotamus, lion and crocodile. A further significant shift occurred around 7500 years ago, when the imagery of regional engravings begins to emphasize human subject matter. This suggests a fundamental change in attitude, whereby man came to conceive of himself apart from nature.

Not long after the figures shown here were created, a series of droughts forced local populations to migrate north, east and south. Consequently these early designs may be precursors of forms of expression that subsequently developed across the continent.

Kneeling Bull with Vessel, Artist unknown
Silver, H: 16.3 cm / 6½ in, Metropolitan Museum of Art, New York

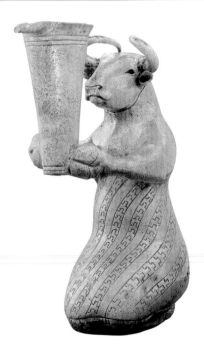

This figure is one of the earliest known examples of sophisticated metalworking in art. The silver statuette comes from southwest Iran at a time when that area was closely connected to the world of southern Mesopotamia (modern Iraq). The two regions saw the appearance of the first cities and of writing at the end of the fourth millennium BC, and artefacts such as this can be seen as products of rapidly changing cultural environments. In Iran the period is known as proto-Elamite, after the probable language of the area's earliest writing. Although there was a steep decline in the quality of pottery at this time, rare surviving metalwork such as this testifies to the emergence of new and sophisticated artistic techniques and themes.

The meaning of the piece is unknown and may relate to now lost mythological themes. Part bull and part human, the sculpture contains pebbles, the purpose of which may have been to make a noise when shaken. The rendering of the figure is naturalistic in its representation of the bovine head and the body's curves, yet it retains the simplicity and aesthetic appeal of a schematic, semi-abstract work. The figure is far from austere, however: its humble pose contrasts with the valuable silver of which it is made, and despite the figure's supernatural form, the posture seems inappropriate to either deity or demon.

Palette of King Narmer, Artist unknown
Siltstone, H: 64 cm / 2 ft 1 in, Egyptian Museum, Cairo

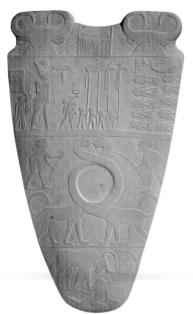

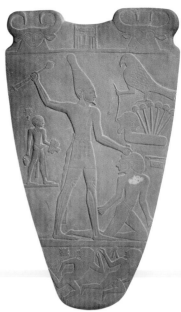

This votive (an object offered to a deity) was presented by King Narmer (reigned c.3000–2972 BC) to the temple at Kom el-Ahmar (Hierakonpolis), in modern Al Minya, Egypt. Palettes such as this were used to prepare paint for ritual make-up; this one, carved in low relief, is non-functional, but it retains the characteristic shape of the serviceable object.

The scenes express the might of the king and his ability to suppress any opposition. Narmer's name is flanked on both sides by two cow-headed goddesses. On the front (left), the king inspects the bodies of decapitated enemies. Two long-necked felines are probably a version of the lion-taming motif that was widespread in the ancient Near East. At the

bottom, the king, as a raging bull, destroys an enemy settlement. On the back (right) is the prototype for what was to become a traditional scene showing the king slaying an enemy – a statement of the King's sovereignty over a recently united Egypt.

The palette of Narmer is one of the earliest objects displaying the conventions governing Egyptian two-dimensional representations. Figures are arranged in registers on a single ground line, and humans are shown as composite images: the face in profile, with only one eye, the shoulders in front view, the waist in three-quarter view, the arms and legs again in profile. These conventions would remain in use throughout the rest of ancient Egyptian history.

c. **2600** BC
Iraq

Sumerian Votive Statuettes, Artist unknown
Gypsum, inlaid shell, black limestone and bitumen paint, H: 72 cm / 2 ft 4½ in (left);
59 cm / 1 ft 11¼ in (right), Iraq Museum, Baghdad

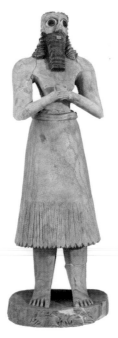

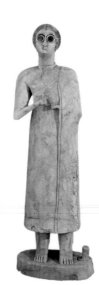

These figures, significantly larger than the other statues with which they were found, were discovered deliberately buried beneath the floor of the Square Temple at Eshnunna (modern Tell Asmar) and were initially thought to represent gods. They are now interpreted as performing the same function as their smaller companions: standing upright in the temple, facing the statue of a god on behalf of human dedicants. Sculptures such as these were placed in temples to pray constantly for the individuals who had dedicated them, their wide eyes expressing their constant attention and devotion to the deity. More than simple object symbols, they were considered to perform the act of prayer on behalf of those who,

on some level that is no longer understood, they physically represented.

That no statue of a god has been found in the temple is not surprising, as the deity statues were probably constructed of precious metals laid over wooden cores. Like the vast majority of ancient metalwork, these Early Dynastic period (c.2900–2350 BC) statues would eventually have been melted down and their materials recycled.

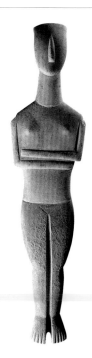

Marble figurines were produced throughout the Cycladic islands of Greece during the Early Bronze Age (third millennium BC). A range of stylistic groups has been recognized, and individual hands identified by some scholars. This example is one of several by the so-called Goulandris Master; it dates to c.2800–2300 BC. The form of most figures is conventional: a standing or reclining posture, legs together and arms crossed below the chest. The apparent austerity of the face with its prominent nose gives a false impression, since on many examples facial features and details such as body paint or tattoos were added in paint.

Cycladic figurines were held in high esteem by early twentieth-century artists such as Picasso and Modigliani, whose work they influenced. They have proven popular on the international art market (partly due to misconceived perceptions of their minimalist abstraction), leading to illicit excavation and forgeries. As a result of a lack of knowledge about the archaeological context of most figurines, their function and significance is unclear. Some of those from licit excavations have been found in burials, others in settlements, and various theories suggest roles for them as mythological characters, deities, adorants or apotropaic figures. Alternatively, they may have served as ancestor symbols, replacements for human sacrifices, or even children's toys.

Bull Vessel, Artist unknown
Painted ceramic, H: 35.5 cm / 1 ft 2 in, American Museum of Natural History, New York

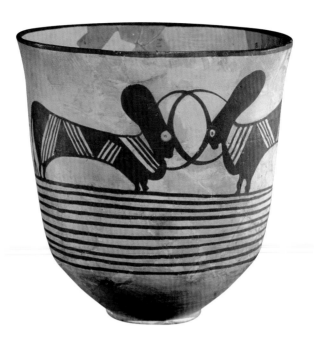

Many of the communities that settled in the valleys of modern Baluchistan in northern Pakistan during the Neolithic period (c.7000–5500 BC) developed distinct regional pottery styles that flourished independently until they became integrated into the wider Indus Valley ceramic tradition. This unique, intact vessel from Damb Sadaat, in the Quetta valley, is indicative of one of those highly specialized ceramic styles that developed in the western uplands of the Indus, known as Quetta ware.

The stylized bulls form a sophisticated frieze-like design above lines that circle the vase, part of a well-developed Bronze Age (c.2600–1200 BC) ceramic painting tradition.

As with most Quetta ware, the vessel is decorated with a black-on-white slip and was wheel-made. The humped zebu cow, indigenous to South Asia, held a particularly important role within the cultural and economic traditions of the Indus Valley. Zebu are frequently depicted on ceramics from this region and period, a reflection of the animal's importance to the pastoral communities of Baluchistan.

Bronze Age, Indus Valley Tradition

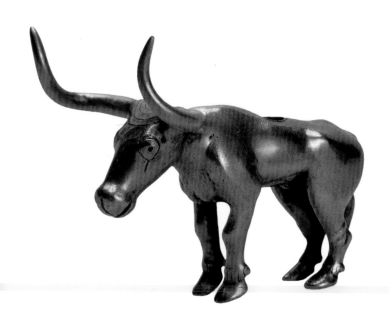

This spectacular gold bull was discovered in a large mound (*kurgan*) near Maikop, in the northern Caucasus region of Russia, in 1897. The burial chamber contained the skeleton of an elite, probably royal male wearing several superb necklaces and a conical diadem of gold hoops that were decorated with gold rosettes similar to finds from the late third-millennium city of Ur, in southern Iraq. A number of silver tubes found in the tomb are thought to have been supports for a curtained canopy over the body, or free-standing standards. To four of these hollow rods were once affixed this gold bull, its twin, and two silver bulls.

The bull was cast using the lost-wax process (for an explanation of which, see the King of Akkad, p.31),

with a vertical hole left through the centre of the body to accommodate the silver tube. The inclined head is decorated with incised concentric circles between the inward-curving horns, and incised lines also represent the mouth, nose, eyes, the fur above the hooves, and the hair of the tail.

The bull is reminiscent of Mesopotamian sculpture during the third and early second millennia BC (see the Kneeling Bull with Vessel, p.22), and several other artefacts from the burial employ motifs commonly seen in Sumerian and Elamite art. As such, the Maikop *kurgan* provides valuable evidence for the influence of the ancient Near East on the cultures of the Bronze Age Caucasus region.

c. **2500** BC
Iraq

Standard of Ur, Artist unknown
Shell, red limestone and lapis lazuli on wood, 21.6 x 49.5 cm / 8½ x 19½ in,
British Museum, London

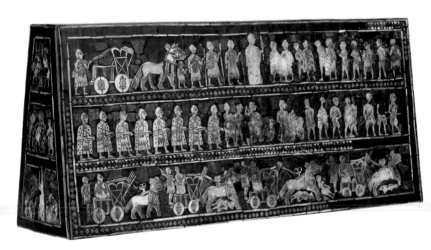

Discovered in the royal cemetery of Ur during
the 1930s, the standard of Ur is one of the most
important examples of narrative art from ancient
Mesopotamia (modern Iraq). The intricate mosaics
that form its panels are composed of cream shell, red
limestone and brilliant blue lapis lazuli, which must
have originated in far-off Afghanistan. The piece
is known as a 'standard' because the excavator, Sir
Leonard Woolley, thought it was carried on a pole.
This now seems unlikely, although its actual use is
still uncertain; the scenes may have decorated the
soundbox of a musical instrument.

The standard's two sides, known as 'war' and
'peace', were intended to be read from bottom to top,
although events in such compositions are not always
depicted in strictly chronological order. In the bottom
register of the war panel, shown here, we see the battle
itself: onager-donkey crossbreeds pull the chariots of
Ur over the bodies of the city's enemies. In the middle
register, Sumerian soldiers kill the last of the enemy
fighters while driving a group of prisoners before
them. In the top register the captives are brought
before the king, shown in the centre as physically
larger than other men. Behind the king can be seen his
own war cart. The peace panel, on the opposite side,
shows a procession of goods being carried up to a royal
banquet, normally interpreted as a celebration of the
victory depicted on the war panel.

Louvre Scribe, Artist unknown
Painted limestone, H: 53.7 cm / 1 ft 9 in, Musée du Louvre, Paris

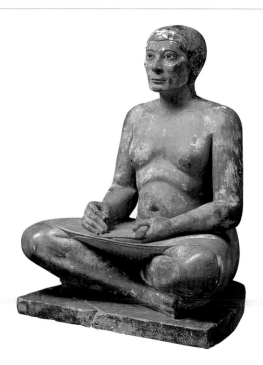

This statue was probably found in the tomb of an official called Kai at Saqqara, near modern Cairo. Although it bears no inscriptions, we can be fairly certain that it represents the tomb owner himself. The scribe is seated cross-legged on the ground, apparently holding a reed pen (now lost, if it ever existed) in his right hand, while his left hand grasps a papyrus roll on which he is writing, spread on his firmly stretched kilt.

The ability to read and write was essential for anyone holding an administrative office in ancient Egypt, which explains the popularity of scribe sculptures: even the highest officials liked to be represented as scribes. The face of the man conveys concentration, suggests intelligence, and gives the impression of individuality. This may imply that the sculptor tried to record the actual appearance of the tomb owner, but this is unlikely. Nevertheless, the quality of this piece is such that we must assume that it was made in one of the workshops that normally specialized in the production of royal sculptures. There was a considerable difference between statues created for kings and those made for commoners. This is one of the most impressive non-royal statues of the Old Kingdom (c.2647–2124 BC).

Folkton Drums, Artist unknown
Chalk, H (left to right): 8.7 cm / 3½ in; 10.7 cm / 4 in; 11.8 cm / 4½ in,
British Museum, London

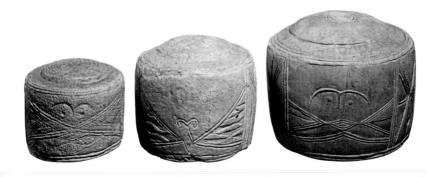

These drum-shaped objects were found in 1889 during the excavation of a Neolithic burial mound (c.2800–2000 BC) in North Yorkshire, England. The central burial in the mound was surrounded by two concentric ditches, into which several further graves had been cut. One of these graves contained the body of a young child, accompanied by the three 'drums' shown here and a bone pin.

The drums are made from intricately carved, solid lumps of chalk. They are entirely unique: no comparable objects have ever been found. The techniques used to carve them are very similar to those used in woodworking, however, and it is possible that similar wooden objects (which no longer

survive) may once have existed. The shapes of the drums echo those of broadly contemporary Grooved ware pottery vessels, which are often decorated with similar lozenges of incised lines. Two of the drums display 'eyebrow and eye' motifs, which represent an extremely rare depiction of the human form in prehistoric British art.

As these mysterious objects are unique, it is very difficult to ascertain the role they would have played in the life of their owner. The fact they were buried with a child may indicate that they were toys or even some kind of musical instrument. Their inclusion as grave goods could suggest that they had some kind of spiritual or symbolic significance.

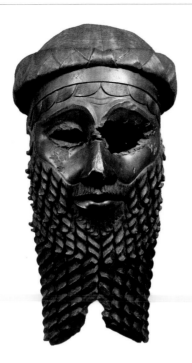

This remarkable copper head represents a king of Akkad (a still unidentified city in what is now southern Iraq), one of the rulers of what was arguably the world's first empire. Although it seems certain that the sculpture represents a specific individual, and is one of the earliest portraits in Mesopotamian art, the identity of the subject is still debated. Traditionally it has been assigned to Sargon (reigned c.2334–2279 BC), founder of the Akkadian empire and remembered as an ideal king and hero. Recent scholarship, however, ascribes the portrait to Sargon's grandson, Naram-Sin (reigned c.2254–2218 BC), who in later tradition is seen as the epitome of the bad king, responsible for the downfall of the empire and ruling dynasty of Akkad.

The entire piece is very finely worked, but the minute detail of the king's beard and hair is particularly striking. The bust was made using the lost-wax process, whereby the head was first modelled in clay, which was then covered with a wax layer into which details were carved, followed by a covering of clay. When fired, the wax melted away, leaving a void between the two clay elements, into which molten metal was poured. Finally, fine detail such as the texture of the hair was chased or incised on the cold surface. The severe damage to the king's eyes, probably originally inlaid with coloured stones, is thought to have occurred in antiquity, possibly as a deliberate and violent attempt to disfigure the portrait.

Cylinder Seal, Artist unknown
Serpentine, H: 3.9 cm / 1½ in, British Museum, London

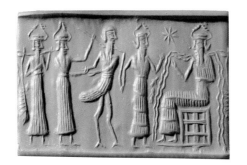

This Akkadian cylinder seal (see the King of Akkad, p.31) shows the god Ninurta presenting the captured Anzû bird (known in Sumerian as Imdugud) to Ea, from whom he stole the Tablets of Destiny (in other versions this role is played by Enlil). Two attendant gods stand behind. Ea, identified by the streams of water flowing from him, was god of the freshwater ocean beneath the ground. He was also associated with crafts and magic. His importance here is shown by his size and by the fact that he is seated. All the gods in ancient Mesopotamian art are depicted with horned caps. Anzû is depicted as a birdman, but in other representations he combines the attributes of eagle and lion.

Invented in Mesopotamia in the fourth millennium BC, cylinder seals are one of the most important sources for the iconography and art of the ancient Near East. Seals were unique to their owner, and a great variety of subjects and styles are represented. Carving techniques became more sophisticated over time, with the use of specialized drills and cutting tools. The type of stone was chosen in some instances because it was more easily carved, and in others for the attractiveness of the stone itself (as in this case). Seals were pierced through the centre, allowing them to be worn on strings or metal pins, and we can assume that the seal as well as its impressions would have been visible in some way.

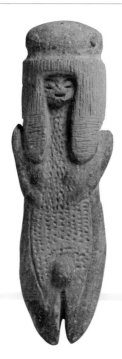

The Valdivian culture of coastal Ecuador created the earliest known ceramic human figural art in South America, beginning around 4000–3500 BC. This figurine, dated to the end of the third millennium BC, was made of two rolls of clay pressed together and then sculpted to form the standing figure – the standard method of production for these objects. Most of the figurines are nude females, prompting their interpretation as fertility objects of some kind, but some, as here, show both male and female sexual characteristics: breasts and a lower abdominal protrusion that has been interpreted as male genitalia. The front of the figurine is punctuated with incised dots, the arms, legs, breasts and supposed phallus left bare. The elaborately styled hair, typical of Valdivian figurines, frames the face; the bulbous coiffure would remain popular for millennia among the peoples of western Ecuador.

Often but not exclusively from domestic contexts, and frequently found intentionally broken, the figurines may have played a role in rituals concerned with daily life and survival, such as healing ceremonies. Their highly stylized renderings attest to the artists' sculptural sensitivity and to the expressive possibilities of the understated form.

Notched Bannerstone, Artist unknown
Banded slate, 13 x 14 cm / 5 x 5 in, Steve and Susan Hart Collection,
Huntington, Indiana

The rare ovate shape of this unusually fine
bannerstone, dated to c.3000–1000 BC, is enhanced
by the addition of side notches that together produce
a balance and symmetry unmatched in this category
of ancient Native American objects. Despite the
relatively small size of bannerstones, the holes drilled
down their centres led early scholars to infer that
they were ornaments or emblematic 'banners' placed
on poles. Since most examples were random finds or
looted from graves, recognition of their true function
was delayed for some time. The few identified in
archaeological contexts, plus the result of various
experiments field, now indicate that these pieces
served as counterweights for *atlatls* (throwing sticks).

In North America they were the major hunting tools
prior to the bow and arrow, only about 1000 years ago.

Most bannerstones are relatively simple in form,
but since they require bilateral symmetry for balance,
their manufacture provided the makers with the
opportunity to create a wide range of impressive and
imaginative forms. The flaring wing form of the ovate
type seen here is best known from the region south of
the western Great Lakes, but variations of this type
appear all over the eastern part of the continent. A
wide range of other shapes is known from all parts of
North America.

Flame-Rimmed Vessel, Artist unknown
Terracotta, H: 61 cm / 2 ft, Cleveland Museum of Art, Cleveland, Ohio

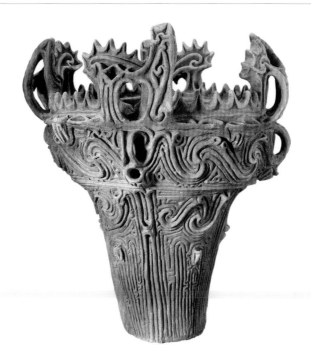

This remarkable coil-built vessel of the Middle Jomon period (c.2500–1500 BC) was produced by one of the earliest societies to occupy the Japanese archipelago – the pre-literate hunter-gatherers known as Jomon (c.10,500–300 BC), who occupied Japan during the Neolithic period. To the archaeologists who discovered this and similar vessels in the early twentieth century, the serrated motif around the rim suggested flames, leading to the descriptive term 'flame-style vessels' (*kaen-shiki-doki*).

Such vessels have often been found to contain traces of carbonized food, but they are in a better state of preservation than plainer earthenware food vessels, suggesting that they may have been used in a ceremonial or ritual context. The elaborate design reinforces this theory, with the dynamically crested handles and spiral wave motifs pointing in the same direction and strengthening an appreciation of the vessel's overall form. The exact significance of the design and the function of the vessel nevertheless remain unknown.

More than 50 vessels of the type have been found, but only in the Shinano River valley, a remote region of northeast Honshu, the main Japanese island. These nearly sculptural artefacts represent one of the finest creative achievements of the Jomon culture.

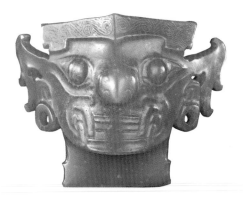

Like the *taotie* mask (see the Face Plaque, p.39), this face combines human features with the large fangs of a monster. The facial details are finely carved to stand out prominently in relief. The creature has large holes in its ear lobes and wears a crown-like headdress, through which a pattern of scrolls and lines appears to suggest hair.

Even as early as the Neolithic period (c.6500–1600 BC), artefacts made of jade travelled widely across China. Designs related to those of the Shijiahe culture (c.3000–2000 BC) of Hubei Province in central China appear on jades of the east coast, and include a number of carved faces. The purpose and significance of these artefacts are unknown, but in later centuries

people evidently liked them, perhaps seeing in them a similarity with the *taotie* design familiar from ritual bronzes. Examples of such faces have been found in tombs of the Shang and Western Zhou periods (c.1600–771 BC), as far apart as Jiangxi Province in the southeast and Shaanxi Province in the northwest, though whether they had been collected or copied is a matter of some debate.

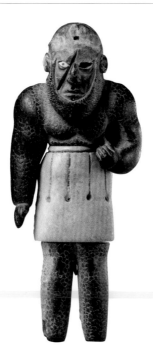

This figurine is said to have come from the Fars region of Iran, but it is more likely an artefact of the Oxus civilization of Central Asia. These sedentary Bronze Age people, who occupied northern Afghanistan, southern Uzbekistan and western Tajikistan around 2200–1700 BC, had an impressive material culture that included monumental architecture, bronze tools, elaborate clay figurines and the so-called 'scarfaces'. These are composite figures made of green chlorite incised to resemble serpents' scales, with white calcite for the skirt. Here, the surviving eye is made of calcium carbonate, presumably from shell. A band of meteoric iron encircles the head, in which there is a small hole for the insertion of horns.

These dragon-men of Central Asian mythology represented the violently malevolent forces of the underworld, and their power was contained not by killing but by silencing them. This was accomplished with a slash across the right cheek and the insertion of nails (now lost) in the tiny holes on either side of the lips, to prevent the scarface from speaking. Thus dominated, the being became benevolent. The figure was carved to hold a vessel under his left arm, perhaps valuable water being withheld.

Dragons and serpents are fundamental in early mythology, symbolizing primitive, malicious forces of nature. They seldom take human form, however, and these few figures are unique.

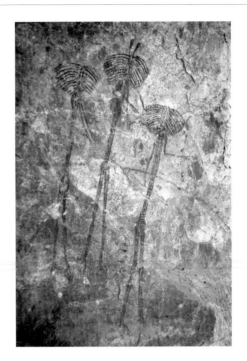

These three attenuated and willowy figures enhance a large hillside shelter in central Tanzania. It has been suggested that the distinctive configuration of their prominent heads may represent elaborate hairstyles or headdresses. This painted passage is striking for the extreme delicacy of the wispy, ethereal forms. So organic is their appearance that they evoke the imprint of a fossilized fern or finger.

Unlike Europe's Palaeolithic paintings, which are found deep within caves, painted and engraved images in Africa tend to occur in far more accessible cliff shelters and below shallow overhangs. In eastern Africa almost all of the rock art is found on a massive inland plateau that extends from the Zambezi River

valley to Lake Turkana. This corpus consists primarily of paintings concentrated in central Tanzania, which have been attributed to ancestors of the modern Sandawe people. In this region it appears that artists worked predominantly in a single primary colour, relying exclusively on red, black or white. Paintings whose subject matter is rendered in red tones feature animals, people and abstract geometric motifs.

Face Plaque, Artist unknown
Bronze and turquoise with traces of hemp, 14.2 x 9.8 cm / 5½ x 4 in,
Institute of Archaeology, Chinese Academy of Social Sciences, Beijing

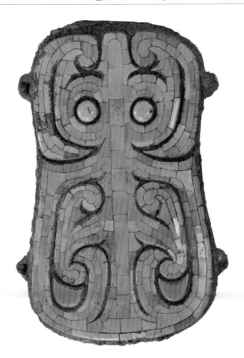

The design of this attractive plaque, dated to the eighteenth century BC, is not purely abstract but conceals a fanciful image of a face, arranged in matching halves on either side of a central snout. Perhaps it is related to the British Museum's jade face (p.36). Before the end of the millennium the 'mirror-image' face would become a frequently used motif in the bronze designer's pattern book, known as the *taotie* decoration and often described as a monster. The exact significance of these images is still not properly understood.

As its quality suggests, the ornament comes from an elite tomb; four loops show that it was meant to be hung or tied to a garment or other surface. Erlitou,

in Henan Province, where the object was found, may have been the capital of the Xia realm, forerunner of the Shang state (c.1600–1045 BC), and bronze foundries were among its craft workshops. Two similar plaques have been found at Erlitou and three more at Sanxingdui, in Sichuan Province. They are early examples of the bronze caster's art, and ally it with the skill of precious stone working that was by now long-established in parts of China. The combination of bronze with turquoise indicates contemporary aesthetic taste as well as economic value.

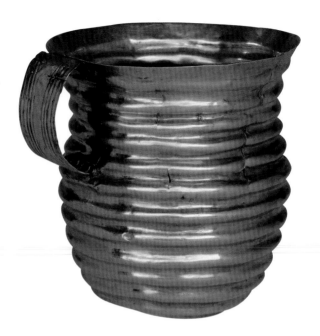

This Early Bronze Age (c.1700–1500 BC) cup is made from intricately crafted sheet-gold beaten into shape from a single piece of metal. Its ribbed construction would have added strength to the vessel, as well as serving a decorative purpose. A limited number of comparable cups, made from silver, amber and shale as well as gold, have been found at various sites across northwestern Europe.

The cup is testament to the highly sophisticated metalworking techniques that developed during the Bronze Age (c.2200–800 BC), by means of which gold neck-rings, earrings and even a cape were produced, along with bronze weapons and tools. Many of these objects were found in burial mounds, suggesting that they may have been symbols of power associated with people who had perhaps gained influence through continent-wide metal exchange networks.

The cup was found in 1837 by workmen quarrying for stone within a burial mound in Cornwall, southwest England. It had been placed with the body inside a stone cist (box-shaped chamber); other grave goods included a bronze dagger, glass beads and a pottery vessel. According to the ancient law of treasure trove, the cup, being gold, was declared property of the Crown. It remained in the British royal family for almost a century, most notably being used by King George V to hold his collar studs.

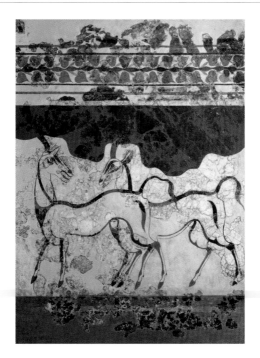

Many Late Cycladic (c.1600–1050 BC) frescoes have been preserved at the Bronze Age town of Akrotiri on the island of Thera (Santorini) as a result of the volcanic eruption that destroyed the site during the sixteenth century BC, burying it under ash and pumice. The wall paintings were found in situ in houses and other buildings, albeit in tiny pieces.

This fresco of two antelopes comes from a small room in Building Beta, a shrine complex, together with a scene on an adjacent wall of two boxing boys. The antelopes are depicted in outline, yet the overlapping composition creates a sense of depth; the turned-back head of the first has been said to express the competitive belligerence characteristic of the species. The juxtaposition of these animals, which were painted on three walls, with a pair of young boys on the fourth, apparently engaging in ritualized fighting, suggests a programme for the decoration of the room based on confrontation or ritual challenge.

The survival of the Thera frescoes has provided information about the techniques used in Bronze Age wall paintings. The stone was first covered with a layer of mud and straw, followed by several layers of plaster. Both the *buon fresco* technique (painting when the plaster is still wet) and *fresco secco* (painting on dry plaster using a material such as egg white as a fixative) were used. Colours were often mineral-based, such as the red made from iron-rich soil or haematite here.

c. **1550** BC
Greece

Inlaid Dagger Blades, Artist unknown
Bronze, gold, electrum and niello, L: 23.8 cm / 9¼ in (lion hunt),
16 cm / 6¼ in (panther and ducks), National Archaeological Museum, Athens

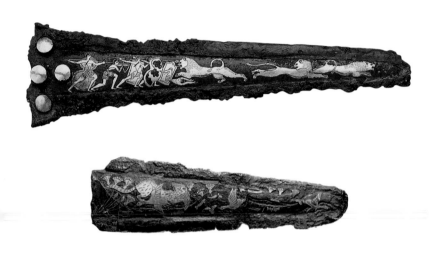

To make these striking daggers, dated to c.1600–1500 BC, different coloured metals (gold and electrum) were inlaid on a metal backing that was sunk into the bronze blade of each dagger. The black filling is niello, a compound of copper and silver sulphides that melted and solidified to a shiny, metallic surface when heated. The blades were attached to short hilts (now lost) by means of gold rivets.

On the lion hunt blade (top), from Shaft Grave IV at Mycenae, the hunters carry weapons and shields of the characteristic Early Mycenaean (c.1600–1390 BC) figure-of-eight and 'tower' types. Similar battle scenes occur on other objects from the Shaft Graves, such as seals and a gold ring, and in later frescoes from the

palaces of Pylos, Mycenae and Tiryns. On the second dagger (bottom), from Shaft Grave V, a cat or panther chases ducks in a Nilotic landscape. The Egyptian scene was probably known to the early Mycenaeans via Cretan representations, for at this early stage mainland Mycenaean art was much influenced by Minoan styles and techniques. Use of precious materials to create portable prestige items is typical of both Minoan and Mycenaean artistic production.

Set within two grave circles, the Shaft Graves at Mycenae contained offerings of extraordinary wealth, including gold masks, stone and metal vessels, and weaponry, the last suggesting the great value placed on warrior prowess in the early Mycenaean chiefdoms.

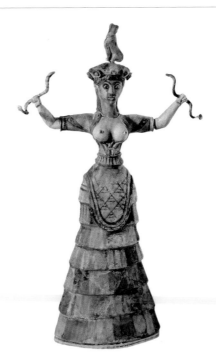

This figurine, dating to the Neo-palatial period (c.1600–1425 BC), is one of three faience female statuettes found in the Temple Repositories at the Minoan palace of Knossos – two stone-lined cists (box-shaped chambers) located near the Throne Room that contained pottery, clay seal impressions and faience objects. She wears the typical Minoan female costume, consisting of a tight, breast-revealing bodice and flounced skirt, and holds two writhing snakes in her outstretched arms; she is one of two 'assistants' to a larger figure.

The location of the Snake Goddesses near the Throne Room suggests that they may have been used in ritual performances at the palace. They may also be linked to 'mistress of the animals' representations, a Near Eastern-derived cult motif consisting of a female flanked by two animals (see also the Cosmetics Box Lid, p.51).

Faience is an artificial vitreous material with a silicate body (made from sand or crushed quartz) and glazed surface layer, coloured with metal oxides. The technology was imported from Egypt or the Levant during the second millennium BC and used in a range of vessels, inlays, seals and figurines. The Snake Goddesses are the most elaborate faience objects known from Crete, featuring intricate modelling, polychrome patterning and complex assembly from multiple parts (torso, limbs and snakes).

c. **1475** BC
Greece

Vapheio Cups, Artist unknown
Gold, H: 8.4 cm / 3½ in (left), 7.8 cm / 3 in (right),
National Archaeological Museum, Athens

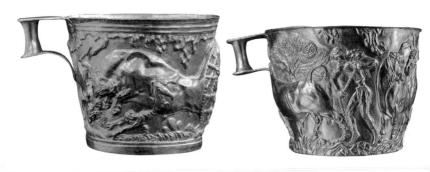

Although found on the Greek mainland in the
Vapheio tholos tomb, near Sparta in southern
Greece, these two Early Mycenaean (c.1600–1390 BC)
gold cups are generally agreed to be of Cretan
manufacture. Like similar precious metal vessels and
other prestige items found in mainland burials (see
the Inlaid Dagger Blades, p.42), they are thought to
be too advanced in technique to be locally produced at
this time, and the shape has a long history in Cretan
pottery, first seen in the early Middle Minoan period
(c.2000–1900 BC). Bull leaping was a popular artistic
theme in Minoan Crete, probably representing a
ritual sport or performance practised in the palaces.
Narrative scenes in landscape settings are also known

from Aegean wall paintings on Crete and the island
of Thera (Santorini).

Both cups feature bull scenes, but contrast in tone:
one violent, the other peaceful. On the first cup (left),
a bull is caught in a net, throwing one huntsman to the
ground while another attempts to grasp its horns. On
the second (right), a cow is used as a decoy to enable a
huntsman to tether the leg of a bull. In both cases, the
human and animal figures are worked in high relief,
the astonishingly detailed modelling – hammered
from the reverse side using the *repoussé* technique –
giving a strong sense of effort and motion. The twisted
torso of the netted bull, in particular, vividly portrays
the animal straining to free itself.

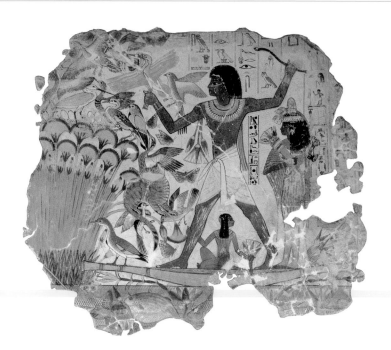

Rock-cut tombs on the Theban west bank (opposite modern Luxor) were often decorated with exquisite paintings like this one from about 1500 BC. The owners were important officials of state and local administration, or priests. The theme of hunting fowl was usually paralleled by spearing fish; the latter scene was also present here (there are remains of the spear in the bottom left corner) but is now lost. Nebamun, a 'reckoner of grain', is shown standing in a small skiff about to launch a throwstick among the flock of birds rising from a papyrus thicket. Such scenes did not reflect contemporary reality. Rather, they maintained the traditional theme of provisioning and combating the forces of chaos represented by the wild fish and

birds in the marshes. The inclusion of a cat reflects the ubiquitous presence of this animal in contemporary Egyptian households. Unfettered by the strict conventions that applied to representations of people, in this creature the artist produced a masterpiece that undeniably surpasses the boundaries of Egyptian conventions and could be easily mistaken for a modern artistic creation.

New Kingdom, Eighteenth Dynasty

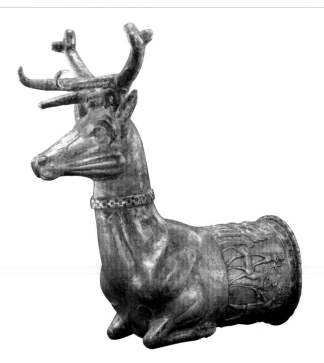

By the late second millennium BC, when the Hittite empire (c.1380–1200 BC) flourished in Anatolia, the stag already had a long history as a religious symbol. Scenes decorating the body of this ornate silver rhyton (a vessel used for pouring liquid offerings) give clues to its ritual significance. The relief shows the pouring of a libation before a male and a female deity, both of which hold birds of prey; the male figure stands on the back of a stag. Two other figures making ritual offerings accompany the pourer of the libation, and behind them is another possibly dead stag, a tree from which hang a quiver and hunting bag, and two spears. The scene simultaneously suggests a ritual hunt and a special status for the stag as a sacred animal.

The most remarkable feature of the vessel, which dates to the fifteenth to thirteenth century BC, is, of course, the beautifully rendered stag's head. Attached to the main body of the vessel at the collar, the horns were added separately. Modern reactions to an ancient image can be highly misleading, but the sense of great dignity and elegance this brilliantly observed and executed figure immediately evokes, even for the present-day viewer, would certainly be appropriate in reverence for a deity to whom the stag was sacred. In performing a libation, liquid would have been poured into the rhyton at the wide funnel at the top, and out through a small hole in the stag's chest.

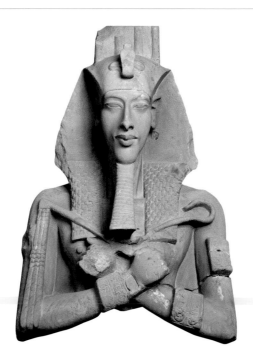

This fragment of a colossal statue of King Akhenaten (r. c.1353–1337 BC) was some 4 metres (13 ft) tall when complete. It is one of many that originally stood with their backs attached to pillars in temples built by this religious reformer for his new state deity, the Aten (the sun-disc), at Karnak East, in southern Egypt.

The king is shown in the new representational style that appeared early in his reign and which probably owed a great deal to his own personal appearance. The image is brutally unflattering: the king's face is gaunt, with hollow eyes, a prominent nose, conspicuously sensuous lips and a sharp chin. His neck is unusually long. The wristbands and armlets display the names of the Aten.

This sculpture is a far cry from the earlier idealized representations of Egyptian kings, but it was imitated in portrayals of other members of the royal family (see Akhenaten and Nefertiti with Daughters, p.48) and even in non-royal representations. The radically severe style was characteristic of the early phase of Akhenaten's reign but was softened in later years.

c. **1345** BC
Egypt

Akhenaten and Nefertiti with Daughters, Artist unknown
Painted limestone, 32.5 x 39 cm / 1 ft x 1 ft 3½ in, Ägyptisches Museum, Berlin

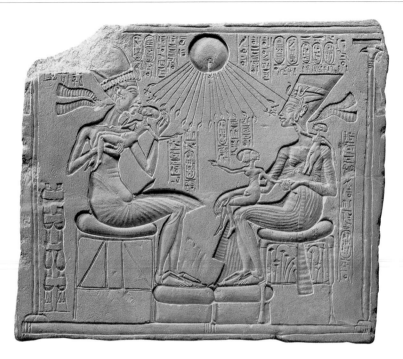

This relief-decorated slab probably formed the central part of a small altar in a house at El-Amarna, the new capital of Egypt founded by King Akhenaten (reigned c.1353–1337 BC). Its subject reflects the profound changes that took place in Egyptian religion during Akhenaten's reign, the so-called Amarna period. The king's reforms replaced the previous multitude of gods by one deity, the impersonal sun-disc (the Aten), and the king and his family acted as the Aten's closest worshippers and confidants.

The art of the Amarna period was also radically new, and this relief demonstrates novel subject matter as well as the new style of two-dimensional representations. The king, his chief wife Nefertiti

and their three daughters are shown in a scene of informal family bliss. Akhenaten's figure is ungainly, pear-shaped and long-headed – far from the manly idealized figures of his predecessors. Nevertheless this possible element of realism in the new art seems to be subverted by the fact that Akhenaten's queen and children display features – conspicuously long skulls – that conform, as if in sympathy, to the king's physiognomy. The representations were carved in sunken relief (the figures being deeper than the original surface of the stone), a characteristic technique of the Amarna period.

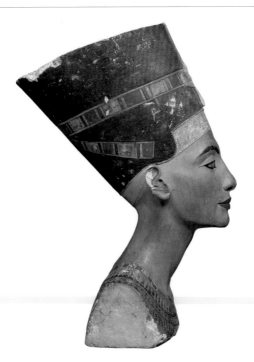

This piece was meant to serve as a model of Queen Nefertiti, to be imitated in other productions of the sculptors' workshop at El-Amarna, where it was found. Nefertiti was the chief wife of King Akhenaten (reigned c.1353–1337 BC), and it seems that she was as zealous in promulgating the changes in Egyptian religion as her husband (see Akhenaten and Nefertiti with Daughters, opposite). She is shown wearing a crown, special to her, with a protective cobra (now mostly lost) and a broad necklace around her neck.

Statues that did not show a human body in full remained very unusual for most of Egyptian history, but the intended use of the sculpture explains its form. The fact that Nefertiti's left eye is unpainted may be

explained in the same way: the two sides of the human face were portrayed symmetrically, but the right profile was always considered the more important representation.

The arts underwent huge changes during the reign of Akhenaten, yet there are only a few hints of this here, the most obvious being the queen's very long neck. This bust almost certainly dates from the later phase of the Amarna period, when most of the earlier representational extremes had been abandoned.

Mask of Tutankhamun, Artist unknown
Gold, glass, lapis lazuli, obsidian, carnelian, quartz, felspar and faience,
H: 54 cm / 1 ft 9¼ in, Egyptian Museum, Cairo

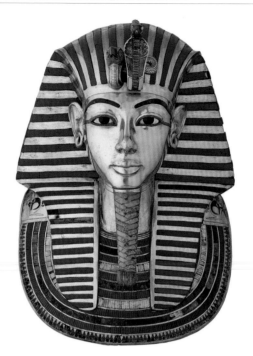

The mask of King Tutankhamun (reigned c.1336–1327 BC) is one of the most readily recognized icons in Egyptian art. It was found on the king's mummy buried in the Valley of the Kings, on the west bank of the Nile opposite modern Luxor. The tomb was discovered by the English archaeologist Howard Carter and Lord Carnarvon in November 1922.

The youthful king is shown wearing a *nemes*, a striped royal headcloth, with the heads of a vulture and a cobra – the symbols of the protective goddesses Nekhbet and Wadjet. He has a ceremonial beard attached to his chin and a broad collar with hawk-head terminals around his neck. Heavy cosmetic lines accentuate the king's eyes. The mask is made of gold

with inlaid semi-precious stones, glass and faience. An inscription from the so-called *Book of the Dead* is incised on the back.

The face is the most important identifying feature of a person, and in order to preserve it the ancient Egyptians affixed a mask over the mummy's shoulders and head. This does not mean that we should regard Tutankhamun's mask as his portrait; it was, rather, an idealizing image that conformed to the established Egyptian notions of how this king was represented.

Cosmetics Box Lid, Artist unknown
Ivory, 13.7 x 11.5 cm / 5½ x 4½ in, Musée du Louvre, Paris

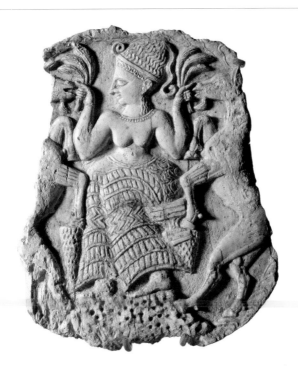

This thirteenth-century BC ivory carving, originally the lid of a box that probably held cosmetics or jewellery, shows interesting Aegean and specifically Mycenaean influence on a traditional Near Eastern subject and composition. A divinity – a goddess whose name differs across the eastern Mediterranean and Near East but who is commonly known as the 'mistress of the animals' – is surrounded by symbols of natural life broadly relating to the fertility of the land. Here the goddess feeds ears of corn to two goats reared up on their hind legs in a manner traditional in Mesopotamian art.

Links to Mycenaean art are visible in the costume of the goddess, in the profile and expression of her face, and in the arrangement of her hair. Like many later ivories (see the Lioness Devouring a Boy, p.62), this is a good example of artists from Syria and the Levant producing original hybrids based on the arts of many Mediterranean and Near Eastern societies. The elephant ivory of which the lid is made also hints at the world of long-distance trade and interaction. The lid comes from Minet el-Beida, the ancient port of Ugarit (Ras Shamra), in Syria.

c. **1200** BC
Peru

Standing Female Figure, Artist unknown
Terracotta, H: 48 cm / 1 ft 7 in, Museo Nacional de Arqueología, Antropología e Historia del Perú, Lima

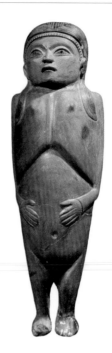

This is one of the earliest known ceramic figural sculptures from the site of Curayacu, on Peru's Central Coast. The woman's elongated torso is framed by her arms; these curve inwards towards her hands, which rest on her abdomen, drawing attention to her reproductive capabilities and perhaps indicating a pregnancy.

Little is known of the Curayacu culture, the ceramic sculptures of which are among the most sophisticated works from this time in Andean history (late Initial Period to Early Horizon, c.1500–900 BC), but the technically excellent portrayal of the three-dimensional form deserves further research into the origins and developmental history of the style.

Large abstract sculptures rendering female and male figures continued to be made in the region for more than two millennia, this sculpture being an early expression in an artistic tradition characterized by remarkably imaginative variation. The artistic use of clay first occurs later than other media in ancient Peru, in particular the fibre arts and gourd carving (often decorated by the technique of pyro-engraving). Interestingly, the production techniques and resulting visual characteristics associated with gourd carving and textile weaving were transposed to clay, its plasticity being particularly adaptable to such cross-media reflections.

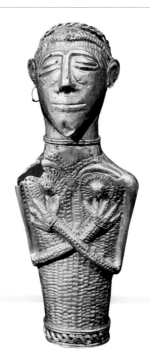

This small bust, nicknamed the Prince of Marlik and quite possibly representing a royal individual, was found in the cemetery of Marlik near the Caspian Sea in northern Iran. The shape of the chest has led to some questioning of the figure's gender. The material represented is thought to be chain mail, however, which has been taken to suggest an elite male, and the points on the chest have been interpreted as elaborate buttons of a kind found during the excavations. Made of gold, the figure is hollow (as can be seen at the damaged shoulder) and ornamented with a diadem and earring in gold wire – originally a pair, because both ears are pierced. The piece is made of unusually pure gold, making it soft and malleable. The main

technique used in its shaping was *repoussé* (in which the design is hammered out from reverse).

Other examples of very elaborate metalwork from Marlik come in the form of dishes and cups; a gold beaker decorated with a pair of bulls is perhaps the finest. Other human figurines, made in pottery or bronze, are quite different in form and far simpler, and have virtually none of the surface detail seen here. As a result, this is one of only a very few images that reveal anything about the clothing or jewellery of the people who were buried in Marlik's tombs. They are believed to have been nomadic and, as with most non-sedentary populations, very little of their material culture survives.

c. **1200** BC
China

Bei Goblet, Artist unknown
Ivory and turquoise, H: 30.3 cm / 1 ft, Institute of Archaeology, Chinese Academy of Social Sciences, Beijing

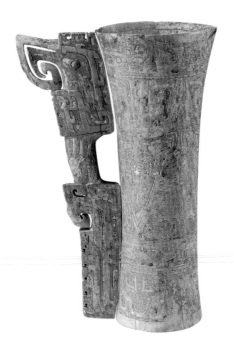

Ivory, like any organic material, is subject to decay, and Shang tombs have not yielded many examples. This *bei* drinking vessel was found with a matching twin in the Shang dynasty (c.1600–1045 BC) tomb of Queen Fu Hao at Anyang, the imperial capital. Both pieces had fallen into pieces and required extensive restoration. Its body was made from a single elephant tusk, onto which a separately carved handle was pegged. The turquoise inlay is reminiscent of the face plaque from Erlitou (p.39), but the decorative patterns formed by the blue stone and the incised lines in the ivory (*leiwen*, 'thunder patterns') are typical of designs used by bronze casters, and include the *taotie* face. The top of the handle is cleverly shaped like the crested

head of a bird, with a sharp curving beak and a neatly inlaid eye.

Of all the royal tombs excavated at Anyang, only that of Fu Hao had not been robbed. She was the consort of King Wu Ding (reigned c.1250–1189 BC) and was evidently a major political and military figure in her own right. Included in the rich cache of her grave goods were many bronzes and jades, hairpins, bone objects and cowrie shells.

Psi Figurine, Artist unknown
Painted terracotta, H: 35 cm / 13¾ in, Archaeological Museum, Nauplion

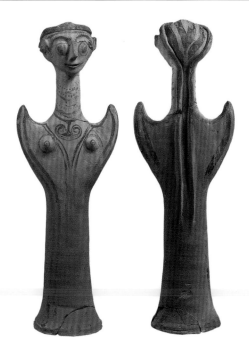

The majority of Late Mycenaean (c.1390–1050 BC) figurines took one of three shapes: Psi, Phi and Tau, named after their resemblance to letters of the Greek alphabet. This figurine is of the Psi type, but is also related to the 'goddess with upraised arms' type that gained widespread popularity during this period. The lower body is a tube, while the conical breasts are modelled in relief; the figure wears a diadem on her head, and strands of moulded hair fall down her back. Her gown and necklace – which resembles actual Mycenaean moulded beads fashioned in gold, glass and faience – are painted. The face of the figurine is striking, her modelled eyes, long nose and slight smile giving the figure a lively and engaging appearance.

Simple terracotta figurines are one of the most numerous surviving classes of Mycenaean material culture. Made by potters, they were mass-produced during the fourteenth and thirteenth centuries BC and continued to be made into the twelfth century BC. They have been found in cultic, funerary and domestic contexts and may have represented deities or adorants, served an apotropaic function, or even been used as toys, a range of possibilities comparable to that of the earlier Cycladic marble figurines (see the Cycladic Figurine, p.25). This example dates from the century after the destructions that devastated the palaces on the Mycenaean mainland c.1200 BC.

Human Figure, Artist unknown
Bronze, H (including base): 261 cm / 8 ft 4¾ in, Institute of Archaeology and Cultural Relics Bureau, Sichuan Province

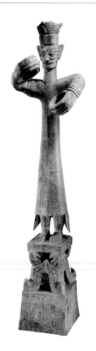

This astonishing monumental bronze figure was found in 1989 in Burial Pit 2, one of two sacrificial pits at Sanxingdui in Sichuan Province; it dates to the twelfth century BC. The main body comprised four parts and was deliberately broken at the waist; both figure and pedestal were evidently cast in sections. The awe-inspiring effect of the head and face, with its huge eyes and ears and uncompromisingly set mouth, was re-emphasized by the elongated torso and the exaggerated arms and hands.

The god – or priest, or ruler, or whatever he was – may have been holding an elephant's tusk; large quantities of tusk fragments were found in the pits. The elephant appears to have had some cultural or

religious significance for the owner of the tomb: the base on which the figure stands is surmounted by four stylized animal heads, possibly those of elephants, and the pit contained the remains of animal sacrifices.

The figure was accompanied by some 50 more bronze heads with similar features, but no surviving bodies. The contents of this burial pit and its companion tomb have provided archaeologists with some of the most extraordinary discoveries ever made in China, and have revolutionized ideas about the distribution of bronze technology and the nature of regional culture during the later Shang dynasty (c.1600–1045 BC).

Beak-spouted Jar, Artist unknown
Ceramic, H: 17.4 cm / 7 in, Freer Gallery, Smithsonian Institute, Washington, DC

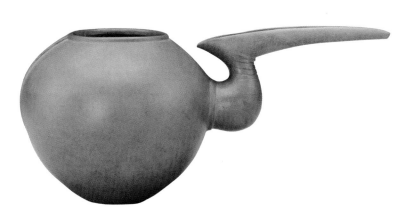

The great Near Eastern archaeologist Sir Leonard Woolley wrote that 'the surprise which a visitor to a Museum expresses at the age of a given object is in exact proportion to his recognition of the essential modernity of that object. It is the surprise of one who sees his horizon suddenly opening out.' So this jar, with its perfectly executed clean lines and very modern simplicity, challenges our notions of ancient and modern aesthetics. At the same time, however, the resonance of such a piece with the material culture of our contemporary world is deceptive: we can know very little about the aesthetic and symbolic concepts guiding its production, but we can be certain nonetheless that their relation to the notions

of minimalism and the abstract that underlie much modern sculpture are distant indeed.

In its shape this piece, dating to between c.1400 and 800 BC, resembles many other 'beak-spouted' jars from northern Iran. The name reflects interpretation: the shape is thought to refer to that of a highly stylized bird. The blending of figurative elements, especially birds and animals, with more abstract shapes and patterns is a characteristic of ancient Iranian art from as early as the fifth millennium BC (see the Ritual Bowl, p.12).

The origin of this vessel is unknown. Other beak-spouted jars have frequently been found in tombs, but the precise function of these vases remains unclear.

Fang Zun Vessel, Artist unknown
Bronze, H: 58.3 cm / 1 ft 11 in, National Museum, Beijing

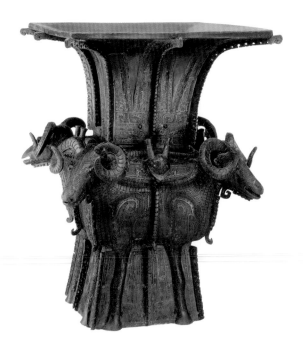

Many kinds of wine vessel were used in Shang dynasty (c.1600–1045 BC) ceremony and ritual. Some were slender and elegant in form, others were heavier and subject to greater ornamentation and decoration. Though most *zun* were shaped like circular vases, examples with squared corners such as this also occur and are known as *fang* ('square') *zun*. This is one of the very best, dug up by peasants in 1938 in Yueshanpu, Hunan Province, a part of south-central China that by the late Shang period was producing fine vessels far away from metropolitan Anyang (the Shang capital). It dates to between 1300 and 1030 BC.

The entire lower half of the vessel consists of four brilliantly modelled rams, one at each corner, seen head-on from the tips of their horns to the bottom of their hoofs. Their horns and ears were again cast separately, and then inserted into the main vessel mould before it was poured. The flanges down the edges of the *zun* have been turned neatly into their beards. The shoulders of the *zun* occur halfway up. Above them the sides are flared to the rim in conventional manner and are decorated in familiar style with geometric patterns of straight lines, loops and swirls. Around the shoulders slide four serpentine dragons, poking their heads out from between the backs of the rams; these were cast onto the *zun* in separate pours.

c. 1050 BC
Mexico

Olmec Head, Artist unknown
Andesite, H: 220 cm / 7 ft 2½ in, Museo de Arqueología de Xalapa,
Universidad Veracruzana, Xalapa, Veracruz

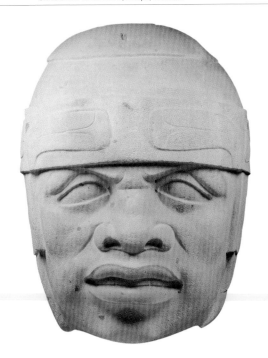

The Olmecs are considered the 'mother culture' of ancient Mexico, since they originated many of the scientific and intellectual, architectural, spiritual and artistic features shared by all later Mesoamerican cultures. This monumental stone carving, one of a score of surviving examples, is among the finest portraits of an Olmec ruler. It was found at San Lorenzo, the dominant site in the region during Early Formative times (c.1200–900 BC), ruled by powerful individuals who claimed supernatural sanction for their overlordship. Ten royal portrait heads have been found here, the distinctive physical characteristics of each reflecting the facial idiosyncrasies of an individual sovereign. As here, each portrayal is distinguished by a unique head wrap or politico-religious attribute.

None of the Olmec monumental portrait heads has been found in its original position; all were intentionally buried or pushed into surrounding ravines in ancient times, probably as a result of social revolt and/or political upheaval. As the backs of the heads are flattened and relatively devoid of details of hair and headdress, the sculptures may originally have been placed against a wall. Wherever they were originally displayed, these colossal heads accentuate the individual's face and were meant to impress the viewer by their massiveness, bold sculptural form and singular expression.

c. **1050** BC
Mexico

Seated Man and Youth, Artist unknown
Terracotta, H: 13.5 cm / 5¼ in; 11 cm / 4½ in, Princeton Art Museum,
Princeton University, Princeton, New Jersey

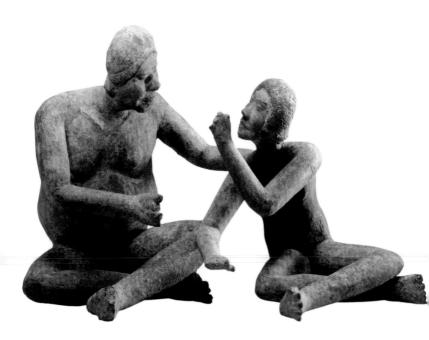

Early Formative period (c.1200–900 BC) artists of the
Xochipala culture expertly fashioned in clay realistic
portrayals of the human figure, rendering scenes of
both daily life and ritual activities. Here, an older
man speaks to a younger one, who lifts his head as if
listening intently to his elder. The raised arms, tilted
heads and gesturing hands accentuate the dynamism
of the pair's interaction.

No Mesoamerican culture after Xochipala
equalled the dynamic expressiveness of this figurine
tradition. The lack of later examples throughout
central Mexico is not due to artistic failure, but
instead must pertain to other social or aesthetic factors
not yet understood. The Xochipala sculptural style

shares certain artistic and iconographic features with
Olmec-style art from the central highlands of Mexico,
especially the Las Bocas tradition of neighbouring
Morelos, but the Xochipala culture of western Mexico
represents an independent society, the origins and
later developments of which have yet to be defined.
The region is only now becoming the focus of
archaeological and art historical investigations, and
questions of early Olmec influence and later cultural
manifestations remain to be answered.

The Lovers, Artist unknown
Rock carving, H: 50 cm / 1 ft 7¾ in, In situ, Vitlycke, Bohuslän

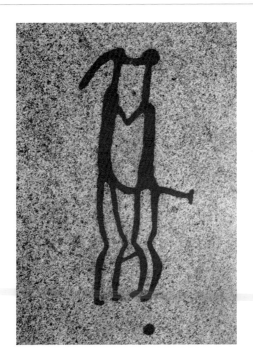

Rock art abounds in early Scandinavia, and one of the most interesting concentrations is in western Sweden. Particularly noteworthy is the group of carvings at Bohuslän, which displays considerable variety and provides a valuable clue to Swedish Bronze Age (c.1800–500 BC) beliefs and society.

The detail here (the bright paint is a modern addition) is an element in an assemblage of engravings that appear to represent the 'sacred marriage', a ritual intended to ensure fertility among livestock on land or (in the case of depictions involving boats) at sea. The two figures shown here embracing and holding hands (the one on the left is assumed to be female) are overseen by a much larger figure with phallus (not shown), brandishing an axe and armed with a sword, who on account of his size may represent a god or possibly a priest. Other associated depictions include one of bestiality, and the representation of a chariot.

Swedish Bronze Age rock engravings remarkably anticipate later Scandinavian art, and include perhaps the earliest depictions of elements that occur in later Viking mythology.

Lioness Devouring a Boy, Artist unknown
Ivory, gold leaf, lapis lazuli and carnelian, c. 10 x 10 cm / 4 x 4 in,
British Museum, London

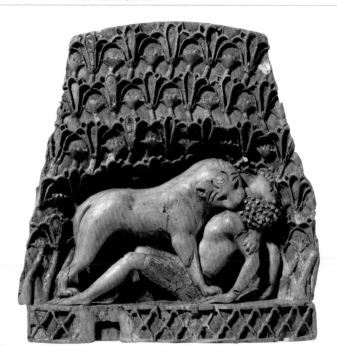

This vivid scene, carved in ivory and originally inlaid with lapis lazuli and carnelian (some traces of which survive in the latticework base and the floral ornamentation above and around the figures), is one of the finest and best-known examples of Phoenician art. It was found at Kalhu, modern Nimrud, in northern Iraq, in the palace of the Assyrian king Ashurnasirpal II (reigned c.883–859 BC), but is thought on stylistic grounds to have been produced in a Phoenician city located on the eastern Mediterranean coast.

Phoenician ivories are characterized by their incorporation of elements from many disparate and far-flung artistic traditions, reflecting the enormous Mediterranean and Near Eastern networks across

which Phoenicians and many others were able to trade and interact. Combinations of Pharaonic Egyptian and Mesopotamian iconography are common, but in this case the major elements are firmly African in origin. Against a background of papyrus and lilies a lioness attacks the throat of an African boy. The image appears eroticized: as the victim's head is thrown back in abandon, one leg of the lioness reaches round his shoulders in an embrace. Certainly the scene communicates the passion of the violence.

Originally made for a piece of furniture, this panel is one of a pair dated to the ninth or eighth century BC. Its partner was stolen from the Iraq Museum in 2003.

Dipper Cup, Artist unknown
Gold, H (cup): 10.3 cm / 4 in, National Museum, Copenhagen

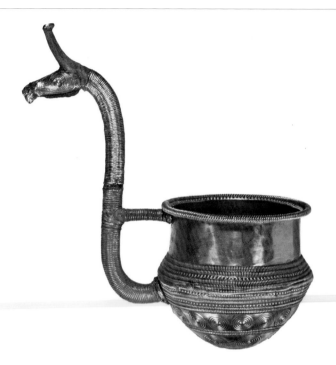

Among the peoples of the northern European Bronze Age there was a recurrent custom of leaving offerings to the gods in peat bogs. Among the deposits of the later Bronze Age was that at Borbjerg in Denmark, where the offerings included this stunning dipper cup.

The Late Bronze Age (c.850–500 BC) was a period of considerable prosperity in Scandinavia, when imported ores were turned into an array of fine bronzes. Not only were ores imported, but also complete artefacts, and this dipper cup is one of a series of gold vessels imported from further south. The incorporation of concentric circles as a decorative motif would have been quite familiar in Scandinavia, where they were frequently used as a sun symbol.

Not content to use the gold cup in its original state before offering it to the gods, some local requirement necessitated the addition of the sinuous animal-headed handle, fastened to the bowl with a thin septum. The treatment of the head, which must represent a horse, despite its curious 'horn', is similar to the head of the horse on the copper and gold Trundholm sun car from Sealand, Denmark, and some animal sculptures found in the Hallstatt culture (c.720–480 BC) of Iron Age Europe.

c. **750** BC
Mexico

Ceremonial Gathering, Artist unknown
Jadeite, serpentine, sandstone, cinnabar, H: 20 cm / 8in (figurines, max);
25.5 cm / 10 in (celts, max), Museo Nacional de Antropología, Mexico City

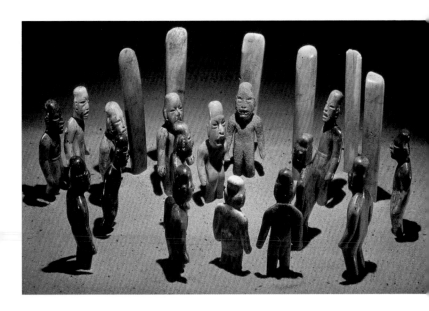

This unique offering was found buried below the courtyard floor of Complex A, the main ceremonial precinct of La Venta, which was the pre-eminent Olmec centre during the Middle Formative Period (c.900–600 BC). It depicts a ritual event in which 16 men stand in the formalized pose of shamanic transformation. The grouping probably represents a solemn vision-quest rite by spiritual practitioners, its importance to the Olmec underscored by their preserving the act in precious stone.

The figures – 13 of serpentine, two of jadeite and one of sandstone – are carved in typical Olmec style, with elongated heads, slanted eyes, fleshy faces and rounded bodies. The sculptor achieved a delicate balance between the schematic portrayal of a ritualized stance and the naturalistic rendering of the human physique.

The sandstone figure faces the others, who are arranged in a rough semi-circle. Six celts (axes or chisels), rising behind the sandstone personage, are embellished with incised imagery representing the earth monster and a figure flying to the supernatural realm. These celts define the ritual space and also symbolize the *axis mundi*, the 'world tree' that ancient Mesoamerican peoples believed supported the tri-level cosmos of underworld, earth and heavens.

Dipylon Krater, Dipylon Master
Painted ceramic, H: 123 cm / 4 ft, National Archaeological Museum, Athens

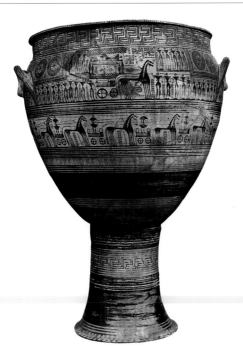

This monumental krater (a vessel used for mixing wine and water, particularly at the *symposion*, or drinking party) originally served as a grave marker for a male burial at the Kerameikos cemetery in Athens. Its size and intricate decoration indicate that the grave was probably that of a wealthy and influential individual.

The krater, covered with a series of figured friezes, represents the Geometric (c.900–700 BC) painting tradition at its most developed, the rectilinear designs having evolved from earlier Geometric styles. The main scene shows a *prothesis* or laying-out ceremony. Lying on a bier, the dead man is surrounded by mourners, who tear their hair in ritualized gestures. In the lower frieze, further aspects of an aristocratic lifestyle – horse-drawn chariots and shield-clad warriors – are depicted.

This is one of the earliest examples of a narrative scene on Greek pottery, as opposed to purely decorative friezes of animals or geometric motifs, or naturalistic designs of flowers and sea creatures. The roles of the actors are recognizable and must mirror some of the real-life activities of those attending an eighth-century BC funeral. Although the painting is highly stylized, the painter's desire to make explicit all the relevant details of the scene means that everything that is known is depicted: the dead man under his chequered grave shroud and every one of the horses' legs, for example.

Winged Bulls, Artist unknown
Alabaster, H (max): 420 cm / 13 ft 8½ in, Musée du Louvre, Paris

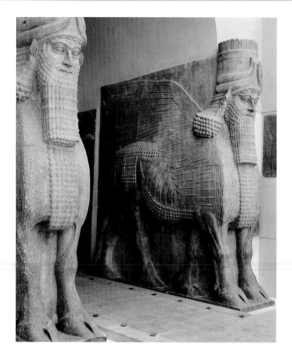

The human-headed winged bulls and lions that stood at the gateways of Neo-Assyrian (c.911–609 BC) palaces at Nineveh, Nimrud (ancient Kalhu) and Khorsabad (ancient Dur-Sharrukin) are among the most iconic examples of ancient Mesopotamian art. These bulls come from the palace of Sargon II (reigned c.721–705 BC) at Khorsabad. They are larger than their predecessors and modelled in particularly high relief. Great attention has been paid to the elaborate beards and hair, the horned caps marking the figures as divine, and to the feathers of the bulls' great wings. While they give the impression of sculpture in the round, in fact only the heads are conceived in three dimensions. The presence of a fifth leg in this view shows that to some extent the piece was conceived as two distinct compositions, one to be viewed frontally and one in profile.

Such sculptures are associated with the beginning of major excavations in Iraq, chiefly conducted by Paul-Émile Botta – excavator of these colossal winged bulls from Khorsabad – and by Sir Austen Henry Layard. The recovery of sculptures and reliefs from the palaces of ancient Assyria became a matter of imperial competition between France and England. The figure were celebrated on their arrival in Europe, and, although the decipherment of the cuneiform script was in its infancy, the magical and protective roles of the statues were quickly recognized.

Shakko-dogu Figurine, Artist unknown
Earthenware, H: 36.1 cm / 1 ft 2 in, National Museum, Tokyo

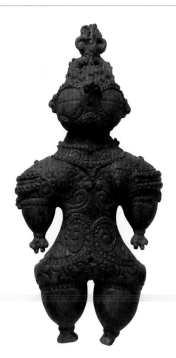

The centuries of the Final Jomon period (c.1000–300 BC) were a troubled time in Japan, with the climate growing colder and food supplies diminishing. Under these circumstances, the people of the Japanese archipelago sought to contact the unseen forces of nature and the universe with ever greater frequency. At a distance from individual villages, for example, they began to construct stone circles with a vertical central stone pointing to the skies, the precise function of which is unknown. Isolated populations also seem to have begun more actively banding together, especially along the eastern coast of the main island, where vessel types appear to have become standardized.

Residents of the far northeast confronted the situation by producing earthenware female figurines such as this, called *shakko-dogu*, with goggle-shaped eyes, a dense surface pattern that almost subsumes the breasts, and exaggerated proportions in the extremities. The figurines are usually found damaged in a major part of the body, for instance the arm or eye, as though deliberately broken during a ceremony; those with damage limited to the feet, as here, are extremely rare. The details of their role in ritual remain uncertain.

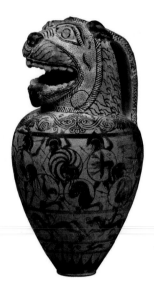

This little *aryballos* (unguent flask) is a typical example of the Protocorinthian style produced in Corinth and widely exported throughout the Greek world and beyond from c.720 to 600 BC; it comes from Thebes, in central Greece. Hallmarks of the style are the miniature size, friezes of painted decoration, and a combination of outline and black-figure technique, in which details are incised into figures painted in black silhouette. Vessels with animal heads such as this lion model were one of the more elaborate shapes in the range of small pots produced.

The main frieze on the belly of the vessel shows a hoplite rank (the Greek heavy-armed citizen militia) breaking up in battle. It is characteristic of the miniature style that an entire battle has been shown on such a small vessel. Below are friezes of horse riders and a hare hunt. These friezes exemplify the typical subjects of Protocorinthian decorated pottery: hoplites, warriors on horses, and animals. The boxy shape of the lion's head is characteristic of north Syrian lion figures, and the incision technique has been linked to Syrian and Phoenician metal bowls, similarly decorated with figured friezes and imported from the Levant to Greece from the ninth century BC.

Dying Lion, Artist unknown
Alabaster, 16.5 x 30 cm / 6¾ x 11¾ in, British Museum, London

Among the palace reliefs of the Assyrian kings unearthed by British and French excavators in the nineteenth century (see the Winged Bulls, p.66) are some of the most vivid and informative artworks of ancient Mesopotamia. Among these, the once boldly painted lion-hunt reliefs of Ashurbanipal's (reigned c.669–631 BC) North Palace at Nineveh, characterized by their subtle and intricately detailed low-relief execution, are particularly impressive.

The reliefs of Ashurbanipal represent the culmination of millennia of depictions of the king's role in mastering the forces of nature, often represented by lions even in very early scenes. By this time the lion hunt was a formalized sport, and the

reliefs show lions released from cages to be shot with arrows and speared. The depiction of the lions' deaths is extremely graphic, as this panel shows, but rendered with a remarkable attention to detail and unflinching recognition of the suffering of the dying animal. From a contemporary perspective this last is perhaps the most surprising aspect of such scenes: lion-hunts are intended to show the virtues of the king, but the dying lions are perhaps the most arresting features of these scenes. Symbolizing the chaotic forces of nature, the lions' agony was, if anything, cause for celebration, and was almost certainly not intended to produce the sympathy felt by modern viewers.

Kouros ('youth') statues began to be produced in Greece towards the end of the seventh century BC. The New York *kouros* exemplifies the standard stance, with left leg forward and arms by the sides. *Kouroi* served varying purposes: they have been found in the sanctuaries of male deities and were used as tomb markers for aristocratic burials. In this respect, the statues served to heroize the deceased through immortality in stone; they have been interpreted as embodiments of the elite ideology of *kalokagathia*, 'noble beauty'.

Although the marble from which he is made came from the Greek island of Naxos, the technical expertise for monumental figural stone carving came from Egypt, as did (according to later authors) the canon of measurements used to plan the proportions of the body. This *kouros* is the only surviving example to match perfectly this canon as described by the Greek historian Diodoros in the first century BC.

The form of the statue was dictated by the original block of stone from which it was carved. The incised anatomical details are almost decorative, including the arching musculature of the chest and the crisply delineated kneecaps. With its rigid frontality and steady gaze, this *kouros* interacted directly with its viewers and stands in contrast with one of the last examples of the type, the Kritios Boy (p.84).

c. **585** BC
Iraq

Lion Relief from the Processional Way at Babylon, Artist unknown
Glazed terracotta, L: 227 cm / 7 ft 5½ in, Musée du Louvre, Paris

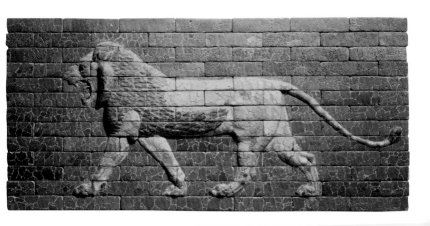

Excavations from the late nineteenth to the early twentieth century revealed the centre of the capital city of King Nebuchadnezzar II (reigned c.604–562 BC) at Babylon. This lion comes from the central Processional Way leading to the spectacular Ishtar Gate; both processional way and gate were covered in brilliant blue glazed bricks and vivid animal reliefs. The lion was associated with Ishtar, goddess of love and war, while reliefs on the gate itself showed the bulls of the storm god Adad and the dragons of Marduk, city god of Babylon and head of the Neo-Babylonian pantheon of deities.

The spiritual capital of Mesopotamia also became its political capital in the late seventh century BC, and was later to be a capital of the Achaemenid empire (c.550–330 BC) and that of Alexander the Great (356–323 BC). For two millennia, however, the city was known only through the descriptions of Greek writers and Biblical accounts, from which it gained its reputation as a 'city of sin'. It was not until the late eighteenth century that detailed descriptions of the ruins began to be made and excavations undertaken.

The German excavators shipped these reliefs back to Berlin, where they and the Ishtar Gate were painstakingly reconstructed to form the centre of the Vorderasiatisches Museum. Single relief panels are now also held by other museums, such as this example, which is displayed in the Louvre.

Neo-Babylonian Culture

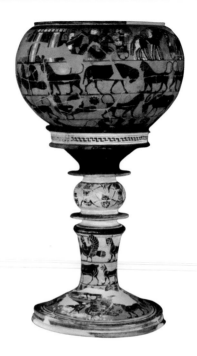

This black-figure dinos (a mixing bowl for wine and water) is the first surviving example of a pot signed by a Greek potter or painter, here Sophilos (fl. c.580–570 BC), and it is his largest surviving work. The pot stands at the beginning of a tradition of naming characters with painted labels (see also Ajax and Achilles Playing Dice, p.76). In this case, the upper register shows the marriage of Peleus, who stands before his house, to the sea-goddess Thetis. A procession of divinities makes its way to the wedding, allowing the painter great scope in distinguishing gods and goddesses by dress and attributes. Dionysos, god of wine, carries a vine branch, for example, while Zeus and Hera arrive by chariot.

The shape of the dinos imitates stand-mounted metal vessels, and its use at drinking parties makes the wedding celebration scene particularly appropriate. The painter has adopted techniques from proto-Corinthian and Corinthian pottery (see the Macmillan Aryballos, p.68), such as the outline technique and miniaturist style, though there is much more variety in the depiction of individual characters. Decoration is still arranged in friezes, the mythological scene at the top, with animals and floral designs below.

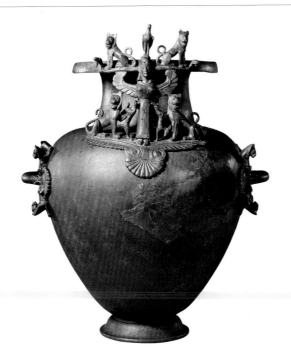

Found in the tomb of a Celtic 'prince' buried at Grächwil, near Bern, Switzerland, this elegantly decorated vase (which has been restored) illustrates the integration of Greek art and customs into the society of Celtic Europe. The *hydria* was an ovoid, three-handled water jug used in the Greek-style banqueting ceremonies adopted by the tribes of northern Europe. This vase was a display piece – the vertical handle is so ornate as to make it unusable.

The sheet bronze body is decorated with cast bronze handles composed of figures commonly represented in the art of the Mediterranean world. It depicts the *potnia theron* ('mistress of animals'), a winged nature goddess in a long robe holding a hare in each hand and flanked by roaring lions. (For another variation on the theme, see the Snake Goddess, p.43.) On top of her tall crown an eagle perches between two lions on bearded snakes. Open wings and a pendant palmette attach to the shoulder of the vase, and two horizontal handles are attached with palmettes that end on all four edges with couchant lions.

The style of the figures resembles that of contemporary figurines from Archaic Sparta and its colony in southern Italy, Taras (Tarentum, modern Taranto). Scholars have speculated that it was produced by Tarentine craftsmen and then exported, perhaps as a diplomatic gift, to a ruler on the far side of the Alps.

Tarentine Style

Cult Wagon, Artist unknown
Bronze, L: 48 cm / 1 ft 7 in, Steiermärkisches Landesmuseum Joanneum, Graz

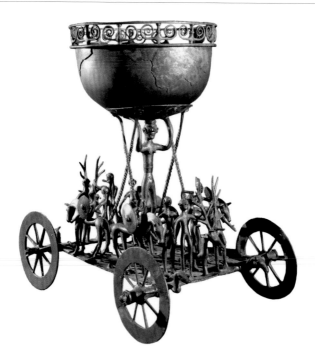

Miniature cult wagons have been known since at least the middle of the Bronze Age (see the Trundholm Sun Car, p.136), and other wagons of Hallstatt date (c.750–450 BC) include examples carrying cauldrons; nevertheless, the group of figurines on this sixth-century BC wagon from a 'princely' burial (*Fürstengrab*) found in 1851 at Strettweg, Styria, in Austria, is unique.

The base of the four-wheeled wagon has an openwork radial pattern, and cattle heads ornament the axles. In the centre is a female figure, perhaps a goddess, who holds a dish above her head; this supports a bronze bowl. In front of and behind the female are two symmetrical groups of cast figurines, in each of which two people hold the antlers of a stag. Behind the central female figure is another woman, and a man with an erect phallus who wields an axe. On either side of these figures are mounted warriors who wear helmets and carry spears and shields. The figures may represent a hunt or the sacrifice of a stag, perhaps with the large woman/goddess presiding over the ceremony or making an offering.

Although it has been thought that the Strettweg wagon must have been influenced by works from Greece, its origins lie in the Iron Age of central Europe, perhaps with some influences from Italy in the inspiration of the figural work.

This magnificently detailed sculpture, which comes from Psametek's tomb, shows the chief steward and the goddess Hathor in her manifestation as a cow. On her head, the cow wears a sun-disc with two tall plumes and a cobra. In the text on the base of the statue Hathor is described as 'mistress of the western desert' (the site of the necropolis in which the statue was found).

Egyptian sculptors always faced a rather delicate task when representing people in the company of gods, because of the need to convey accurately the correct relationship between human and divine. The idea of protection was usually expressed by placing the protector behind the protected, the former shielding the latter with raised arms. Deities who manifested themselves as birds did this by enveloping the protected person in their wings. Here, the same idea was expressed by placing the figure of Psametek under the neck of the Hathor cow, which towers over him. Because of the difficulty presented by carving in stone, a thin connecting section of stone (sometimes called 'negative space') was left below the cow's belly and between the chest of the animal and the figure of Psametek.

Late Period, Twenty-sixth Dynasty

c. **540** BC
Greece

Ajax and Achilles Playing Dice, Exekias
Painted ceramic, H: 61 cm / 23¾ in, Musei Vaticani, Museo Gregoriano Etrusco, Rome

This belly amphora (used to hold wine or oil), signed by the Athenian potter and painter Exekias (fl. c.550–525 BC), shows Ajax and Achilles playing dice inside a tent; each is identified by his name written nearby. The warriors are still armed, making this a moment snatched during battle and a scene of surprising domesticity in the midst of war. Achilles throws a four to Ajax's three, and he dominates the scene physically, the plume of his helmet reaching high above Ajax's head. The picture hints at future events: although Achilles will die in battle and Ajax will rescue his body from the field, another warrior (Odysseus) will win Achilles' armour, and Ajax will commit suicide in shame. Although the characters are not distinguished

in terms of their facial features, the two warriors are individualized through their shield designs and posture. The scene is simple, elegant and powerful, the concentration of the figures palpable.

The quality of Exekias' draftsmanship is seen in the lace-like detailing of cloaks and greaves, the finely drawn eyes and the fingers. The black-figure technique was particularly appropriate to fine detail: figures were painted as black silhouettes against the red background of the vessel, with details created by incision through the black paint to the background below. The dignity and sculptural quality of Exekias' figures, as much as his detailed precision, gave vase painting for the first time a claim as a major art.

c. **515** BC
Greece

Euphronios Krater, Euphronios and Euxitheos
Painted ceramic, Diam: 55.1 cm / 1 ft 10 in, Museo Nazionale Etrusco di Villa Giulia, Rome

This calyx krater, used for mixing water and wine, was signed by Euphronios (c.520–470 BC) as painter and Euxitheos as potter and was produced at the beginning of the red-figure tradition. In contrast to the earlier black-figure technique (see Ajax and Achilles Playing Dice, opposite), the background of the pot was painted black with the figures left in the ochre colour of the base slip. Detail could then be added by painting, as opposed to the earlier process of incising into the black slip, permitting far greater detail and subtlety of line. Euphronios was one of the so-called 'Pioneers', innovators in red-figure technique who experimented with the depiction of movement, foreshortening and complex compositions.

The scene depicts the winged figures of Sleep (Hypnos) and Death (Thanatos), directed by the messenger god Hermes, bearing the body of Sarpedon from the battlefield of Troy. Sarpedon's musculature is studied, and the artist has attempted to show three-dimensionality in the three-quarter view of his body, his left leg and right shoulder twisted – not entirely successfully – towards the viewer.

Like many Greek pots, the Euphronios krater was probably looted from an Etruscan tomb. So many Greek vessels known today come from Etrurian cemeteries that they were believed until as late as the nineteenth century to be Etruscan rather than Greek.

c. **510** BC
Italy

Apollo of Veii, Attributed to Vulca of Veii
Painted terracotta, H: 181 cm / 5 ft 11 in, Museo Nazionale Etrusco di Villa Giulia, Rome

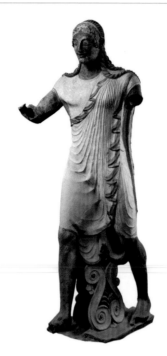

This figure of the Etruscan god Aplu (Gk: Apollo) is one of a group of near life-size statues discovered in 1916 at the Portonaccio sanctuary, just outside the walls of the rich Etruscan city of Veii, north of Rome. It was found with statue bases made to fit atop the ridge pole of a temple that was probably dedicated to Menrva (Lat: Minerva, Gk: Athena).

The figures portrayed scenes from the adventures of Hercle (Lat: Hercules, Gk: Herakles), including his dispute with Aplu over the Keryneian deer. The god strides powerfully along the plane of the roof, drapery clinging to his hard, muscular body. He wears a light, short-sleeved tunic and red-bordered, elaborately pleated *tebenna*, the Etruscan crescent-shaped mantle.

In standard Etruscan convention, his male flesh is coloured dark red, and long black locks splay out over his back and shoulders. Between his legs a columnar support merges with the drapery hems, moulded in a relief of double-volutes trimmed with palmettes.

Aplu's stylized facial features and details such as the drapery folds and leg muscles are not rounded, as we would expect in the plastic medium, but are rendered in sharp-edged ridges and angular planes, as if the clay had been carved with a knife. The effect is similar to Etruscan bronze sculpture and may have been a trademark of the artist known from a cryptic literary reference as 'Vulca of Veii', who made statuary for the Roman Capitolium.

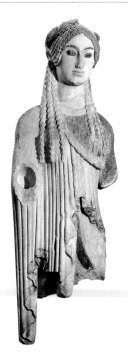

The *kore* ('maiden') figure was the female counterpart of the male *kouros* ('youth') statue type, the standard representation of the human figure during the Archaic period (c.700–480 BC). Whereas *kouros* statues were often set up as grave markers, *korai* were more common as dedications in the sanctuaries of female goddesses. This example was found on the Athenian acropolis, part of a large group of sculptures buried on the Acropolis after the Persian sack of Athens in 480/479 BC.

This *kore* is a late example of the type, the 'archaic smile' of the earlier sixth century BC (see the New York Kouros, p.70) here replaced by an expression of quiet repose, anticipating the Severe style of early Classical

sculpture (e.g. the Delphi Charioteer, p.86). Still elaborately braided, her plaits of hair hang more freely over her shoulders, while hair frames her forehead in a less wig-like manner than earlier statues. The *kore* is clothed in a *chiton* (tunic) and *himation* (cloak), with considerable attention paid to the fall of the folds of cloth across her body and from her (missing) right arm, outstretched in votive offering. Physical forms are more defined than in earlier *korai*, and the facial features are more plastically modelled. Traces of pigment still survive: the flesh was left in the white of the marble, but the hair and lips were tinted red, the upper *chiton* typically painted blue or green, and the lower *chiton* patterned in red, yellow, brown and black.

c. **500** BC
Nigeria

Nok Figure, Artist unknown
Terracotta, H: 92.1 cm / 3 ft ¼ in, Minneapolis Institute of Arts, Minneapolis, Minnesota

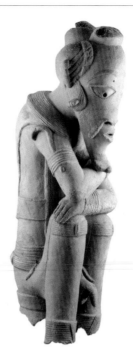

The agricultural Nok civilization, dating from the middle of the first millennium BC to around the first millennium AD, produced the earliest known sculptural works from sub-Saharan Africa and pioneered the smelting of iron on the continent. The only traces of this society that have survived, beyond a few pottery wares, iron implements and smelting furnaces, are their extraordinary fired clay sculptures. Figures such as this have been found principally near the town of Jos and over a vast territory towards the southern edge of the savanna in Nigeria, east of the Niger River and north of the Benue. Works include miniature solid figurines as well as large-scale figures such as this, hollow and built up with coils of clay.

As is common among these sculptures, the figure is depicted in contemplative attitude, suggesting profound introspection. The representation emphasizes bodily ornament in the form of lavish beadwork and a coiffure that consists of a complex arrangement of buns – an elaboration that contrasts with the simple linear definition of the facial features. Nok works are distinctive for the manner in which eyes, nostrils and ears are consistently incised into the clay surface before firing, and the pupils and nostrils punctuated by pin-hole perforations. Also characteristic is the triangular form of the eyes, framed by the sweeping curvature of the eyebrow and pronounced arc of the lower lid.

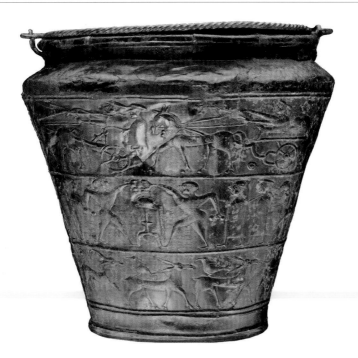

Concentrated around northeast Italy, the eastern Alps and Slovenia, so-called Situla art is unusual in the European Iron Age in that it is figural; as its name indicates, the style is found exclusively on metal situlae, sheet-metal vessels of bucket shape. This late example, dated to the late sixth or early fifth century BC and found in Vače in 1882, is characteristic of the Slovenian group. Worked in *repoussé*, the scenes, in typically tripartite arrangement, may depict a festival. The upper zone shows a procession of horses, mounted horsemen, and chariots and carts, the last perhaps engaged in a race. The middle section depicts a banquet with seated men; one holds a sceptre, one plays the panpipes, and others are being offered food

and drink. Men thought to be boxers compete for a plumed helmet set on a stand between them. On the lower frieze are beasts of prey, hinds and ibexes.

The zonal decoration and friezes of animals and mythical beasts derive from Greek works (see, for example, the Sophilos Dinos, p.72, and the Macmillan Aryballos, p.68), themselves subject to many influences, particularly Near Eastern. The use of zones and the iconography are often thought to have been transferred via Etruscan art, but there was probably more direct contact with the East through the Greek colonies at the head of the Adriatic. Nevertheless, the sheet-metal situla form, the use of *repoussé*, and the costumes depicted with fine punch work are all local.

Delegations Bearing Gifts, Artist unknown
Limestone, c.260 x 150 cm / 8 ft 6¼ in x 49 ft 2½ in, In situ, Persepolis

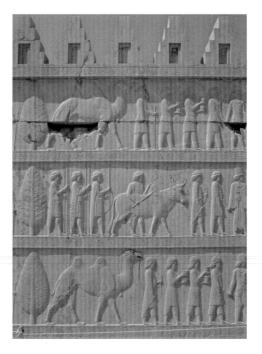

The ruins of the Achaemenid city of Persepolis are about 50 kilometres (30 miles) northeast of modern Shiraz in Iran. The famous friezes from the Apadana, probably a great audience hall of which this relief (dating to c.500–470 BC) is only a small part, depict representatives of the many nations making up the Persian empire bringing gifts to the king. Triple registers of reliefs lead to large staircases, and it is thought that the images depict the kind of ceremonial events for which the Apadana was intended. The delegations can be identified by their dress and by the gifts they bring; those shown here come from from the northeast of the empire. The figures in the top and bottom registers have been identified as Parthians or

Bactrians, led by ushers in Persian and Median dress. The precise identity of the delegation in the middle register is uncertain.

Although the reliefs at Persepolis draw heavily on those of Assyrian palaces (see the Dying Lion, p.69), their subjects are very different. The Assyrian reliefs focus on the strength of the king as hunter, warrior and conqueror. The Apadana scenes, in contrast, depict an empire at peace and paying tribute to the Great King by common consent. Neither image, of course, can be taken as an accurate representation of the nature of power and politics in the empires; rather they represent idealizations of the relationship between the king and the world.

This dying warrior comes from the east pediment of the Doric temple of Aphaia on Aegina. Dated to c.490–475 BC, the east pediment is slightly later than the west, the two sets of sculpture having replaced originals that were removed shortly after installation, either due to damage or perhaps for political reasons: the prominent inclusion of Athena may have been a deliberate challenge to Athens after many years of war between the city and the island. Each pediment depicts a sack of Troy, with Athena the central character in both.

By the end of the Archaic (c.700–480 BC) and beginning of the Classical (c.480–323 BC) period, rigid frontality had been abandoned, and the warrior is depicted in three-quarter view, designed to fit into the triangular end of the pediment. Sculpted completely in the round, the warrior's musculature is realistically modelled, his nakedness heroizing him in death and increasing the pathos induced in the viewer at the sight of the final moments of this youthful warrior.

The pediment was first excavated in 1811 and reconstructed in the Munich Glyptothek by the Danish sculptor Bertel Thorvaldsen, Antonio Canova having turned down the commission. Typical of nineteenth-century tastes, this restoration involved many new additions and extensive scouring of the marble. The composition was later reworked when additional pieces of sculpture were discovered in 1901.

The Kritios Boy has been described both as the last Archaic (c.700–480 BC) *kouros* ('youth') and as one of the earliest surviving examples of Early Classical Severe Style (c.480–450 BC) Greek sculpture. His stance follows the tradition of the Archaic *kouros*: one leg slightly forward, hands by his sides (see the New York Kouros, p.70). However, while the left leg continues to be straight and weight bearing, the right leg in this sculpture is relaxed at the knee; the sculptor has accurately portrayed the natural results of this pose higher in the body, by pushing the pelvis up on the figure's left side and curving the spine, giving the sculpture a sense of movement. The shoulders, however, remain strictly frontal.

In contrast to the fixed 'smile' of an Archaic-period *kouros*, the Kritios Boy's lips are relaxed and his expression austere, typical of the Severe Style. His now hollow eyes would originally have been inlaid in another material, increasing the sense of life. Thanks to the slight turn of the head, the figure no longer engages directly with the viewer as the *kouroi* did – the sculptor has introduced a sense of voyeurism in the piece, while the slim yet soft musculature of his boyish figure adds to the charged sexuality of the polished Parian marble.

c. **475** BC
Italy

Double-flute Player, Artist unknown
Fresco secco, H (wall): 170 cm / 5 ft 6 in, Museo Archeologico Nazionale, Tarquinia

The Tomb of the Leopards in the Monterozzi necropolis, Tarquinia, is a fine example of the painted tombs of Archaic Etruria, where movement, colour and ritual scenes were paramount. The rectangular rock-cut chamber was designed to evoke the impression of a caterer's tent at an aristocratic funeral. It is painted with a checked, textile-patterned ceiling and wooden banquet couches with reclining couples who watch musicians and dancers perform. The outdoor setting is established by the springtime shrubs, on which blue-green leaves are just opening.

The flautist shown here marches in wide steps to the left, energetically playing. His large almond eyes, huge hands (both characteristic of Etruscan art

and intended to emphasize the vitality of the figure), and big feet are drawn hastily in black; the skewed proportions emphasize his swinging movement, alert glance and expert fingering of the pipes. Seen by torchlight, the bright colour palette (black, red, orange, green, blue, yellow), bold forms and energetic movement would have made a striking impression.

Etruscan tomb painting may reflect the techniques and innovations of now-lost Greek wall painting, and Greek vases, commonly placed in Etruscan tombs, have been used to help date the paintings in Etruria. The works are most valuable, however, for the light they shed on the rituals, religious beliefs and daily life of elite Etruscans.

c. **475** BC
Greece

Delphi Charioteer, Artist unknown
Bronze, glass, copper and silver, H: 180 cm / 5 ft 10 in, Archaeological Museum, Delphi

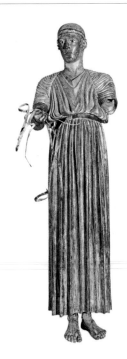

The Delphi Charioteer once commanded four or six horses, of which only fragments now remain. The base inscription reveals that the group was set up by Polyzalus, tyrant of Gela, a Greek colony in Sicily, following the victory of his chariot team in the Pythian Games at Delphi in 474 BC. The charioteer is shown not in action but after the race, when the successful team was presented to the watching crowd.

The Severe Style (c.480–450 BC) sculpture was made using the direct hollow-casting method: a wax model was made over a clay core and a clay mould formed over the top; the clay was heated so that the wax melted, after which it was fired further and molten bronze poured in to replace the wax. This resulted in thicker, more uneven casting than the slightly later indirect method (seen in the Riace Warrior, p.89).

The charioteer is complete but for his left arm, and he retains his inlaid glass eyes, copper eyelashes and lips, and the silver meander pattern on his headband. He is clad in a *xystis*, a long, belted garment worn by charioteers; the straps crossing his upper back and shoulders prevented it from inflating with air during the race. Youthfulness is conveyed in his soft features and curls, while the slight incline of his head reveals a certain humility. His severe expression and the elaborate folds of his garment place the charioteer in between the stylization of earlier Archaic sculpture and the idealization of the later Classical period.

Sokoto Male Head, Artist unknown
Terracotta, H: 33 cm / 1 ft 1 in, Musée du Quai Branly, Paris

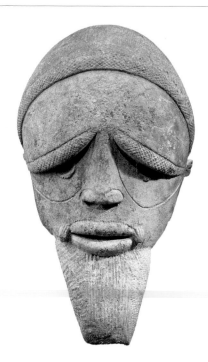

Some 400 kilometres (640 miles) from the Nok cultural centre (see the Nok Figure, p.80), a series of terracotta sculptures were unearthed at the so-called Tumulus of Karauchi near Sokoto in northern Nigeria. As none of these works has been documented in controlled excavations, little is known about the culture that produced them. Most of the vestiges of this tradition are male human heads such as this, which would originally have been part of cylindrical statues. They appear to be closely related technically to the works of the roughly contemporaneous Nok people. Given the sophistication of these sculptures, scholars have speculated that some as yet unknown tradition may have preceded them.

The head appears to have been the focal point of both Nok and Sokoto figurative representation, both in terms of its scale and its definition of features inscribed into the clay through a subtractive approach. Other stylistic conventions distinguish Sokoto representations from contemporaneous Nok ones. The summit of the head is defined by a broad forehead surmounted by a comparatively plain and unadorned crown, in contrast to the complex arrangement of buns on a Nok figure. Although the eyes are pierced, as in Nok faces, there is a heaviness to the broad brows that project in strong relief. Positioned at a raking angle, these powerfully define the cast of the face and are further accentuated with bold cross-hatching.

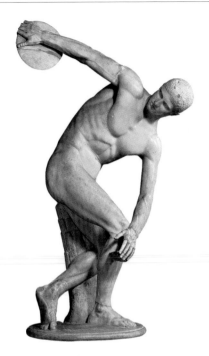

One of the most famous of Greek sculptural figure types, the original bronze Discobolos (c.470–440 BC) is lost, but the sculpture is known from various Roman copies, each easily identified by the tree trunk support. Since marble is heavier and has less tensile strength than bronze, Roman sculptors used increasingly imaginative supports for their copies.

Attributed to Myron (fl. c.480–440 BC), the sculpture is a masterful study of torsion and movement; not surprisingly, it was one of the sculptor's most famous pieces, according to the Roman writer Pliny (first century BC). The athlete is depicted frozen in time, in the moment before the release of the discus, his body twisted and arm raised, every muscle straining and the veins on his arms swelling with physical effort.

In some versions of the Discobolos, the head of the athlete looks downwards rather than back at the discus. Charles Towneley, one of the richest and most influential collectors of the eighteenth century, owned a copy of this type. He was assured by the Pope's expert that his was the true pose, contrary to current critical opinion. The Discobolos was later popularized in the opening sequence of Leni Riefenstahl's 1938 film of the Berlin Olympics, *Olympia: Fest der Völker*.

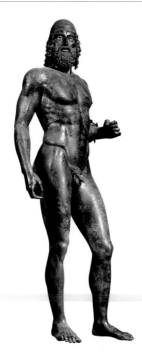

This warrior is one of a pair found in the Riace marina, in southern Italy. It is a rare survivor, as metals were melted down and recycled in antiquity, so most Greek bronzes are known only in later Roman copies, these usually in marble. It has been suggested that the High Classical (c.450–375 BC) warriors formed part of a larger monument, perhaps one at Olympia commemorating the Persian Wars. The powerful stance and size of the figure, and his pose supporting his shield on his left arm and spear on his right, is an eloquent expression of strength and perhaps heroism.

The hollow sculpture was cast using the indirect lost-wax method, first modelled in clay or wood, with piece moulds taken in clay or plaster. These were lined with wax, then filled with a clay core. The resulting wax and clay duplicate was covered in clay and heated, so that the wax melted and ran out; after further firing, molten bronze was poured in to replace the wax, leaving a thin layer of bronze between the two clay layers. The moulds could be reused or new moulds made from the original figure, making it possible for many casts to be produced from a single model (though one recent theory suggests that the torso and limbs of the warriors were cast from life). This was a sculptural process that allowed for a high degree of naturalism, seen in the curls of hair and veins in the arms. Further details include silver teeth, copper lips and nipples, eyes and eyelashes, all inserted separately.

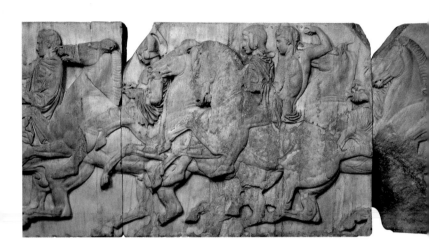

These blocks of Pentelic marble come from the northern part of the 160-metre (525-ft) sculpted frieze that encircled the main rooms of the Parthenon, the temple to Athena on the Athenian acropolis.

The Parthenon's decorative programme, said by the Roman writer Pliny to have been designed by Pheidias (fl. c.490–430 BC), was unique for its time in its inclusion of so much architectural sculpture: both pediments, all 92 metopes and the frieze were carved and painted. The frieze began at the southwest corner of the internal building (inside the colonnade), the corner nearest the viewer as he approached from the acropolis gateway, and proceeded in both directions to a climax on the east front. Interpretations vary, but

the frieze clearly represents a procession – perhaps the Great Panathenaia, held every four years in honour of Athena – with horsemen, marshals, charioteers, musicians, water-carriers and sacrificial animals.

The depth of the relief never exceeds 6 cm (2.4 in) and is deeper at the top than at the bottom, to compensate for the height at which it would have been viewed. Within this shallow depth, nevertheless, are shown horses up to four deep. Variety was achieved through subtle differentiation in elements such as headgear and the contrasting poses and motion of the animals. A striking unity is maintained through the calm, noble expressions of the figures and the rhythmic repetition of horse and human legs.

Warrior Taking Leave of his Wife, Achilles Painter
Painted ceramic, H: c.42 cm / 1 ft 5 in, National Archaeological Museum, Athens

During the Classical period (c.480–323 BC), the white-ground lekythos (oil jug) was an exclusively funerary vessel form. With a narrow body, long neck and single handle, the lekythos was used to anoint the bodies of the dead with oil, or as an offering. The thin white slip on the body of the vessel was painted with polychrome decoration, the light-coloured ground giving the painter great freedom of expression; the style was probably influenced by wall painting.

This vessel is one of the Achilles Painter's masterpieces. The scene is set in the women's quarters of a house, indicated by the jug, mirror and soft cap hanging on the wall above the seated female; before her stands a warrior holding helmet and shield.

A quiet gravity joins the two figures, the separation between them imparting a clear sense of death. The eye as a shield device was a symbol of defiance and defence, but here, turned in profile and continuing the gesture of the warrior towards his wife, it harmonizes with the sadness of the scene.

The statuesque quality of the calm, composed figures is characteristic of the Achilles Painter's work. Known particularly for his white-ground lekythoi, he also painted red-figure amphorae, calyx kraters and lekythoi.

c. **435** BC
China

Zun and Pan Assemblage, Artist unknown
Bronze, H: 30.1 cm / 1 ft (zun); 23.5 cm / 9¼ in (pan),
Hubei Provincial Museum, Wuhan

A *zun* was a container for wine and a *pan* for water. The components shown here must have been made as an integral unit of the two vessels, a combination that has been tentatively identified as a wine cooler. The elaborate openwork dragon decoration was cast by means of the new lost-wax process before being attached to the two piece-moulded vessels. Its intricate, worm-cast effect is curious, but it is not out of place among the swirling lines of clouds, dragons, serpents and other imaginary creatures commonly encountered on high-quality bronze and lacquered goods of the Warring States period (481–221 BC).

The set was found in the tomb of Marquis Yi (d. c.433 BC), ruler of the state of Zeng, in Suixian, Hubei Province. Zeng was small and politically insignificant compared with its powerful neighbour, the state of Chu, but the marquis had nevertheless been laid to rest in a large underground suite of four rooms, with rich southern-style tomb furnishings even more extensive than those found in larger kingdoms of the same period. An inscription in the middle of the *pan* says that it was made for Marquis Yi, but scientific examination has shown that the dedication had been altered, and that it had originally belonged to Yi's predecessor, Marquis Yu.

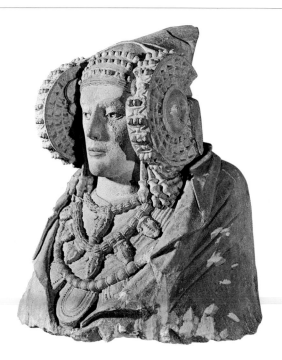

This enigmatic sculpture was discovered in 1897 at Elche in Alicante, on the southeast coast of Spain. In addition to the Punic (western Phoenician) and Greek influences that have been seen in the stylistic treatment of the figure, the Lady of Elche presents interesting native elements in its ornament and costume; as such, it is considered a masterpiece of Greco-Iberian hybrid art. Iberian elements of the sculpture have been identified in the elaborate headdress and jewellery, which correspond with descriptions of Iberian women left by Artemedorus of Ephesus, a Greek writer who visited the Iberian peninsula around AD 100. Greek influences are seen in the hollow eyes, which would have been inlaid

with coloured glass, and in the realism and detail of the figure, which was executed in a severe style that suggests a possible early fifth-century BC date, though other suggestions range as late as the Hellenistic or Roman periods.

The intricate ornamentation and unusual headdress of the figure have been meticulously studied in an attempt to discover her identity, but many questions remain unanswered. She is assumed to represent an indigenous goddess of fertility and death. A hollow opening at the back is also found in other sculptures from this period, such as the Lady of Baza (also in the Museo Arqueológico, Madrid) and reinforces the notion that the sculpture served a ritual function.

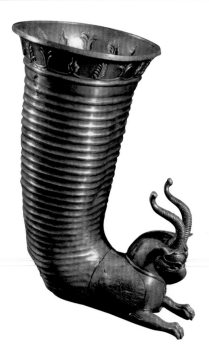

Opulent Persian banquets owe much of their later fame to the ancient Greek historian Herodotus, whose vivid description of the abandoned camp of the Persian commander Mardonius following the battle of Plataea (479 BC) lists incredible quantities of luxurious textiles and gold and silver vessels. The description was partly a narrative device intended to contrast Persian luxury with Greek restraint, but there was truth to the account of the Achaemenid aristocracy's great wealth and of the luxurious trappings of court life, of which this piece gives some indication.

The silver rhyton (a horn shape libation vessel) is said to have come from Erzincan in Turkey, and is one of the finest surviving examples of fifth- to fourth-century BC Achaemenid tableware. The piece shows delicate gilding and the beautifully rendered head and upper body of a griffin. Used both as a cup and a pourer, it would have been filled via the funnel and liquid then poured out through a hole in the griffin's chest. The hole is small enough to cover with a finger when not pouring or when using the vessel as a drinking cup.

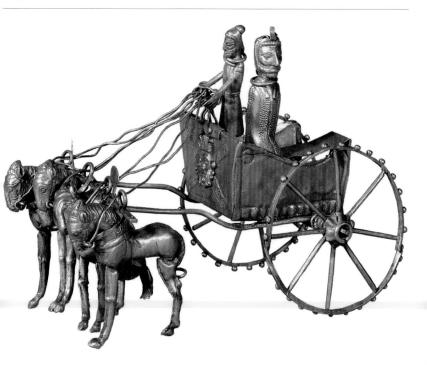

This exceptionally finely worked model chariot comes from the Oxus Treasure, a group of gold and silver objects and coins discovered some time before 1880 in the region of Takht-i-Kuwad on the River Oxus, in what is now Tadjikistan, and after an eventful journey sold in India. Some of the pieces were bought by the Director General of the Archaeological Survey of India, Sir Alexander Cunningham. These he sold to Sir Augustus Walloston Franks, who in turn bequeathed them to the British Museum.

The level of detail in the model is such that many aspects of the full-size chariot's construction can be identified, including a floor apparently consisting of interlaced leather straps and what are probably diagonal support struts on the front of the chariot, behind the protective figure of the Egyptian god Bes. The riders, the driver and a larger seated figure, both wear dress distinctive to the Median tribes of Iran, and are fixed to the chariot with gold wire, which is also used to represent the horses' reins.

Beautifully crafted though many parts of the Oxus Treasure are, it is thought that the objects were originally put together as a hoard, valued as precious metal rather than for their workmanship.

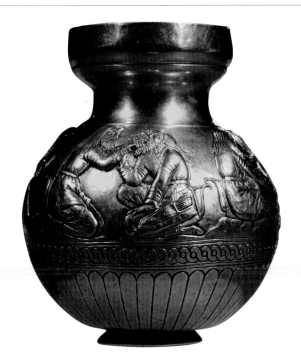

Scythian art before the sixth century BC is dominated by zoomorphic motifs and only very rarely depicts human beings. With escalating Greek contact, however, human figures and narrative scenes began to appear, with a corresponding increase in iconographic and compositional complexity.

This chased electrum (a naturally occurring alloy of gold and silver) vessel was excavated from the Kul Oba *kurgan* (burial mound), near Kerch on the northern shores of the Black Sea, in 1830. By the fourth century BC, Scythian *kurgan* burials were extremely rich in grave goods, and much of the metalwork shows clear Greek influence, while frequently depicting scenes from everyday Scythian life. In the scene shown here,

the left-hand figure appears to be extracting a tooth from the mouth of his companion.

The merging of Greek and Scythian styles has led to debate over whether these objects were made by Scythian goldsmiths or by Greeks – either itinerant metalworkers or in Greece expressly for Scythian customers. The shape of this vessel shows Classical influence, as does the chased guilloche and tongue-pattern decoration on the lower part of the body. The figures, however, are unmistakeably Scythian, as is the typically low relief. Whether made by a Greek or Scythian, the vase is an excellent example of the strong hybrid style of the region.

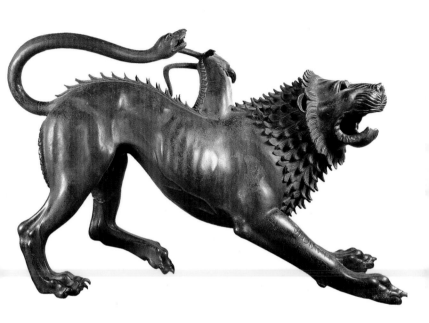

This bronze chimaera, from the first half of the fourth century BC, has been famous since its discovery on 15 November 1553, near the Porta San Lorenzo of the Etruscan city of Arezzo. An inscription in Etruscan reads 'gift to Tinia' (Lat: Jupiter); it was surely a votive offering in some sanctuary located outside the city walls. The hollow-cast statue is near life-size, and its pose and wounds (bleeding gashes on the goat's neck, just visible below the head turned away, and on the lion's left hind leg) have been taken as evidence that it was part of a group portraying the mythical slaying of the monster by Bellerophon. The letter forms of the inscription are characteristic of northern Etruria, and it was probably created by a master in Arezzo.

The lean, naturalistic forms of the smooth body, with muscular legs, bony paws and protruding ribs and veins, contrast with the formalized, intensely textured, flame-like tongues of the long mane. Such stylization of pelt, and the simplified, mask-like face and eyes, are found in Archaic Etruscan works, such as the well-known Capitoline Wolf of Rome (c.480 BC). The Slaying of the Chimaera was a popular motif in Etruscan art, and like the Capitoline Wolf, this chimaera has inspired artists ever since its discovery. The animal appears in Medieval art as a hybrid monster, with human face and serpent tail; later versions often morph into a sphinx-like creature.

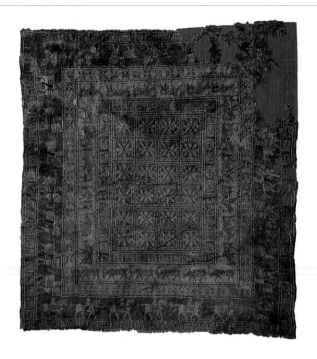

The fourth-century BC Pazyryk carpet is the oldest surviving pile carpet known, buried in Barrow 5 at Pazyryk in the Altai Mountains of southern Siberia and preserved by permafrost. The once bright red, blue and green dyes have faded, but even so the carpet glows. The central field of schematized lotus-bud rosettes is surrounded by five successive borders showing fantastic eagle-griffins; fallow deer or elk; more lotus-bud rosettes; riders and their horses, alternating between a mounted rider and a human figure walking beside his horse; and more eagle-griffin motifs. One interpretation of the horse-and-rider border suggests that it depicts a funeral procession, perhaps for the chieftain buried with this rug. The

wool carpet contains an average of 225 knots per square inch, totalling more than 1.25 million knots.

The nomads of the high Altai maintained cultural and trading contacts with Central Asia, China and the Near East, and imported objects found in the Pazyryk burials include Chinese mirrors and silks, as well as fabrics and other artefacts from Persia (modern Iran). The excavator of the carpet saw Achaemenid Persian influence in it, citing resemblances between these horsemen and relief carvings of mounted processions at Persepolis; it is generally agreed, however, that the carpet was probably made in the Altai. Its exceptional workmanship indicates that the techniques of carpet weaving were well understood by this time.

Gayer-Andersen Cat, Artist unknown
Bronze, gold and silver, H: 42 cm / 1 ft 4½ in, British Museum, London

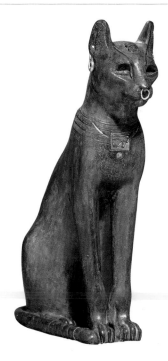

This bronze statue of a cat, named after the owner who gifted it to the British Museum, represents a manifestation of the Egyptian goddess Bastet. The two images of the *kheprer* dung beetle (one on her forehead, the other on her chest) link the cat to the sun god, and the pectoral with a plaque displaying the *udjat* eye is a reference to the hawk god Horus, whose symbol it was. The cat has gold earrings and a nose-ring, and her eyes were originally inlaid. Engraved necklaces encircle her neck. This is almost certainly a votive object presented to a temple where the goddess Bastet was worshipped.

The sculpture gives the impression of spontaneity and free creativity, but it represents an iconic image of the cat that had been established nearly two thousand years earlier. Some of the details were the result of Egyptian artistic conventions, such as the tail always neatly placed along the right side of the body, but they soon became obligatory. This is one of the finest non-human sculptures known from ancient Egypt – elegant, zoologically faithful and conveying with unnerving accuracy the self-assurance and concentrated gaze of the animal.

Raimondi Stela, Artist unknown

Granite, H: 195 cm / 6 ft 4½ in, Museo Nacional de Arqueología, Antropología e Historia del Perú, Lima

This tall stela (or stele, a stone slab) was part of a monumental sculptural programme adorning the Black-and-White Portal, the formal entrance into the New Temple. This was Chavín de Huantar's main ceremonial structure during the Late Early Horizon (c.500–200 BC). Named for its discoverer, the Raimondi monument is a *tour de force* of technical expertise and multi-dimensional imagery. Its low-relief carving is typical of the best Chavín stonework, especially those sculptures portraying supernatural beings. Chavín artists perhaps chose the low-relief format for representations of spirits (in contrast to their typically three-dimensional representations of humans) to accentuate their mystery, the viewer's

difficulty in discerning the complicated imagery serving to highlight the mystical nature of the spirit.

The Raimondi Stela features the Staff God, a deity related to agricultural fertility and the earth. Inverting the stela reveals a second deity who descends from the heavens, its lower body comprising a group of nested spirits. The style and imagery of the stela suggest a direct association with the Black-and-White Portal and its two carved columns – one of white stone, the other black – that combine to present a complementary image. Together, they convey the most fundamental religious principle in Chavín and later Andean societies, that of duality within a universal oneness.

Colonna Venus, Original by Praxiteles
Marble, H: 205 cm / 6 ft 8 in, Musei Vaticani, Rome

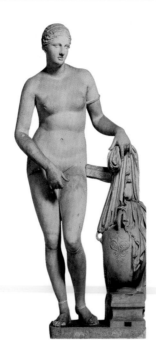

The Aphrodite of Knidos was the first female nude sculpture in ancient Greece. The first–century AD writer Pliny relates how Praxiteles (c.400–330 BC) produced two statues, one draped and the other nude. The people of Kos chose the former, leaving Knidos, on the southwest coast of modern Turkey, with the nude Aphrodite. The statue attracted considerable fame and was widely imitated by Hellenistic and Roman sculptors; over 60 versions at varying scales are known from across the Mediterranean. The Colonna Venus is one of many copies of the original, which was destroyed in a fire in Constantinople in AD 476.

Praxiteles' work (for another statue possibly by him, see the Marathon Boy, p.104) was famed for its charm and wit, seen here in the goddess's right hand, which serves to draw attention to the genital area she ostensibly conceals, and in the water jug that provides a pretext for her nakedness. Her body is rendered in soft curves, the smooth, rounded surfaces of her breasts, belly and thighs invitingly tactile.

The Colonna Venus has been seen as a faithful version of the Knidian Aphrodite on the basis of third-century AD coins minted in Knidos that depict the statue in a similar pose. An alternative argument sees the Colonna type as a Hellenistic variant, the original being better represented in the versions that are said to show the goddess as less vacant, with greater awareness of and response to the viewer.

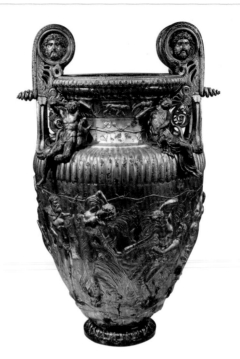

This bronze krater from Tomb B at Derveni, in Greek Macedonia – an exceptional survival and an astonishingly elaborate piece – served as the ash urn for a cremation burial, holding the remains of a man and woman. The high tin content in the metal makes it appear gold at first sight; details such as the grape vine and ivy leaf garland were added in silver. The main scene, hammered from the reverse side in a high relief *repoussé* technique, shows Dionysos and Ariadne with maenads and satyrs. Four separately cast figures are attached to the shoulder, turning the vase into an elaborate, sculptural work.

The Dionysiac theme is suitable for a wine-mixing vessel, though the thin layer of wax inside this krater shows that it was never used in this way. Macedonian tombs of the fourth century BC are renowned for their wealthy offerings, and this grave was particularly rich, with bronze greaves and breastplate, iron spearheads and silver vessels among the goods that accompanied the deceased. The vessel is inscribed 'Astion, son of Anaxagoras, native of Larisa' (a city in Thessaly), though it is unclear whether this refers to the owner or the craftsman who made it.

c. **325** BC
Italy

Larth Tetnie and Thanchvil Tarnai, Artist unknown
Alabaster, 214 x 117 cm / 7 ft x 3 ft 10 in, Museum of Fine Arts, Boston, Massachusetts

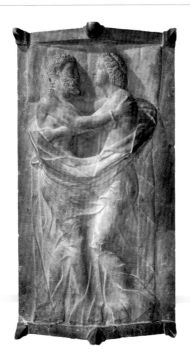

A pair of sarcophagi found in 1846 in a tomb in the Ponte Rotto necropolis at Vulci must have been specially commissioned by the aristocratic Tetnie family. Two couples – parents and their son and daughter-in-law – each had a sarcophagus with effigies of themselves on the lid.

This lid is from the sarcophagus of the son and his wife, Larth Tetnie and Thanchvil (Lat: Tanaquil) Tarnai, and dates to the second half of the fourth century BC. The alabaster allows for fine detail and intricate poses that resemble the styles current in fourth-century BC Greek sculpture (see, for example, the figures on the Derveni Krater, opposite). The couple lie against huge pillows embracing and gazing into each other's eyes. Larth, with meticulously combed hair and Greek-style beard, wears only a bracelet; Thanchvil has a fashionable large earring against her finely waved and fastened hair. The draped mantle lends movement and reveals the forms of their lower bodies beneath. The sculpture tells a story of devoted spouses and affords a rare glimpse of marital intimacy and family affection in Classical Etruria.

It is unusual in Etruscan art for the husband to recline on his wife's right side; perhaps it was a preference of the Tetnie, or a Greek artist, ignorant of Etruscan customs, may have carved the lid.

Found in a shipwreck off Marathon, northeast of Athens, and dated to c.325–300 BC, the Marathon Boy is a rare example of a surviving bronze sculpture from ancient Greece, most of which were melted down and recycled in antiquity. With his slim limbs and soft musculature, the figure is immediately recognizable as an idealized youth, but his precise identity – if such there be – is uncertain. The style is Praxitelean, and it has been suggested that the Marathon Boy was actually a late work by the famous sculptor, better known for his works in marble (see the Colonna Venus, p.101).

The youth's *contrapposto* pose generates a characteristically Praxitelean, sinuous S-shape

through his body, adding to the erotic appeal of his adolescent figure. His outstretched right arm is typical of the late Classical period (c.375–323 BC), when more three-dimensional views became popular and figures acquired a certain grace and lightness. The boy is naked but for his headband, looking at what he once held in his outstretched right hand. He might represent Ganymede, cupbearer to the gods, pouring wine, though other interpretations suggest that he may be Hermes, the god of athletes, or simply an attractive youth.

The oversized, beautifully designed antlers of this remarkable creature exhibit 'zoomorphic juncture', the convention of incorporating smaller animals (here, only their heads) to represent certain details of a larger animal's body. The practice is extended also to the creature's snout and tail, which are shaped like raptors' beaks, and its body is decorated all over with clouds. Similar elements feature on earlier Chinese artefacts, and clearly the creature has mythical implications.

The Warring States period (481–221 BC) figurine comes from an Ordos tomb at Nalin'gaotu, Shenmu County, Shaanxi Province, and may have been made either in one of the central Chinese states or by one of the gold-loving pastoral tribes from Central Asia.

Zoomorphic juncture is commonly seen on artworks of the Sarmatians, a nomadic people who occupied the Central Asian steppe lands during the later first millennium BC, and the zoomorphic treatment of some Ordos artefacts may reflect contemporaneous Siberian and Central Asian styles.

The 12 small holes round the edges of its four-petal base suggest that the object may have been part of a leader's headdress. Its form fits comfortably within the group of 'cosmic deer' that appear across Central Asia, notably in Barrow 2 at Pazyryk, where the finial of a staff is shaped like a griffin in a similar pose, and where a well-preserved male body was tattooed with a design almost identical to that on this creature.

Eastern Zhou Dynasty, Warring States Period

Winged Horses, Artist unknown
Painted terracotta, 114 x 124 cm / 3 ft 5 in x 4 ft,
Museo Archeologico Nazionale, Tarquinia

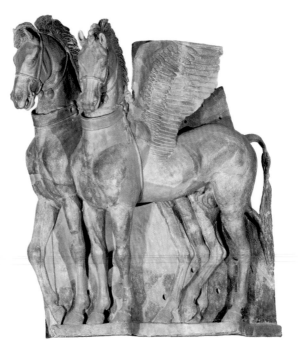

The remodelling of the great temple of the Etruscan city of Tarquinia in the Hellenistic period (323–27 BC) incorporated a set of plaques (now restored) depicting the chariot of a beautifully dressed goddess drawn by this remarkable pair of winged horses that date to the end of the fourth century BC or later. The temple, known by the modern nickname Ara della Regina (Altar of the Queen), would have dominated the view of the city from the south. An inscription suggests that it may have been dedicated to the goddess Artumes (Lat: Diana, Gk: Artemis). Etruscan temples had open gables beneath a tiled roof, with the ends of the roof beams sheathed from the elements by ornately decorated terracotta plaques, such as this.

The spirited horses are powerfully rendered, prancing and champing at the bit. Their swelling muscles and tendons contrast with the movement of pricked ears, deeply textured manes and feathered wings. In addition to the highly inefficient collars of draught horses, these steeds wear *bulla* (bubble) amulets attached to their bridles, common for pets throughout Italy; children often wore similar amulets.

Because of their position near the temple roof, the relief of the horses' heads is much deeper than that of their feet. They seem to lean out towards the viewer, but optical perspective would have made them look quite natural when high on the temple gable.

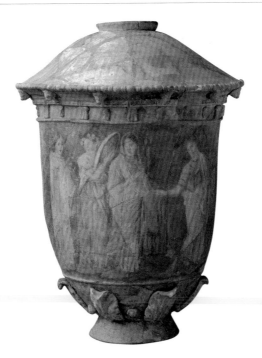

This painted funerary urn is an example of an extremely unusual and unique Hellenistic (323–27 BC) ceramic tradition, known only from the small town of Centuripe in Sicily. Characteristic features are elaborate vessel shapes that often incorporated high feet and lids with moulded finials, relief ornament and polychrome decoration in tempera.

This handleless bell krater has moulded leaves at the base and a frieze of moulded lion heads (probably originally gilded) below a rim of beading at the join between body and lid. On the body of the vase, a group of stately, elegantly dressed women are depicted against a red background. The vessel was first primed with white before decoration was added in black

outline and a wide range of colours: red, pink, purple, blue, yellow and black. The figures are depicted on a single ground line with little sense of space, a Classicizing style by comparison to some of the busier, more crowded Hellenistic compositions (compare the Derveni Krater, p.102). The similarity between the style of Centuripe ceramics and the Pompeian wall paintings of the first century BC, especially those in the Villa of the Mysteries (see the Mysteries Fresco, p.128), supports the theory that Pompeian artists copied Hellenistic paintings.

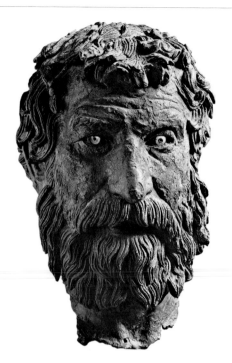

This third-century BC bronze head of an elderly man, perhaps the portrait of a philosopher, shows great attention to the particularities of physical appearance in the lined brow, hooked nose, heavy jaw and dishevelled hair. The identification is based on the powerful expression of inner character in the steady gaze and calm demeanour, indicative of a deep inner life; the wildness in his shaggy hair, moreover, suggests a philosophical disregard for superficial outward appearances.

Portrait sculpture in the Hellenistic period (323–27 BC) was more individualizing than the idealizing style of the Classical period, but many heads were nevertheless not contemporary likenesses, but rather attempts to capture the character of a well-known historical figure: Homer or Sophocles, for example.

The head was found in the excavation of a shipwreck off the coast of Antikythera, an island off the southern Greek mainland; the wreck contained around 100 bronze and marble sculptures. The ship has been dated to c.80–50 BC, indicating that it was part of a Roman booty shipment, perhaps that of the Roman general Sulla, who sacked Athens in 87/86 BC. The head may have been cast in Athens, renowned for its portrait sculpture and the centre of philosophy in the Greek world in the Hellenistic period.

Ban Chiang Jar, Artist unknown
Painted terracotta, H: 43.5 cm / 1 ft 5 in, Rijksmuseum, Amsterdam

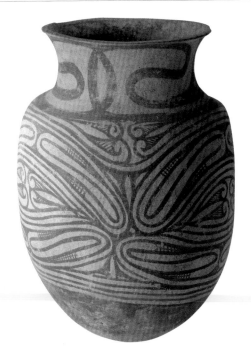

Developed over a period of almost 4000 years, the pottery of Ban Chiang (c.3600 BC–AD 200) represents one of the longest and finest pre-historic ceramic traditions known today, and reached a level of refinement and sophistication unsurpassed for its time. This large jar is an excellent example of the Late Period style. Early Ban Chiang pottery consisted of black and grey incised wares, which gradually evolved into more complicated and refined red-on-buff coloured pots with curvilinear and geometric designs. These in turn evolved into a more free-flowing, artistic tradition culminating in Late Period (c.300 BC–AD 200) pottery of the type shown here. These high-quality vessels were placed over the body

of the deceased before burial and represent a key part of the funerary rituals of the Ban Chiang people.

Here, the rigid, geometric triangle and rectangle motifs of the previous period have gone, replaced by graceful curved lines and curls. This freer, looser form of decoration is a testament to the fluidity of the artist's technique and his culture's appreciation of style. Continuation in pottery styles from earlier periods can still be seen, however, in the common colour scheme, with red-on-buff slip still employed.

Ban Chiang Culture, Late Period

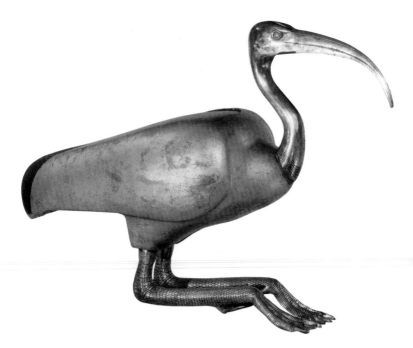

Although this object appears to be a stunningly beautiful animal sculpture representing the Egyptian ibis (*Ibis religiosa*), it is, in fact, an animal coffin. The ibis was regarded as one of the manifestations of Thoth (Egyptian: Djehuti), the god of wisdom, learning and writing. During the Ptolemaic Period (c.332–30 BC), ibises and other animals and birds linked to deities were bred at special farms associated with temples. When they died, they were mummified and buried in communal animal cemeteries. The bodies of deceased ibises were often wrapped in linen and placed in jars or wooden boxes, but some were put into small coffins made in the form of the animal itself, perhaps in imitation of anthropoid coffins made for humans.

The main part of this ibis-shaped coffin is made of wood and is hollow. The dead bird was inserted through an opening, which was closed with a lid, on the back of the coffin. The head, with the characteristic curved beak, and the legs are completely naturalistic and are made of silver, the eyes of gold-lined rock crystal.

Copies of two different Hellenistic (323–27 BC) sculptural groups of Gauls (more properly, Galatians) have been found in Rome; this dying warrior is one of the larger group, thought to have originally been set up in Pergamon. The Galatians, a European Celtic tribe, invaded cities on the west coast of Asia Minor from Thrace (modern Bulgaria) in 278 BC. Attalos I of Pergamon defeated them in battle in the 230s BC, and the original version of this group was probably created as a victory monument in the 220s BC.

This wounded warrior is elevated to heroic level through his nakedness, elegance of pose and dignity of expression. At the same time, the realistic modelling of his taut musculature and the details of his facial

expression individualize him. His hairstyle and neck torque mark him out as a Galatian; his moustache and clean-shaven cheeks indicate his noble status.

This Roman copy was found in the seventeenth century and purchased by Pope Clement XII in 1737. It was removed to Paris by Napoleon but was returned to Rome in 1815, following the defeat of the French armies. It was probably made sometime from the first to third century AD.

Kneeling Archer, Artist unknown
Painted terracotta, H: 130 cm / 4 ft 3¼ in, Museum of Terracotta Warriors and Horses of Qin Shi Huangdi, Xi'an

The archer, rapt in concentration, kneels on his right knee. The remains of a wooden bow and bronze arrowheads found nearby, and the position of his arms and hands, suggest that he once held a crossbow and arrow. He was one of some 8000 lifesize terracotta warriors, horses and chariots discovered in three pits from 1974 onwards near Xi'an, in Shaanxi Province. Real chariots and weapons were also found.

The army, buried near the mausoleum of Qin Shi Huangdi (reigned 221–210 BC), was probably intended to defend the emperor in the spiritual world, so verisimilitude was important. The figures were made with astonishing attention to detail. The limbs, head and body were moulded and fired separately before being joined together; hair and armour were modelled on wet clay. Some figures still retain traces of the coloured paint that completed them.

The finds authenticate written records of Qin's outstanding military capacity and give historians a unique glimpse into the organization and equipment of one of the ancient world's most ruthless armies. The man who commissioned the terracotta army and founded China's first imperial dynasty (221–206 BC) was also responsible for the construction of the Great Wall around his country's northern frontiers. Ruthless and despotic as he is supposed to have been, he nevertheless conceived empire on a more advanced scale than any previous ruler in Chinese history.

Battersea Shield, Artist unknown
Bronze and red enamel, H: 77.7 cm / 2 ft 6½ in, British Museum, London

Sophisticated metalwork techniques and complex linear designs – abstract patterns derived from nature, such as stylized faces and entwined plant motifs – were characteristic of the Celtic peoples of Iron Age Europe and were employed with great elegance. The La Tène-style decoration on this shield (named after the settlement site in Switzerland where the culture was first described) was produced using the *repoussé* technique of hammering from the reverse side, highlighted with engraving and stippling. The swirling knot-work and owl-like faces are hallmarks of Celtic art (see also the Desborough Mirror, p.137).

The shield has been associated with Belgic immigrants or may be of continental manufacture.

The decoration is confined to three roundels, and the design is punctuated with 27 framed studs in red enamel, a colour believed to possess magical protective properties. The Battersea shield as it survives is only the thin metal facing to a now-perished wooden support and was not produced for use in battle. Rather, the lustrous bronze and brilliant red accents were a mark of status and spectacle in ritual display.

The shield was dredged in 1857 from the River Thames at Battersea, where it had probably been offered as a sacrifice or ritual gift between c.350 and 50 BC. Its designs and those of other La Tène finds helped inspire a nineteenth-century Celtic revival in arts and crafts linked with a mythical Celtic past.

Hu Ritual Vessel, Artist unknown
Bronze, gold and silver, H: 50 cm / 1 ft 7¾ in, Victoria and Albert Museum, London

The decorative technique of inlaying bronze vessels such as this with graceful, symmetrical designs in contrasting metals became popular towards the end of the Zhou dynasty (c.1045–256 BC), when centres in both north and south China produced objects with abstract patterns made of rhythmic curlicues. The practice continued into the Han dynasty (206 BC–AD 220). By this period, the production of metal vessels had become commonplace, and ever more elaborate casting and inlay techniques were employed to mark the luxury status of ritual artefacts. Goldsmiths further developed techniques to rival designs produced in highly coloured lacquer wares and textiles.

Despite the show of opulence, however, precious metals were used economically. The gold pattern produced on this *hu* ritual vessel, a shape introduced in the middle part of the Western Zhou dynasty, was inlaid in two layers: thin strips of non-precious metal were coiled closely together and hammered into chiselled depressions, then overlaid with gilding. The quality and complexity of the vessel is evidence of the highly developed artistic sensibility of the Chinese elite in the last centuries BC, and while the precise function of such vessels is uncertain, their placement in royal and aristocratic tombs attests to their status.

This bronze figurine of a dancer, dated to the third or second century BC and named after a previous owner, is a masterpiece of Hellenistic bronze casting. Veiled and wrapped in voluminous drapery, she has been identified as a professional entertainer from Alexandria, whose performances mixed elements of dance and mime. It is not known where the sculpture was actually made, though Egypt is possible.

During the Hellenistic period (323–27 BC), artists experimented much more than previously with the portrayal of movement, modelling bodies in new and ambitious poses (see the Laocoön, p.125). This dancer is characterized by her torsion, her head and right shoulder dipping over her taut right leg, her right arm wrapped around her body and over her left shoulder. With no principal viewpoint, she is conceived fully in the round. The figure is dressed in a generous *chiton* (tunic) that trails behind her in heavy folds and shows through the transparent *himation* (mantle) wrapped around her head and mouth and held tight across the body in her left hand. The gauzy veil covering the dancer's face erases her individuality but adds to her seductive mystery. Light plays across the complex texture of the drapery (deep folds, sharp pleats and taut, flat areas), contributing to the figure's sense of whirling motion.

This enigmatic horn-shaped object belongs to the Sa Huynh culture (c.500 BC–AD 300) of south and central Vietnam. Considering its small size, the 'horn' has been carved from hard stone with great skill and delicacy; the lower end forms a small cavity that may have been used to hold a liquid. This may indicate a ritual function for this object, and it has been suggested that the vessel was, in fact, a funerary offering. Alternatively, it could have functioned as a form of jewellery.

The Sa Huynh culture is known primarily through archaeological excavations and surface finds from sites along the shores of central Vietnam; as research continues, it is becoming clear that this was a coastal-based society. A distinctive characteristic of this culture was its production of high-quality stone jewellery made from minerals such as nephrite, a variety of jade. These highly prized objects became part of a far-reaching trade network, with stone jewellery from the Sa Huynh culture reaching as far as central Thailand, the Philippines and Botel Tobago island southwest of Taiwan.

This rectangular stele (stone slab), from Bori Helal, near Chemtou in Tunisia, displays within a long narrow panel a row of eight almost identical figures – seven male, one female. The bodies are flat, with arms and details of costume lightly incised. The heads are more fully modelled, with rounded cheeks and almond eyes, and the resulting shadows draw further attention to them. The male figures all have long, curly hair, and all but one (at the far left) are bearded; their identical costumes fasten on the right shoulder. Nevertheless, the sculptor has made each face individual, with variations in the shape and carving of features. The female figure (fourth from right) wears a diadem or hair-band, earrings and armlets.

There are few close parallels to this chiselled relief block, which is one of the rare examples of sculpture belonging to the Numidian kingdom of north-west Africa before it was absorbed into the Roman Empire; the piece dates to the second or first century BC. The figures are thought to represent local gods, known from a few other monuments. The depiction of the deities may be influenced by the art of Carthage or Rome, but the execution is highly stylized and has no similarities to Punic (Carthaginian) or Roman images. The closest parallels are the frontally facing images on Libyan funerary monuments of the Roman period, which exhibit a similar local response to Classical forms.

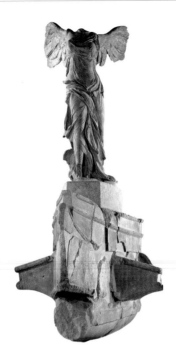

This figure forms part of a victory monument constructed when the famous sanctuary of the Great Gods on the island of Samothrace was at its most prosperous under Hellenistic (323–27 BC) royal patronage. The winged goddess Nike (Victory), perched on the prow of a sculpted ship, may have been dedicated by the people of Rhodes in commemoration of a specific naval victory. Made of Parian marble and originally part of a fountain, the ship was designed to be set in water in an open enclosure.

The Victory skilfully blends contrasting baroque and Classicizing tendencies in Hellenistic sculpture. The figure's spiralling effect is achieved through the oblique angles of the wings and the positioning of the left leg, emphasized by the robes billowing between the legs. The transparency of the wet drapery reveals the nude female body in the manner of late fifth-century BC Classical works, but the theatricality of pose, vigorous movement and sense of volume are a prelude to the Pergamon sculptures (see opposite).

Excavated in 1863, the discovery of the work marked a revival of interest in original Greek sculpture by art academies intent on perpetuating Classicism and Academicism. Some early twentieth-century artists, on the other hand, reacted against it as an embodiment of the artistic canon, declaring a roaring motorcar more beautiful (see Boccioni, *Unique Forms of Continuity in Space*, p.445).

Pergamon Altar Frieze, Artist unknown
Painted marble, H: 230 cm / 7 ft 6½ in, Pergamonmuseum, Berlin

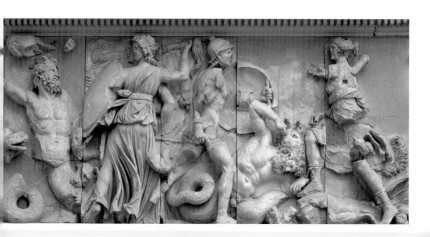

Pergamon (modern Bergama, north of Izmir on the Aegean coast of Turkey) was the capital of the Attalid kingdom formed by one of Alexander the Great's generals; it displaced Athens as one of the great art centres of the world during the Hellenistic period (323–27 BC). The Great Altar, created for King Eumenes II (197–160 BC), was set on a podium surmounted by a high superstructure, which was lavishly decorated with a monumental frieze showing the mythical battle between the Olympian gods and the giants. This gigantomachy was designed to suggest both the victory of the Hellenistic world over barbarism and, more specifically, of Attalus I over the Galatians (Gauls).

This scene shows Hekate, Greek goddess of magic and witchcraft, about to thrust her torch at a giant; his snake-tailed lower body is being attacked by a lion, while a serpent in turn bites the shield of the goddess. While the iconography is firmly rooted in the Classical tradition, the baroque style of the sculpture is a characteristic of Hellenistic art. Dramatic use is made of swirling drapery, tense musculature and writhing bodies. The larger-than life-size figures, of which there are more than 100, appear to be sculpted in the round thanks to the rich play of light and shadow produced by the extremely high relief. Up to 40 sculptors are said to have worked on the altar, including one called Pyromachos of Athens.

c. **170** BC
China

Lady Dai Funeral Banner, Artist unknown
Silk and natural pigments, H: 205 cm / 6 ft 8¾ in, Hunan Provincial Museum, Changsha

A number of Han-period silk funerary banners exist, but none is as finely painted or iconographically rich as this from Tomb I at Mawangdui in Changsha, Hunan Province, from the Western Han dynasty (206 BC– AD 9). Painted with cinnabar, red ochre, silver, indigo, vegetable soot ink and clamshell white, it was draped on the innermost of four coffins housing Xinghui, the Marchioness of Dai, widow of the Prime Minister of Changsha. Scholars have argued endlessly over its interpretation, but it is generally agreed that this is the first extant illustration of the soul's route to the realm of the immortals.

The guiding principles seem to derive from the *Chuci*, or *Songs of the South*, an anthology of

poetry compiled by the semi-mythical Qu Yuan. The vertically arranged registers correspond to the structure of the cosmos; upon death the path of the soul echoes birth, life and rebirth or return to the first ancestor. The lowest section represents the underworld, where souls undergo their first metamorphosis. The central section is the earthly realm, divided into a lower scene showing a group of attendees seated round the shrouded corpse behind ritual vessels, and an upper one showing the deceased in the centre, as if crossing to the 'other' world. The topmost section represents the land of the immortals: sinuous dragons bounded by the sun and moon with their symbols the toad and the raven.

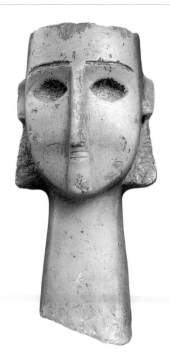

From as early as the eighth century BC the South Arabian kingdom of Saba (Biblical Sheba, modern Yemen) played a major role in the caravan trade of the ancient Middle East and was famed for its valuable aromatic resins. Although trade brought influence from other Asian and Mediterranean artistic traditions, Sabaean art developed and retained a very distinctive style, exemplified in hundreds of stone sculptures discovered in funerary and votive contexts. The long, narrow nose, high ears and geometric design or this piece are all common features of this art.

Archaeologists believe that the role of anthropomorphic sculptures in South Arabia changed substantially over time. The earliest are thought to

be idols, but later pieces almost certainly represent worshippers in votive offerings and the deceased in funerary monuments. This head, dated to c.300–1 BC, would originally have served as part of a funerary stele (stone slab), where it would have been inserted in a hole carved into the stone, which was marked with the name of the deceased. As these niches cut right through the stelae, the sculpture is in the round. Original decoration would have included painted hair, inlaid eyes of blue glass or lapis lazuli, and jewellery; the holes visible on the earlobes may have been used to attach earrings.

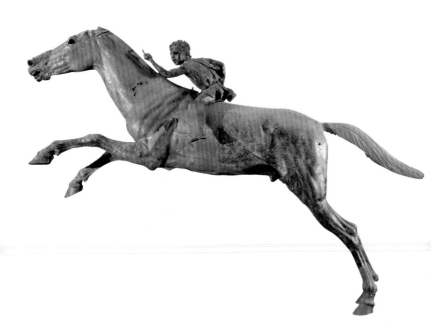

This work, which was painstakingly reassembled after the discovery of fragments off Cape Artemision, Euboea, in 1928 and 1937, affords a rare glimpse of the vigour and realism of bronze Hellenistic groups. There are no close parallels for the approximately life-size horse in mid-gallop, carrying a boy jockey (probably a professional) who glances back over his shoulder; most other equestrian statues are of the static, cavalry type, none of them capturing as this does the thrill and vitality of a horserace.

The sculpture was cast in sections by the indirect lost-wax method (on which technique see the Riace Warrior, p.89) and the pieces then welded together. The eyes of both horse and rider, as well as the Nike

(winged Victory) brand on the horse's right hind thigh, were once inlaid, and there was an intricate bridle. The dating of the group is based on its classicizing features, the twisting pose of the jockey, and the portrayal of ethnic characteristics, which was popular during the multi-cultural Hellenistic period: the boy's physical traits are Ethiopian, and his skin originally had a black patina, but his hairstyle is Greek. The size and quality of the sculpture suggest a royal or aristocratic commission; it has been suggested that it was plundered from the Greek city of Corinth by the Roman general Mummius in 146 BC and was on its way to Pergamon in Asia Minor when its ship sank.

Alexander Mosaic, Artist unknown
Mosaic, 310 x 580 cm / 10 ft 3 in x 19 ft (with frame),
Museo Archeologico Nazionale, Naples

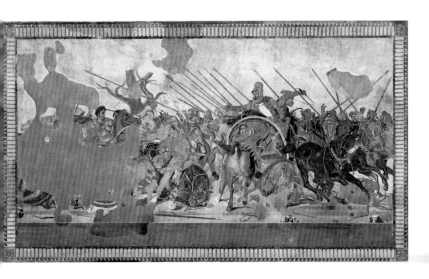

This Roman floor mosaic may reflect a lost Greek original. The mosaic paved a reception hall that opened through colonnades onto twin peristyle gardens in the House of the Faun, the grandest house in Pompeii. The source was probably a Hellenistic fresco painted in the late 330s BC, after the battle of either Issos in Asia Minor (modern Turkey) or Gaugemela, in Iraq; in both cases the armies of Alexander the Great (left) routed those of the Persian emperor Darius (right).

One of the finest surviving ancient figural works in any medium, the entire work was made in the *opus vermiculatum* technique, using extremely small stone tessarae. The term comes from the Latin for 'worm',

referring to the lines of tiny tessarae that snake around features in the mosaic. The technique supports nearly limitless detail, allowing the viewer to appreciate both the dramatic battle and small decorative minutiae on every figure, including facial expressions, fine fittings on weapons and armour, and trappings on the horses. The technique is usually reserved for particularly distinctive central panels (*emblemata*) within larger floor mosaics made of bigger tesserae; an *opus vermiculatum* mosaic larger than 3 x 5 metres (roughly 10 x 16 feet) is extraordinary, indicating the wealth and status of the Pompeian family who owned this house.

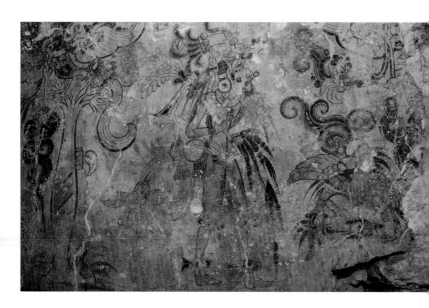

This mural, discovered in 2001, is the most significant Mayan discovery in recent years. The visual complexity and style of the painting demonstrate that the Preclassical Mayan world, which spans the period from 2000 BC to AD 200, was an advanced civilization much earlier than previously suspected. The mural covered the four walls of a chamber, two of which survive. The vivid colours are remarkably well preserved, and the survival of half the cycle allows a reconstruction of its narrative.

The western wall, which visitors would have faced upon entering the room, depicts the foundation of the Mayan universe and the institution of kingship. Five trees of creation, or *ceibas*, mark the four cardinal points and the centre of the cosmos. Four youths, different aspects of the deity Hunahpu, perform the ritual of self-bloodletting. In this detail, Hunahpu is shown as a hunter with two birds tied to his belt in the act of piercing his penis. His blood gushes down next to a turkey smoking over a fire, Mayan symbolism for the creation of the sky; the *ceiba* is in the far left and holds up the newly created sky. Hunahpu was also known as Ajaw, meaning 'god day' or 'king day', and as such served as a personification of the king.

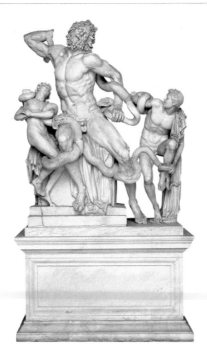

The Laocoön is one of the most famous, admired and debated sculptures of the ancient world. Discovered in Rome in 1506, experts are still divided on whether it is a Hellenistic original dating to the second or first century BC, or a later Roman copy of the first century AD. The Roman writer Pliny the Elder saw the work at the house of the future emperor Titus (reigned AD 79–81) in Rome and attributed it to three Rhodian artists, whose names are also associated with the monumental mythological sculptural groups discovered in the fantastic cave at the Villa of Tiberius near Sperlonga, south of Rome.

The sculpture depicts the Trojan priest Laocoön, who warned against letting the Greek horse within

the walls of Troy and as a result was crushed to death, along with his two sons, by serpents sent by the gods favourable to the Greeks. The moment shown summarizes the story, depicting Laocoön struggling against the serpents as they wrap themselves around his legs and arms, his muscles straining and his anguished face contorted. Whenever it was fashioned, the style is typical of the Hellenistic baroque, with its complex composition, dramatic poses and exaggerated expressions (see also the Pergamon Altar Frieze, p.119, for another example of Hellenistic baroque).

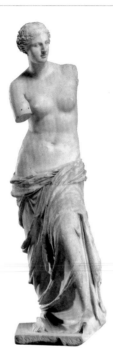

Discovered in 1820 on the Greek island of Melos, the Venus di Milo was long considered the work of a fifth-century BC student of the Athenian sculptor Pheidias (c.490–430 BC) and thus the embodiment of the Classical canon of female beauty. Although the basic pose and the position of the drapery echo a widely copied Early Classical (c.480–450 BC) Aphrodite type, stylistic considerations now place the work between 150 and 50 BC. In this Hellenistic sculpture the artist gives the figure more dramatic drapery than earlier types (cf. the Colonna Venus, p.101), and soft, sensuous flesh, adapting and innovating to create a timeless masterpiece. A now lost section of the base bore the signature of Alexandros of Antioch.

The goddess would have been admired by young Greek students and athletes in its setting in a niche at the civic gymnasium of Melos. The surviving armless icon, of Parian marble, is far from her original appearance, however. Created in sections joined with dowelling rods, the most convincing reconstruction shows the goddess with her right arm gesturing to her left hand, which rested on a plinth. In her left palm an apple would have signalled her victory in the Judgement of Paris and punned on her island location of Melos ('apple'). She wore metal jewellery and was probably originally painted for greater realism.

Yakshi, Artist unknown
Sandstone, H: 163 cm / 5 ft 4¼ in, Patna Museum, Bihar

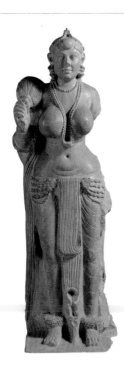

The Mauryan Empire reached its zenith under the Buddhist emperor Ashoka (304–232 BC), a convert who was responsible for a flowering of Buddhist art and architecture across India in the third century BC. Although Persian or Persian-trained Greek sculptors, who moved to the region after Alexander the Great's incursions in the fourth century BC, introduced new stone-carving techniques and motifs, sculptural forms nevertheless remained characteristically Indian.

This Yakshi, or female nature divinity, often called the Venus di Milo of India, is a masterpiece of free-standing Ashokan sculpture; made of Chunar sandstone, she holds a yak's-tail fly-whisk (*cauri*), a sign of honour. Such figures may have served to accustom Mauryan worshippers to the newly official faith, the sculptures either worshipped independently or functioning as guards of honour at Buddhist shrines. This piece, dated broadly to c.300 BC–AD 100 and found at Didargani in Bihar, possesses a powerful monumentality and voluptuous realism, with sensuous folds of flesh and an hourglass waist. The slight bend in the left leg endows the figure with a subtle impression of graceful motion, which some observers have described as the 'gait of a swan', while the fine gloss of the skin, referred to as 'Mauryan polish', contrasts starkly with the meticulously carved details of her adornments.

Mauryan Empire, Ashokan School

c. **50** BC
Italy

Mysteries Fresco, Artist unknown
Fresco, H (figures): c.162 cm / 5 ft 5 in, In situ, Villa of the Mysteries, Pompeii

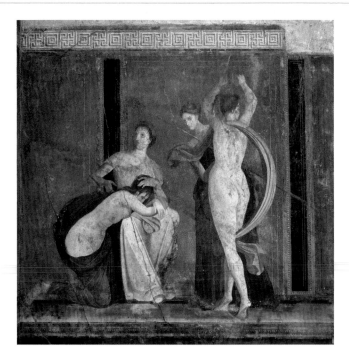

This detail from a large fresco preserved on three sides of a room in the Villa of the Mysteries at Pompeii is painted in the Greek technique for large-scale works called *megalographia* ('large painting'), the name reflecting the fact that the figures are life-size. The Romans writers Vitruvius (c.75–15 BC) and Petronius (c. AD 27–66), among others, discussed the style at length. The subject of this fresco is traditionally thought to be an initiation rite for a cult of Dionysos and Ariadne, who are the only identifiable figures in the wall painting. In this scene, the semi-nude inductee (left) is apparently receiving a ritual beating from a winged victory figure (out of the frame to the left). Whether the dancing figure (right) is the inductee again, and

what the dance may mean, are unclear, as are many other details.

Much of the villa was richly decorated in the so-called Second Style of Pompeian wall painting, dating to c.90–20 BC, with techniques of linear perspective used to create illusionistic space, in this case an elevated stage and simulated coloured marble revetment. The imaginary space is not deep, however, being closed off by a back wall to focus attention on the large, colourful figures. The design was undoubtedly of Greek origin, a source commonly tapped by Roman figural painters, but it may have been rearranged here, making it difficult to interpret specific scenes.

Bat Effigy, Artist unknown
Jadeite and shell, H: 28 cm / 11 in, Museo Nacional de Antropología, Mexico City

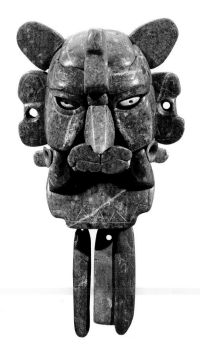

This unique adornment is fashioned from 25 pieces of carved jadeite, with shell inlays for the eyes. It is a marvel of lapidary expression in both its execution, particularly notable for its high polish, and its emotive quality. The artwork has been variously identified as an anthropomorphized representation of a jaguar or the image of a supernatural bat. Although Zapotec portrayals of these two predatory animals share the rounded ears and snarling upper lip, this piece can be identified as a bat by the protuberance on the lower forehead and the bib-like form hanging below the chin, both of which are unique to Zapotec renderings of a supernatural being based on the vampire bat (family Desmodontidae).

Found in an elite burial dating to the late Formative to early Classic period (Monte Albán II: c.200 BC–AD 100), this object may have been worn as a pectoral (chest medallion) or belt ornament. Its three oblong pendants recall later Maya belt plaque assemblages that include the head of the Maize God or other spiritual being, typically with three jadeite plaques hanging below the head. Jadeite was the most precious stone in ancient Mesoamerica, and rulers and other members of the nobility expressed their high status by adorning themselves in fine objects crafted from this stone.

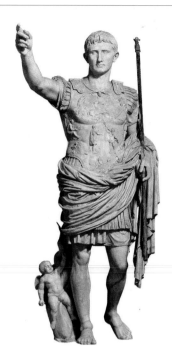

In 31 BC, Octavian (later known as Augustus; reigned 31 BC–AD 14) ended a century of civil war that marked the end of the Roman Republic, and became the first Roman emperor after defeating Marcus Antonius and Cleopatra at the battle of Actium. His hands were as bloody as any, however, so he shrewdly crafted a propagandistic programme – both political and artistic – designed to accustom the Roman state and citizens to his new authority. Key messages thus appear in this famous statue, found in the Villa of Livia at Prima Porta, near Rome. These concern especially peace-making, diplomacy and a return to the putative 'good old days' of Roman respectability and virtue.

Cupid, at Augustus' ankle, symbolized his family's claim to noble descent from the goddess Venus. The veristic style of literal accuracy (e.g. Julius Caesar, p.133) is rejected here, replaced by the idealized face, proportions and pose of a Classical Greek figure; for Augustus, the Classical style symbolized a golden age of the past, although the imagery is Greek rather than Roman. Augustus' approved artists developed a signature pattern in the rendering of his forelocks, making this (or any) statue of him identifiable despite the idealization. The breastplate illustrates one of Augustus' greatest diplomatic triumphs, the recovery of military standards previously captured from Roman legions by the Parthian empire in the east.

Portland Vase, Artist unknown
Glass, H (preserved): 24 cm / 9 in, British Museum, London

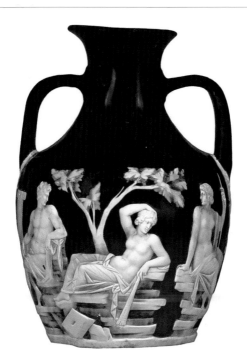

One of the most beautiful examples of the gem-cutter's art, the Portland Vase was discovered in Rome in the late sixteenth century. The blue glass core (the base is now missing) was partially blown and then dipped in melted white glass; this was then reheated and blown to form the pot, probably in a mould; the handles were applied separately. A gem-cutter then carved the white glass to create the figures in cameo technique, letting blue show through in varying degrees to create subtle tonal gradations. The artist created perfectly proportioned figures with anatomical details articulated in thinner, darker glass.

The affectedly idealized style and its similarity to other Roman cameos suggest a date in the Augustan period (31 BC–AD 14), but the iconography is controversial. The side of the vase not shown is thought to represent figures from the mythical marriage of Peleus and Thetis, but the side shown here is less readily interpreted. The reclining female figure has been identified as Helen of Troy, Dido, Atia or Octavia (sister of Augustus), the latter two being attempts to reconstruct an Augustan propagandistic message (cf. the Prima Porta Augustus, opposite).

The vase inspired Josiah Wedgwood (see the Apotheosis of Homer Vase, p.393), who made several copies in jasper ware. A glass version was finally achieved in 1876, resulting in a fashion for cameo glass that lasted until the end of the Victorian era.

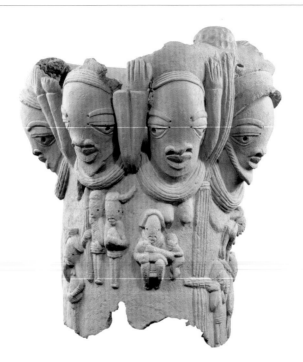

Every aspect of this early African sculpture, dated very broadly to between 500 BC and AD 500, makes it an exceptional piece. The hollow cylinder is formed of large terracotta figures with different scenes on their chests, representing a pictorial cycle. It is believed that below the chest scenes a waistband would have run around the figures, then loincloths and lower limbs.

The small detailed scenes show the daily life of the Nok people of central Nigeria: agricultural tasks, transport and preparation of food, aspects of motherhood. The alternate male and female figures that serve as backdrop to the small scenes hold up a serpent. This recurrent motif in Nok sculpture has been associated, as in many African cultures, with the creation of the world, fertility of both land and people and the realm of the ancestors.

The intact whole would have measured about a metre (3 ft) in height and is believed to have once functioned as the base for a now lost monumental statue, the whole ensemble probably serving as an altar to the tribal ancestors in a cult of good health.

Julius Caesar, Artist unknown
Basalt and rock crystal, H: 41 cm / 1 ft 1 in, Altes Museum, Berlin

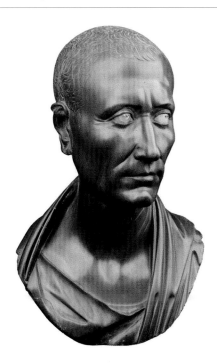

This portrait of Julius Caesar is an example of Republican verism, characterized by a literal, accurate depiction of the figure. Idealization was inappropriate for Republican patrician male portraits because men achieved fame and status only at the end of a long, arduous career, the *cursus honorum*. This included military service (crucial in Caesar's case), decades of public service and, in old age, membership in the Roman senate.

The Roman historian and biographer Suetonius attests to Julius Caesar's vanity, but this portrait shows little idealization (although the *dictator* does appear with more hair here than Suetonius reports). The facial wrinkles and sunken cheeks are clearly

appropriate for an authoritative, patrician Roman, but such details are also kept to a minimum, giving the portrait a majestic, not battered, presence. This is enhanced by the rich sheen on the polished green-black Egyptian basalt and the characterful gaze of the inlaid rock crystal eyes.

Republican patrician busts usually ended at the neck, but this piece includes some of the chest and toga, not common until the first century AD. It is probably a copy of an original for which Caesar would have sat – carved posthumously as homage paid by the Julio-Claudian emperors to the progenitor of their dynasty.

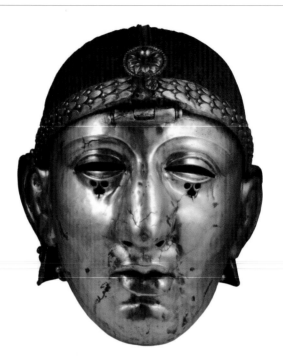

The kingdom of Emesa (modern Homs) in Syria grew wealthy as a result of its key position on trade routes between the eastern Mediterranean and the Near East. This helmet was found in the royal necropolis there and was clearly intended for use by a member of the high elite, probably the king himself.

Despite the artistry of the silver mask, it seems that the helmet was designed to be used in combat as well as for ceremonial purposes, for the pierced teardrop holes under the eyes serve the practical function of increasing the wearer's field of vision. Some textual support for this interpretation comes from the Greek historian Arrian (b. c. AD 86), who described masked participants in tournaments held among the Roman

cavalry. Those areas of the iron helmet not coated with silver were originally covered with textiles, now lost. The focus of the piece, however, would always have been the beautiful silver mask, which may have been modelled after the features of its owner.

Bimaran Reliquary, Artist unknown
Gold and garnets, H: 6.5 cm / 2½ in, British Museum, London

The practice of relic veneration has been central to the maintenance and spread of Buddhism for more than two millennia. Relics of the Buddha – whether bodily relics or relics of use, such as his robe or bowl – are considered to embody his 'living presence' and are often placed inside brick or stone-faced burial mounds called stupas.

This stunning gold reliquary inset with garnets was found in a turned steatite globular casket within Stupa 2 at Bimaran in eastern Afghanistan. An inscription on the stone casket mentioned that the reliquary contained bone fragments of the Buddha, but when the stupa was excavated in the nineteenth century the gold lid and the bone were missing. Four coins dated

c. AD 50 were found near the reliquary and suggest that this object is of similar date. Its style is Gandharan, with a distinctly Hellenistic Greek aesthetic.

The importance of the reliquary lies in the depiction of the two standing Buddhas in the gesture of reassurance (*abhaya mudra*), and attendant images of the gods Brahma and Indra within a series of eight ogee arches. These are some of the earliest known images of the historical Buddha and are similar to the many largely undated stone sculptures from the same region of northwest India ruled by the Central Asian Kushan Empire in the first three centuries AD.

Still Life, Artist unknown
Fresco, H: 74 cm / 2 ft 5 in, Museo Archeologico Nazionale, Naples

The Praedia of Julia Felix, where this painting was found, was a privately owned entertainment complex (part of it suggesting adult entertainment available, apparently, only to men) near the amphitheatre at Pompeii. In addition to its other amenities, the complex included several prominent *cauponae* (fast-food stands) facing directly onto the street. The eighteenth-century Bourbon excavators did not record the find-spot of this fresco, but still lifes showing foodstuffs were commonly painted in *cauponae* to illustrate typical wares. It might also have come from one of the private dining rooms located in the complex, or from the small house possibly occupied by the proprietress.

Still lifes of this sort became common in Roman wall painting after c.50 BC, either as part of larger painting schemes or, as probably in this case, independently. The slightly painterly style of the work is confident, and the artist shows off his considerable proficiency by faithfully representing the tactile qualities of variously textured objects and by selecting particularly challenging motifs, including the subtle blue glass pitcher with objects visible through it, shiny metal, feathers and eggs.

Desborough Mirror, Artist unknown
Bronze, H (with handle): 35 cm / 1 ft 1¾ in, British Museum, London

Bronze mirrors from throughout the La Tène phase of the Iron Age (mid-fifth to mid-first century BC) are found occasionally in western Europe, but they were particularly popular in Britain. Decorated mirrors are found only in Britain, and most date from after the subjugation of the continental Celts by Rome. The first-century AD Desborough mirror (found in Desborough, Northamptonshire) may have been made before the Emperor Claudius invaded Britain in AD 43, but it was likely to have been buried after the conquest in a grave that was probably, but not necessarily, that of a female.

One side of the mirror plate is plain, and the other, shown here, was decorated with an incised design. The pattern uses fold-over symmetry that was set out with a compass, arranged in a mixture of lines and shapes that are filled with basket-weave hatching of the sort seen on the Snettisham Great Torque. The likelihood that both sides were highly polished would have helped to display the contrast between the hatched decorative shapes and the smooth shapes, both of which were defined by engraved lines and reflected light in different ways. Although apparently complex, the underlying pattern on the Desborough mirror is simple and is based on the lyre or palmette pattern seen on contemporary vessels.

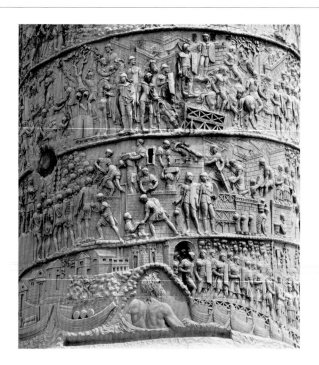

The Roman Empire reached its geographical zenith when Trajan (reigned AD 98–117) conquered Dacia (modern Romania) in AD 107. The emperor maintained the popularity engendered by this victory by commissioning vast public works, including a law court and library and this carved column in the Forum of Trajan, which commemorated the conquest of Dacia and served as Trajan's tomb.

War spoils decorate the base of the column, reminding Rome that Dacian war booty paid for Trajan's projects. The 30-metre (100-ft) shaft was decorated with a spiral frieze narrating the Dacian campaigns in generic scenes showing battles, camp-building, negotiations etc. Since the viewer would

probably have had no personal knowledge of Dacia or the campaign, no greater specificity was necessary.

Unfamiliar imagery was also difficult to recognize from a distance, so the artists used standardized scenes familiar from coins, such as the *adlocutio* (address) and the *profectio* (setting out), shown in this detail. The army exits a gateway and crosses the Danube River (male allegorical figure) on a floating bridge at centre bottom. Realism was less important than clarity, and sometimes a 'bird's-eye view' was used, tilting the ground plane up to reveal figures further. The tiny town behind the soldiers, which had to be recognizable as a town, was best expressed with entire buildings, even if they were out of scale.

c. AD 110
Philippines

Maitum Anthropomorphic Jars, Artist unknown
Painted terracotta, H (left to right): 72 cm / 2 ft 4½ in; 40 cm / 1 ft 3½ in;
36.5 cm / 1 ft 2½ in, National Museum of the Filipino People, Manila

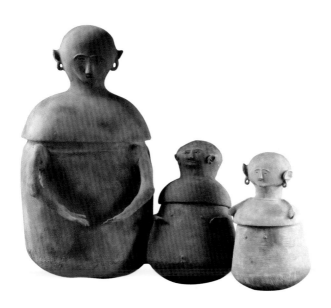

These fascinating anthropomorphic jars, dated to c.5 BC–AD 225, were discovered in 1991 at the Ayub cave, Pinol, Maitum Saranggani Province, on the island of Mindanao. They formed part of a larger collection of pottery vessels, the like of which had not been seen before in prehistoric Southeast Asia. The jars consist of a lid in the shape of a human head that sits on the body of the vessel, and the body has further human characteristics: a pair of arms, nipples and a navel. The large jar on the left is a secondary burial vessel that held the remains of multiple bodies; the small jars were for infant burials. The jars were coloured with red paint made from hematite, a locally available mineral.

These jars and the cave in which they were found clearly served an important function in the funerary customs and beliefs of the region. Within the anthropomorphic jars were placed smaller decorated burial jars containing remains of the dead, usually consisting of small bones and teeth. Like objects in many prehistoric cultures in Southeast Asia, the Maitum jars reflect the care and concern to which people went to care for their deceased. This can be appreciated further when one considers that no anthropomorphic jar is identical to another. Each has its own distinctive features, which may reflect the individuality of the people associated with them.

c. AD **150**
Italy

Unswept Room, Herakleitos, after Sosos of Pergamon
Mosaic, L: 405 cm / 13 ft 3½ in (entire floor as preserved), Musei Vaticano,
Museo Gregoriano Etrusco, Rome

This second-century AD *opus vermiculatum* mosaic
was made with tiny tesserae, enabling great detail. It
is Roman, but it is based on a famous lost original by
one of the few Hellenistic Greek mosaicists known
by name, Sosos of Pergamon (fl. second century BC),
and signed in Greek by one Herakleitos, otherwise
unknown. It depicts detritus on the banqueting hall
floor after an obviously sumptuous feast. This motif
was popular in Roman floor mosaics, indicating the
patron's wealth, whimsy and sophistication.

The mosaic – whether an accurate copy of Sosos'
original or simply an emulation of it – forms a frieze
around three sides of the dining hall, corresponding
to the positions of the banqueting couches on which

Romans reclined. As can be seen in this detail,
the illusionism is splendid: the *opus vermiculatum*
technique is employed only for the actual objects,
while the white floor behind is in conventional large
tesserae, giving the appearance of real objects on a
coarse mosaic floor. Mosaic 'shadows' cast by bones
and shells on the white floor are angled as if caused
by light coming in through the real door. When a
banquet was held in this room, the illusionistic debris
would have been joined by the real thing, tossed down
by the banqueters and adding to both the deception
and the amusement. As a final light-hearted touch,
elsewhere on this floor a tiny mouse is shown sniffing
a small nut.

Funerary Portrait of a Roman Soldier, Artist unknown
Encaustic on panel, 40 x 20 cm / 1 ft 3 in x 8 in, Myers Museum, Eton College, Windsor

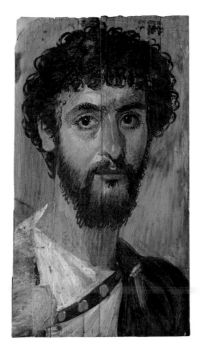

Hundreds of funerary portraits, painted with pigmented wax on wooden panels, have been found in the Fayyum (Philadelphia) region of Egypt, conserved by the arid climate. These are portraits of Roman citizens, mostly Greek Egyptians descended from Alexander's soldier-veterans, and were applied to mummies in place of a sculpted death mask; they were either incorporated into the wrapping or painted on the casket.

This second-century AD work is an early example of a mummy portrait, resembling the fairly naturalistic style of contemporary Rome, with tonal gradation and cast shadow to describe form. The loose brushwork of varying thickness over a blackish-grey undercoat indicates haste and low cost rather than expressionism. By the fourth century AD, Roman tastes in portraiture had evolved towards considerable stylization, seen in later Fayyum portraits as well.

In isolation and detached from the mummies for which they were made, Fayyum portraits look like conventional Roman portraits of moderate quality, a type common in Pompeian frescoes. In contrast, when seen attached to the mummy as originally intended, the illusionistic space around the head makes the painting look, oddly, not like a mask that served as the face of the mummy, but like a window opening into the wrapping or mummy case, the portrait a representation of the person inside, gazing out.

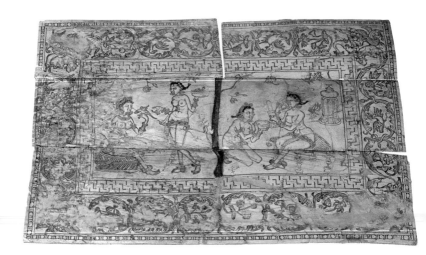

A great hoard of objects, possibly trade goods, was found at Begram (ancient Kapisha) near Kabul in 1938–39, the diverse origins of which testify to the wide trading connections of this region under the Kushan empire in the first three centuries AD. This box cover was one of many ivory objects excavated alongside Hellenistic bronzes from Greece, lacquer from Han China and Roman glass.

The Begram ivories are the largest body of ivory work to survive from Central or South Asia from before the sixteenth century, though ivory carving was probably widespread in ancient India: an Indian mirror handle in the form of a woman was found at Pompeii and thus dates before AD 79, and inscriptions

at Sanchi in central India refer to the work of ivory carvers. Although it is not known for certain where this box lid was made, the four women with full figures and abundant jewellery, two playing with a bird and two applying make-up, are very similar to stone sculptures produced across northern and central India between around 200 BC and AD 200. The border decoration, on the other hand, is unmistakably Hellenic in inspiration.

Kushan Dynasty, Gandharan Style

Drunken Courtesan, Artist unknown
Sandstone, H: 102 cm / 3 ft 4 in, Delhi National Museum, New Delhi

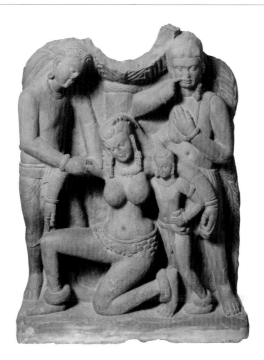

Heavy-set, cheerful-looking figures such as this, produced in Mathura during the Kushan dynasty (first to third century AD) and sculpted from distinctive mottled red 'Sikri' sandstone, evolved from indigenous sculptural traditions and are dramatically different from their grey, Greco-Roman-style counterparts being produced in Kushan workshops from Gandhara. The voluptuousness of the lady in this second-century AD image, naked apart from her heavy girdle, anklets and bangles, is reminiscent of Shunga dynasty sculpture, particularly the second-century BC *yakshi*s (female tree spirits) from Bharhut stupa.

This humorous, unusual montage may depict a scene from one of the earliest known plays from the Indian tradition of Sanskrit dramas – a secular comedy of errors called the *Mricchakatika* ('The Little Clay Cart'), written by the dramatist Shudraka possibly as early as the first century BC. It is a twisting tale of romance, intrigue and mistaken identity and involves a beautiful courtesan named Vasantasena, who is perhaps the central character in this group. She is in her garden and has stumbled, sleepy-looking and smiling, perhaps intoxicated; a young man and unhappy-looking child help her to her feet. The man behind her left shoulder raises his finger to his lips in the time-honoured gesture of surprise in Indian art.

Effigy Hand, Artist unknown
Sheet mica, L: 25 cm / 9 in, Ohio Historical Society, Columbus, Ohio

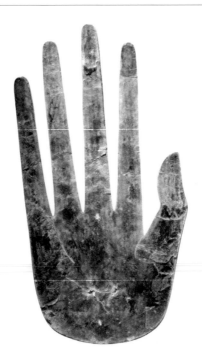

This stylized and oversized representation of a human hand, from Burial 47 in Mound 25 of the Hopewell Mound Group, Ross County, Ohio, is the most stunning single item found among a wide range of ancient luxury goods buried with their dead. It dates to between c.100 BC and AD 500. The power of Hopewell leaders was demonstrated by cutouts of sheet copper and friable mica – difficult to craft and made of materials often imported from far away – and this large hand, fashioned from delicate natural sheet mica, is a perfect example of this symbol of authority.

The cultural diversity associated with the emergence of social stratification and power in the upper Mississippi drainage basin at this time is reflected in the use of exotic goods as burial offerings. The technical skills and originality of the makers of this hand cutout reveal not only a creativity unique to Hopewell artisans, but also an extensive understanding of geology within and beyond their home territory. Many elements of Hopewell culture, including mortuary patterns and the building of mounds, had their origins in the Central American lowlands during the Maya Early Classic period, (c. AD 200–600), long before the emergence of the Mississippian chiefdoms.

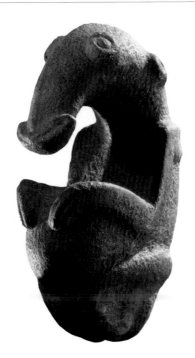

This small greywhacke (sandstone) sculpture, found in the Ambumb Valley, Enga Province, may represent an anthropomorphized echidna, or spiny anteater, a small mammal with a long, slender snout that is native to Papua New Guinea. The animal is shown sitting upright with its front legs resting, like arms, on its rounded belly. The fullness of the belly may signify abundance or fertility, possibly even pregnancy, although the figure also appears to have male genitalia.

Little is known about the original use of early figures like this. The hybrid human-animal form suggests that the sculpture may represent a deity of some kind, for the anthropomorphizing of animals

as a way of harnessing their otherworldly powers is common among early cultures. Similar sculptures have been found throughout the Papua New Guinea Highlands, and the stone sculpture of the region also includes pestles in the form of phallic birds and bowls shaped like birds with spread wings. When contemporary Highlanders dig up figures like these in their gardens, they often use them in rituals associated with the fertility of gardens and livestock.

c. AD **275**
Peru

Nasca Jar, Artist unknown
Painted ceramic, H: 54 cm / 21½ in, Museo Nacional de Antropología, Arqueología
e Historia, Lima

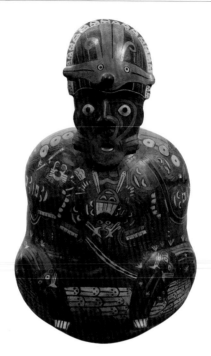

This large jar, an early masterpiece of Nasca ceramic art dated to c. AD 200–350, is decorated in polychrome slip with one of the most complex examples of ceramic painting of the Nasca culture: the artist has expertly interweaved representational and symbolic motifs over the entire surface of the vessel. It portrays one of the aspects of the so-called Anthropomorphic Mythical Being, a pre-eminent supernatural in the Nasca pantheon associated with ideologies of warrior sacrifice and agricultural fertility.

The deity is adorned with typical gold accoutrements, including headband and the gold-painted element attached to his nose and covering his mouth; its tentacle-like ends extend across his cheeks and upwards to encircle his eyes. Nose masks made of sheet gold and hammered into this form have been found in Nasca burials and seem to represent feline whiskers. His decorated mantle recalls the spectacular embroidered cloth of the Paracas tradition, the Nasca people being its direct inheritors, if not the same people as those who created the famous textiles. The deity also sports a necklace of human trophy heads, a symbol of life-generation and, by extension, agricultural fertility. The cross-legged position and bulbous vessel form recall those of a mummy bundle, and this masterpiece may represent just such a mummy bundle of an important Nasca man dressed in the guise of the Anthropomorphic Mythical Being.

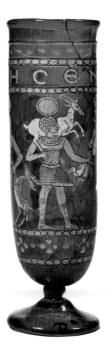

This is one of an almost identical pair of tall cylindrical flutes with slightly flaring rim on a short stem and round foot. The body of the vessel is divided by two decorative bands framed by narrow borders. The lower band has four-petalled flowers, while the upper carries a text in Greek that reads 'Drink, so you shall live'. The dark blue glass is painted in opaque colours enriched with gilding, and shows three figures bringing offerings to the Egyptian god of the underworld, Osiris. The offering-bearers, one woman and two men, all have sun-discs on their heads, perhaps indicating that they represent divine souls. Each brings a live animal – goat (or perhaps antelope or oryx), deer or fowl.

Almost every fragment of the shattered glasses was recovered from a Meroitic tomb in the western necropolis at Sedeinga, in Sudan, and they may have been ritually broken during funeral ceremonies that took place in the second half of the third century AD. Scholars are still divided as to whether the glass was locally made or imported from Roman Egypt. Large quantities of fragile Roman glass are commonly found in Meroitic burials, and it is possible that glassworkers from Egypt were working in the Meroitic kingdom. Stylistically, the painted figures have close affinities with tomb paintings from Roman Egypt.

The ancient kingdom of Aksum, about 600 km (373 miles) north of Addis Ababa, flourished between the first and eighth centuries AD and is one of the most important, if little known, ancient civilizations. Bordering the Red Sea, it fostered an active trading community, with high technological skills and, uniquely for Africa, its own coinage. Perhaps its greatest legacy is a group of approximately 200 grave stelae made between the third and fourth centuries AD, which range from unworked slabs to monumental structures. This example, weighing approximately 160 tonnes, is one of a group of seven and is the tallest stele to remain standing *in situ*. Five of the group are in ruins and one, taken by the Italians during

their occupation in the 1930s, has only recently been returned to Ethiopia. The tallest, fallen or perhaps never erected, lies in pieces and would have reached 29.5 metres (97 ft).

The group are thought to have served as grave markers for the Aksumite elite and are carved to represent buildings up to 13 storeys high. Here, representations of doors (some with 'locks'), windows and the beam ends of timber supports have been hewn into the rock, and it is thought that an icon was fixed to the rounded summit. It is unlikely that Aksumite buildings exceeded three storeys, but the details of the stelae are thought to represent actual architectural features of the time.

In AD 285 the emperor Diocletian (reigned AD 284–305) won the civil wars that had beset Rome for decades. To consolidate his power, he finally abandoned all pretence of constitutional rule and instituted legal reforms, making the empire baldly totalitarian. In an attempt to secure the succession and maintain the enlarged bureaucracy of the state, he created the Tetrarchy ('rule of four'), dividing the vast Roman Empire in two and putting an emperor and vice-emperor in each half. On Diocletian's death, however, conflict between the Tetrarchs spawned a fresh civil war, eventually won by Constantine.

Tetrarchy required cooperation between the four rulers, which is the subject of this group made of purple porphyry, a stone traditionally used for imperial sculptures. The gestures of embracement (solidarity) and hands on sword hilts (authority) matter, whereas verism (naturalism) does not. Until the mid-third century AD, imperial portraits had followed a tradition that went back to Alexander the Great, with recognizable features, however idealized the face (cf. the Prima Porta Augustus, p.130). The creator of the Tetrarchs suppresses this personal identity in favour of a collective, impersonal image that represents the office rather than the man. This more abstract style would continue throughout the fourth century AD and become characteristic of Early Christian portraiture.

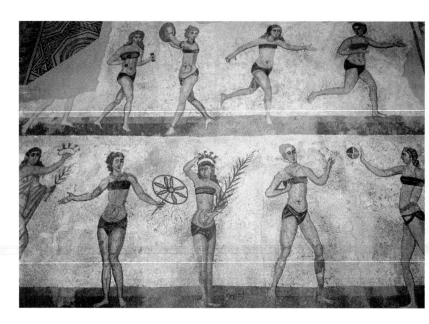

This detail is from one of the many floor mosaics found in the fabulous early fourth-century AD villa at Piazza Armerina on Sicily. The villa was palatial in scale and dazzling in its creature comforts and decorations, both on the walls and on the floors. Every important room had figural mosaic floors, while lesser rooms had mosaics of elaborate geometric or floral motifs. Throughout the villa, the imagery was light-hearted, with an assortment of amusing motifs popular with patricians: hunting, public entertainments and scenes of *putti* (naked cherubs, with or without wings) shown in adult occupations.

Athletic contests could involve either men or women. This example is famously the latter, not least because of the precocious appearance of the bikini. Although there were serious Olympic games for women, we may presume a less lofty motivation for the appearance of this motif in the floor mosaics of an elite villa; it was added later than the rest of the floors in the villa, indicating a patron with specific requirements. The Late Antique date is obvious in the figural style: although idealized figures would have been appropriate for this athletic topic, we see instead the stiff, stylized figures of the fourth century AD, similar to the contemporary *opus sectile* panel of Junius Bassus (see Hylas and the Nymphs, p.152).

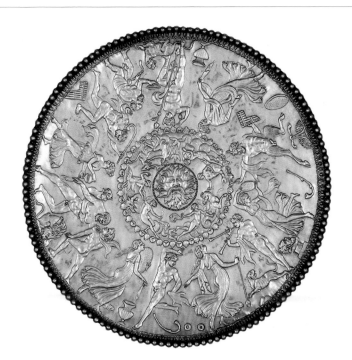

The Mildenhall Treasure, found in Suffolk in 1943, is one of the largest hoards of late Roman silver found in the frontier zone of the Roman world. It comprises over 30 pieces of silver plate, including a spoon inscribed with the letters *chi-rho*, the monogram of Christ.

The Oceanus dish is the largest item in the hoard; its name comes from its central mask of the sea god Oceanus surrounded by nereids (sea nymphs) and sea monsters. An outer ring shows Bacchus (Gk: Dionysos) with a panther, Hercules, Pan, Silenus, maenads and satyrs (followers of Bacchus), and the dish thus seems to relate to the cult of Bacchus, the wine god, as do some other items in the treasure.

A related plate with Pan and a maenad bears an inscription on the back naming 'Eutherius' in Greek; he has been identified by some as one of the leading figures in the court of the emperor Julian the Apostate (reigned AD 360–368), who led the pagan backlash against Christianity. Eutherius never came to Britain, but the plate could have been a gift to the Christian Lupicinus, a general who served in Roman Britain.

The dish was probably made in Rome, the main design being cast in low relief and details added by engraving. One of the finest examples of silverwork from the Roman Empire, the dish and the rest of the treasure were intended almost certainly for display, rather than for use as tableware.

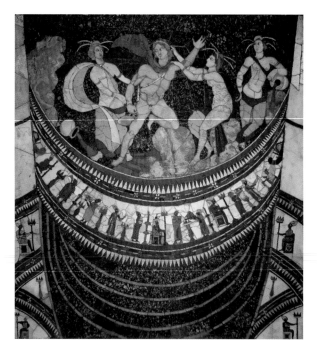

Junius Bassus, who was appointed consul (Rome's highest civilian office) in AD 331, has left us two remarkable artworks – his sarcophagus and the *opus sectile* panels from his basilica (law court) in Rome. *Opus sectile* ('cut work') is intarsia, with thinly sliced veneers of stone and glass cut to fit specific parts of a design; it first appeared around 100 BC. It is a majestic art form, affordable only to the wealthiest nobility – a statement of worldly success that Bassus makes with gusto. The surviving fragments from his basilica include Bassus himself in a chariot at the circus, predatory animals attacking prey, and this, the grandest fragment – a mythological scene depicting the story of Hylas, servant of Hercules. He was sent

to fetch water for the Argonauts, but water nymphs lured him into the spring, where he drowned. Below the Hylas scene is a simulated Egyptian frieze of glittering colour, but its meaning is unknown.

The idealized Classical style was no longer current by the fourth century AD, but this is a laudable attempt at its reproduction. The artists have carefully shaped the intarsia pieces so that their edges form useful outlines, such as Hylas' musculature. Although the poses are affected and the proportions and contours awkward, the exquisite materials give a jewel-like quality that compensates for the figural oddities. With figures about 40 cm (16 in) tall, this scheme was a visual feast, covering large portions of the basilica.

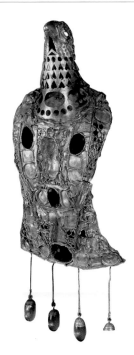

This eagle-headed fibula (a brooch or decorative safety-pin for fastening garments) formed part of a hoard discovered in the fortress and villa complex of Pietroasa in Dacia (modern Romania), on the frontier of the Roman Empire. This seat of power has commonly been associated with Athanaric (d. AD 381), leader of the Tervingi tribe (traditionally known as the Visigoths). At this time, the Goths were forming more settled communities and assimilating many artistic techniques and materials from the Roman world; indeed, the fibula was possibly inspired by similar late Roman ceremonial jewellery. Athanaric may have buried the treasure as an offering to the gods in a bid to seek protection from the Huns, a nomadic martial

people from the eastern steppes who swept into the Roman Empire in AD 378.

The bird has been identified as either an eagle or a phoenix, both motifs common in the Roman world and among the Hunnic peoples. A cradle on the bird's breast once held precious stones, and the body was encrusted with semi-precious stones. After 40 years in Soviet Russia, where it was sent for safekeeping just before the Bolshevik Revolution, the fibula, referred to as the Hen and Her Golden Brood, was returned to Romania in 1956 and used by the dictator Nicolae Ceausescu to promote national pride in the country's mythological past.

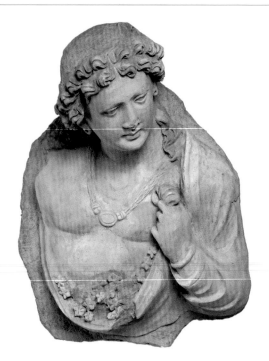

Buddhist culture and art flourished across the Gandhara region at the 'crossroads of Asia' in modern north Pakistan and eastern Afghanistan between the first and sixth centuries AD. Large numbers of monasteries were founded, each one including many stupas (Buddhist monuments, often reliquary monuments) that were decorated with images of the Buddha, bodhisattvas (beings who have postponed Nirvana in order to assist others), attendant monks or celestial beings such as this.

In the late Gandhara period (fourth to sixth centuries AD), large numbers of images were made in stucco or clay on wooden armatures, alongside the earlier preference for grey schist. This image comes from the monastery of Tapa-Kalan at Hadda, near Jalalabad, one of many monastic sites in the Kabul valley. It depicts a Buddhist *deva* or celestial being, one of a pair holding flower petals to scatter over a Buddha image alongside. Many such stuccoes are enlivened with painted details. This vivid, expressive figure is striking for its deeply Hellenizing character, long after the decline of the Indo-Greek Bactrian kingdoms in the northwest of India and Central Asia (see also the Vessel Showing Scythian Life, p.96).

Scenes from the Lienü zhuan, Artist unknown
Lacquer on wood, 80 x 38 cm / 2 ft 7½ in x 1 ft 3 in, Datong City Museum, Datong, Shanxi Province

This is one face of a panel from a double-sided, lacquered screen that was placed near the coffin in the tomb of Sima Jinlong (d. AD 484) at Datong, in Shanxi Province. The four pictures, and four more on the back, illustrate stories of virtuous women drawn from the *Lienü zhuan* (*Biographies of Virtuous Women*) by Liu Xiang. At the top, the mythical emperor Shun is seen with his wives. At the bottom, the Lady Ban, a favourite of the Han emperor Chengdi (reigned 32–7 BC) is refusing to accompany him in his palanquin for fear of distracting him from state business. The artefact is a rare example of screen painting from this period, and may itself have once stood in the imperial court. Its bright red background is also encountered in

contemporaneous wall paintings from Dunhuang in Gansu Province.

Sima Jinlong was a half-Chinese and half-Xianbei of southern Chinese ancestry. As a mark of favour from the Northern Wei dynasty (AD 386–534), he was buried in the imperial mausoleum in Datong, where the Xianbei Tuoba rulers had established the Wei dynasty after conquering parts of northern China. Analogous decoration, of scenes eulogising filial piety, appears in another Tuoba tomb found in Ningxia Province, dating to AD 467–470. Together, the two sets of paintings are evidence of the Tuobas' readiness to embrace Chinese culture as they aimed to extend their control over territory further to the south.

Celestial Women, Artist unknown
Fresco, H: c.100 cm / 3 ft 3 in, In situ, Sigiriya

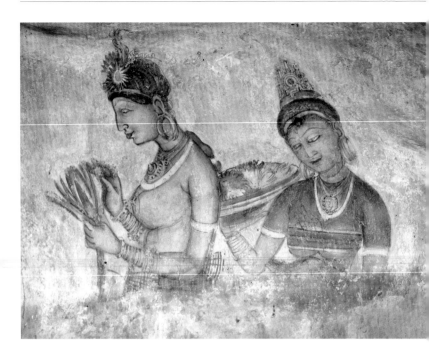

Halfway up the precipitous west side of a 200-metre (650-ft) high rock that rises sheer above the forested plain of northern Sri Lanka are the fragmentary survivals of a vast wall painting showing elegant, bejewelled women; they are part of one of the oldest known wall paintings of South Asia. Sigiriya, or 'Lion Rock', is an ancient rock-shelter monastery that became the site of an elaborate royal palace in the late fifth century AD during the reign of Kasyapa I (reigned AD 477–495), with a lake, vast gardens and scattered monasteries laid out below.

Twenty-two half-figure paintings of women, approximately life-size, have survived for 1500 years on the plastered surface of the cliff, which retains its natural contours. The original mural probably spread over a much larger area of the rock surface, covering an area perhaps as much as 140 metres (460 ft) long and up to 40 metres (130 ft) high. These elegant bejewelled females float above clouds, which cut them off at the waist, and hold flowers, boxes or trays in their hands. The outlines of early drafts of the women can be seen through the paint of some of the final figures, indicating changes in composition and colour that took place in the course of the work. Scholars have identified the figures as the ladies of Kasyapa's court in procession or, more likely, as *apsara*s, celestial beings who scatter flowers over kings and heroes.

Buddha with Two Bodhisattvas, Artist unknown
Painted limestone, 138 x 90 cm / 4 ft 6½ in x 2 ft 11½ in,
Qingzhou Municipal Museum, Shandong Province

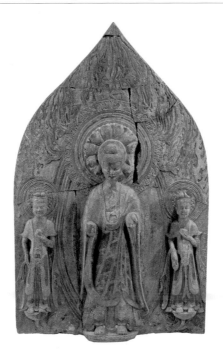

Stunning finds of large numbers of Buddhist statues have been made in and around Qingzhou, in Shandong Province, indicating that this was a major Buddhist cultural centre in the fifth and sixth centuries AD. Many of them, however, like this one from Qiji Temple, had been deliberately broken, evidence probably of the anti-Buddhist persecutions of AD 574–577. When the Buddha in this triad was sculpted, he was smiling soothingly and giving the *abhaya* ('fear not') gesture with his left hand and the *varada* ('gift-bestowing') with his right. It was just the kind of message the Tuoba rulers of the Northern Wei dynasty (AD 386–534) would have wanted to send to calm the nerves of their conquered Chinese subjects.

(For another artwork indicative of the Wei embrace of Chinese culture, see Scenes from the *Lienü zhuan*, p.155.) Traces of gilding and colouring remain, though not as brightly as on many other stelae of this era.

The dating of this piece to the late fifth or early sixth century AD is assisted by the Buddha's *ushnisha* (hair bun), which was pronounced in late Northern Wei art but flattened throughout the Northern Qi period (AD 550–577), and by the dress of the three figures. In the mid-fifth century AD, Buddhas were still shown wearing Indian-style fashions, but under Emperor Xiaowen (reigned AD 471–499) they adopted Chinese-style monks' robes with a sash, as seen here.

Northern Wei Dynasty

c. AD **500**
India

Vishnu Asleep on the Serpent Shesha, Artist unknown
Sandstone, L: 400 cm / 13 ft 1½ in, In situ, Vishnu Temple, Deogarh, Madhya Pradesh

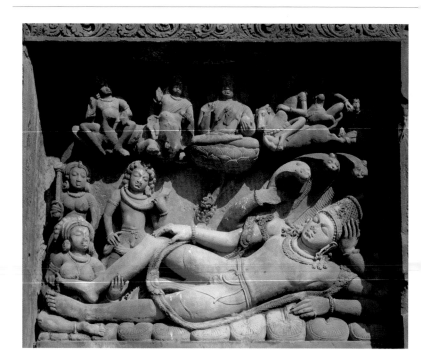

The Gupta period (c. AD 320–550) is hallowed as the 'golden era' of Indian art and culture. The political stability achieved by the dynasty created an atmosphere of peace and tolerance in which scholarship and the fine arts, both Brahmanical and Buddhist, flourished. This panel, set in an exterior wall of the Vishnu temple in Deogarh, Madhya Pradesh, is a superlative example of Hindu sculpture from the period and boasts a mastery of composition and form that justifies the Gupta reputation.

The panel shows how complex Hindu mythology and iconography had become by the fifth century. It depicts the beginning of creation, in which Vishnu, sleeping on the multi-headed snake Shesha and

floating on an infinite, cosmic ocean, dreams the universe into existence. From his navel grows a lotus, which opens to reveal the god Brahma, the Creator (visible in the top centre of the image), flanked by a cast of other Hindu deities that fly overhead to witness this great event; their number emphasizes the importance of the occasion. Vishnu's peaceful slumber is captured perfectly in the gentle naturalism of his face and body, and also in small artistic details: the realism of Vishnu's posture as he rests his crowned head against his upper, left arm; the image of Lakshmi, his dutiful wife, lovingly massaging his feet; and the gentle, affectionate faces of the snake, curled protectively over the sleeping god.

c. AD 500
India

Bodhisattva with Lotus Flowers, Artist unknown
Fresco secco, H (wall): 411 cm / 13 ft 6 in, In situ, Cave 1, Ajanta, Maharashtra

A series of 30 impressive cave temples at the site of Ajanta, along the Waghora River in western India, was constructed for the Buddhist community from the second to the first century BC. The population thrived and continued to use these temples as prayer halls and monasteries, and a few of the caves' interiors were adorned with fresco paintings such as the detail shown here. These sophisticated artworks provide a glimpse into the earliest forms of painting found on the Indian subcontinent.

The interior of Cave 1 was transformed during the fifth and sixth centuries AD, as artists covered the walls with illustrations from Buddhist narratives known as the *jataka*s, which recount the previous lives of the Buddha. The walls of the entrance hall that leads to the shrine are painted with depictions of bodhisattvas, compassionate individuals who have chosen to postpone attaining enlightenment. Pictured here is the beautiful, sinuous form of the bodhisattva Vajrapani (Bearer of the Thunderbolt), who holds his right hand in the gesture of *vyakhyan mudra* to symbolize the teachings of the Buddha. The artist's technique in making key figures considerably larger than the surrounding ones accentuates this bodhisattva's importance and is visually reminiscent of three-dimensional sculptural panels found within the Ajanta complex.

Virgin and Child with Saints and Angels, Artist unknown
Encaustic on panel, 68.5 x 49.7 cm / 2 ft 3 in x 1 ft 7½ in,
St Catherine's Monastery, Sinai

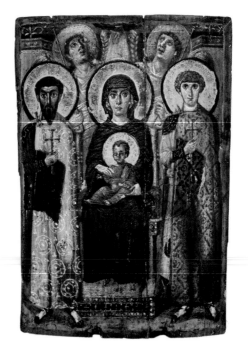

Outstanding in terms of its age and preservation, this Early Byzantine (AD 324–843) icon, probably from Constantinople (modern Istanbul), depicts the Virgin enthroned with the Christ Child and flanked by Saint Theodore on her right and, probably, Saint George on her left. Behind, two angels look up to the heavens and to God, who is represented by a hand reaching down to earth. The style of the painting is complex, combining the fleeting brush strokes of Classicism for the angels with a more frontal and abstract handling for the saints, more typical of Early Christian art. These stylistic differences may refer to the corporeality of the saints in relation to the ethereality of the angels, or it may simply be an aesthetic choice. The grouping of the figures suggests a hierarchy of intercession, allowing the viewer access to God through the saints, the Virgin with her child, and the angels.

The icon, which dates to the sixth century AD, is housed at the monastery of St Catherine in Sinai, which possesses a unique collection of early icons that have probably been there continuously since that date; they reveal formative Early Christian imagery that has remained remarkably consistent through time.

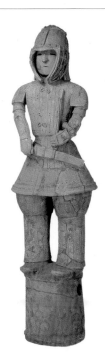

To guard the royal dead and to demarcate their entombed world from that of the living, the early Japanese produced clay statuettes called *haniwa* and positioned them atop the mounded graves, or *kofun*, of rulers and ministers. The first examples were shaped like ritual vessels on a stand, but as the custom took hold – advancing eastwards along the main island – the vessels were replaced by ever more elaborate and varied figures. Excavated examples include priestesses and entertainers, domestic animals and manor houses.

The sixth-century AD example here, representing a warrior preparing to draw his sword, is one of the few *haniwa* figures to be designated a Japanese National Treasure (*kokuho*). The detailing closely compares to actual sections of armour manufactured around the same time and buried with other grave goods. Circles of applied clay represent rivets securing the metal helmet, and thinly incised horizontal lines along the body armour's flaring lower edge represent leather straps binding the armour plates. The figure wears an archer's arm guard on his left arm and carries a stylized quiver with arrows on his back. The craftsman who created this *haniwa* evidently possessed first-hand knowledge of military gear and skill enough to translate that knowledge into a dignified representation of a young soldier-at-arms.

c. AD **550**
Italy

Empress Theodora and her Attendants, Artist unknown
Mosaic, 264 x 365 cm / 8 ft 8 in x 12 ft, In situ, San Vitale, Ravenna

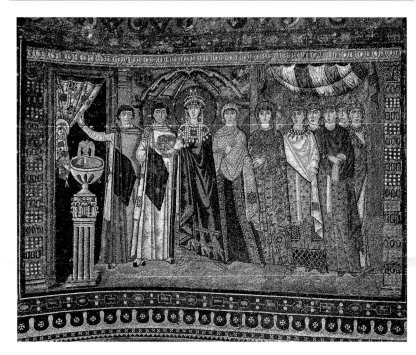

This Early Byzantine (AD 324–843) mosaic presents Theodora, wife of the Byzantine emperor Justinian (reigned AD 527–565), dressed in rich robes and a bejewelled crown and holding a precious chalice. She is flanked on her left by female attendants and on her right by two men, probably eunuchs, one of whom holds back a curtain to usher her through the doorway past a fountain. Theodora's early life as a circus dancer is far removed from this image of her. Each of the figures stands frontally, facing the viewer, almost floating in space and only barely placed on solid ground. Their depth and richness is not achieved through three-dimensional representation but in the ornate pattern and form – a style usually seen as a break from Classicism and perhaps associated with the presence of a spiritual being.

The mosaic, along with its pair on the opposite wall, showing Theodora's husband, Justinian, is situated in the chancel of San Vitale church, near the altar, thus creating the impression of the imperial couple, as it were, assisting in the celebration of the Eucharist or Mass. Theodora and Justinian never visited Ravenna, then capital of the declining Roman Empire, but this mosaic was made shortly after the Byzantine rulers claimed the city and must have served as a mark of their secular and religious power.

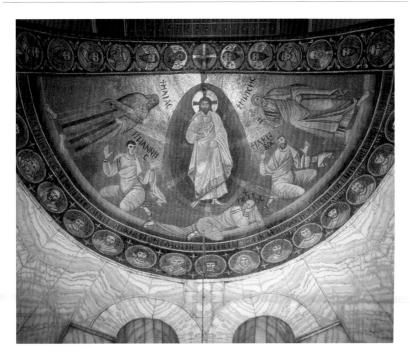

This Early Byzantine (AD 324–843) mosaic at St Catherine's Monastery in Sinai depicts the Transfiguration of Christ and is set in the apse of the church. Three of Christ's disciples had accompanied him to Mount Tabor and are shown here with the prophets Moses and Elijah, astonished at the revelation of Christ in the Light of his Glory. Framing this scene are the 12 apostles, prophets and two monks. Although the church is now decorated with many icons and a high iconostasis, or icon screen, in the absence of these the gold and coloured glass mosaics (for more on which see Christ Pantokrator, p.229) would originally have drawn the eye to this spectacular vision above the altar.

St Catherine's Monastery has been a pilgrimage site since at least the fourth century AD. The church was rebuilt under the emperor Justinian (reigned AD 527–565), following the death of his wife, Theodora (see Empress Theodora and her Attendants, opposite), to whose memory he dedicated this work.

Panel from a Funerary Couch, Artist unknown
Painted and gilded marble, 61 x 34.5 cm / 2 ft x 1 ft 1½ in, Miho Museum,
Shiga Prefecture, Japan

On this relief-engraved white marble panel, still showing traces of its original painting and gold leaf, we see clouds sailing above the head of a camel laden with merchandise, three protective horsemen and, in a separate band at the bottom, a huntsman (right) pursuing a deer (centre). The figures have Turkic features, and wthe camel is reminiscent of the Sui- and Tang-period (AD 581-907) pottery figurines that commemorated the trans-continental Silk Road trade.

The late sixth- to early seventh-century AD panel is one of 11 that once stood on three sides of a funerary couch, perhaps that of a wealthy Central Asian, since no Chinese images appear; the scenes may represent incidents in his life. At this time tombs were built as sets of underground chambers, partially decorated and furnished. The coffin itself stood on a platform in the innermost chamber, the 'bedroom'. Two columns shaped like watch-towers flanked the front of this coffin, similar to the corner-posts that helped to support the curtains round couches and beds, and here symbolic of the passage from the world of the living to that beyond. Two other sets of carved stone slabs of this kind are known, one found in Gansu Province, the other in Xi'an. The latter decorated a couch in the tomb of a Sogdian aristocrat who had settled in China.

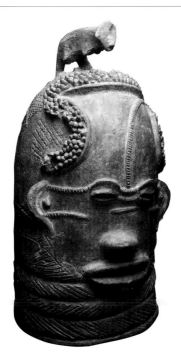

This is one of seven clay heads discovered in the late 1950s at the site of Lydenburg in South Africa; the corpus comprises the earliest known sculptural artefacts from southern Africa, dated to the sixth or seventh century AD.

The hollow, cylindrical head is life-size, the face stylized so that facial features are articulated as a series of ellipses modelled in relief. The rims of the eyes and mouth circumscribe horizontal apertures, and the nose is defined as a broad projecting mound, while semi-circular ears extend out laterally. At the top of the head is a finial that takes the form of a creature of some sort. Contrasting textures are suggested by the surface elaboration of the head,

which is defined by alternating fields of dense passages of raised pellets and networks of incised linear grids. Traces of white pigment survive, as well as specularite, a silvery pigment made from hematite.

To date, the Lydenberg heads remain unique creations unrelated stylistically to any other pre-colonial artefacts found in sub-Saharan Africa. Their form indicates that they were designed as elements of ceremonial costume or regalia – this example could have been worn as a helmet mask.

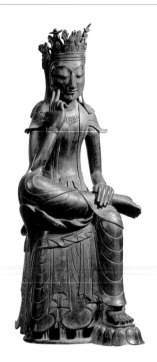

Association of the pensive posture with the bodhisattva Maitreya, the Future Buddha, seems to have begun in East Asia in the late sixth century AD, and two ornamental stupas (Buddhist monuments) in the diadem of this bronze figure confirm its identity as Maitreya. The practice of Buddhism first reached Koguryo from northern China by the fourth century AD, but a figure such as this cannot have been commissioned without official approval, and its transcendent beauty is made all the more remarkable by the knowledge that the Silla (c.5 BC–AD 668) court had formally adopted Buddhism only earlier in the century to which this sculpture can in all probability be attributed.

Cast in metal of less than one centimetre (½ in) thick by the lost-wax process (for an explanation of which see the Bodhisattva Tara, p.193), its slender body and hands are particularly graceful and its facial features distinctively Korean. The impression of intense concentration is achieved by the clever devices of lowered eyes, tight lips and the gentle forward inclination of the body resting on the right elbow. The left foot is placed on a lotus. The incised folds of the skirt and the covering on the deity's stool are in northern Chinese style, though the kingdoms of Paekche and Silla generally derived more of their cultural inspiration from the southern Chinese dynasties of the Yangzi delta.

Spring Excursion, Attributed to Zhan Ziqian
Ink and colour on silk, 43 x 80.5 cm / 1 ft 5 in x 2 ft 7¾ in, Palace Museum, Beijing

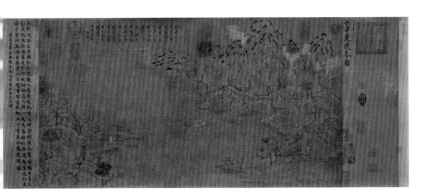

In this detail of the right half of the painting *Spring Excursion*, men and women enjoy the spring scenery by the side of a lake. Some are on horseback, others on foot, and some are taking a trip in a boat. The ripples on the water, the shape of the hills and their sparse vegetation, and the conformation of the newly sprouting trees may all have a certain stylization about them, but it is by no means unrealistic. Perhaps most admirable is the way the painter has paid attention to the handling of space, and the relative proportions of humans and their natural surroundings.

Whether this is the oldest surviving Chinese landscape painting, as has sometimes been suggested, is uncertain, but it might be if it actually came from

the brush of Zhan Ziqian (c. AD 550–618). He served as an official at the Northern Zhou (AD 557–581) and Sui (AD 581–618) courts through the later sixth century and was renowned as a painter of landscapes, human figures, horses and religious subjects. The style and colouring are appropriate for an early date, and the Song Emperor Huizong (reigned 1101–1125), whose collection included 20 pictures by Zhan, attributed this to him. Nevertheless, modern experts are not wholly convinced.

Bodhisattva, Artist unknown
Painted terracotta, H: 72 cm / 2 ft 4¼ in, Musée Guimet, Paris

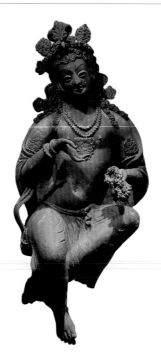

The Gandharan school of Buddhist sculpture outlived the Kushan dynasty (first to third century AD) and the fifth-century AD invasions of the 'White Huns', and continued to evolve in pockets of Afghanistan and Kashmir until about the seventh century AD. The monastery of Fondukistan was one of the last enclaves of Buddhist art in Gandhara, lavishly decorated with polychrome niches housing groups of figures such as this from the Mahayana Buddhist pantheon.

The Fondukistan style, sometimes described as 'rococo', is highly distinctive. Over the centuries, influenced by Gupta and, to a lesser extent, Central Asian, Persian and Turkestani art, the Kushan-period bodhisattvas developed from the muscular princes of

the Hellenistic ideal into highly stylized young men with elaborate coiffures and exaggerated postures.

The fleshy, large-featured face of this bodhisattva shows clear links with Kashmiri sculpture, his exaggerated brows arching over a broad forehead, his heavy-lidded, almond-shaped eyes gazing compassionately, his full mouth and small chin giving way to the soft folds of his neck. The body and limbs are softly sinuous, a languorous stylization shown in particular in the elongated curves of the fingers and toes, echoing the loose flow of his robes. The stylized opulence of the Fondukistan aesthetic made its way along the Silk Route and came to influence Chinese art, notably in the Dunhuang cave paintings.

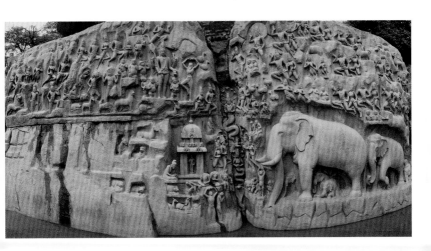

Around 150 figures and animals are spread across this vast relief that faces the sea in the former port city of the Pallava dynasty (late third century AD to early tenth), including life-sized elephants, grooming monkeys, deer, lions, and many divine beings. Interpretations of the relief hinge on the identity of the emaciated, bearded man at the centre, above the shrine building; he performs feats of austerity, standing on one leg and looking at the sun through his fingers. Is this Arjuna, the Pandava hero from the Hindu epic, the *Mahabharata*, in pursuit of divine weapons from Shiva, who stands alongside? Or is it Bhagiratha, who persuaded Ganga, the river Ganges, to come down to earth to purify the ashes of his

ancestors? Both events took place in the Himalayas, and the waters of the Ganges literally flowed down the central cleft of the relief from a pool above the rock.

Whatever its story, this relief should be understood as having many layered meanings, like the finest Sanskrit court literature of the period. Ultimately, these mythic narratives may be a eulogy to the royal patron of Mahamallapuram (Mamallapuram), the 'City of the Great Wrestler'. One title of Narasimhavarman I (reigned AD 630–668) was Mahamalla, the 'Great Wrestler', an epithet shared with Arjuna, who fought Shiva. The Pallava dynasty is said to have descended from heaven, just like the Ganges; indeed, their palace stood above this relief.

c. AD **675**
Mexico

King K'inich Hanab' Pakal, Artist unknown
Stucco and pigment, H: 24.5 cm / 9½ in, Museo Nacional de Antropología, Mexico City

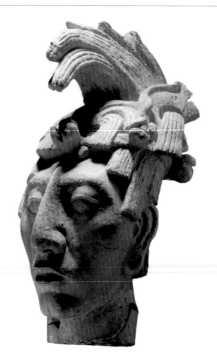

This portrait head renders in detail the physical likeness of the great Palenque ruler K'inich Hanab' Pakal (reigned AD 615–683) and comes from his tomb, which featured a monumental carved stone sarcophagus and carved lid. This stucco sculpture portrays Pakal simultaneously as a historical person and in his resurrection as akin to the Maize God, his transformation indicated by the maize leaves arching forward over his head. The same theme is expressed more fully on the carved sarcophagus lid. Modern art historians frequently state that portraiture as the graphic representation of physical likeness was not practised by the artists of the ancient Americas, but this work, among others, belies this statement.

Although found in the king's tomb, the head was probably part of a full-figure tableau adorning one of the elite structures in the heart of the city. The Classic Maya, who lived in southern Mexico, Guatemala, Belize and northern Honduras, constructed monumental stone buildings that were originally covered with plaster and paint, the ceremonial structures often adorned further with modelled and painted stucco imagery. These stucco narratives often feature portraits of the powerful rulers who governed the city and were key participants in religious and cosmic rites.

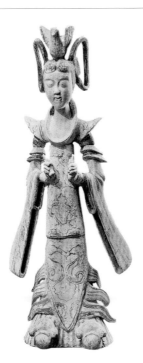

This is one of a small group of late seventh- or early eighth-century AD figurines, now scattered in museums across China, Japan and Europe, which to judge from the similarity of their distinctive and detailed appearance and their almost identical dimensions may have come from the same workshop. Since this example was unearthed near Xi'an, the imperial capital, the workshop was probably located there or nearby.

All the pieces were brightly painted with a floral pattern and left unglazed. Traces of gold leaf remain on a few. The girls' costumes are unique among examples of Tang female dress, in particular their high sculpted shoulders, the sleeves with double pleats above the elbows, and the triple flames or plumes, presumably stiffened, that project from the lower skirt. One figure has a wide belt with a heavy buckle, and all wear elaborate headdresses and heavy shoes with turned-up toes.

Some authorities identify the subjects as dancers performing Emperor Xuanzong's (reigned AD 712–756) 'Rainbow Cloak and Feather Gown' dance. Others prefer to call them ladies-in-waiting. Certainly they bear no resemblance to other Tang figurines of dancers, who invariably wear long sleeves that cover their hands. Slender figures such as these dancers possess were fashionable in the seventh century AD and out of keeping with later eighth-century tastes.

Tang Dynasty

Four Female Attendants, Artist unknown
Fresco, 110 x 270 cm / 3 ft 9 in x 8 ft 8 in, In situ, Takamatsuzuka Tomb, Nara

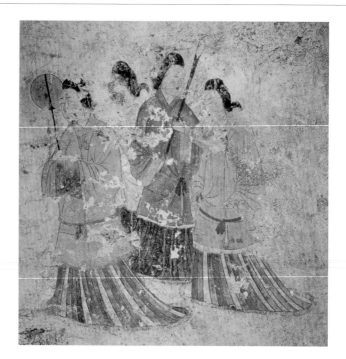

Four beauties advance in a stately procession along the western wall of the Takamatsuzuka tomb in Nara, from the Kofun or Nara periods (c. AD 300–794). Their hair is arranged in neat chignons, and they wear belted jackets and elegantly trailing skirts with red, blue, green and white stripes. Their attire, together with their aristocratic processional insignia, suggests that they are ladies of the court.

Facing them from the far end of the same wall (not shown here) is a group of four male courtiers, equally well dressed. Between these two groups appears the proudly rearing figure of the white tiger of the West, one of four mythological creatures that were worshipped in pre-Buddhist Chinese cosmology.

The opposite wall of the tomb chamber depicts the bounding green dragon of the East, likewise flanked by separate groups of male and female attendants.

The iconography probably originated in China, and the style used for the figures of the women generally recalls Tang Chinese (AD 618–906) depictions of beauties. The women's hairstyles and jackets, however, reflect Korean taste. The tomb paintings are therefore not only exquisite examples of the most advanced wall decoration techniques of the time and the first-known depictions of secular figures in the history of Japanese art – they also constitute important evidence of an active and multi-faceted contact between the Japanese archipelago and the Asian mainland.

Standing Dignitary, Artist unknown
Wood, mother-of-pearl, greenstone and lapis lazuli, H: 10.2 cm / 4 in,
Kimbell Art Museum, Fort Worth, Texas

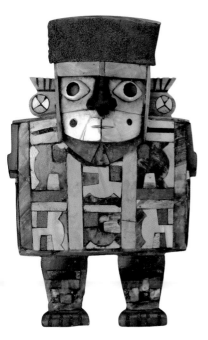
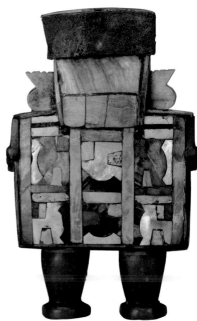

This finely crafted wooden figurine, dated to c. AD 500–900, portrays a member of the Wari aristocracy, a member of a culture that developed in the southern highlands of Peru and began to spread its influence throughout Peru in the fifth century AD. Wari art shares many iconic and stylistic features with that of Tiwanaku of the adjacent Bolivian highlands, including similar renderings of the same primary deity (probably a solar god) and his winged attendant, and a masterful manipulation of imagery within a strict grid format. This compositional design is particularly notable in Wari textiles.

This figurine's high rank is indicated by his tall hat, large ear ornaments and, especially, by his elaborate tunic, decorated in typical Wari style with wide vertical bands filled with geometric motifs. The same pattern frequently embellishes actual surviving tunics worn – judging from their fine quality – by members of the Wari elite. The effusively abstract designs depict the solar deity's winged attendant, who frequently also adorns other Wari artworks, including painted ceramics and carved stone monuments. Miniature renderings in wood, semi-precious stone or precious metals of Wari men richly adorned in ceremonial dress, as here, have been found in ritual caches buried underneath palaces and in other ceremonial contexts, suggesting that they may have served as diminutive portrayals of the rite's participants.

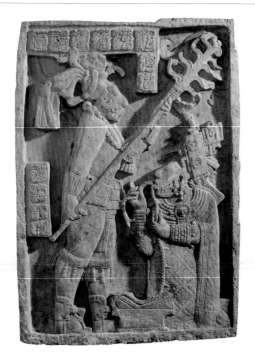

This is one of three lintels from Structure 23, a royal building flanking Yaxchilán's main plaza and belonging to the queen, Lady K'ab'al Xook. These lintels are renowned for their richness of detail, virtuoso composition and masterful manipulation of the sculptural medium to mimic two-dimensional brushwork. The artist employed compositional diagonals and figural gesture and gaze to direct the viewer's eye throughout the picture plane, and through deep cutting away of the background, the figures acquire a visual clarity unusual in late Classic period (c. AD 600–900) Maya art.

The lintel, dated by its hieroglyphs very precisely to 2 November 702, records a multi-faceted ceremony that celebrated the twenty-eighth anniversary of Its'amnaj B'alaam's accession to kingship on 20 October 681 and the eightieth anniversary of his father's enthronement. The scene shows the king holding a torch to illuminate his wife, Lady K'ab'al Xook, who is making a blood offering: she pulls a rope through her tongue, causing sanctified royal blood to fall into a basket filled with strips of paper that will be burned as an offering, as described in the accompanying hieroglyphic text. The elaborate motifs of the clothing suggest the exquisite textiles of the Classic period, which survive only in pictorial depictions such as this.

Harp Player, Artist unknown
Painted plaster, 132 x 56 cm / 4 ft 4 in x 1 ft 10 in,
National Museum of Antiquities, Dushanbe

The city of Pendzhikent, situated on the ancient Silk Road in modern Tajikistan, was the centre of a cosmopolitan Sogdian kingdom that flourished from the fifth to the eighth century AD, until the Arab expansion across Central Asia. Many of the houses and palaces in the city yielded elaborate wall decorations, and this harp player from a palace complex is one of the best-preserved fragments, excavated in the 1950s and here restored.

The painting exemplifies the facial features and figural elements of eighth-century Pendzhikent art, with the eyes half-closed, the figure shown in three-quarter view with narrow waist and wide shoulders, and the hands with long, slender fingers. The result

is an intensity of expression and a lightness of stance, though the warm ochre and cream colours against a dark blue ground help to intensify the solidity of the figure. The scene from which this harp player came may have been a frieze depicting feasting, dancing or religious rites, commonly used to decorate the principal room of a home or palace. The identity and social status of the figure is unknown, although one may presume from her clothing that she belonged to the town's nobility. The form of the arched harp is thought to have originated in Persia before being transmitted to Central Asia via India.

c. AD **715**
UK

Lindisfarne Gospels, Bishop Eadfrith of Lindisfarne
Ink, colours and gold on vellum, 34 x 25 cm / 1 ft 1½ in x 9½ in, British Library, London

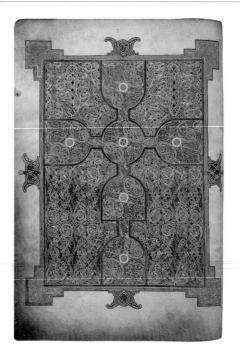

These magnificent Gospels (AD 680–720) were produced on Lindisfarne, or the Holy Island, off the coast of Northumbria in northern England, and are a key example of the Insular style of the British Isles. This Hiberno-Saxon style is a fusion of disparate influences, combining curvilinear organic motifs and abstract patterns of the Celtic La Tène style, elements of Graeco-Roman fretwork and Coptic motifs (see, for example, the Desborough Mirror, p.137). The decorated pages that precede each Gospel (this is f.26v, introducing the Gospel according to St Matthew) are known as carpet pages because of their resemblance to oriental rug designs; they functioned almost as traditional prayer mats, helping the reader

prepare to move on to the pages of Holy Scripture that would follow.

The artist-scribe Bishop Eadfrith was truly innovative in the style, preparation and materials he used. Intricate geometric designs were traced out on the back of the sheet of vellum in reverse with compass and divider, with details added freehand in lead point. A light was then placed behind the sheet so that the design showed through, and the colours were applied. The palette is particularly rich, showing a skilled knowledge of the natural pigments available to the artist. The elaborate pattern is reminiscent of contemporary bejewelled crosses that symbolically allude to the second coming of Christ.

Ardagh Chalice, Artist unknown
Silver, gold, lead, enamel, malachite, amber, mica and rock crystal, H: 17.8 cm / 7 in,
National Museum of Ireland, Dublin

This chalice, probably from the eighth century AD, is one of only two surviving liturgical chalices of this type; its construction bears testament to the consummate skill of Celtic craftsmen. The vessel is composed of 354 pieces held together with 20 rivets, and is decorated using a wide variety of techniques: hammering, lost-wax casting, filigree, engraving, stippling, *cloisonné* and enamelling. The chalice is decorated with scrolls in the Ultimate La Tène style (a curvilinear, pan-European art originating in Iron Age Switzerland and Northen France), plain interlace, plaits and frets typical of Celtic art of this period. The filigree work of the gold band, with its animals, birds and geometric patterns, is comparable to that of the

Tara Brooch (p.181), and below this strip the names of the Apostles are incised in a style similar to the initials of the Lindisfarne Gospels (opposite).

The Ardagh Chalice probably formed part of the liturgical treasury of some early Irish church or monastery and would have been used for the distribution of the communion wine; a similar chalice was discovered along with a ladle for straining grape seed from the wine. The hoard from which this vessel came was discovered in 1868 in a circular earthwork at Reerasta, Ardagh, where masses had been held in the late seventeenth and eighteenth century, a time when the Irish Catholic faith was suffering severe suppression at the hands of the English.

This portrait-like head came from a full-figure sculpture, the masterful modelling of the face hinting at the expressive power of the full artwork, now lost. Its fragmentary condition makes its artistic provenance, original form and meaning particularly difficult to ascertain, but it is, nonetheless, an exceptional example of the sensitive naturalism that characterizes the Lirios-style ceramic sculptures of central Veracruz and adjacent eastern Oaxaca. The male head, dated to the late Classic period (c. AD 600–900), is adorned with a nose ornament, elaborate chin strap and neck wrap composed of a triple strand of tubular beads with what appears to be a knotted cloth tie at the front. The thick cord that originally encircled

his head and neck suggests that the figure was a portrayal of a captured nobleman.

Two attributes suggest that this piece may have come from Veracruz rather than Oaxaca. First, ritual decapitation of full-figure sculptures was a common ceremonial practice throughout central Veracruz and is seldom found in Oaxaca. Second, the figure's pupils are indicated by spots of black asphalt paint, a technique often used by Veracruz artists to accentuate certain features of their sculptures and one very rare in contemporary Oaxaca. The sculpture may have been made in Veracruz and exported to Oaxaca as part of social, political or economic interaction between the two cultures.

Vajra-Wielding Deity, Artist unknown
Painted terracotta with gold, H: 170 cm / 5 ft 7 in, Hokke-do (Sangatsu-do) Hall,
Todai-ji Temple, Nara

Brandishing the *vajra*, a symbolic Buddhist weapon translated as either 'diamond' or 'thunderbolt', this figure of Shukongo-jin (Sanskrit: Vajrapani) stands ready to strike down the next violator of Buddhist truth. The figure exemplifies the powerful realism achieved by Japanese sculptors of the Nara period (AD 710–794), who used the malleable medium of clay to define the veins throbbing and muscles charged with supernatural ire.

Reddish tones for the skin and gold along the edges of the armour bring the deity to life. The colours are exceptionally well-preserved because for most of the year the figure stands hidden from view in a secret shrine, vigilantly guarding the sacred icons around it

from dangers to the north. An internal wooden frame supports the figure.

According to legend, in the early eighth century AD a pilgrim prayed day and night to this statue, which was located at the time in a nearby provincial temple. The statue's legs emitted beams of light that reached to the imperial palace. The emperor summoned the pilgrim to the capital and was inspired by his religious fervour to construct the magnificent temple complex known as Todai-ji, completed in AD 751. The provincial temple and its miraculous statue were incorporated into this new centre of Buddhist faith.

Dinwoody Petroglyphs, Artist unknown
Incision on rock, 200 x 660 cm / 8 ft 2 in x 18 ft, In situ, Wind River Valley, Wyoming

The impressive Dinwoody-style petroglyphs, concentrated in the Wind River drainage basin and the southwestern part of the Bighorn River valley, in western-central Wyoming, incorporate complex anthropomorphic representations and linear ornamentation; animals are rare, and narrative depictions – hunting or ritual scenes – do not occur. The members of this hunting and gathering culture, dating to c. AD 100 to 1400, used sophisticated techniques (fine pecking and smoothing, variation in line thickness, shading) to incise a variety of figures up to a metre (3 ft 3 in) tall, often in clusters, as seen here. Rock varnish on the cut surface enables us to date individual carvings and to understand the sequence of these elaborate carvings. The ritual significance of the petroglyphs, if any, is a mystery.

A remarkable concentration of figures in classic Dinwoody style is found at Legend Rock in Wyoming (site 48H04); examples continued to be incised here as late as 1800. The animal petroglyphs in the Coso Mountain Range of eastern California have also been linked to Dinwoody. A very different tradition can be seen in the principal elements of the 'En Toto Pecked' tradition of rock art in the nearby Bighorn River basin (c. AD 1–1150), in which dense chipping is used to depict stick-like human figures with shields. These separate styles offer important clues to the different areas used by native cultures in this rugged region.

Tara Brooch, Artist unknown
Silver gilt, amber, polychrome enamel, glass and pearls,
Diam (ring, external): 8.7 cm / 3½ in, National Museum of Ireland, Dublin

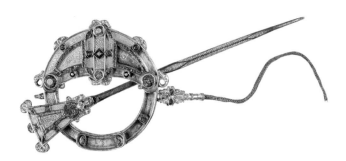

Penannular (open-ring) brooches were used by Celts as cloak pins, worn on the shoulder or breast. The Tara Brooch, washed up on the shore at Bettystown, County Meath, in 1850, is one of the earliest pseudo-penannular brooches, in which the apparent opening is actually closed.

Little is known of Irish metalwork prior to the eighth century AD, but the Tara Brooch shows that by this time the Irish Celts were capable of advanced metallurgy. The brooch includes cast elements, filigree work, rich gilding, gem-set polychrome enamels, amber and pearls. Every inch is richly ornamented with intricate abstract designs known as Celtic knotwork, which on close inspection reveal

themselves as a multitude of interlaced dragons, birds and wild beasts. The elaborate geometric forms are a late flowering of the Iron Age La Tène style (see, for example, the Desborough Mirror, p.137). More directly, goldsmiths drew inspiration from the designs and motifs employed in manuscript illumination, and clear parallels can be seen with the style of the Lindisfarne Gospels (p.176). Although the brooch actually has no connection to Tara Hill, the mythological seat of the Irish kings, an item of such superb workmanship and expensive materials would have been worn by a high-ranking member of Celtic society, not only for its decorative effect but also as a mark of status.

Smiling Celebrant, Artist unknown
Painted terracotta, H: 47.3 cm / 1 ft 6¾ in, Metropolitan Museum of Art, New York

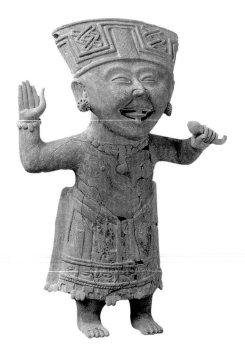

The so-called 'smiling figures' in Nepali style from central Veracruz, in east-central Mexico, portray ritual celebrants, perhaps individuals intended for ritual sacrifice. The region is known for its thousands of ceramic sculptures with no archaeological provenance, a lack that limits any understanding of the area's cultural history or meaning of the artworks; nevertheless, some interpretations can be offered. The survival of many more smiling heads than associated bodies suggests ancient ritual decapitation of the effigy and the intentional destruction of the body. The figures' typically puffy cheeks, protruding tongue and ecstatic grin depict an enraptured condition produced by ingesting hallucinogenic substances or an intoxicating beverage, perhaps *pulque*, the fermented sap of the *maguey* plant. Imagery portraying a god of *pulque* are found at various sites in the region, especially in the main ballcourt at El Tajín.

The artist who created this late Classic period (c. AD 600–900) piece expertly captured a dynamic pose suggesting dancing and perhaps singing, implied by the rattle in the upraised hand and the open mouth. This interpretation is reinforced by the entwined *ollin* or 'movement' symbol on the head wrap, which was later the symbol of Xochipilli, god of dance, music and poetry. The finest of these figures have the elaborately decorated hip wrap and headdress, which attest to the exquisite textile tradition of ancient Veracruz.

Flying Dragon, Artist unknown
Gilt bronze, 34 x 28 cm / 1 ft 1½ in x 11 in, Shaanxi History Museum, Xi'an,
Shaanxi Province

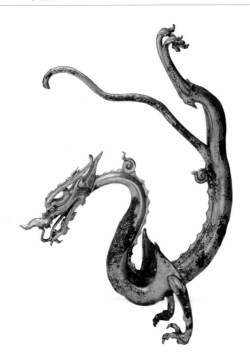

Some dragons move through China's art history by
swimming and twisting like serpents; others walk
on four bronze or golden legs. This beautiful creature
seems to have flown down, perhaps to adorn and
protect a roof on which it has just landed. Its mane
and whiskers are still streaming backwards from its
exquisite head, its rear legs and sinuous tail are thrown
forward by the force of its interrupted descent, and its
miniature wings have yet to be folded away. It was one
of a pair and seems to have been made to be admired,
though it has been suggested that it was intended to be
buried in the foundations of a building as a talisman.

It was in the Tang period (AD 618–906) that gold
was first fully appreciated by the Chinese for its beauty

and physical qualities, one of which – like the quality
attributed to jade – was the durability that gained it an
association with immortality. Like the dragon, gold
also had imperial connotations. In the Tang capital
of Chang'an (modern Xi'an), goldsmiths worked
with partners from Central Asia to create objects
with all manner of intricate designs, and were well
patronized by the court. The site where this dragon
was discovered, at Caochangpo, near Xi'an, Shaanxi
Province, lay about 5 kilometres south of the Daming
Palace at Chang'an, with which it is likely to have had
some connection.

Tang Dynasty

Yakushi-nyorai, the Medicine Buddha, Artist unknown
Wood with pigment, H: 170 cm / 5 ft 7 in, Golden Hall, Jingo-ji Temple, Kyoto

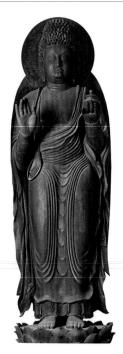

In AD 769, the Buddhist prelate responsible for the empress's health and spiritual well-being hinted that he might like to become the next emperor. At the command of certain shrine deities in the south, he was immediately driven into exile. The deities later ordered the Buddhist community to transcribe 10,000 sutras, construct a temple, and enshrine a new Buddha image in order to purge the land of spiritual illness. This sculpture of Yakushi-nyorai (Sanskrit: Baishyaguru), the Medicine Buddha, was the imposing result. The heavy features and massive form reflect the influence of recent eighth-century AD continental styles, but the almost pitiless expression and piercing gaze were new, perhaps considered appropriate to ward off the

spirits of the ambitious prelate and his followers. Also unusual for Yakushi, the right hand is raised in the 'fear not' (Sanskrit: *abhaya*) gesture, as if to endow the figure with as many protective attributes as possible.

Similar to other 'plain-wood' Buddha figures, the surface of this sculpture was left essentially unpainted, except for some details, possibly to maintain the natural purity of the single block of Japanese cypress from which the figure was carved. Perhaps for similar reasons, the unpainted surfaces were left unpolished; even small worm holes were not disguised. Single-block wood construction would remain the preferred technique for Japanese Buddhist images throughout the early Heian period (AD 794–1185).

Coclé Pectoral, Artist unknown
Gold alloy, 26 x 18 cm / 10¼ x 7 in, University Museum of Archaeology and
Anthropology, University of Pennsylvania, Philadelphia, Pennsylvania

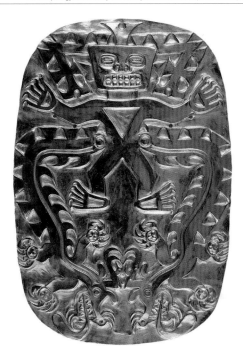

This large gold disk from Sitio Conté, made by the Coclé people of central Panama, is embossed with the image of a human figure that represents a shamanic practitioner in the throes of spiritual ecstasy. His otherworldly state is signalled by the crenulated lightning-like rays emerging from the top of his head, symbolizing the emergence of soul force. The shaman's transformation into his spiritual animal 'other' is indicated by his caiman feet and hands and by the supernatural lizard-like creatures emanating from his waist.

This object, dated to c. AD 500–1100, is a well-crafted example of a type of embossed gold disc that has been found in burials on the chests of the interred.

It is assumed that those burials with the greatest numbers of gold discs, including many displaying fine craftsmanship and such iconic motifs as this shaman's image, are the interments of high status members of Coclé society, including the ruling elite. Sixteenth-century Spanish descriptions of indigenous peoples of the region comment that their gold body adornments symbolized supernatural power and high social rank. Extending this observation back in time, it is likely that the gold discs of the earlier Coclé society, with their embossed mythical beings and shamanic forms, were worn by the elite as indicators of social, political and spiritual authority.

This solid-cast Avalokiteshvara, the Bodhisattva of Infinite Compassion, sits in the 'pose of royal ease' (*rajalilasana*), with his right leg raised up and the left hanging down beside the rich folds of his waistcloth. His serene expression is combined with a gentle gesture of offering. A small meditating image of Amitabha, the 'cosmic' Buddha of our era, is missing from his ornate hairpiece. This is one of the finest bronze images produced in the later Anuradhapura period (late seventh century AD to late tenth), Anuradhapura being the capital of Sinhala culture until AD 993; the statue was found in Veheragal, Anuradhapura district. Unlike some bodhisattva images in, for example, Tibet, those from Sri Lanka

rarely have multiple arms and are comparatively understated, however ornate.

Sri Lanka has the longest continuous Buddhist tradition in the world. This image was found in 1968 in the ruins of a monastery in Mihintale, the site where Buddhist missionaries from north India met the Sinhala king in the third century BC. Theravada Buddhism has dominated the island's history since that time, with an artistic emphasis on images of the historical Buddha, Siddhartha, and tales of his previous lives, the *jataka*s. But Mahayana Buddhism, with its more diverse pantheon of Buddhist beings and deities, also made its mark between the seventh and tenth centuries, as this image suggests.

This is folio 291v from the Book of Kells, the magnificent Gospel that was probably produced on Iona, the Scottish island where St Colomba died in AD 597; it has been dated to between AD 725 and 825. The Book of Kells is often regarded as a form of holy relic commissioned for the translation of the saint to a new shrine, rather than a practical liturgical text. It is the most extravagant and richly ornamented of the so-called Insular Gospels, works produced in Ireland, Scotland and Northern England from the seventh to the late eighth century AD. The richness of colour was achieved by the use of expensive materials such as lapis lazuli from Afghanistan, ground to powder to create the brilliant blue hues. Given its relic-like status, it is

surprising there is no gold leaf; instead the illuminator has employed orpiment, a vivid yellow obtained from trisulphide of arsenic.

The Christian motifs of the iconography, ultimately derived from the Mediterranean tradition, are transformed by the Insular propensity for stylized ornamentation. Love of the abstract takes precedence over natural representation, the strict geometry even extending to much of the body of John the Evangelist on this page. The saint's halo forms part of a larger brooch-like design closely comparable with contemporary gold work. A magnifying glass is needed to pick out such fine details as the intertwined wild beasts.

Hiberno-Saxon Insular Style

In the early ninth century AD, Archbishop Ebbo of Reims (reigned AD 816–835) gathered together a number of artists who had worked under Charlemagne (reigned AD 768–814) to create an important school of manuscript illumination, based on the study of monuments and manuscripts from antiquity, as well as contemporary works from the British Isles and Italy. These artists also maintained close links with Byzantium and developed an inventive, exuberant style that was imbued with an expressive variant of Late Antique illusionism.

The Ebbo Gospel, a key work of the Carolingian Renaissance, written for Ebbo at the abbey of Hautvillers near Reims, shows in its images the loose, rapid brushstrokes full of nervous energy that set the style apart from others across Europe. On this page (folio 18v) it is most notable in the tight flowing folds of St Matthew's robe and the loose curls of his hair, as well as in the light, almost impressionist handling of the landscape. The conception of space is still rudimentary, with little sense of recession; the apostle's body casts a shadow onto the scenery like a stage backdrop. Earlier depictions of the Evangelists portrayed them as imposing, philosopher-like figures, whereas here Matthew is wearing Classical dress and sandals and sits upon a Byzantine cushion; his dynamic posture suggests a forceful expressivity not seen previously.

This Central Javanese period (AD 732–929) relief carving from Prambanan Temple in central Java depicts a scene from the Indian epic, the *Ramayana*. Rama, the protagonist of the story, and his brother Lakshmana, depicted carrying a bow, are in search of Sita, Rama's wife, who has been abducted by the evil demon king Ravana. They encounter Marica and Subahu, depicted to the right of the composition, whose spirits are trapped in the bodies of demons. Rama and Lakshmana defeat the demons, and the grateful spirits advise Rama how to find his wife.

The 72 *Ramayana* relief panels of Prambanan Temple exhibit an unsurpassed vividness and naturalism, combining to create arguably the finest ever depiction of this epic in stone. While extremely popular in India, the story was never depicted there in narrative relief form – whereby the tale is illustrated following the narrative arrangement of the actual story – whereas this form of composition was common in Java. The Javanese version of the *Ramayana* shows clear adaptations and reworking to suit the tastes and sensibilities of those who carved and viewed it, and the naturalism characteristic of the Central Javanese style is also distinctive.

Pope Gregory the Great (d. AD 604) was the author of the reformed liturgy of the Holy Mass adopted under the Holy Roman Emperor Charlemagne (reigned AD 800–814), and this late ninth-century AD plaque probably served as a book cover for his text. A Frankish work from northwest Europe, its precise place of manufacture is not known. It visualizes the legend whereby Gregory writes the divine words that the dove of the Holy Spirit has whispered in his ear. In the lower register, his scribes copy the liturgy for dissemination.

Ivory carving and manuscript painting were closely allied arts in the Carolingian age, both drawing on the same repertoire of Antique and Early Christian prototypes, as well as the art of Byzantium (seen in the acanthus-leaf border) and the Near East. Typical of much Carolingian art, the pictorial elements are squeezed into the visual frame. The figures are cut in deep relief and handled with a detailed, animated realism; even the text of the scribes can be read. The miniature palace carved above the pope suggests both the exterior of the study setting and a view from a distance. Gregory is framed by classical columns, a central arch and drawn back curtains, motifs that would later evolve into a standard setting for the representation of learned men.

This mosaic is situated in the soaring apse of Hagia Sophia, the vast and architecturally daring church erected in Constantinople (modern Istanbul) by the emperor Justinian (reigned AD 527–565). The Christ Child, clad in gold and holding a scroll, is seated on his mother's lap. She is dressed in a voluminous blue *maphorion*, or robe, and the ornate backless throne with plump cushions stands behind a *suppedion*, or footstool. The dating of the mosaic to the ninth century, in the Middle Byzantine period, relies on a homily given by the patriarch Photios in AD 867, which celebrated the restoration of images after the end of the last period of iconoclasm in AD 843. He spoke with great wonder of the 'lifelike imitation' of

the Virgin and described the mosaic as symbolizing the Incarnation of Christ, the apse corresponding to the cave of the Nativity.

Hagia Sophia was converted into a mosque in 1453, when the Ottomans conquered the city, after which the figural decoration throughout was concealed by plaster. This mosaic and several others were uncovered during restoration work between 1935 and 1939.

AD **868**
China

Frontispiece to the Diamond Sutra, Artist unknown
Ink on paper, 27 x 533 cm / 10½ in x 17 ft 6 in, British Library, London

This edition of the *Diamond Sutra*, a text that had first been translated into Chinese by the Indian missionary Kumarajiva in the fifth century AD and was used by several sects, consists of seven pages pasted together into a long scroll. Six of the pages comprise the text, but the first – at the right-hand end of the scroll – acts as a frontispiece showing Buddha preaching to his disciple Subhuti. A note at the left-hand end, with a date corresponding to 11 May 868, tells the reader that the book was paid for by one Wang Jie in memory of his parents. (One could accrue merit by sponsoring the copying of sutras and other Buddhist texts.)

The scroll was discovered in the Dunhuang Caves of Gansu Province by Aurel Stein in 1907. Although

a portion of an earlier printed sutra has been found in Korea, this is believed to be the oldest complete copy of a printed book in the world. Block printing, preferably using hard pear wood for the carved blocks, had been invented in China, in the eighth century AD or perhaps earlier, as a means of studying and spreading the Buddhist faith. The intricacy of line seen here, together with the precise reproduction of the textual brushwork further on in the scroll, demonstrate the high level of skill and commitment on the part of the artists who produced it.

Bodhisattva Tara, Artist unknown
Bronze, jade and black stone, H: 117 cm / 3 ft 10 in, Danang Museum, Danang

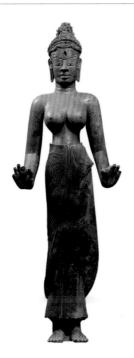

This large, stylized, but gentle bronze sculpture of Tara, consort of the compassionate bodhisattva Avalokiteshvara, comes from a huge ninth-century AD complex devoted to the Tantric Mahayana form of Buddhism, located near Mi So'n at Dong Duong, Quang Nam Province, in central Vietnam. The statue was cast using the lost-wax technique, in which a clay model is covered with wax, then another clay layer; the piece is heated so that the wax runs out and the clay is fired, the space left then being filled with molten metal. The inlaying of the eyes, eyebrows and details of the hair was chased after casting, when the metal was cold. The hands are held in an unusual 'have no fear' position.

The style of the sculpture is distinctive to the Champa culture, which existed from the fifth to the nineteenth century along the eastern seaboard of Southeast Asia. The Chams, probably originally from Borneo, were expert navigators and were among the first peoples to reap the economic and technological benefits of the maritime trade route that linked China with India and Rome from the beginning of the last millennium. Their sacred art draws on Indian, Chinese and Malay sources but imitates none, and is strikingly idiosyncratic and powerful.

Champa Culture, Dong Duong Style

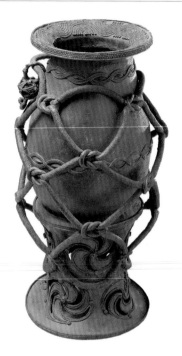

In 1938 a man uncovered a cache of bronze artefacts while digging a water cistern at Igbo Ukwu, a small village in southeastern Nigeria. Subsequent excavation revealed the remains of a shrine or ritual storehouse for sacred vessels and regalia, dated to around the ninth and tenth centuries AD, from which this vessel was recovered. It is considered the most impressive creation identified with an ancient civilization that is believed to have been a precursor of contemporary Igbo peoples of Nigeria.

This elegantly composed object is a virtuosic marvel that required a series of successive castings joined together with poured molten metal. The artist rendered in bronze – a costly medium – an everyday terracotta water vessel and the netted rope sometimes used to carry it, thus transforming the ordinary into a precious object. The globular vessel with flared rim is supported within this arrangement on an ornate pedestal base. The network of knotted filaments that encases the vessel and the pedestal fully resolves the unity of the interconnecting forms. Igbo Ukwu's metallurgists were not only the earliest workers of copper and its alloys in West Africa, but they executed what remain to this day among the most elaborate and technically demanding lost-wax castings produced in the region. Their highly distinctive style is unique within African art.

Head of Shiva, Artist unknown
Sandstone, H: 46 cm / 1 ft 6 in, Musée Guimet, Paris

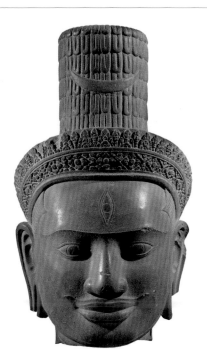

The third forehead eye and the crescent moon in the pile of hair identify this head as that of the Hindu deity Shiva, who reigned supreme in Khmer sacred art from around AD 800 to 1200. Carved in finely textured greenish sandstone, the face has hard, staring eyes but a slight smile, lifted by a fine moustache. It conveys the power and mischievousness of the fearsome deity whose image resided in the Khmer temples of state in human or *linga* (a stylized phallus) form. The origin of this sculpture, brought back from Angkor by a French colonial mission in the late nineteenth century, is unknown.

The Bakheng style dates from the early Angkor period, when the Khmer capital was moved to Angkor by Yashovarman I (reigned AD 889–910). Named after a hilltop temple at Angkor built by the same king, the style is characterized by a beautiful, somewhat remote, geometric and hieratic design – frontal, rather stiff, and with an imposing sense of authority. The firm, simple lines seen here skilfully delineate the eyes, the single eyebrow, the hair at the temples, the intricate crown and the high, hat-like pile of hair.

Khmer Culture, Bakheng Style

c. AD 923
China

Musicians, Artist unknown
Painted marble, 82 x 136 cm / 2 ft 7 in x 4 ft 5 in, Hebei Provincial Cultural Relics
Institute, Shijiazhuang

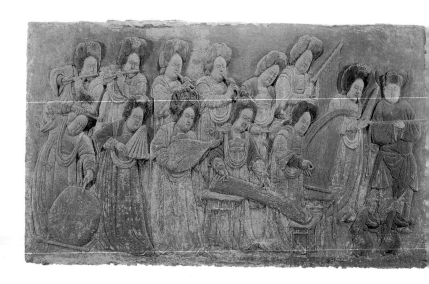

From ancient times, music had been enjoyed and respected in China as a principal art form, drawing man and heaven together in cosmic unity. Plentiful visual evidence of this can be found on vertical and horizontal scrolls, ceramic figurines, tomb murals and sculptures. A carefully carved and painted relief such as the one shown here is rare, however.

When Wang Chuzhi died in AD 923, his tomb at Xiyanchuan, near Quyang in Hebei Province, was furnished and decorated appropriately for a high official such as he. On the east wall of the tomb chamber a group of 13 attendants and a child wait upon him. Here, on the west wall, an orchestra of 12 female instrumentalists, their male *chef d'orchestre*, and two

small dancers perform for him. Two of the musicians play flutes, two play vertical pipes with detachable reeds, and there is a small drum, a *fangxiang* (iron chimes), and a *sheng* (mouth-organ); in the front line are a large drum, *paipan* clappers, a bent-necked lute, a *zheng* zither, and a *konghou* harp. The detail and accuracy of the stone carving are remarkable. The women are plump, as later Tang taste preferred, but these date to the succeeding Wudai, or Five Dynasties period (AD 906–960). They wear identical costumes and have similar piled hairstyles typical of court ladies. Their eyes are lowered, deep in concentration.

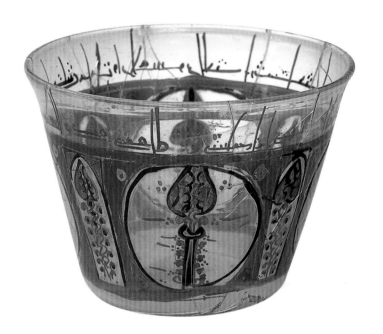

Early Islamic artists are known to have experimented with a range of techniques to make and decorate luxury objects. The shiny decoration of this glass beaker, the precise origin of which is unknown, was achieved by staining the surface with a suspension of finely powdered oxides of copper or silver and then firing the object in a reducing (oxygen-poor) kiln at about 600°c (1112°F). This temperature was high enough to fuse a thin film of metal to the surface but insufficient to soften the glass and cause the object to collapse.

Syrian glassmakers seem to have developed the lustre technique in the first centuries of Islam, and a few such objects are dated to the late eighth century AD; this is a rare example of a complete vessel and may date to a century or more later, under the Fatimids (AD 910–1171). Around the rim is an undeciphered Arabic inscription, and below is a design executed in three colours (ochre, orange and brown), with alternating circular and arched panels, each containing an abstracted vegetal motif. The plant motifs are derived from the nonfigurative style developed at Samarra in modern Iraq, the ninth-century capital of the Shi'ite Abbasids; during the Abbasid period the lustre technique was also applied to ceramics.

Fatimid Dynasty

Ritual Knife, Artist unknown
Gold, turquoise and pigment, H: 43 cm / 1 ft 5 in, Museo Nacional de Arqueología, Antropología e Historia del Perú, Lima

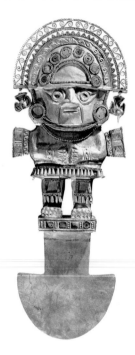

The handle of this ceremonial knife (*tumi*), dating to between AD 900 and 1100 and found in the Lambayeque area of the North Coast of Peru, depicts the so-called Sicán Lord, the primary deity of the Sicán. He stands in an authoritative pose with hands clasped against his torso. His semi-circular headdress symbolizes a rainbow and the arc of heaven, its celestial identity affirmed by the two tiny birds hanging from each end of the arc. The deity wears a knee-length tunic, its border and his knee bands embellished by a row of miniature conical tinklers. Sicán artists frequently used semi-precious stones and shell, and the delicate inlay of this metalwork is among the finest multi-media works of ancient Peru.

Under their ruler Pacatnamú, the Chimú conquered the Sicán people around 1100 and absorbed their art style, iconography and trade networks. The remarkable similarity of subsequent Chimú artworks indicates that they also probably commandeered Sicán's renowned metallurgists and ceramicists to create objects of beauty and prestige to highlight the growing power of the Chimú state. Many of these exquisite creations were placed in the rich tombs of the Chimú elite, which were filled with hundreds of finely crafted items of gold, silver, wood, shell, fibre and earthenware that preserve the creativity and technical mastery of the artists of Sicán.

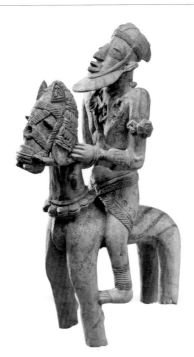

This idealized representation of a bearded and helmeted warrior in his prime, dated between the ninth and the twelfth centuries, appears to portray an archetype rather than act as a portrait. It was originally covered with a red slip, and traces of other different coloured paints survive. The extensive descriptive details that define both the figure and his mount are incised into and painted on the surface.

This is a fine example of the immensely varied figurative sculptures in terracotta and cast alloy copper from Mali's Inland Niger Delta, often associated with the ancient urban centre of Djenne-Jeno, 3 kilometres (1.8 miles) southwest of the modern city of Djenne. The site was settled around 250 BC

and was continuously occupied by an ethnically diverse population for over a millennium before its abandonment around 1500; its decline may relate to the arrival of Islam in the region.

Horses were introduced into the region from North Africa through trans-Saharan trade around AD 1000, providing local leaders with a significant military advantage over their neighbours. An equestrian imagery was subsequently created to refer at once to the leadership and cavalry of a number of medieval African states, among them the Mali Empire (c.1200–1400), whose power depended in part on its cavalry of 10,000 horsemen.

c. AD **965**
Italy

Otto I Presenting a Model of His Church to the Enthroned Christ, Artist unknown
Ivory, 13 x 11.3 x cm / 5 x 7½ in, Metropolitan Museum of Art, New York

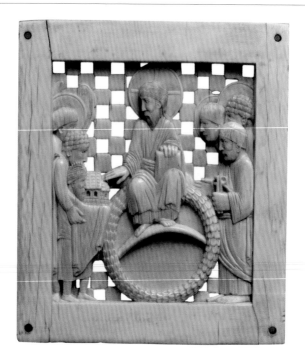

This is one of 19 surviving plaques that formed part of a liturgical furnishing. Christ is enthroned upon a mandorla (circle of light) that clearly resembles the Classical funerary wreath, with an open chequerboard behind him. He is blessing a model of a church presented by Emperor Otto I (Otto the Great; reigned AD 962–973), who, as a humble donor, is depicted smaller than the company of patron saints. The military St Mauritius, patron saint of the Ottonian Empire, is shown behind Otto, presenting him to Christ. St Peter, clutching the keys to Heaven, and other unidentified saints complete the composition.

The ivory (AD 962–968) was destined for Otto's imperial church dedicated to St Mauritius in Magdeburg, Saxony, which was raised to the seat of an archbishopric in AD 968. This plaque, and the accompanying series of scenes from the life of Christ, must have been made for the dedication of the church in that year. Probably carved in Milan, an important imperial and artistic centre, the iconography is drawn from Carolingian and Byzantine traditions. The engaging style of these Milanese ivories exemplifies the Ottonian tendency towards increasing abstraction and monumentality, with uncomplicated figures, geometric setting and emphatic gestures.

Tillotama Pediment, Artist unknown
Pink sandstone, 196 x 269 cm / 6 ft 5 in x 9 ft 1 in, Musée Guimet, Paris

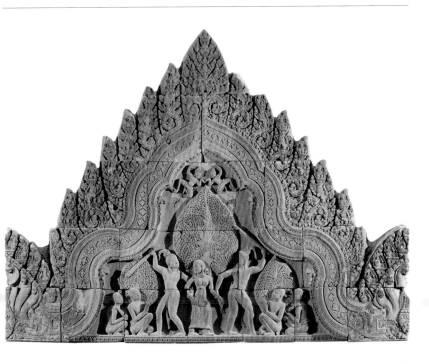

The beautifully carved and exceptionally well-preserved Banteay Srei (Citadel of Women) temple, 40 km (25 miles) outside Angkor, is considered by many to be the jewel of Angkorian sacred art. The temple is built in pink sandstone of such high quality that the profusion of detailed carving is still crisp today. The opening of the temple is dated to AD 967 by an inscription, which attributes the construction to the Brahmin Yajnavaraha, senior Shaiva guru under King Jayavarman V (reigned AD 968–1001).

This deeply carved pediment is from the east porch of the temple's third gate. It relates the story of Tillotama, from the classic Hindu sacred narratives known as the *Mahabharata*. Tillotama was a celestial

nymph (*apsaras*) created by the gods to restore peace by bringing about a self-destructive battle between two demi-god brothers, Sunda and Upasunda, who had been causing trouble across the heavens. Their fight over Tillotama is caught dramatically in the lobed pediment topped by leaves and ending in many-headed *naga* (a supernatural being with snake and human attributes). The naturalistic figures, which contrast to the more static style of Khmer sculpture in the round, define the Banteay Srei style, along with the imaginative composition and the blending of graceful figures and luxuriant vegetation. These are the first well-preserved Khmer narrative scenes, and they would influence the course of Khmer decoration.

c. AD **975**
France

Reliquary of St Faith, Artist unknown
Gold, silver, copper, rock crystal, precious stones, pearls, cloisonné enamel and
yew wood, H: 85 cm / 2 ft 9¼ in, In situ, Church of Sainte Foy, Conques

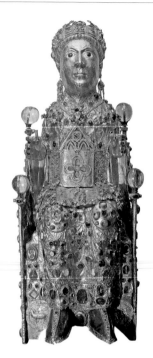

During the early Middle Ages, large, free-standing
sculpted images other than those of Christ still bore
overtones of pagan worship. In the late ninth century
AD, however, resplendent reliquaries (repositories for
relics of saints) in human form began to be produced.
This reliquary of the female child martyr St Faith
was believed responsible for countless miracles and
made the monastery of Conques a site of international
pilgrimage. One pilgrim, Bernard of Angers, recounts
how the statue attracted such crowds that it was
impossible to kneel.

The form of the reliquary is a result of centuries of
accretions. The head is Late Antique, possibly that of
a Roman emperor of the fifth century AD, hence the

saint's less than feminine features. The main body, of
beaten gold on a wooden core, is from the late tenth
century. Around the turn of the millennium, the saint
was given a crown and throne, symbols of her celestial
glory. Generous donations by the faithful, including
Carolingian rulers, encrusted the figure with jewels
and gold work. In the fourteenth century a Gothic
monstrance (receptacle for the host) was inserted into
the breast so that the relics could be directly viewed.
Finally, in the nineteenth century, the long feet had
to be replaced, almost completely worn away by the
hands of pilgrims.

Golden Virgin, Artist unknown
Gold leaf, wood, precious stones, cloisonné enamel and silver, H: 75 cm / 2 ft 5½ in, Essen Cathedral, Essen

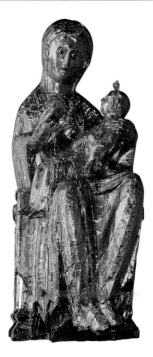

This Virgin and Child statuette was probably produced in Cologne at the behest of Matilda II (AD 949–1011), abbess of the convent of Essen. It is both the earliest surviving statue of the Madonna and the earliest free-standing sculpture in medieval northern Europe, and it occupies a pivotal position in the post-Antique re-emergence of monumental sculpture in Europe.

Dated to c. AD 980–1000, the piece is carved from a single block of wood covered with gold leaf and decorated with jewels and, for the eyes, *cloisonné* enamel. The enthroned Madonna holds an orb, or 'apple of salvation', an attribute of Christ also alluding to the Virgin's role as redeemer. The oversize Christ child sits across her lap in the Late Antique manner rather than in the frontal Byzantine posture. There is a new-found feeling of tenderness between mother and child, despite the stylized rigidity of the modelling.

As granddaughter of Otto I, Matilda ruled over one of the foremost communities of nuns in the Ottonian empire, and this commission may have had political overtones. Matilda was godmother to the infant emperor Otto III, under the regency of his mother, Theophanu, and the powerful Madonna figure could be read as representing support for the divine right of this Byzantine princess to rule in Otto's stead.

Queen Sembiyan Mahadevi as the Goddess Uma, Artist unknown
Bronze, H: 107 cm / 3 ft 6 in, Freer Gallery of Art, Smithsonian Institution,
Washington, DC

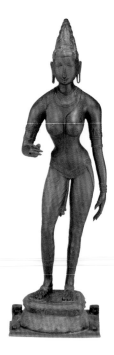

Uma, or Parvati as she is known in northern India, is the consort of Shiva and mother of Ganesha and Skanda; she appears in representations alongside Shiva, or alone. Hindu temples in the Tamil country of southern India often have large collections of bronze images of Uma. The statues, always depicting the goddess as a slender, beautiful woman with full breasts, are carried outside the temple in festival processions, draped in silk, precious jewellery and garlands of flowers.

On this figure from Tamilnadu, the rings on the base of the sculpture are for attaching the bronze to a palanquin, or covered litter. The figure may have held a lotus flower (now missing) in her right hand.

The smooth modelling, restrained ornament and graceful posture are all characteristic of the finest bronze-casting of the Chola period (to the thirteenth century). This image may have been cast as a royal portrait of the renowned Chola queen Sembiyan Mahadevi, who was an important patron of the arts, building temples and commissioning bronzes between AD 941 and 1001. Modelling a portrait on a deity in this way blurred the division between the human and divine worlds.

Archangel Michael, Artist unknown
Gilded silver, enamel, precious stones and pearls, 44 x 36 cm / 1 ft 5¼ in x 1 ft 2 in,
San Marco Treasury, Venice

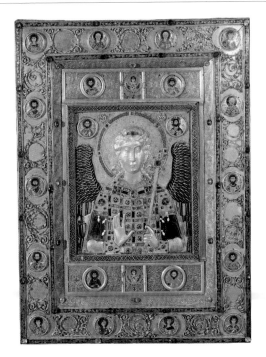

This large portable icon, dating to c. AD 975–1050, may have come from a church dedicated to the archangel Michael in the Great Palace of Constantinople (modern Istanbul), the seat of the Byzantine emperors. Michael and the archangel Gabriel were frequently associated in Byzantine art with imperial grandeur (see also the Council of Archangels, p.275). In the central panel the archangel is depicted frontally in silver gilt wearing a richly decorated *loros*, a majestic gown, and holding a jewelled sceptre. His face is exquisitely fashioned in *repoussé*, raising it from the surface of the image. Above, below and in the frame are a series of enamelled roundels with busts of various saints, archangels, Christ and the Virgin Mary.

The Treasury of San Marco in Venice has a renowned collection of Byzantine metalwork that was brought to the West when Crusaders sacked Constantinople in 1204. This icon is one of the finest examples of Byzantine metalwork that adorned the major churches in the 'Queen of Cities', many of which had imperial patronage. The back is decorated with stamped silver and gilt showing a cross and further images of saints.

Middle Byzantine Period

The monumental *moai* of Rapa Nui (Easter Island) are among the most immediately recognizable Pacific art forms. The preface to the official account of Captain James Cook's third voyage (1776–1780) notes that 'a *feeling imagination* will probably be more struck with the contemplation of the colossuses of Easter Island, than of the mysterious remains of Stonehenge'. The *moai* have inspired a number of modern artists: the Surrealists, in particular, were drawn to the art of Rapa Nui, interpreting it as a direct expression of the unconscious mind.

In fact, these figures represent deified ancestors. They were erected on stone altars, *ahu*, inside ceremonial enclosures that belonged to particular lineages. The typical pose of the figures, with hands framing a rounded belly, is found throughout Polynesian sculpture. Some *moai* wear a red stone cap that may represent a headdress or stylized topknot, as seen here on the second figure from the right. Rapa Nui men, like other Polynesian males, often grew their hair long to signify *mana*, or spiritual power.

Archaeologists believe that the people of Rapa Nui used a system of sledges and rollers to slide the figures down to the coast from the mountains in which the stone was quarried. At the *ahu*, the figure would have been moved onto the platform via a ramp, and then set upright using levers. Many of the figures originally faced inland, to watch over the people.

These four warrior effigy columns supported the ceremonial building atop the pyramidal platform of Temple B in the main plaza of Tula, capital of the Toltec state. They portray Toltec warriors wearing the butterfly pectoral, feathered helmet, tied loincloth and sandals typical of these paladins. The sloping sides of the platform continued the war theme on panels carved with images of eagles and jaguars, probable symbols of Toltec military orders, holding human hearts in their mouths. Separating these panels were frontal portrayals of a human face emerging from the open mouth of a composite monster with bird, jaguar and serpent features – the war serpent icon that first appeared at Teotihuacan in the third century AD.

Toltec culture rose during the ninth century AD to fill the political void created by the demise of once-powerful Teotihuacan, which had previously dominated central Mexico. Although never achieving the same level of political strength and geographic extent, Toltec society nevertheless commanded central Mexico during the early Post-Classic period (c. AD 900–1200) and heavily influenced the Maya of Chichén Itzá in Yucatan. The predominance of war and sacrificial imagery in Toltec monumental art borrows heavily from the iconography of military power developed earlier at Teotihuacan and presages the later Mexica (Aztec) culture that flourished in the fifteenth century.

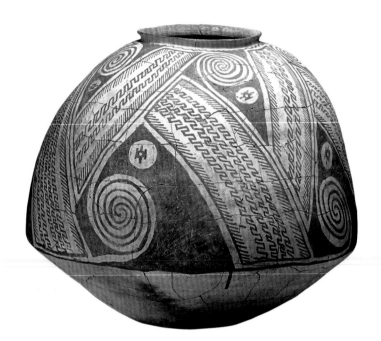

This is an outstanding example of Sacaton Red-on-Buff pottery, which is used by archaeologists to define the Sedentary phase (c. AD 900–1100) of the Hohokam culture. It represents a period of major achievement in the long evolution of red-on-buff ceramics made by peoples living along the Gila and Salt rivers in south-central Arizona.

The brilliantly integrated geometric designs were painted over the buff slip, using powdered hematite to create the red colour. The designs were drawn using a fine brush of local plant fibres. The diagonal bands of the design are outlined by lineal borders that turn into large, complex spirals, balanced by small circles in reserve. The complex rhythms of the pseudo-panels

are repeated five times around the shoulder, extending from the neck down to a carination, or sharp angle, that marks the upper margin of the dish-shaped base. This broad surface is called a 'gila shoulder', an element characteristic of this pottery. This fine vessel is one of the largest known examples of Sacaton Red-on-Buff, with a volume of more than 94 litres (100 quarts).

Altar Front at Basel Cathedral, Artist unknown

Gold and copper on oak, precious stones, pearls and beads, 120 x 178 cm / 3 ft 11¼ x
5 ft 10 in, Musée National du Moyen Âge, Paris

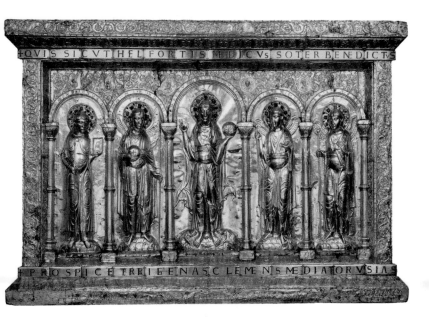

Many altar fronts were made of metal during the
Middle Ages, but very few have survived. The
antependium (altar front) from Basel Cathedral is
an outstanding example stemming from an imperial
commission: made between 1016 and 1019, it was
donated to Basel Cathedral for its consecration in
1019 by Henry II (reigned 1002–1024) and his wife,
Kunigunde, whose diminutive figures can be seen
kneeling at the feet of the central figure of Christ.
He is flanked by the archangels Raphael, Gabriel
and Michael, and by St Benedict, father of western
European monasticism.

The antependium was made using the *repoussé*
technique, in which the relief design is hammered

from the back of the sheet metal. The style is
considered a synthesis of late Ottonian goldsmithery,
characterized by the integration of the decorative
motifs, precious stones and reliefs into an overall
surface pattern. The hierarchic frontality reflects
Byzantine influence, as does the arcade's plain
gold background, a feature that also appears in the
illuminated manuscripts of Reichenau, where this
piece may have been created. The half-relief figures
on stylized rocky mounts are slightly elongated, with
supremely elegant drapery that does little to suggest
the human form beneath. The structural qualities
of this nascent monumental style signal the gradual
transition from Ottonian to Romanesque art.

c. **1030**
India

Chandesha Receiving a Garland from Shiva and Parvati, Artist unknown
Granite, H: c.150 cm / 4 ft 11 in, In situ, Gangaikondacholapuram, Tamil Nadu

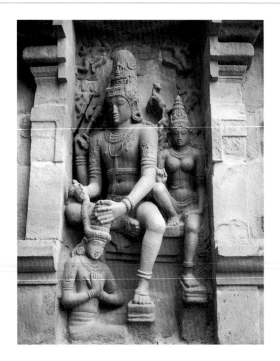

Chandesha was a cowherd and great devotee of Shiva in southern India. He was rewarded for his total devotion to the god by being garlanded and attaining an eternal place alongside Shiva. Chandesha is one among a group of 63 Shaiva poet-saints (*Nayanmar*) who sang in devotion to the god between the sixth and ninth centuries across the Tamil country. Their poetry attained canonical status in Chola-period (to the thirteenth century) temple worship, and their images appeared in the temples themselves.

In this huge wall relief, one of many large Shiva sculptures set in niches that ornamented the exterior of the Gangaikondacholapuram temple, the god wraps a flower garland around the devoted Chandesha's head while his consort Uma (Parvati) looks on. The patron of this temple, Rajendra I (reigned c.1012–1044), was also a devotee of Shiva, and viewers may have identified the king with Chandesha. The temple was built as a victory monument c.1030 at the heart of a new imperial capital named after its patron, the 'City of the Chola who Conquered the Ganga (River Ganges)' (Gangai-konda-chola-puram).

Buddha Shakyamuni, Artist unknown
Ink, colour and gold on paper, 11.6 x 10.7 cm / 4½ x 4¼ in, Cleveland Museum of Art,
Cleveland, Ohio

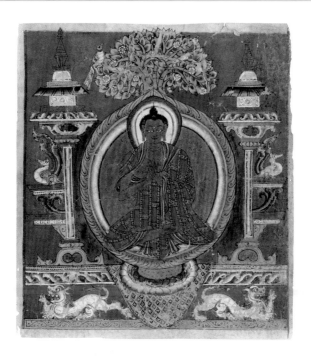

This miniature votive painting from Tholing
Monastery exemplifies the exquisite forms of early
western Tibetan painting, from the eleventh to
thirteenth century. Early in this period, Buddhism
underwent a renaissance in the Tibetan regions after
a period of repression, and one of the results was a
prolific output of Buddhist art. The western regions
of Tibet turned to the neighbouring state of Kashmir
for religious and artistic inspiration, as Kashmir was
one of the last flourishing centres of Buddhism in its
Indian homeland.

In the centre of this painting, in an elaborate
architectural frame, the Buddha performs the gesture
of turning the wheel of law (*dharmachakra mudra*).

Fantastic pairs of lions and swirling plume-tailed
birds accompany him. A pair of reliquaries is perched
on the top of the pillars to either side, and above the
Buddha sprouts a flowering tree, whimsically painted
with a pair of colourful birds of paradise.

Characteristic of early western Tibetan painting,
the colours used here are saturated and sparkling.
Also typical of the style are the tiny facial features
spaced widely in the ovoid face, especially the narrow,
elongated, startlingly white eyes. Movement and
elegance of form are apparent in the way the robe is
draped over and under the right shoulder and arm of
the Buddha, and in the fluid articulation and light
shading of the bared parts of the body.

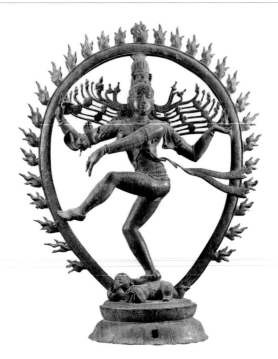

The best-known image of Shiva, indeed the quintessential deity of Tamil south India, is that of Nataraja, the 'Lord of the Dance'. Images of a dancing Shiva are known from other parts of India, but Shiva in the pose of the Dance of Bliss (*ananda tandava*) is a specifically Tamil creation from around the early Chola period (eighth or ninth centuries AD). By the tenth century, Nataraja became a central icon of the Chola dynasty and one of the most exquisite products of the bronze-caster's art.

Dancing in a ring of fire, with his long, matted hair flying from each side of his head, he holds an hourglass drum in one right hand, and fire in one left hand; with his other two hands he offers deliverance and reassurance. In Nataraja's hair is a small figure of Ganga, the personification of the River Ganges, who flows from heaven through his hair; underneath his foot is Apasmara, the dwarf-like personification of ignorance and forgetfulness. This image has been interpreted as representing Shiva's role in the destruction of the universe only in order to recreate it afresh in India's cyclical conception of cosmic time.

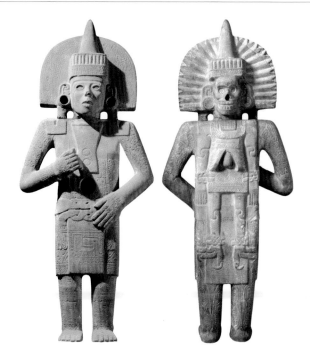

This monumental sculpture is one of the finest stone artworks known from the Huastec people of northern Veracruz; it dates to the early Post-Classic period, c. AD 900–1200. The artist skilfully interwove local aesthetic and iconographic features with those of the powerful Toltec of highland Mexico, the dominant force in central Mexico at this time. Typical of Toltec art is the pose of the figure and the cylindrical head wrap; Huastec features include the fan-shaped headdress and the curvilinear motifs on the body. Such artistic intermingling indicates continued interaction between these cultures, from sometime before AD 100 to its period of greatest intensity in the late fourteenth to early sixteenth centuries.

This imposing yet serene male figure probably held some type of standard or sceptre in his clenched right hand. He wears a conical headdress typical of Huastec ceremonial garb, backed by a half-circle fan of crenulated cloth or paper. Two discs of black obsidian (volcanic glass) embellish his ear spools, and a larger disc is inlaid into his abdomen, perhaps representing a divination mirror or opening to the spiritual realm. His clothing and body are adorned with intricate incised designs. The rear of the sculpture (right) features a skeletal head and smaller skeletal body suspended down the back of the front-facing human figure. The significance of this monumental work of art eludes current research.

In the era when Chinese landscape painting finally came of age, this is one of its best-known examples and arguably one of the most influential on future generations of artists. Through its mixture of the solid and the intangible, the visible and the hidden, Guo Xi (c.1020–1090) recreated a sense of the complexity and depth of nature that he loved and of which he was in awe. Using no more than brush, ink and water, he conjured up pine needles of the deepest black and swathes of pale grey, drifting mist. Human beings and their artefacts take up their insignificant places amid the enormity of mountains, waterfalls, boulders and tall trees. The twists and turns of Guo's shifting style set new standards for realism and beyond, stirring the viewer's imagination as he had argued in his essay *Lin quan gao zhi* (*Lofty Ambition of Forests and Streams*) that the best pictures should do.

In that same essay, Guo had written of using a dominant mountain, such as the one he paints here, to symbolize the authority of the emperor. *Early Spring*, with its implications of new beginnings for both himself and the Chinese state, was painted during a time when Guo's patron, Emperor Shenzong (reigned 1067–1085), backed the novel policies of his reformist prime minister Wang Anshi. It is an optimistic picture of (ultimately unrealized) social harmony under benevolent autocracy.

Bayeux Tapestry, Artist unknown

Wool and linen, 0.5 x 70.4 m / 1 ft 7¾ in x 230 ft 11¾ in (total), Centre Guillaume le Conquérant, Bayeux

The Bayeux Tapestry (c.1066–1082) is not technically a tapestry, but an embroidery of coloured wool on a linen backing. It recounts the events surrounding the Norman conquest of England in 1066, and it is believed to have been commissioned by William the Conqueror's half-brother Odo, Bishop of Bayeux, given the flattering portrayal and prominent role he is given in the tapestry. After the conquest, Odo was made Earl of Kent, and the tapestry may have been designed and stitched there. Anglo-Saxon needlework, or *opus anglicanum*, was famed throughout Europe at this time, and the embroidery workshops of Canterbury and Winchester are both strong candidates; some scholars, on the other hand, favour Normandy in France. The artisans employed in such workshops were Anglo-Saxons, Normans and Bretons, both men and women from secular as well as religious backgrounds.

The tapestry has been held in Bayeux Cathedral, built by Odo, since at least 1476 and may have been completed for its consecration in 1077. Nevertheless, many argue that it was intended for a courtly audience and was once housed in a secular setting, perhaps a banqueting hall. This scene depicts Bishop Odo saying grace at the feast before the battle, and Duke William in discussion with Odo and his brother Robert, Count of Mortain.

This western Tibetan Buddha performs the gesture of touching the earth with his right hand (*bhumisparsha mudra*), recalling the moment when the historical Buddha Shakyamuni called upon the earth to witness his enlightenment; his left hand rests in his lap in the gesture of meditation (*dhyana mudra*). The Buddha's curls are painted with blue pigment, and the decorative element that emerges from his headdress is painted gold; such colouring of statues is common in Tibet. This sculpture was clearly revered, since it also acts as a reliquary, with relics sealed inside.

In an Indic tradition that traces its origins to Gupta-period (c. AD 320–550) art, the Buddha's upper garment moulds itself to his smooth, full body.

The influence of the art of eastern India of the Pala period (c. AD 800–1200) is shown in the square face and the dip in the eyelids, and the definition of the abdominal muscles is characteristic of medieval Kashmiri art. While interactions between different strains of Indic cultures were constant and variously manifest in western Tibetan sculpture, this piece nevertheless is unusual and not easily categorized.

Landscape Screen, Artist unknown
Colour on silk, 150 x 43 cm / 4 ft 10 in x 1 ft 5 in (each panel),
Kyoto National Museum, Kyoto

During the middle years of the Heian period
AD 794–1185, after centuries of Chinese influence, the
Japanese began to express native preferences in culture
and the arts. This six-panel screen, from c.1050–1100,
represents an important stage in the process of
cultural self-definition as it affected painting.

The foreground depicts an elderly Chinese
gentleman seated in front of a thatched hut. He
is holding a writing brush but his gaze is directed
behind him as if suddenly caught by the beauty of the
landscape. Tradition identifies him as Bo Juyi (AD
772–846), one of China's greatest poets and a
literary figure well studied in Heian court circles.
Young Chinese officials are shown waiting nearby,
perhaps hoping the master will spare a moment
for consultation. This Chinese-style foreground
is balanced by the distinctly Japanese style of the
background: a depiction of a bay flanked by low, pine-
covered hills. The season is late spring, with cherry
blossoms and wisteria in full bloom. This idyllic
world, with small birds perched on rocks and ducks
paddling in a stream, represents a rare, early example
of *yamato-e*, or Japanese-style painting.

The usual Japanese art term for landscape is
sansui ('mountains and water'), but at some point
in its history this screen became incorporated into
esoteric Buddhist ordination rituals, leading to its
identification by the specialized variant term, *senzui*.

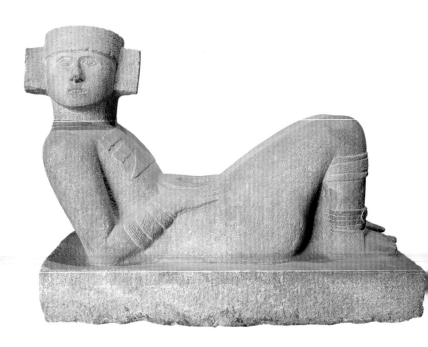

This reclining figure, cradling an offering dish on his abdomen, portrays an elite personage. His status is signalled by the jadeite jewellery that encircles his knees, hanging around his chest and embellishing his cylindrical headdress; his large earspools and elaborate sandals are those of the Maya nobility. The early Post-Classic period figure, dated to c.1000–1200, resembles the many sculpted renderings of Chichén Itzá warriors on pillars and doorjambs of ceremonial buildings in the heart of the city. The monumental impression of this relatively small sculpture comes from the sense of massiveness of the original block of stone from which the figure was carved (compare Moore's *Recumbent Figure*, p.463).

Reclining male figures with offering dishes were called *chac-mool* by the nineteenth-century French archaeologist Désiré Charnay, who undertook extensive excavations at Chichén Itzá, where he was the first European to see these singular sculptures. Charnay interpreted the reclining figures as royal portrayals and therefore called them by a term he thought meant 'Tiger King'. Although incorrect, the term now refers to all sculptures of this form, which originally functioned as figural altars for receiving offerings, especially human hearts and small animals, during religious rites with political overtones.

Bodhisattva Guanyin, Artist unknown
Wood, gesso, mineral pigments and gold, H: 98.43 cm / 3 ft 2½ in,
Minneapolis Institute of Art, Minneapolis, Minnesota

This exceptional wooden statue from the northern part of China represents the bodhisattva Guanyin (known as Avalokiteshvara in India, Chenrezig in Tibet, and Kannon in Japan). Guanyin was, and still is, one of the most widely worshipped of South and East Asian deities. Generally regarded as female in China, though depicted as male elsewhere, she is the goddess of mercy and special protector of women and travellers.

Carved in sections and then joined together under the Northen Song dynasty (AD 960–1126), this statue has lost the gilt crown that once covered the bodhisattva's sumptuous hairstyle, but the crystal still shines from her eyes and enough remains of the gold leaf and mineral pigments to show the original splendour of her clothing. She sits in the lotus position and her hands form the *vitarka* ('debating') *mudra* (ritual hand movement). A gentle smile conveys her soothing sense of compassion, notwithstanding the richness of her clothing and jewellery, which befit her status as a divinity.

c. 1108
Spain

King David as Musician, Master of the Platerías
Granite, H: c.162 cm / 5 ft 4 in, In situ, Santiago de Compostela Cathedral

This masterful statue of King David as a musician, from the south portal of the cathedral of Santiago de Compostela, in northeast Spain, illustrates the episode in which David plays his lyre to King Saul and calms the evil spirit afflicting him. The early Romanesque style seen here is sometimes referred to as the 'plaque style' because of its resemblance to the rather flat Carolingian and Ottonian ivories (see, for example, St Gregory with the Scribes, p.190), and the image of the Greek lyre itself is based on Byzantine miniatures and ivories. Here, however, the sculptor endows the figure with a new, greater relief and more fluid modelling in a mature Romanesque style. The cross-pollination of ideas in the region is evident in

the borrowing of the distinctive cross-legged pose from the façade of St Sernin in Toulouse.

The cathedral was the culmination of one of the major pilgrimage routes of the Middle Ages, and its statuary reflected the wealth and status of the religious centre for which it was made. The exchange of artistic ideas across the Pyrenees at the time has led to great debate over the relative roles of French and Spanish artists in Romanesque innovations. Stonemasons were itinerant craftsmen, and sculptors from Jaca, Loarre, Toulouse, Moissac and Conques may have been assembled to work on the second stage of the great cathedral around 1100.

Creation and Temptation of Adam and Eve, Master Wiligelmus
Marble, H: c.91 cm / 3 ft, In situ, Modena Cathedral

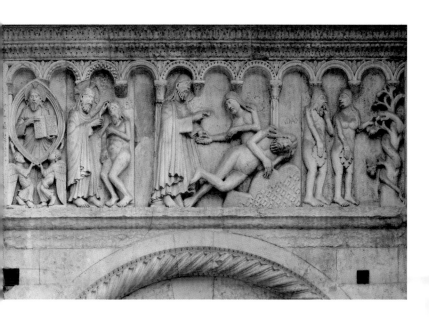

By the beginning of the twelfth century, the new artistic language of Romanesque sculpture, begun in northern Spain, Lombardy and southern France, had developed a mature representational sophistication. Romanesque sculptors frequently borrowed motifs and composition from antique sculpture, and here we see the re-emergence of the horizontal frieze with narrative scenes running from left to right. (For an ancient Roman version see Trajan's Column, p.138.) Here on the lintel of the west façade of the cathedral, the biblical episodes taken from the Book of Genesis have broken through the barrier of the architectural arcade to create a continuous narrative. The solid, squat figures are no longer in low relief but deeply cut, some almost in the round. They exhibit human emotions and reactions: one can see Adam's look of recognition when he bites the apple in the Expulsion scene (right). The sense of dramatic movement and the use of gesture have a theatrical quality, and it has been demonstrated that the frieze relates specifically to a contemporary liturgical drama, *The Play of Adam*.

Master Wiligelmus, the creator of the Modena cathedral sculptures, is considered the first great artistic personality in Italian sculpture. The new social status awarded the artist is evident from the epigraph on the façade of Modena Cathedral, which reads: 'Your sculpture, Wiligelmus, now shows how much honour you are worthy of among sculptors.'

Auspicious Cranes, Emperor Song Huizong
Ink and colour on silk, 138 x 51 cm / 4 ft 6½ in x 1 ft 8 in,
Liaoning Provincial Museum, Shenyang

The 20 cranes that here circle the southern gateway to the Northen Song (AD 960–1126) imperial palace in Kaifeng show the kind of exact draughtsmanship that can been seen in other paintings by the famous Song spainter-emperor, Huizong (reigned 1101–1125). One of the identifying characteristics of his work was attention to detail: here, the roof of the gate has been drawn with geometrical precision, the birds' plumage is accurately depicted, and the sky is a true blue. Yet overall, design takes precedence over realism. Each bird is a separate study with no complicating overlapping, and together they have been formed by imperial preference into a pleasing pattern. First, though, a contemporary Chinese viewer would have been struck by the picture's message. Cranes were birds of good omen, and their appearance on the fifteenth day of the first moon in 1112 prompted the emperor, a believer in portents, to record them here.

Emperor Huizong was a great art collector and benefactor of the imperial Painting Academy, but he was a better artist than politician. Despite the optimism inspired by his trust in Daoism, he so mismanaged foreign policy that Kaifeng was overrun by the Jurchen invaders, who eventually conquered northern China, and he was captured in 1126. Thereafter the capital was transferred south to Hangzhou; the date marks the transition from the Northern to the Southern Song dynasty.

Vladimir Icon, Artist unknown

Tempera on panel, 77.5 x 53.3 cm / 2 ft 6½ in x 1 ft 9 in, Tretyakov Gallery, Moscow

This celebrated icon of the Virgin and Child, dating to c.1100–1125, may have been one of two that are known to have gone from Constantinople to Kiev in the twelfth century. The Virgin tenderly lowers her cheek to the child, who wraps his arm around her neck and nestles to her face. She inclines her head as if in contemplation, while the child looks lovingly at his mother. Extraordinarily graceful and emotively poignant, the icon has been famed and revered for its miraculous powers.

Vladimir, the Kievan ruler, converted to Christianity in the late tenth century on marrying Anna, sister of the Byzantine emperor Basil II; as a result, the early Russian church was strongly dependent on Byzantine models for both painting and architecture. The Vladimir Icon was held as a palladium, an icon thought to ward off evil, and was placed in the Cathedral of the Dormition in the city of Vladimir. Moved to Moscow in 1395, it suffered damage at various times, and cleaning in 1919 suggested that only the faces and a little of the background are original. These remain, however, very fine examples of twelfth-century Byzantine painting.

Jun Ware Bowl, Artist unknown
Glazed stoneware, H: 13.8 cm / 5½ in, Percival David Foundation
of Chinese Art, London

The stoneware of this twelfth-century deep bowl was prepared for firing by the application of an opaque glaze over its entire surface, apart from the foot rim. The glaze thinned around the top edge, giving a translucent effect on firing, but otherwise remained thick, and slight crackling appeared on both exterior and interior surfaces. The unfinished impression left where the bottom hem of the glaze failed to cover the foot was not thought to compromise the aesthetic effect – rather the reverse, and the fact that three spur marks on the inside of the vessel had been rubbed down shows the care with which it had been made. This bowl is proof that utility and artistic beauty could both be appreciated in a single piece.

Jun, which was developed through the tenth and eleventh centuries in the kilns of Henan, Hebei and Shanxi provinces, reached its peak during the reign of Emperor Huizong (reigned 1101–1125). It was one of the great ceramic wares of the Song period (AD 960–1279), and in a rare mark of imperial appreciation Huizong ordered large quantities of it, rather than relying solely on the offerings that kilns routinely sent to the court.

Eve, Gislebertus
Limestone, W: 130 cm / 4 ft 3¼ in, Musée Rolin, Autun

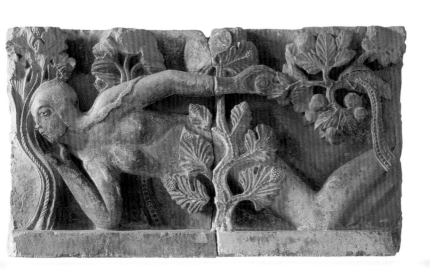

The sculptors of the late eleventh century, called on to build ever more monumental, richly decorated churches and monasteries, began to examine antique sculpture with a fresh eye. Gislebertus (fl. c.1120–1140) probably first worked on the abbey of Cluny in Burgundy, where there were early classicizing trends. He then moved on to the Cluniac church of St Lazare in Autun, constructed under Bishop Étienne de Bage (reigned 1112–1139) and in part inspired by the city's old Roman Porte d'Arroux.

Gislebertus signed the west portal at St Lazare and carved as well the now lost north portal, on the lintel of which was carved this rare large-scale nude of Eve (c.1120–1135). She slithers on her belly like a serpent in search of Adam, calling for him with her cupped hand while reaching back for the apple. The sensitively modelled figure is an embodiment of greed and betrayal, as well as tempting sensuality. Gislebertus's portrayal of Eve is an entirely novel solution to this biblical episode, which uses the imposed format of the lintel to his advantage. The entire iconographic programme of the Romanesque tympanum (the space between the lintel and the arch) provided models for the Christian faithful; on Ash Wednesday the liturgy charged penitent sinners to pass prostrate through this portal, beneath the serpent-like Eve.

The Tale of Genji (c.1010), by Murasaki Shikibu, is often considered the first novel in world literature. Its 54 chapters explore the complex romantic and personal relationships of Hikaru Genji and other members of the imperial court. Artists have depicted the tale countless times over its thousand-year history, but never with greater dignity than in this, the earliest known illustrated version (c.1100–1125). Twenty pictures survive from what originally constituted a set of 10 or more handscrolls with over 150 illustrations. This one relates to the evocative 'Suzumushi' ('Bell Cricket') chapter.

On the night of the full moon, Genji travels with other members of the court to visit the retired emperor, whom he learned in an earlier chapter was actually his son. Along the way, several of the younger nobles celebrate the rising moon with an impromptu concert of flute music. The celebration continues at the retired emperor's residence.

Viewed in the Japanese manner from right to left, the rhythmic sequence of diagonal floor lines seems to carry the sound of the courtier's flute back towards the private room where Genji (beside the pillar) and the emperor (facing the viewer) sit quietly composing poems. The aerial perspective, as though the palace roof had blown away (*fukinuki-yatai*), is a device characteristic of these paintings.

c. **1135**
UK

Bury Bible, Master Hugo
Pigments and gold on vellum, 48 x 26 cm / 1 ft 6¾ in x 10¼ in,
Corpus Christi College, Cambridge

The Benedictine Abbey of St Edmund in Bury
St Edmunds, Suffolk, was one of the largest and
wealthiest religious houses in twelfth-century
England. Abbot Anselm (c.1121–1148) encouraged
the running of its scriptorium (writing room) along
continental lines. The sacrist Hervey (who was
responsible for the general care of the church) paid
for a lavish Bible, dating to 1125–1136, even importing
calfskin from Scotia (Scotland or Ireland) for the
exceptionally large pages.

This exquisite illumination is the frontispiece to the
Book of Deuteronomy and shows two scenes from the
book, framed by symmetrical leaf motifs. The upper
composition depicts Moses and Aaron proclaiming

the Law to the Israelites; the lower shows Moses
pointing out the clean and unclean beasts. The style
exemplifies the strong Byzantine influence that swept
across Europe at the end of the eleventh century. The
interplay of garment and body, with the Byzantine
'damp fold', creates a sense of volume and gives
the figures a rhythmic grace. The more naturalistic
contours and modelling of the faces are also Byzantine
in manner (compare the Alexander Romance, p.258).
Master Hugo was a professional itinerant artist-
craftsman of undoubted versatility, and his title attests
to his respected position. He also created the bronze
west doors of the abbey, a great bell, and a crucifix for
the Monk's Choir.

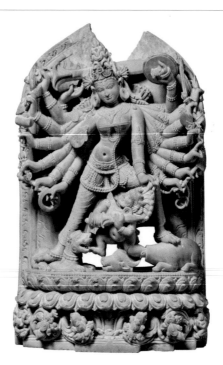

The Pala dynasty of Bengal and Bihar reigned c. AD 800–1200, and while early Pala art was predominately Buddhist, towards the end of Pala rule, as the Hindu population expanded, more Hindu deities were portrayed. Pala sculpture evolved from Gupta traditions (cf. Vishnu Asleep on the Serpent Shesha, p.158) but became increasingly stylized, going on to have an important influence on Tibetan art.

The shape of this stele, which dates from around the twelfth century, is typical of the Pala period, but its diminutive size and the detail and sensitivity of modelling therein make it an exquisite and unusual example of its kind. It depicts the Hindu goddess Durga slaying the buffalo demon Mahisha. Mahisha obtained a boon from the god Brahma that made him invincible to all males, including the male Hindu deities. Unable to vanquish the increasingly powerful and destructive demon, the gods pooled their sacred energies and created the 16-armed warrior goddess Durga to defeat him, giving her their weapons, one for each of her multiple hands. Here Durga has sliced off Mahisha's head, and from the buffalo's neck jumps the squat, true form of the demon. He gazes up in wonder at the fierce beauty of the goddess as she grips his hair and plunges her trident into his chest (now missing), her lion mount biting his toes. Durga stands on the double lotus pedestal typical of the period, its swirling stylized leaves adding to the energy of the piece.

Set in the central dome of the twelfth-century monastic church at Daphni, outside of Athens, this powerful image shows the bust of a mature, austere Christ, with a cruciform halo, grasping a copy of the gospels, his *Logos* or Word. The inscriptions comprise a Greek abbreviation for the name Jesus Christ. This type of Christ figure is known as the Pantokrator, literally 'Ruler over All', the Almighty, and this is the sense felt by the viewer who enters this Middle Byzantine (AD 843–1261) church to find the figure presiding in awe-inspiring supremacy from above.

During the Byzantine period, mosaics moved from the floors, where they were mostly commonly installed during Roman times, to the walls and ceilings.

Characteristic of Byzantine work, the glass *smalti* used here were laid without grout and at slight angles to the wall surface, allowing the reflection and refraction of light through each square of glass. Tesserae were also often backed with reflective gold leaf, to create a further impression of opulence within the church.

The image of Christ is often set in the dome of Byzantine churches, with the Virgin and Child frequently found in the apse (see p.191). Various scenes from the life of Christ and the Virgin were installed in prominent places in the church, and vaults and arches were filled with portraits of the saints.

Deposition of Christ, Artist unknown
Painted wood, H: 158 cm / 5 ft 2¼ in, Musée National du Moyen Âge, Paris

The Gregorian reforms of the twelfth century restored the primacy of Easter celebrations within the Christian Church. Visual images of the Descent from the Cross served to counter heretical ideas denying Christ's death, and the popularity of the theme is attested by a variety of life-size figures from across Europe. This Christ Crucified from Auvergne, made from poplar with traces of polychromy, constitutes a rare example of grand devotional sculpture in wood from the Romanesque era in France.

The expressive quality of the figure dates it to the twelfth century, at the end of the Romanesque era. It would not originally have been seen in isolation, but rather as part of a life-size tableau of

the Deposition. Christ is already dead, his head lolling on his right shoulder, eyes closed. This is no longer the triumphant, majestic Saviour of earlier centuries (as, for example, in the Transfiguration of Christ, p.163), but the suffering Christ, a theme that developed through the Gothic period (twelfth to fifteenth centuries in northern Europe). The right arm is not original and may once have been jointed to allow it to be moved by means of a cord, perhaps as part of a ceremonial re-enactment of the Deposition on Good Friday. The life-size, coloured figures in such spectacles would have offered the illiterate masses a vivid reminder of Christ's suffering and death.

Chancay Female Figure, Artist unknown
Painted earthenware, H: 64 cm / 2 ft 1¼ in, Musée Barbier-Mueller, Geneva

Human effigies such as this female figurine are found frequently in Chancay burials, in the dry deserts of the central coastal region of Peru. The arid climate there has preserved the organic offerings placed with the dead, and these burials have been the focus of looting activities for decades as grave robbers seek out the well-crafted textiles, carved wood sculptures and other perishable objects found in the interments. Pottery vessels and large figural ceramics also accompanied the dead, the nude figures probably originally dressed in clothing appropriate to the function, gender and represented social position of the object. This female, dated to c. AD 900–1400, wears an elaborately woven headband, and the tiny holes at the

top of her head probably held hair or other material denoting head ornamentation.

Chancay ceramicists display a marked sensitivity to the three-dimensional object, successfully portraying the human body as an abstract rendering that remains true to the form's fundamental shapes. These figures typically are depicted in a ritualized pose with attenuated upraised arms and open hands. The head is usually fashioned as a trapezoidal shape flattened at the front and back, perhaps an exaggerated representation of the type of cranial deformation seen on actual skeletal remains, in which the back of the skull was intentionally flattened when the person was an infant to accentuate the facial features.

Secular mosaics re-emerged in the West at the end of the eleventh century, after several centuries during which they had decorated exclusively churches. After their conquest of Sicily, the Norman kings embarked on a lavish building programme that included the installation of mosaics, wanting to conjure up the splendour and sumptuousness of the imperial Byzantine court in Constantinople and importing Byzantine mosaicists for the task.

This mosaic covers one of the walls of the Chamber of Roger II, actually completed during the reign of his son William I (reigned 1154–1566), in a remodelled Arab palace. It shows a hunting-inspired scene with pairs of animals, mythological centaurs and exotic trees set against a gold background. It would have reflected the menagerie in the gardens visible from the windows. Roger's court was a melting pot of Greek, Norman and Arabic cultures, and his critics even referred to him as the 'baptized sultan'. Although the motifs as seen here may have been inspired by antique mosaics and paintings, the design reflects the strong influence of Islamic art, particularly the 'Umayyad art of northern Africa. The mosaic decoration of Norman Sicily was to have enormous influence on Northern European artists, particularly those working in England and Germany.

1164
Japan

Taira Dedicatory Sutra, Artist unknown
Colour, gold and silver on paper, 25.8 x 28.8 cm / 10 x 11 in,
Itsukushima Shrine, Hiroshima

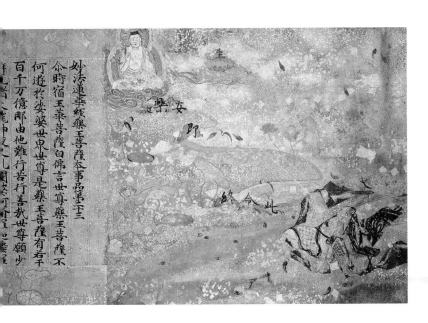

As leader of the most powerful family in western Japan, warrior Taira no Kiyomori (1118–1181) decided in 1164 that his recent military triumphs called for a gift of thanks to the clan's tutelary deity. He commanded his sons and chief vassals each to copy on to the most lavish paper available a scroll from the *Lotus Sutra* and other key Buddhist texts. The scrolls were then fitted with richly decorated frontispieces and covers and presented to the Great Shining Deity of Itsukushima Shrine, the Taira clan's protector.

This frontispiece to chapter 23 of the *Lotus Sutra* exemplifies the project. It shows a lady dressed in colourful court robes and seated on the golden shore of a flourishing lotus pond. The air around her is aglow with clouds of gold and silver foil. Three golden beams of light touch her, and she turns, suddenly aware of the presence of Amida (Sanskrit: Amitabha), the merciful buddha who rules the Western Paradise. Inscribed within the scene is a phrase from chapter 23, promising that for those who hear and practise the sutra's teachings will come a second birth in paradise. The word 'birth' appears inscribed above the lotus blossom floating on a pink cloud, just to Amida's left.

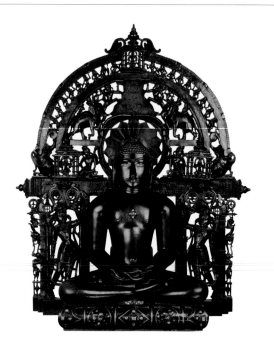

This unusually large altarpiece from western India bears the image of the sixteenth of the 24 *jina*s (Jain saints, 'those who overcome'), Santinatha. He is honoured for having saved and reinvigorated Jainism during an era when it was perilously close to dying out. Santinatha is usually identified by a deer at the base of his lion throne, both of which are missing from this bronze; however, an inscription at the base of this image identifies the *jina* and dates the sculpture to the equivalent of 29 April 1168. The glow of the burnished, dark copper alloy and silver inlay accentuates the beauty of this composition and highlights the smooth, long-limbed, stylized figures that are typical of western Indian sculpture from this era. The perfect

stillness of Santinatha's meditation contrasts with the busy altar, the graceful bend and movement of the flywhisk bearers to either side of him, and the joyously marching elephants and flying celestials.

*Jina*s that are shown seated in meditation with cranial bumps and elongated ears look similar to Buddha figures; however, they bear the mark of a *shrivatsa* (an auspicious diamond-shaped symbol) in the centre of their chests, as does the Hindu god Vishnu, and they typically look straight ahead rather than downwards. Jainism divided into two sects, the Shvetambaras (white clad) and the Digambaras (sky clad). Digambara monks go without clothes, and thus, as in this case, *jina*s may be depicted naked.

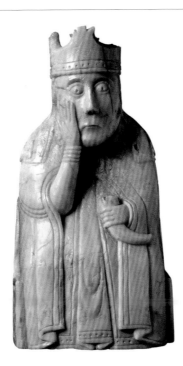

This figure of a queen is one of 93 Scandinavian chess pieces found in a hoard near Uig on the Isle of Lewis, possibly hidden by a merchant en route to a wealthy Norse settlement in Ireland. The Outer Hebrides of Scotland were under the political control of Norway in this period (second half of the twelfth century), and the pieces have been connected with Trondheim, where similar work has been found.

Romanesque art has often been characterized by its quest for monumentality, even in the minor arts, and these figures possess a powerful feeling of weight and volume despite their diminutive size. The short, heavy pieces, full of compressed energy, are reduced to the simplest elements necessary for their identification.

Their abstract regularity and cubic symmetry fuse the earlier Insular or Scandinavian tradition with the conservative elements of Romanesque art.

The carving is handled with great precision and shows a feeling for the ornamental beauty of line and curve, in which everything is subordinated to the overall design. The figures' postures are relatively generic, but they nevertheless possess great wit and character. This queen has a sombre expression highlighted by the concerned hand on her cheek, like the other seven examples of queens in the hoard. She differs, though, in being the only figure shown holding a drinking horn.

Romanesque Style

c. **1190**
Iran

Freer Beaker, Artist unknown
Enamelled ceramic, H: 12 cm / 4 in, Freer Gallery, Smithsonian Institution, Washington, DC

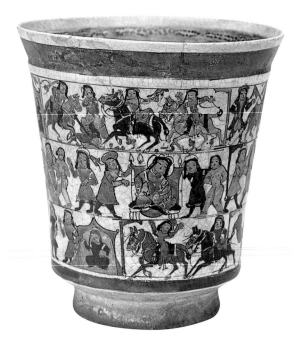

By adopting a new fabric for the body of their pots, called stonepaste or fritware and made of a mixture of ground quartz and white clay, potters at Kashan in central Iran during the late twelfth century ushered in a burst of creative activity unparalleled until the rise of Staffordshire pottery in eighteenth-century England. They decorated their finely thrown or moulded shapes in various ways, the most expensive of which were two overglaze techniques – lustre (see the Lustre Mihrab, p.250) and enamelling (Persian: *minai*).

This enamelled beaker, brilliantly painted in blue, green, red, black and white over a transparent glaze, is one of the most elaborate and curious examples of this method of decoration. It is decorated with three

registers that illustrate scenes from the ancient love story of the Iranian hero Bizhan and the Turanian princess Manizha. The story is best known from Firdawsi's epic poem, the *Shahnama*. Manizha and Bizhan meet while out hunting. Their tryst is discovered and Bizhan is thrown into a pit, sealed with a boulder, to be rescued later by the hero Rustam.

The 12 incidents on the beaker differ slightly from the written version and were probably adapted from an oral tradition. In order to follow the story, the user needs to turn the beaker in the hands. The images probably served as mnemonic devices, encouraging the drinker to recite the poem while consuming the contents of the beaker.

c. **1190**
UK

Paris Psalter, Artist unknown
Pigments and gold leaf on vellum, 48 x 32.5 cm / 1 ft 7 in x 1 ft ¾ in (folio),
Bibliothèque Nationale, Paris

The Paris Psalter, widely considered the finest example of English twelfth-century illumination and dated to 1180–1200, is the last of three psalters from Christ Church, Canterbury, to depend on the imagery of the ninth-century Utrecht Psalter, produced in the most influential of the Carolingian court schools. The Utrecht Psalter and other Anglo-Saxon illustrative sources employed a line drawing style, and the artist's handling of space is similar here, although the parchment surface is entirely painted, with gilded backgrounds and faces fully modelled in a Byzantine manner. The artist's imagination has also taken him beyond his prototypes to depict many scenes in a novel manner of outstanding pictorial subtlety.

This page, the illumination to Psalm 1, shows Christ (centre top) indicating to a man the path of the good to his right – represented by the book of law and the fruitful tree – and the path of evil to his left, with the chair of pestilence and the mouth of hell. The style employed is not found in any other Canterbury school manuscripts, and it is possible the illuminations were created by an itinerant secular artist. The quality of execution and the expense of the full-page illustrations suggest that the psalter was a royal commission, and strong comparisons have been drawn with stained glass windows in Canterbury Cathedral.

Sometime between the mid-twelfth and early thirteenth centuries, a Japanese master draughtsman and two other inventive artists produced a group of handscrolls that must count among the liveliest comic allegories known – the so-called *Choju-jinbutsu giga* (*Humorous Pictures of Animals and People*). Most famous are the first two scrolls, which depict frogs, monkeys, rabbits and other animals engaged in a festival procession and the boisterous pursuits of a holiday outing.

The section illustrated here may originally have been positioned at the head of the extant portions of scroll A, the first in the group. At the right, a monkey foot-solider, dressed in armour of oak leaves and an overturned lotus-leaf helmet, appears to be escorting another monkey, who is dressed in a court hat and carries a sprig of wisteria, as though bearing an offering to a temple. The frog at the far left provides this simian 'official' with the shelter of a lotus-leaf umbrella. The fluid calligraphic lines demonstrate complete mastery of the brush.

Guan Ware Vase, Artist unknown
Glazed stoneware, H: 27.5 cm / 10¾ in, British Museum, London

This superb vase is of dark stoneware with a high iron content. Several layers of glaze were applied, and firing in a reducing atmosphere has produced a pale grey surface with an attractive light brown crackle and an unglazed foot rim of dark brown.

Song dynasty courts ordered fine ceramics from the top commercial kilns for use in sacrificial rites, so in one sense it can be argued that pieces of Ding, Ru or Longqüan ware, so commissioned, may all be described as 'official' (*guan*). In the first half of the twelfth century, however, new kilns were established to produce ceramics exclusively for the court in Kaifeng (capital of the Northen Song, AD 960–1127) and later in Hangzhou (capital of the Southern Song,

1127–1279), the last established after the exiled court had settled into its new home.

There were two centres in Hangzhou. The location of the first, known as Xiuneisi, is still undiscovered but was somewhere near the imperial palace; the second was further away, near the Suburban Altar, and acquired the title Jiaotanxia. The output of these kilns is known specifically as Guan and is of the very highest quality, characterized by the thinness of the body, smoothness of surface texture, careful control of the decorative crackle, and colours ranging from blue and green to grey.

Vajra Defender , Attributed to Jokei
Wood, clay, crystal and pigment, H: 150 cm / 5 ft 1 in, West Golden Hall,
Kofuku-ji Temple, Nara

The powerfully integrated form of this *kongo rikishi* (Vajra Defender), attribted to Jokei (fl. 1184–1212), is a hallmark of the influential Kei school of Buddhist sculptors, which rose to prominence during the early Kamakura period (1185–1333). Based in the ancient capital city of Nara, the Kei artists enjoyed access to important examples of eighth-century Japanese Buddhist sculptural realism, along with more recent developments in the art of Song-period China (AD 960–1279). As here, their sculptures often feature glinting eyes made of inset crystal, which bring the figures to life.

For nearly 20 years, the Kei school mainly worked on replacing religious sculptures lost to arson during the civil war of the early 1180s. Particularly active in this area were Kokei, credited with organizing the school, his son Unkei, and Unkei's disciples Kaikei and Jokei. The shared syllable 'kei' in their art names is a customary Japanese way of showing affiliation with a mentor. Affiliation, however, still allowed for individual development. The naturalistic style of this figure and the textile patterns on the cloth around the waist suggest that Song Chinese art had a somewhat greater impact on Jokei than on his colleagues. The piece is dated to around the turn of the thirteenth century; the pigment was not applied until 1288.

Proto-Dogon Pendant, Artist unknown
Bronze, H: 9.6 cm / 3¾ in, Musée Barbier-Mueller, Geneva

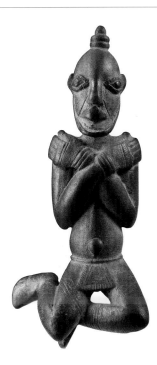

This figural pendant with its formal gesture of crossed arms is closely related stylistically to works from the Djenne region (see the Equestrian Warrior, p.199), as is apparent in the bold projecting facial features and topknot. The site of ancient Djenne is located some 145 km (90 miles) from the Bandiagara escarpment that is home to the Dogon, and the Dogon and their precursors may have been involved in exchanges with Djenne's network of traders and craftsmen. These trans-Saharan trade networks were the conduit whereby copper from Spain, North Africa and the Sahara arrived in urban centres of the Western Sudan.

Throughout the Western Sudan in societies such as that of the Dogon, most sculpture was traditionally created by blacksmiths, who worked in wood as well as metal. Given the complexity of the technology that they commanded, smiths were generally members of a highly respected hereditary caste. The intimate scale and exceptional artistry of this work, dated to the twelfth or thirteenth century, suggests that it was the property of a notable personage who wore it as a personal pendant in the belief that may have had amuletic properties.

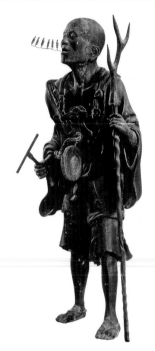

Civil war during the late twelfth century sparked a religious crisis among the people of Japan. Whereas military leaders and princes could accrue good karma by founding temples and commissioning icons and copying sutras (canonical Buddhist scriptures), the common person seemed without recourse to ensure rebirth in paradise. Preachers of the Pure Land (Jodo) sect taught, however, that Amida (Sanskrit: Amitabha), the Buddha of Infinite Light, required only one thing to grant the believer a glorious rebirth: the faithful chanting of the phrase *'Namu Amida-butsu'* ('Hail to Amida Buddha'). This phrase, known as the *Nenbutsu* ('remembering the Buddha'), had formed part of Japanese Buddhist practice for

centuries, but the itinerant Japanese priest Kuya (AD 903–972) singled it out as the key to salvation. He wandered from village to village, dressed in a simple black cloth robe, striking a metal gong suspended from his neck and chanting the *Nenbutsu*.

This imagined portrait by Kosho (fl. c.1200) is a gripping recreation of Kuya's evangelical zeal. The energy of the figure appears entirely concentrated on chanting the blessed phrase, usually written with six Chinese ideographs and here represented by the six miniature figures of Amida issuing from the priest's mouth. The portrait's realism, including the lifelike effect created by the inset crystal eyes, is characteristic of work by sculptors of the Kei school.

Early Kamakura Period, Kei School

Ashmole Bestiary, Artist unknown
Tempera on vellum, 27.5 x 18 cm / 11 x 7 in, Bodleian Library, University of Oxford, Oxford

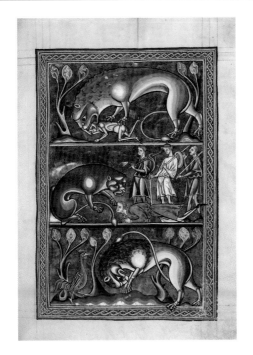

One of only a few full-page illuminations in the Ashmole Bestiary, this three-part representation of the lion illustrates the animal's traditional characteristics. Its young were still-born, and after three days the male lion roared the cubs to life, an obvious symbol of Christ's resurrection. The lion showing compassion to the prostrate and its fear of cockerels provide more general social conduct lessons.

A bestiary is a compilation of descriptive texts on all manner of animals, both real and imaginary. Such books were not meant to be scientific, and equal weight was given to fantastical legends and accurate details. Their purpose was to provide allegories of the natural world, relating it to Christian teachings through morally and spiritually instructive texts. Entries were often accompanied by illuminations that seem at times playful or humorous in nature.

This exceptional example of a bestiary, beautifully coloured with distinctive white highlights and glowing, gilded backgrounds, may have been made in Peterborough around 1200–1210. The natural settings and the animals within them are particularly stylized. There are descriptions of over 100 animals, prefaced – unusually – by the story of Creation. The lion, king of beasts, was considered closest to Christ and was normally the first entry. It was traditionally endowed with three characteristics, which here cover one of the few full-page illuminations.

c. **1205**
China

Pure Distance of Mountains and Streams, Xia Gui
Ink on paper, 47 x 889 cm / 1 ft 6¼ in x 29 ft 2 in, National Palace Museum, Taipei

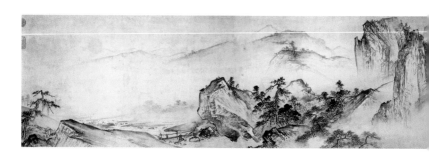

This landscape, a section of the most famous handscroll painted by Xia Gui (fl. c.1180–1224), demonstrates his total mastery of ink to convey both proximity and distance, solidity and space, darkness and light. Like Ma Yuan, with whom he is commonly linked in the so-called Ma-Xia School (see *Landscape in Moonlight*, p.246), Xia makes extensive use of graded depths of ink wash to lead the viewer forward into receding mists. His mood is soft, and at close quarters the dampness of his rain-laden scenery can be cloying. In contrast, when it comes to the angular overhang and sharp ledges of nearby rock formations and the sharp silhouettes of pine trees, his brushwork has been described as bold and fiery, almost violently

expressionistic. He commands, even more than Ma, the thrusting 'axe-cut' (*cun*) strokes first associated with Li Tang (c.1050–1130) to pile up massive cliffs, and uses the most delicate of brush-tip lines to lead in the tiny human figures (seen here in the far left corner, in front of the small building) who make occasional appearances in the *Pure Distance* scroll.

Both Ma and Xia worked in the Hangzhou Academy of Painting, where their concern for a high standard of technique is said to have laid the groundwork for the later Zhe school (see *Pheasants and Hibiscus*, p.302).

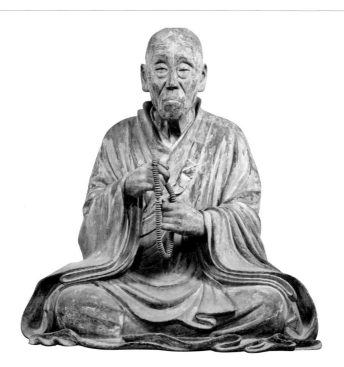

This starkly realistic portrait of the priest Shunjobo Chogen (1121–1206), thought to have been produced shortly after his death, conveys his unshakeable Buddhist faith, as he sits holding a string of prayer beads. His presence is conjured in the smallest details, such as the forward thrust of the head, the firm-set mouth and one eye being opened slightly wider than the other. The layers of heavy priest's robes appear to drape naturally around his aged frame.

During the early part of the Kamakura Period (1185–1333), Japanese art and architecture underwent a profound change that owed much to the efforts of Shunjobo Chogen. He was neither an artist nor a sculptor, but a tireless administrator driven by

religious belief. In 1181, he was appointed to head the reconstruction of Todai-ji and Kofuku-ji, the country's two most important temples, destroyed by arson the previous year. Chogen was already 60 at the time, but he immediately began to travel throughout the provinces, soliciting donations. He also commissioned the Kei school artists (see the Vajra Defender, p.240) to replace the wooden sculptures that the temples had lost, probably encouraging them to work in a synthesis of ancient Japanese and more recent Song Chinese (AD 960–1279) realist styles. He lived to see his efforts completed in 1203.

Early Kamakura Period, Kei School

Landscape in Moonlight, Ma Yuan
Ink and light colours on silk, 150 x 78 cm / 4 ft 11 in x 2 ft 6¾ in,
National Palace Museum, Taipei

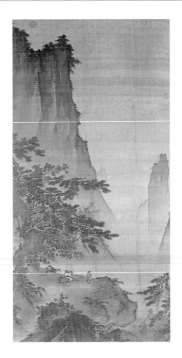

A gentleman, seated at a low table, is toasting the moon. He has been described as a hermit, though a hermit would scarcely have had an attendant standing by, as this man does, and the theme is one that would have struck a chord with any scholar, not necessarily the eremitically inclined. There are few elements in the picture – just rocks, trees and figures.

Ma Yuan (fl. c.1190–1225) was one of China's greatest landscape painters, and almost 150 extant pictures are attributed to him. This is a typical example of his atmospheric style, dated to c.1190–1224. Starkly defined escarpments appear frequently in his mountain scenes, but in this picture he transmutes the almost bare, vertical cliff drop that he often used

as a background device into a diagonal line dividing the surface into sections. To its right is empty space, characteristic of painting by the artist dubbed from the fifteenth century onwards as 'one-corner Ma'. It was, so to speak, positive emptiness, supplying a sense of distance and encouraging the viewer to imagine for himself what lay beyond the mist. It was not really the scholar in the painting whose view of the scenery mattered, but the scholar viewing the painting itself, and the interpretation he put on it.

Tree of Jesse, Artist unknown
Tempera on panel, 27.8 x 8.7 m / 91 ft 2½ in x 28 ft 6½ in,
In situ, Church of St Michael, Hildesheim

The painted ceiling of St Michael's Church in Hildesheim is composed of lime-casein tempera on 1300 individual oak boards and covers 250 square metres (c.985 sq. ft.). Such church decoration was once common, but this is now one of only two remaining instances of such a work in central Europe, the other being in St Martin's Church, Zillis, Switzerland. The main panels show the Tree of Jesse: Christ's earthly genealogy from Adam and Eve, through Jesse and the four kings to Mary and Christ himself. Flanking these scenes are the Evangelists, rivers of Paradise and prophets, and busts of Christ's lesser ancestors.

The painting borrows an iconographic programme in painted glass first employed in 1144 by Abbot Suger in Saint-Denis, near Paris, although the scheme is greatly elaborated. While the iconography is essentially Gothic, the Holy Roman Empire was slow to adopt the new French Gothic style. Instead, the High Romanesque of northeast Germany developed into a particular style known as *Zackenstil* ('jagged style'), seen here, with strong colours and voluminous decorative motifs, and marked by drapery with repeated folds and a characteristic zigzag form. While not immune to the influence of the more fluid drapery and forms of the French Gothic, the primary influence was Byzantine art and Sicilian mosaic work.

c. **1220**
France

God the Divine Geometer, Artist unknown
Ink, tempera and gold leaf on vellum, 26 x 34.4 cm / 10¼ in x 1 ft 1½ in,
Österreichische Nationalbibliothek, Vienna

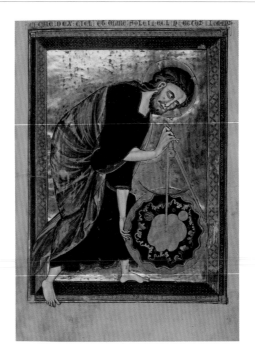

This page is from the earliest surviving and possibly the first *bible moralisée*, a form of picture book in which biblical events were paired with explanatory moralizing scenes, accompanied by short excerpts from the Bible and other religious texts. The elaborate schema, with two columns of four roundels per page, may have been devised by theologians in the Parisian monastic houses of St Germain-des-Prés or St Victor. The volume has over 1000 roundels and is unusual in that the captions are in the vernacular Old French rather than Latin. It has been tentatively connected with the patronage of Blanche of Castile (1188–1252), wife of Louis VIII of France, and has been dated to around 1215–1225.

This full-page frontispiece opens the Book of Genesis and depicts God the Divine Geometer, inscribing the spherical universe with his compass. Unlike other *bibles moralisées*, in which the Creator is depicted enthroned, here he is shown in a more active pose, bending over to complete his task. The act of creation is associated with the technology of artistic production, and by analogy God is the supreme artist. Created in a transitional period between the Romanesque and Gothic styles, the forms have become less strictly linear; curving folds with pronounced shading define God's form.

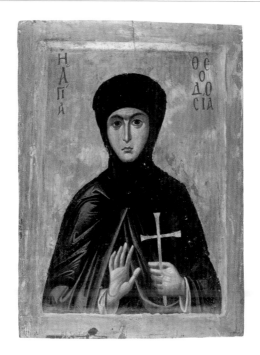

This intense and penetratingly beautiful Middle Byzantine (1204–1261) icon depicts one of the martyrs of eighth-century iconoclasm (the movement for the destruction of icons). St Theodosia's cult did not flourish until the twelfth century, but she was heralded as a fearless defender of icons for defying the imperial troops who had been assigned the task of taking down Christ's image from above the Chalke, the main gateway into the palace in Constantinople. She lost her life in the struggle and is the most significant female saint in the torturous history of iconoclasm. She appears on later icons marking the return of Orthodoxy, which occurred in AD 843. Five icons of Theodosia have survived at St Catherine's

Monastery in Sinai, suggesting the esteem in which she was held at this holy site.

In this painting, dated to the first half of the thirteenth century, Theodosia is dressed in the dark habit of a nun, holding a simple gold cross in one hand. Her face is well defined and intently serious, with a characteristically Byzantine nose, a small, shapely mouth and heavy eyebrows. Her stark form stands out against the gold of the background, on which her name is inscribed in bold red letters.

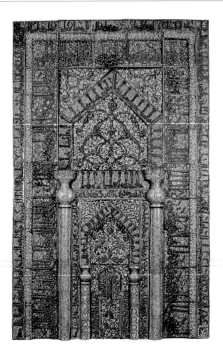

This large mihrab (a niche in the wall of a mosque indicating the direction of prayer towards Mecca) is dated Safar 623 AH (February 1226). It was a key piece in the identification of the style of ceramic painting associated with Kashan, the centre of pottery production in medieval Iran.

The mihrab was removed from the Maydan mosque in Kashan around 1900. One of the largest such ensembles to survive, it is composed of 74 separate tiles creating a series of nested niches. It displays many of the motifs typical of the Kashan style: in addition to moulded inscriptions and arabesque scrolls, the background is filled with dots and minute spirals in white, reserved or scratched out of the lustre ground.

Lustre, one of two expensive overglaze techniques perfected at Kashan (for an example of the other – enamelling – see the Freer Beaker, p.236), was a trade secret known only to a handful of potter families. The stonepaste (fritware) vessel was painted with a mixture made of arsenic, copper, sulphur and other materials, then fired in a special kiln. Quality declined somewhat after the Mongol invasions of 1220, but this ensemble, with its balance between calligraphy and background decoration, lively yet uncluttered arabesque moulding, and crisp but sensitive painting, reflects the artistic and technical achievements of the Kashan potters.

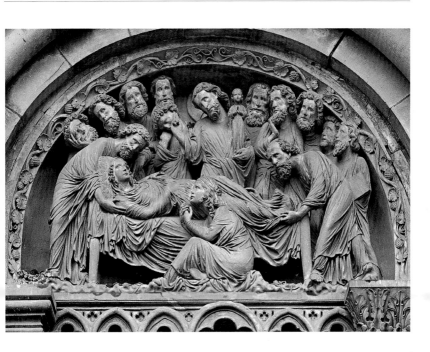

In the thirteenth century, the then-German city of Strasbourg was on the periphery of the Holy Roman Empire and open to northern French influences. Sculptors there, familiar with the art of northeast France, created a new fusion of Germanic and French traditions in a style reminiscent of Chartres Cathedral, possibly through the intermediary of craftsmen who worked at Reims and Sens.

This Dormition of the Virgin (c.1225–1235), on the tympanum of the west portal at Strasbourg Cathedral, has the flowing drapery and the grace of figures seen in Reims. There is a virtuoso attention to detail, particularly evident in the folds of the cloth and the treatment of the hair. The German sculptors were also innovators in their own right, and the relationship of the statuary with its architectural setting is more accomplished than in the French churches. The 12 apostles fan out behind the Virgin and the central figure of Christ, echoing the shape of their restricted setting, their faces soft and melancholic; the composition is both complex and integrated. There is a new-found strength of emotion expressed through a varied repertoire of gestures: the kneeling Mary Magdalene, for example, wrings her hands in grief and agitation. Nevertheless, the proportions and postures of some of the figures still lack a clear grasp of anatomy.

Gothic Style

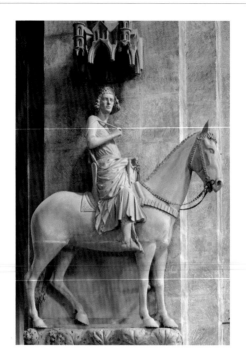

Bamberg Cathedral is a dazzling exemplar of German Gothic sculpture, but it has generated much debate over the nation's artistic evolution and its relative dependence on the sculpture of Reims Cathedral in France (on the influence of Riems, see also the Dormition of the Virgin, p.251). It is clear from certain elements of drapery and anatomy that one of the chief sculptors of the Bamberg atelier had worked previously in Reims; nevertheless, a new pattern of development emerged in the German town.

Although sculptors in Reims had drawn on Antique motifs, this horse and rider possess a different spirit, a more realistic vision of the world. It is one of the first free-standing sculptures in post-Classical

Europe and the earliest life-size equestrian figure since the sixth century AD. The image of the Roman emperor had traditionally been associated with imposing bronze equestrian statues, and this striking emulation of Classical authority is a notable milestone in the evolution of Gothic art.

Despite the newfound realism of the figure, the identity of the rider remains enigmatic. He clearly portrays a historical figure, and has been variously identified as Constantine the Great, King Stephen I of Hungary or one of the Holy Roman Emperors – Henry II, Conrad II or Frederick II. The work has been dated variously to between 1230 and 1240.

Village Scene, from al-Hariri's Maqamat, Yahya al-Wasiti
Ink and opaque pigments on paper, 35 x 26 cm / 1 ft 1 in x 10 in,
Bibliothèque Nationale, Paris

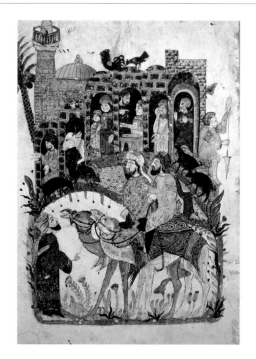

al-Hariri's *Maqamat* ('Assemblies') is the tale of 50 picaresque adventures of a rogue named Abu Zayd of Saruj, as told by the merchant al-Hariri. Its linguistic inventiveness and punning style made it immensely popular among the educated bourgeoisie of the medieval Arab lands, but the verbal pyrotechnics of the text did not readily lend themselves to illustration. Instead, painters focused on another aspect of the text – Abu Zayd's peregrinations across the Islamic lands – and the paintings thereby provide a rare glimpse of daily life at the time.

This illustration comes from the most famous manuscript of the text, a codex copied and illustrated by Yahya al-Wasiti at Baghdad in 634 AH (1237), which is renowned for its lively vignettes. This scene, from the forty-third adventure, shows the two protagonists riding camels in front of a bustling village that includes a market with arched arcades and a mosque with a blue-tiled dome and minaret. Like the hundred other paintings in this remarkable manuscript, this painting provides an open window into life in medieval Islamic times.

c. **1250**
France

St Denis and the Laughing Angel, Attributed to the Joseph Master
Stone, H: c.280 cm / 9 ft 3 in, In situ, Reims Cathedral

The cathedral of Reims is where the kings of France were crowned, and the complex once contained over 2500 statues and statuettes, with over 600 on the west façade alone. The clearest direct imitations of the Antique took place here in the years 1211–1225, but by mid-century a new, more elegant French Gothic style was developing. Jamb figures in the north and central portal, sculpted c.1245–1255, before the western façade was even constructed, illustrate this transition.

The left-hand figure seen here is sometimes identified as the martyr St Denis; he is escorted by an angel who lightly inclines his head and is often referred to as the 'laughing angel'. The latter has been attributed to the Joseph Master, an anonymous figure whose style shows the influence of Parisian sculpture. The sharp facial features and courtly coiffures of Paris are combined with the swirling garments and ostentation of existing sculpture at Reims in a lively and expressive style. The angel is characteristically tall and elegant, with a small head and joyful demeanour. His body has a gentle S-curve sometimes referred to as the 'Gothic sway'. This graceful style was by far the most influential at Reims, inspiring artists through the thirteenth and fourteenth centuries to produce countless sweetly expressive Virgins and angels.

. 1250
Nigeria

Yoruba Female Head, Artist unknown
Terracotta, H: 31.1 cm / 12¼ in, Minneapolis Institute of Arts, Minneapolis, Minnesota

The Yoruba are sub-Saharan Africa's largest ethnic group and were responsible for some of its earliest urban development. Among the tangible traces of the Yoruba past uncovered at the city of Ile-Ife are works in terracotta, stone, copper and brass. Ranging from idealized but naturalistic humanism to severely abstracted forms, the terracottas include almost life-size figures and very small figurines, freestanding heads, animals and figured vessels. These artefacts resonate profoundly with Yoruba accounts of genesis, in which Olodumare, the creator of existence, instructs the divine artist Obatala to model humans from clay. This tradition of sculpting in clay may have developed as early as AD 800, and it ultimately served

as the point of departure for related works that were cast in metal.

This work, dating from the twelfth to fourteenth century, embraces qualities that characterize the tradition at its finest. The delicacy of the subtle modelling of flesh over the facial structure is combined with bold stylization of the almond-shaped eyes, dramatic ridges of the coiffure and deeply incised horizontal creases along the length of the columnar neck. As with the faces of many of the terracotta and cast metal heads from sites throughout Ife, the fine vertical striations may evoke a form of scarification that is no longer found in the region.

c. **1250**
Germany

Uta and Ekkehard of Meissen, Attributed to the Master of Naumburg
Painted limestone, H: c.188 cm / 6 ft 2 in, In situ, West Choir, Naumburg Cathedral

Between about 1245 and 1260, Bishop Dietrich II of Wettin ordered the construction and decoration of the west choir of Naumburg Cathedral. Dietrich was from a noble Naumburg family and had 12 life-size statues of his ancestors, including Uta and Ekkehard of Meissen, erected on brackets on the walls of the new chapel; some polychromy still survives on them. These historical figures were the eleventh-century founding fathers of the cathedral, and their presence was intended to encourage those at Mass to act similarly as benefactors. Associated with pagan idolatry since the Early Christian period, such imposing freestanding statues had only recently begun to be sculpted again. The naturalism and individuality of the German

Gothic figures are unmatched in medieval sculpture, although parallels may be drawn with the sculpture of Bamberg Cathedral (see the Bamberg Rider, p.252). They are not strictly portraits, as those portrayed were long dead; rather, they are idealized likenesses.

The most famous among Dietrich's commissions is Uta, Margravine of Meissen, who stands next to her husband, the Margrave Ekkehard II. The sculptor creates a truly expressive likeness of the cold, haughty noblewoman drawing her cloak up to her cheek. In the twentieth century, Uta was appropriated by the Nazis as the archetype of Aryan perfection, and replicas of her were even paraded through the streets in celebrations of German civilization.

1280

Iraq

Guardian Angels Record the Deeds of Men, Artist unknown
Ink and opaque pigments on paper, 16 x 10 cm / 6 x 4 in,
Bayerische Staatsbibliothek, Munich

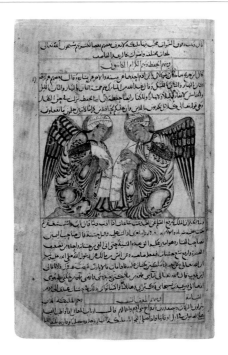

This illustration is from the cosmography entitled *Aja'ib al-makhluqat* (Wonders of Creation) by al-Qazvini (1203–1283), an encyclopedic work that summarizes the literature of the time on astronomy, geography, botany, mineralogy and zoology. This folio comes from the only complete copy of the text known, made three years before the author's death in Wasit, Iraq, the city where he served as *qadi*, or chief judge.

This scene depicts the two angels who record a person's deeds on Judgement Day, the one on the right noting good deeds, the one on the left, evil ones. The wide-ranging and deep-toned colours of earlier manuscripts (see also the Village Scene, from al-Hariri's *Maqamat*, p.253) have been replaced by a more limited palette and a more linear quality achieved by using darker colours to indicate folds. This technique imitates the washes used in Chinese painting, not surprisingly since the manuscript was executed during the period when Mongols ruled Iran and Iraq as well as China; the figures often assume Mongol physiognomy.

The painting is the earliest known representation of scribes at work. Curiously, the angels do not write in codices, the ubiquitous book format in the Islamic lands, but on scrolls, the format used for decrees and documents. The artist appears to have seen these angels as bureaucrats.

c. **1281**
Turkey

Alexander Romance, Artist unknown
Tempera, gold and ink on cotton paper, 33.4 x 24.6 cm / 1 ft 1 in x 9¾ in,
Hellenic Institute of Byzantine and Post-Byzantine Studies, Venice

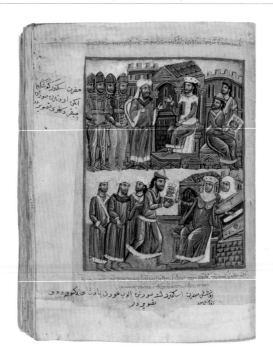

The *Alexander Romance* was an immensely popular story in the Late Byzantine period (1261–1453), based very loosely on the life of Alexander the Great, who was seen as the exemplary ruler and a role model for Byzantine emperors. In the scenes shown here (fol. 143), an artist, seated to the right in the upper register, secretly paints a portrait of the king, who is talking with a visiting official. In the scene below, the artist brings the finished painting to Queen Kondake, who had commissioned it as a gift for Alexander the Great.

The manuscript, which has 250 illustrations, was made around 1261–1300 in Trebizond, the capital of a Byzantine kingdom established on the coast of the Black Sea following the sack of Constantinople in 1204. Its luxurious appearance and references to kingship suggest that the book may have belonged to one of the Trapuzine emperors, perhaps Alexios III Komnenos (reigned 1349–1390).

The dress depicted in the miniatures shows influences from the East and highlights the multicultural nature of Trebizond at the time: turbans like those seen here were worn by Georgians, Armenians and Islamic peoples, the queen and Alexander are in court ceremonial dress, and the artist's hat points to influences from the Latin West. The geographical location of Trebizond and its comparative isolation from Constantinople encouraged interchange with the Islamic states, and with Georgia and Armenia.

Mamluk Flask, Artist unknown
Glass, gold and enamel, H: 43.5 cm / 1 ft 5 in, Metropolitan Museum of Art, New York

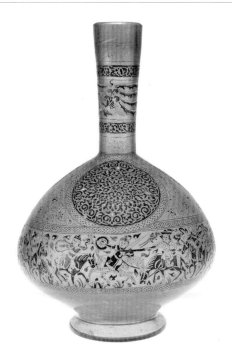

This flask, dating to the last quarter of the thirteenth century, represents the most prized and celebrated type of glassware from the Islamic lands, created by craftsmen in Syria and Egypt during the thirteenth and fourteenth centuries. The bottle was free-blown of colourless, greenish glass, then gilded, then painted with a brush or reed pen in a wide range of bright enamels (red, blue, green, yellow, purple, brown, pink, white, grey-blue and black) suspended in an oily medium. Large, remarkably intact and in very good condition, the bottle is a stunning technical achievement because the gold and varied colours require different temperatures to affix them to the surface. How the glassmakers prevented them from

running together in a single application remains unknown to this day.

The painting is equally astonishing. The main register shows a colourful scene of 14 horsemen carrying shields, bows and other weapons. The mythical bird known as the simurgh (a lion-headed bird) encircles the neck. On the shoulder are three medallions, each with a floral pattern emanating from a central star painted on a brilliant blue ground. The style of painting resembles that found on other enamelled ceramics made in Iran (see the Freer Beaker, p.236), but this type of glass was a speciality of the Mediterranean littoral.

Incense Burner, Artist unknown
Bronze with silver wire, H: 38.1 cm / 1 ft 3 in, Hoam Art Museum, Yongin

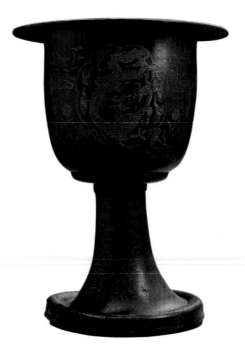

Encouraged by court patronage, Buddhism flourished in Korea during the Koryo dynasty (AD 918–1392). Much of its ritual paraphernalia survives in the form of pottery, metalwork and glassware, none of it more illustrative of the superb craftsmanship of the age than this chalice-like incense burner from the Hung'wang Temple in Kaesong, North Hwanghae Province.

The object was made in two sections, joined together by a flange on top of the pedestal, which fitted into a recess on the bottom of the bowl. Other burners of this kind survive, some bearing inscriptions that name donors and the temple for which they were made, but this is one of only seven dated examples. Koryo potters are famous for developing the special

skill of inlaying their celadon wares with white or black slip, and their fellow metalworkers imitated them, making beautiful bronzes with designs of silver or gold wire inlay. This one is particularly intricate, enclosing patterns of dragons, phoenixes, water birds and plants within four panels.

c. 1290
Japan

New Anthology of Ancient and Modern Verse, Attributed to Emperor Fushimi
Ink, gold and silver on paper, H: 30 cm / 12 in, Freer Gallery, Smithsonian Institution, Washington, DC

Japanese emperors rarely held political power, but instead wielded cultural influence through their mastery of the writing brush. The tradition of imperial court calligraphy originated in the stately yet vigorous calligraphic brushwork of the Middle Heian-period courtier Fujiwara Yukinari (AD 972–1027). His calligraphy is known especially from his transcriptions of classical poems composed in the native 31-syllable form called the *waka*, and written in the fluent native script called *hiragana*. Though often described as a 'woman's hand', *hiragana* has a graceful simplicity that appeals to calligraphers of both sexes. Many emperors worked to advance Yukinari's style, but Emperor Fushimi (reigned 1287–1298), succeeded

beyond those who preceded him by strengthening its calm refinement. Thereafter, calligraphy masters cited his script as the example to follow.

This section of a richly decorated handscroll bears the hallmarks of the emperor's writing. The scroll is a transcription of one of Japan's most important poetry anthologies, the *Shinkokinshu* (*New Anthology of Ancient and Modern Verse*), a collection commissioned by one of Fushimi's imperial forebears. A transcription of this type might have served as a model on ceremonial occasions. The scroll is unsigned, but the attribution to Fushimi was given by Emperor Go-Nara (reigned 1526–1557), a connoisseur and master of calligraphy in his own right.

Lamentation over the Dead Christ, Giotto di Bondone
Fresco, 200 x 185 cm / 6 ft 6¾ in x 6 ft ¾ in, In situ, Cappella Scrovegni, Padua

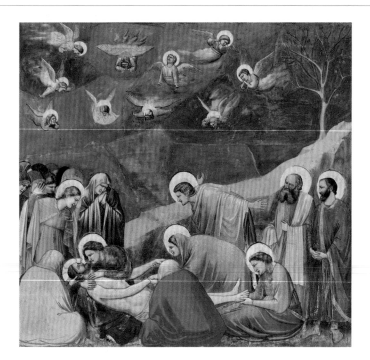

This *Lamentation over the Dead Christ* (1303–1305) is a single episode within the cycle of images painted by Giotto (c.1266–1337) in the Scrovegni (or Arena) Chapel in Padua. Commissioned by Enrico Scrovegni, the son of an infamous usurer, Giotto's fresco illustrates events in the life of the Virgin Mary and narrates the life and ministry of Christ, concluding with an imposing image of the Last Judgement.

Giotto's mastery of technique can be seen in his handling of green undertones, which lend an almost waxy finish to the pallor of Christ's dead flesh as the light from the adjacent south wall windows falls upon the image. This is without doubt a human death.

The upsurge of rock that acts as a backdrop leads the eye on through the cycle, to witness the divine miracle of the Resurrection in the next scene.

Giotto's placement of holy figures within the reality of a three-dimensional space marked a dramatic break with the previous and perhaps more visually remote Byzantine style of art. His images within the cycle for the Scrovegni Chapel would prove highly influential, effectively paving the way for a new artistic movement – the so-called Renaissance or 'rebirth' in Italian art.

Maestà Altarpiece, Duccio di Buoninsegna
Tempera on panel, 247 x 468 cm / 8 ft 1 in x 15 ft 4 in, Museo dell'Opera del Duomo, Siena

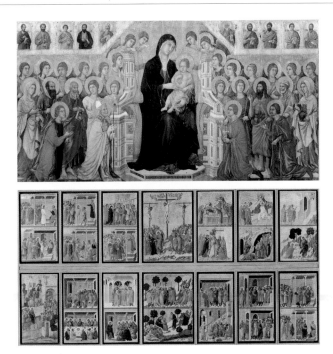

Considered his masterpiece, the *Maestà* (*Madonna Enthroned in Majesty with the Christ Child*; 1308–1311) was commissioned from Duccio (c.1255–1319) by the municipal government of Siena for the city cathedral as a replacement for the iconic panel painting of the *Madonna of the Large Eyes*. The enormous completed altarpiece was carried aloft in ceremonial procession through the streets of the city to its position on the high altar on 9 July 1311, remaining there until 1506.

The front of the altarpiece (top) depicts the enthroned Virgin and Christ Child with attendant saints and angels, surmounted by figures of the Old Testament prophets in the pinnacles. Of the original narrative scenes for the rear of the altarpiece (bottom),

only these 26 from the central section remain. The reconstructed episodes tell the story of Christ's Passion, from the *Entry into Jerusalem* to the *Road to Emmaus*. The division of this narrative into episodes enables Duccio to explore the theme of justice as he recounts in some detail the full import of the trials of Christ. Yet the artist never overplays his hand, demonstrating the Christian message of sacrifice and redemption with delicacy and subtlety.

While upholding Greco-Byzantine traditions, Duccio's altarpiece was also inspired by the French Gothic tradition. Groundbreaking in both structure and design, the *Maestà* is thus a seminal work in the transition to the International Gothic style.

Page from the Holy Koran, 'Abdallah ibn Muhammad ibn Mahmud al-Hamadani
Ink, gold and opaque pigments on paper, 56 x 41 cm / 1 ft 10 in x 1 ft 4 in,
National Library, Cairo

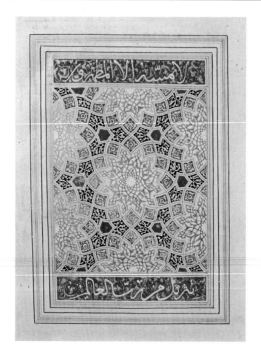

Some of the finest manuscript copies of the Koran were produced in the early fourteenth century for the Ilkhanids, Mongol rulers of Iran and Iraq. These magnificent manuscripts were made in 30 volumes, so that one part of the text could be read aloud each day of the month. They typically comprised a thousand sheets of 'half-baghdadi'-size paper (c.50 x 35 cm / 1 ft 8 in x 1 ft 2 in), with only five lines of large script per page and magnificent full pages of illumination at the beginning and end of the volumes.

The copy from which this page comes, commissioned by Sultan Uljaytu in 713 AH (1313), was transcribed by 'Abdallah ibn Muhammad ibn Mahmud al-Hamadani at his charitable complex in Hamadan, in western Iran; the foundation was endowed by the vizier Rashid al-Din. The manuscript was probably intended for the sultan's tomb at Sultaniyya, and the design of 'carpet pages' like this one bear striking parallels to the stucco vaults in the sepulchre. These designs, which could be reproduced in various media at different scales, attest to the new role of the designer, the pattern and the pattern book in this period.

c. 1313
Russia

St Nicholas Icon, Artist unknown
Tempera on panel, 108 x 79 cm / 3 ft 6½ in x 2 ft 7 in, State Hermitage Museum,
St Petersburg

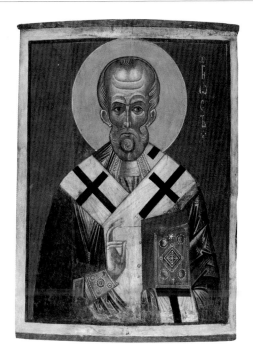

This austere and imposing icon, dated to the first
quarter of the fourteenth century, depicts St Nicholas
positioned with the gospel in one hand, the other
hand raised in blessing. The saint is shown in a
very typical manner for this figure, with a receding
hairline, large forehead and a face marked by age. He
is pictured wearing the dress of a bishop, with a white
omophorion (the brocade band worn by bishops around
the neck and shoulders) embellished with crosses.
The rich red background enhances the serenity of
his features and emphasizes the flat frontality of his
body, characteristic of the Novgorod school of icon
painting. The icon shows the striking stylization of
Russian artists, who adapted shapes into linear flat

patterns, creating a distinct abstraction of design
while nevertheless adhering to the schematic forms
of the body.

Novgorod maintained its freedom from the
Tartars in the mid-thirteenth century and developed
as an independent centre for icon painting with
considerable interchange between the Byzantine
world and Kiev. St Nicholas was enormously popular
in Russia, revered as a miracle-worker, protector
and healer.

Of the four sculpted pillars at the base of the façade of Orvieto Cathedral, scenes from Genesis and the Last Judgement, shown here, have been attributed to the hand of Lorenzo Maitani, an Italian architect and sculptor who established his reputation in Siena. In 1308 Maitani was called on to supervise the construction of Orvieto Cathedral, and two years later he was awarded the title *capomaestro* ('master builder') and worked on the cathedral and other projects until his death in 1330. His most outstanding contribution was the design of the façade.

The sculpted pillars have been called 'sermons in stone', providing a precise doctrinal and eschatological message tracing the story of humanity from its origins

to the end of the world. The designs show a range of influences, including Roman Benedictine models, Antique sculpture and the Franciscan conception of nature. The individual scenes, unified by ascending acanthus leaves, ivy and vines, show a keen feel for linear narrative. The panels are sculpted in a delicate and decorative bass-relief, rich in detail and full of incidental realism. The decorative French Gothic sensibility, common in Siena at the time, is perfectly combined with a powerful handling of anatomy that owes much to earlier Classical models.

c. 1325
France

Hours of Jeanne d'Evreux, Jean Pucelle
Grisaille and tempera on vellum, 8.9 x 6.2 cm / 3½ x 2½ in, Metropolitan Museum of Art, New York

Charles IV of France (reigned 1322–1328) probably commissioned the renowned artist Jean Pucelle (fl. c.1319–1334) to create this lavish book of hours between 1324 and 1328 as a wedding gift for his young wife, Jeanne d'Evreux. The later inclusion of the book in inventories of jewels attests to its exceptional value, and the naming of Pucelle marks a significant shift in the status of the artist.

Despite the remarkably diminutive size of the volume, the figures are endowed with a strong sculptural quality enhanced by the highly unusual use of delicate grisaille (painting using shades of grey) with accents of colour for the illumination. There is a French elegance to the figures, but the animated compositions and convincing sense of space are indebted to Sienese art, particularly the work of Duccio di Buoninsegna. The vivid imagination of Pucelle is evident in the keen observation of the finely handled marginal details or drolleries. Here, an angel within the text supports the Annunciation lodge, and the historiated initial 'D' transforms into a guarded room housing a figure of the queen reading. She is encouraged to meditate on both the joys and the sorrows of the Virgin by the exceptional juxtaposition of full-page miniatures of the Passion and the Infancy of Christ that introduce the devotional hours of each Office.

1333
Italy

St Ansanus Altarpiece, Simone Martini and Lippo Memmi
Tempera and gold leaf on panel, 184 x 210 cm / 6 ft 4¼ in x 6 ft 10½ in,
Galleria degli Uffizi, Florence

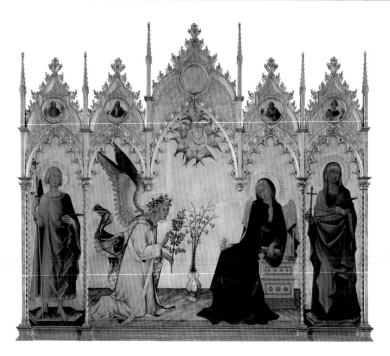

Signed and dated 1333, this painted and gilded altarpiece by Simone Martini (c.1284–1344), created for the chapel of Saint Ansanus in Siena cathedral, depicts the Annunciation, when Gabriel tells Mary that she is to bear the Son of God. Standing to the left and right, the saints – possibly Ansanus and Massima – bracket this central image and are believed to be the work of Lippo Memmi (fl. 1317–1347).

Martini's composition is both opulent and elegant. The viewer is invited to witness the miracle as the archangel Gabriel kneels before the Virgin and speaks the words 'Ave Maria' (Hail Mary), which have been etched in the manner of speech into the surface of the central portion of the panel, together with the date

of the work. The seated Virgin, resplendent in her deep blue mantle, retains her poise as she turns from Gabriel, clasping the robe with her right hand and the Old Testament with her left. Her thumb marks the passage from Isaiah (7:14) that was believed to prophesy the birth of the Christian Saviour. Her pose and gentle blush reflect her humility and chaste perfection, offering guidance to lesser mortals. Indeed, St Bernardino of Siena was prompted to refer to Martini's Virgin during one of his sermons in the cathedral, urging the young women of his congregation to emulate a similar attitude when in the presence of strangers.

Ardawan Captured by Ardashir, Artist unknown
Ink and colours on paper, 41 x 29 cm / 1 ft 4¼ in x 11½ in, Sackler Gallery,
Smithsonian Institution, Washington, DC

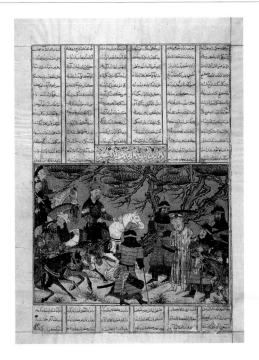

The acknowledged masterpiece of Iranian painting during the rule of the Mongol Ilkhanid dynasty (1256–1353) is the *Great Mongol Shahnama (Book of Kings)*, a two-volume manuscript of the Persian national epic by Firdawsi; the book was presumably made for the last Ilkhanid king, Abu Sa'id (reigned 1317–1353). The manuscript originally contained more than 400 large-format folios with some 200 illustrations, representing an extraordinary range of painting styles and techniques. It was broken up for sale at the beginning of the twentieth century, and today only 58 of its original illustrations are known.

This illustration focuses on Ardawan, last of the Parthian kings, who has been captured by the mounted Ardashir, first of the Sasanian dynasty that was to rule Iran for 400 years before the coming of Islam. The soldier in the centre of the composition, with his back to the viewer, is highly unconventional, and the placing of his foot outside the picture frame lends a three-dimensional aspect to the painting. The large tree in the background is rendered in Chinese style, while the variety of facial features and costumes, especially the hats, on the soldiers and attendants reflects the cosmopolitan nature of the Ilkhanid court.

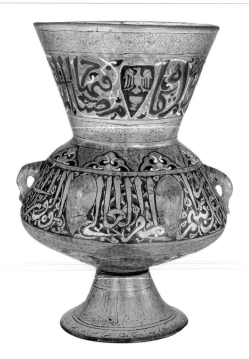

Since the thirteenth century, Syria and Egypt had been major centres for the production of enamelled glass (see the Mamluk Flask, p.259), and under the Mamluks in the fourteenth century, the earlier figural decoration gave way to inscriptions and arabesques, as on this typical mosque lamp. Sultans and amirs commissioned for their charitable foundations hundreds of such lamps, which would have held a small glass container for oil with a floating wick, and were suspended by chains from the ceiling.

This lamp from Cairo has an inscription around the neck painted in blue, referring to the well-known 'Light Verse' (Koran 24:35), which extols God as the light of the heavens and the earth, likening the divine light to exactly this type of lamp. A red shield bears the emblem of the patron, in this case the amir and cup-bearer Sayf al-Din Tuquztimur, whose titles are painted in reserve around the bulbous body. When the lamp was lit, the patron's name and titles would have glowed with divine light, a stunning visual realization of the beautiful Koranic metaphor inscribed above.

1341
Korea

Frontispiece to the Amitabha Sutra, Ch'onggo
Gold on indigo-dyed paper, 22 x 26 cm / 8½ x 10¼ in, British Museum, London

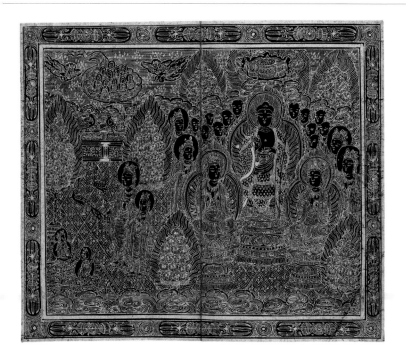

Wealthy sponsors commissioned copies of the great Buddhist scriptures to earn merit and security both for themselves and the state (cf. the Taira Dedicatory Sutra, p.233). The Koryo (AD 918–1392) court created its own Offices of Silver and Gold Letters, where monk-scholars wrote sutras (collections of Buddhist dialogues and discourses) and illuminated them with finely detailed frontispieces reminiscent of the Chinese Diamond Sutra of AD 825 (see p.192). They used gold or silver ink on white, deep blue, purple or yellow mulberry paper, folded like an accordion or rolled horizontally.

This frontispiece, a mid-fourteenth-century example of an illustrated Lotus Sutra, was painted

in gold by a monk named Ch'onggo to honour his mother, and shows Shakyamuni Buddha (the historical Buddha, Sidhartha Gautama) preaching the Amitabha Sutra as two bodhisattvas (one who refrains from or postpones nirvana in order to help others) welcome souls newly arriving in paradise via a lotus pond (bottom left). The Buddha and two bodhisattvas sit to the right of centre, identified by their flaming aureoles and nimbuses. Around them cluster a group of monks and deities, and in the top left corner two devas (powerful, invisible beings) fly attendance on the Buddhas of the Ten Directions. The scene is completed with landscape and geometric patterns.

c. **1350**
Nepal

Chamunda, Artist unknown
Copper, gemstones, gold and pigment, H: 20.32 cm / 8 in, Los Angeles County
Museum of Art, Los Angeles, California

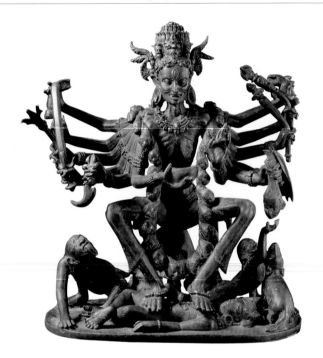

The killer of the demons Chanda and Munda, the Hindu goddess Chamunda is identified with the raging and rampaging Kali, the goddess who ultimately combats attachment and ignorance.

In this composition, from the early part of the Malla period (thirteenth to late eighteenth century), the goddess is fierce and bizarre in appearance. Heavy ornaments draw attention to her skeletal frame, the bared bones of her neck and chest. Her crown carries human skulls, and she wears a garland of freshly severed heads; her feet are firmly planted on a prostrate body. Most of her 12 hands hold weapons; one of her right hands holds a skullcap and a left hand holds a human head. The blood that drips from this head is coveted by the dog and one of the ghouls that accompany her. The second ghoul also cranes his neck and sticks out his tongue expectantly, on Kali's other side. The dog and the spectres that prowl around the goddess create a horizontal circular movement that contrasts with the static, vertical central figure.

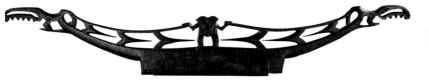

This celebrated Maori carving is named after its place of discovery on the North Island of New Zealand. Most scholars now believe that it was part of a gateway to an enclosure, rather than a supporting element above a doorway. The sculpture is fully carved in the round, which suggests that it was meant to be seen from all sides.

Although early, the composition sets a precedent for much later Maori sculpture. The central human figure is flanked by *manaia*-type figures (mythical creatures with a bird's head and human body), just as in later door lintels; they appear to represent stylized birds or reptiles. The human figure itself is compressed, reduced to a head, legs, arms and vestigial torso. The sculpture exhibits extraordinary symmetry and balance, centred on the human figure, which is nonetheless offset by the dramatic, sweeping thrust of the end figures.

The carving lacks the elaborately detailed surface carving that distinguishes much later Maori sculpture. In its plainer, unadorned style, it evokes the sculpture of Eastern Polynesia, including Tahiti and the Austral Islands.

Bird Monument, Artist unknown
Steatite, H: c.40 cm / 16 in, Groote Schuur Collection, Cape Town

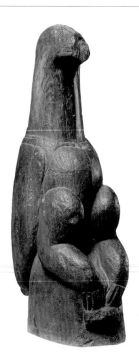

Great Zimbabwe, situated in southern Zimbabwe's granite hills north of the Limpopo River, is one of the most impressive pre-colonial monuments of sub-Saharan Africa. Built by Bantu-speaking peoples, ancestors of the Shona, it flourished between 1300 and 1450 as the residence of the most powerful ruler in the southeast interior of the continent.

The site is today most closely identified with a series of enigmatic bird sculptures carved from a soft, greenish steatite (soapstone), which were originally mounted on columns some 1 metre (c.3 ft) in height. This 'seated' example, typically combining human and avian elements (note the toes rather than talons), comes from the Eastern Enclosure of the Hill Ruin.

The locations of the bird sculptures at what are thought to be ritual centres and sanctuaries in Great Zimbabwe may indicate their religious significance. Birds, especially eagles, were seen as messengers who brought word from the ancestors, and ancestral spirits in turn interceded with the gods regarding such crucial necessities as rain. The bird carvings, in this view, represented in stone the intercessionary role of the royal ancestors. Alternatively, in contemporary Shona culture, an individual's identity derives from a totem that unites him to his ancestors, and these ancient works may have honoured the ruler's lineage, clan and ancestors.

c. **1351**
Bulgaria

Council of Archangels, Artist unknown
Tempera and gold paint on panel, 123 x 77 cm / 4 ft¼ in x 2 ft 6¼ in,
National Art Gallery, Sofia

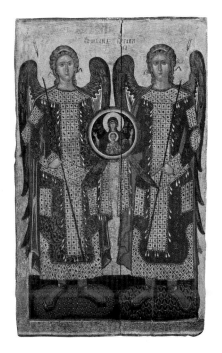

In this icon, the archangels Michael and Gabriel, appearing here virtually identical, stand beautifully attired in splendid robes that mirror those worn by the emperors, both Byzantine and Bulgarian; the identification of the angels with imperial glory is often found in Byzantium (see also the Archangel Michael, p.500). The archangels hold a round icon showing the Virgin with her hands raised in prayer and the Christ Child.

The Bulgars were converted to Christianity in AD 864, and the tsar of Bulgaria and his family adopted traditional Byzantine dress and customs from 1018, when the first Bulgarian empire was taken by the Byzantines. Bulgarian art, including wall paintings and manuscripts as well as icons, was greatly influenced by Byzantine art in both style and iconography. This icon was made for a monastery dedicated to the archangels in Bačkovo, founded in 1083 by a Georgian, Grigory Bakuriani. It would probably have been the main icon of the church. It has been suggested that because the style of this icon is very similar to wall paintings in the monastery commissioned by Tsar Ivan Alexander (reigned 1331–1371), who ruled during the so-called Second Golden Age of flourishing Bulgarian culture, he perhaps also presented this icon to the monks there.

David Vases, Artist unknown
Glazed porcelain, H: 63.5 cm / 2 ft 1 in, Percival David Foundation of Chinese Art, London

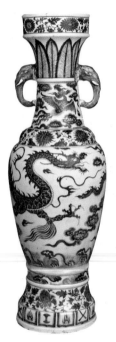 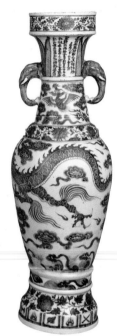

Below the collar on the neck of each of this pair of vases is an inscription of 61 characters. It records their presentation by one Zhang to a temple near Jingdezhen, Jiangxi Province, in 1351, a date that puts them among the earliest extant examples of fine blue-and-white Chinese porcelain.

The vases, of white porcelain with underglaze decoration in cobalt blue, are superb in shape and proportion. Each has two elephant handles, from which rings originally hung, and a hollow foot. The decoration on each is complex and almost, though not quite, identical. On the rim, shoulder and around the upper foot, three bands are painted with arabesques of chrysanthemums, lotus and peonies respectively.

The inscriptions are set among plantain leaves, and phoenixes fly around the lower neck. A dragon writhes about the body of each vase, and round the base are a series of panels containing auspicious symbols.

The origins of this famous ceramic form are uncertain, though the David Vases (so-called because they were collected by Sir Percival David) must represent an already mature stage in its development. Cobalt first reached China under the Mongol regime, and blue-and-white porcelain from the great Jingdezhen kilns was exported to the Middle East, where it was much appreciated: Istanbul's Topkapı Museum now owns a superb collection.

c. 1362
Czech Republic

St Luke, Attributed to Master Theodoric
Tempera and gold leaf on panel, 115 x 94 cm / 3 ft 9¼ in x 3 ft 1 in,
National Gallery, Prague

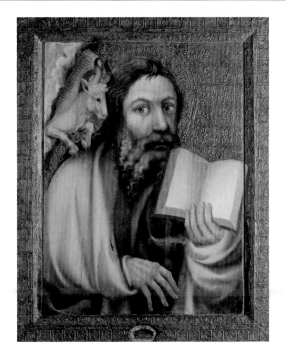

Charles IV was crowned king of Bohemia in 1347 and set out to make his new capital, Prague, the cultural rival of Rome and Paris. In his main imperial residence, the imposing stronghold of Karlstein Castle located outside Prague, Charles commissioned artists to decorate a number of chapels. The most important was the Chapel of the Holy Cross, from which this work comes, which served as a repository for his collection of holy relics and the jewels from his coronation as Holy Roman Emperor.

The chapel's sumptuous decoration, painted between 1360 and 1364, included 127 half-figures of saints, angels and doctors of the Church, created by Master Theodoric (fl. c.1348–1381) and his workshop.

This imperial court painter, the first documented Bohemian artist, created an idiosyncratic style drawing on Italian and Franco-Flemish sources as well as local artistic traditions. His figures, set in sharp contrast to the resplendent punched gold-leaf backgrounds, seem to leap from their restricted pictorial space. St Luke, presented with his symbol, a winged ox, possesses something of the quality of an icon, and the bright luminosity of the palette endows the figure with great expressiveness. The heavily modelled, almost amorphous body type was popular with later central European artists and became known as the Soft style.

1372
Egypt

Page from the Holy Koran, 'Ali ibn Muhammad al-Ashrafi and Ibrahim al-Amidi
Ink, gold and opaque pigments on paper, 74 x 51 cm / 2 ft 5 in x 1 ft 8 in,
National Library, Cairo

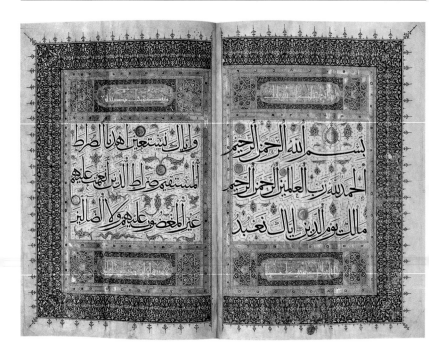

The large Koran manuscripts made for the Mamluk rulers of Egypt and Syria in the mid-fourteenth century were modelled on manuscripts made at the beginning of the same century for their rivals, the Ilkhanid rulers of Iran (see the Page from the Holy Koran, p.264). Those associated with the Mamluk Sultan al-Ashraf Sha'ban are some of the largest known, with each page folded from a sheet of 'full-baghdadi' size (c.100 x 70 cm / 3 x 2 ft). They typically have 13 lines per page, so that the text can be encompassed in a single volume, but the opening pages, including those seen here, are written with script twice the size of that used on ordinary pages and are known as *muhaqqaq jali*.

This manuscript was transcribed by the calligrapher 'Ali ibn Muhammad al-Ashrafi, finished in 774 AH (1372), and endowed by the sultan to his madrasa (religious school) four years later in 1376. The illumination by Ibrahim al-Amidi is equally splendid. The artist used an unusually wide palette, adding brown, light blue, green, orange, red and pink to the standard dark blue, gold, black and white. Such a range of colours is typical of Iranian work and shows that Mamluk Cairo was able to attract the most talented artists from across the Islamic world.

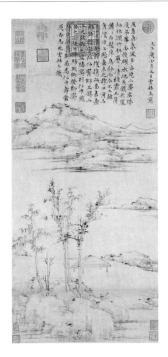

Considering the reputation of Ni Zan (1301–1374) as one of the four Great Masters of the Yuan dynasty (1279–1368), his output was surprisingly limited in range and even in stylistic accomplishment: he was, so to speak, the original Chinese series painter. His scenes were not taken from life, and despite the title of this picture there is thought to have been no actual Rongxi Studio.

Almost all of Ni's paintings, created throughout a known career of 34 years, were composed of similar elements: mountains in the background, water in the middle, and a simple shelter under a few sparsely clad trees in the foreground. In contrast with the depths of detailed and atmospheric landscape painted by Song

dynasty (AD 960–1279) artists, the effect of Ni Zan's style appears casual to the point of offhandedness. He even used ink sparingly, applying it with an almost dry brush and a minimum of brushwork. He certainly did not paint for approbation, either present or future, and yet his delicate, wistful mood painting struck a chord with art connoisseurs. Furthermore, Ni Zan was one of the first artists to shape the concept of the triple arts of the wrist – poetry, calligraphy and painting – as the 'three perfections', promoting the idea that a picture inscribed with an appropriate poem written in a complementary calligraphic style now provided an enhanced source of aesthetic pleasure.

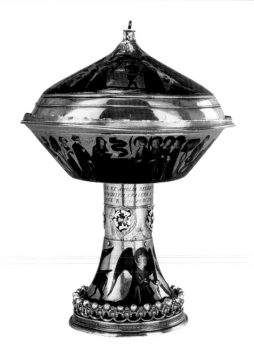

This royal cup was commissioned by the great patron Jean, Duc de Berry (1340–1416), probably for his brother, Charles V of France; it was eventually presented as a reconciliatory gift in 1391 to Charles VI. The cup is a testament to the artistic virtuosity of Gothic goldsmiths. It was fashioned from solid gold in a Parisian workshop around 1375 and is decorated with sunken-relief scenes covered with translucent coloured enamel (*basse taille*), creating a rich tonal variation of light and shade. Charles V was born on St Agnes's day (21 January), and the enamel scenes recount the life and miracle of this virgin martyr with remarkable naturalism, extremely difficult to achieve in enamels.

The cup originally stood on a gold tripod formed of winged serpents and had a crest of pearls on the cover, similar to that on the base, surmounted by a jewelled pommel. The band of English Tudor roses on the stem were added during the reign of Henry VIII (reigned 1509–1547). On the foot are the symbols of the four Evangelists: an angel (St Matthew), as can be seen here, a winged lion (St Mark), an ox (St Luke) and an eagle (St John).

Wilton Diptych, Artist unknown

Egg tempera and gilding on panel, 57 x 29.2 cm / 1 ft 10½ in x 11½ in,
National Gallery, London

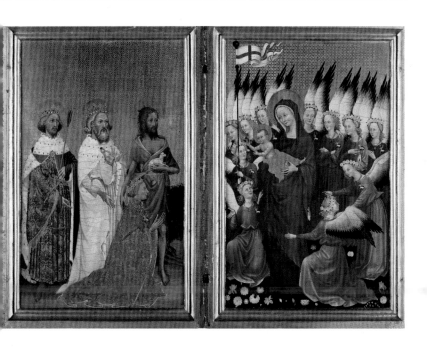

The Wilton Diptych is the finest surviving example of the International Gothic style in England. This refined, courtly style was prevalent across much of Europe, and the diptych has been attributed to Italian, Bohemian, English or, most commonly, French artists. The portable folding oak altarpiece was painted for the English king Richard II (1367–1400), seen kneeling in the left-hand panel. He is presented to the Virgin by his patron saint, John the Baptist, in the presence of St Edward the Confessor and St Edmund, both former kings of England.

The painting is filled with personal symbolism. Richard and the ranks of angels each wears a brooch in the form of his personal emblem, the chained white hart. The monarch's red robes are embroidered in gold with harts and broom cods (broom flower seedpods), also prominent on his collar. The heraldic badge of Charles VI of France on the collar argues for a date for the work of around 1396, when Richard married Isabelle of France and the two monarchs exchanged emblems. Richard has given the banner of Saint George, with a diminutive map of England within the orb atop the pole, to the Virgin for blessing. The diptych may thus be seen as a confirmation of Richard's divine right to kingship.

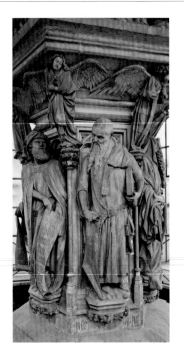

The only surviving works by the Flemish sculptor Claus Sluter (c.1360–1406) are all connected to the Carthusian monastery of Champmol near Dijon, founded by Philip the Bold, Duke of Burgundy and ruler of Flanders. The portal of the church, the duke's tomb and this imposing hexagonal wellhead are all that remain, and their sculptures show a more intense naturalism and monumentality than the prevailing Franco-Burgundian style of the Late Gothic period.

The wellhead (1396–1404), once the base for a giant Calvary scene, is adorned with life-size Old Testament prophets who foretell the death of Christ on the cross in their voluminous scrolls; the prophets Daniel and Isaiah are shown here. They were once brightly coloured and gilded by Jean Malouel (uncle of the Limbourg brothers; see *Les Très Riches Heures*, p.287) and Hermann of Cologne, and would have stood out in great contrast to the blackish hues of the niches and the gilded cornicing. The degree of naturalism is striking: there is a faithful reproduction of distinct surface textures; the faces display every wrinkle of an individual physiognomy and project an intense spirituality; the heavy folds mask a powerful corporeality. Although the imprint of Sluter's artistic genius hangs over this grand project, one should not forget he headed a large team of skilled masons and sculptors, all of whom would have participated in the creation of this piece.

Ganesha, Artist unknown
Ivory, 18.4 cm x 12.1 cm / 7¼ in x 4¾ in, Metropolitan Museum of Art, New York

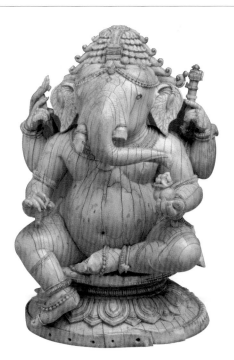

The elephant-headed god Ganesha is one of the best-loved deities in Hindu India. As Lord of Beginnings and Overcomer of Obstacles he is worshipped before any new enterprise or journey. He is always depicted with a plump physique denoting health and wellbeing, and holds a bowl of sweets in one of his four hands. The broken tusk in his lower right hand was used to inscribe the Hindu epic *Ramayana*, recited by the sage Vyasa. Ganesha is also believed to have thrown his tusk at the moon for teasing him about his love of sweets. In his other two hands he holds two entwined snakes and an elephant prod.

This exquisitely carved, seated ivory image comes from the eastern Indian state of Orissa, and the elephant god's hairstyle is similar to the roofs of Hindu temples in this region. Though ivory was used for sculpture and ornaments in South Asia from at least the early centuries AD, because of its organic nature few examples exist from before the fourteenth century (for one very early survival, see the Begram Box Lid, p.142). The prevalence of elephants in the humid, forested coastal regions of Orissa and their use in armies is mirrored in the name of a fifteenth-century dynasty of Hindu kings, the Gajapatis, or Lord of Elephants, making the use of ivory for this image appropriate for the subject.

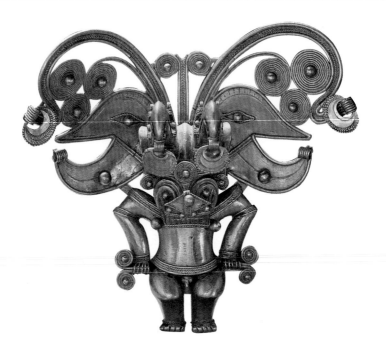

This exceptional example of body adornment portrays a being frequently rendered in Tairona gold artworks, comprising a human male body with animal head. The figure is portrayed in a ritual stance, with knees slightly bent and arms flexed, the hands at the thighs holding a double-spiral form of unknown identity and meaning. The composite figure has been interpreted by scholars as a deity or a human transformed into a spiritual being, with human body, bat head (or mask) and elaborate headdress surmounted by two birds, profile avian forms and flamboyant volutes. This masterfully conceived and unusually large cast pendant, dated to c.1300–1500, was worn by an authoritative member of Tairona society such as a

religious or political leader, its imagery denoting the power and prestige of the wearer.

Gold was the metal of choice for personal adornments of the peoples of ancient South America due to its symbolic associations. The sixteenth-century Inca people said that gold represented the sun and its rays – powerfully sacred emanations that they metaphorically called 'the sweat of the sun'. The Tairona people were the dominant culture of northern Colombia in the fifteenth and sixteenth centuries, and they quickly drew the attention of the Spanish, the invaders amassing and melting into ingots as much Tairona gold work as they could find.

Catching a Catfish with a Gourd, Josetsu
Ink and colour on paper, 111.5 x 75.8 cm / 3 ft 8 in x 2 ft 6 in, Taizo-in,
Myoshin-ji, Kyoto

In a landscape flooded with mist, a ragged peasant
stands beside a stream, aiming to catch a slippery
catfish with a wobbly gourd. Who would attempt
such an impossible feat? Meditating on an absurd or
paradoxical situation is a core exercise in the Rinzai
branch of Zen, which over the centuries accumulated
hundreds of similar thought-problems, called *koan*.
This particular subject was probably devised by the
shogun, Ashikaga Yoshimochi (reigned 1394–1423),
who assigned it to his leading artist Josetsu (fl. c.1400–
1425) for depiction and to 31 Zen priests for comment.

According to the preface in the top right corner
of the scroll from which this detail comes, Josetsu
employed a 'new style' (*shinyo*), for the picture. This

observation may refer to the expressive brushwork,
humid tonality and construction of space in depth,
all features of Chinese Southern Song (1127–1279) ink
landscapes, which Japanese artists were beginning
to study with interest. The priests' comments were
written in the form of Chinese poems and inscribed
together on a sheet of paper; true to Zen, the remarks
are as intentionally nonsensical as the subject. The
painting and comments were originally mounted
on opposite sides of a small screen that stood to the
shogun's right, but at some point they were remounted
as a single hanging scroll. The middle century of the
Muromachi period (1333–1573) is often considered a
golden age of ink painting in Japan.

Icon of the Holy Trinity, Andrei Rublev

Gesso and tempera on panel, 142 x 114 cm / 4 ft 8 in x 3 ft 9 in, Tretyakov Gallery, Moscow

This icon, which is dated variously to 1411 or c.1425, is considered to be the finest of the works of Andrei Rublev (c.1370–1430) and perhaps the most renowned icon in all of Russia. The scene refers to the Old Testament story in which the Lord, in the form of three messengers, visited Abraham and told him that his elderly wife Sarah would bear a son. It depicts the three-in-one Godhead – God the Father, the Son and the Holy Spirit – represented by three angels seated at a table; in the background is the oak of Mamre, where Abraham gave hospitality to the angels and where the Patriarchs (Abraham, Isaac and Jacob) were said to have been buried. It is exquisitely beautiful in terms of abstract patterning, the elegant posing of the bodies,

vivid and harmonious colour and the overriding sense of serenity and unity in which the three elements of the Trinity are indivisible and yet separate.

Rublev, a monk from the Trinity-Sergius Monastery, worked on both frescoes and icons in Moscow and Vladimir. He is first mentioned in 1405 as working with Theophanes the Greek on the iconostasis of the Cathedral of the Annunciation in the Kremlin, and from then on appears to have taken precedence as the most respected painter of the time. This icon was copied many times by subsequent artists.

1412
France

May, from Les Très Riches Heures, Paul, Jean and Herman Limbourg
Pigments on vellum, 22.5 x 13.6 cm / 9 x 5½ in, Musée Condé, Chantilly

The three Limbourg brothers from Flanders – Paul, Jean and Herman – were the most highly regarded of all late Gothic illuminators. Their greatest masterpiece, *Les Très Riches Heures*, produced for Jean, Duc de Berry, is considered the archetype of the International Gothic style. This was essentially a court style, elegant and sophisticated, combining naturalism of detail with overall decorative effect.

Les Très Riches Heures (1412–1416) is an exceptionally lavish illustrated Book of Hours, a collection of texts for the liturgical hours of the day, intended for private devotion. The brothers' style is characterized by a painstaking attention to detail, a subtle line and a vivid sense of narrative. They

were pioneers in the depiction of landscapes and genre details, in which northern Italian and Tuscan influence is evident.

This page shows the traditional May Day celebrations, associated with springtime and the celebration of love. The figures wear leaf crowns and necklaces, and the women are dressed in May green. The knight in black, white and red is Jean de Bourbon II, Count of Clermont, who gazes at his wife Marie, daughter of Jean de Berry. In the background can be seen the Palais de la Cité in Paris, where the couple had married.

Baptism of Christ, Lorenzo Ghiberti
Gilt bronze, 79 x 79 cm / 2 ft 7 in x 2 ft 7 in, In situ, Battistero di San Giovanni, Siena

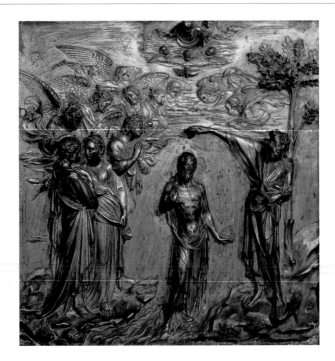

In 1416, when he was already preoccupied with his commission to complete a set of 28 sculpted bronze door panels for the north doors of the baptistery of the Duomo in Florence, Lorenzo Ghiberti (1378–1455) was invited by the Sienese to design a new bronze font for their own baptistery.

The *Baptism of Christ* (c.1423–1427), one of the two panels that Ghiberti completed, shows a centrally placed Christ flanked to his right by attendant angels. The highest degree of relief work that forms the figure of Christ diminishes gently in the receding frame of angels to his right and finally gives way to the finest, low-relief surface work in the angels above and behind him. This type of fine quality, low relief is known as *rilievo schiacciato* (flattened, or 'squashed' relief) and requires the most delicate manipulation of the surface of the medium. The relief is higher again to Christ's left, where John the Baptist's outstretched arm leads the eye to the figure of God the Father in the heavens, and to the descending dove of the Holy Spirit.

The panel demonstrates Ghiberti's technical prowess as both goldsmith and sculptor, and decisively marks the transition from his first set of panels for the north door of the Florentine baptistery, which adhered to the Medieval quatrefoil (four-lobed) format, to his second set, which came to be known as 'The Gates of Paradise' and which use a square format allowing for many more figures and scenes.

1425
Italy

Expulsion of Adam and Eve, Masaccio
Fresco, 214 x 90 cm / 7 ft 2½ in x 2 ft 11½ in, In situ, Brancacci Chapel,
Santa Maria del Carmine, Florence

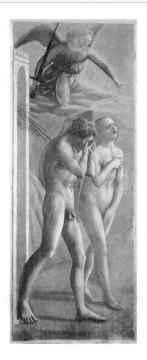

In 1425 two artists, Masaccio (Tommaso di Ser
Giovanni di Mone) and Masolino, were
commissioned by the Brancacci family of Florence to
decorate their family burial chapel with scenes from
the life of Saint Peter. Those images are on two tiers
of the chapel and are flanked on the upper level by
the Old Testament scenes of the Expulsion and the
Temptation, painted between 1425 and 1428.

Masaccio (1401–1428) painted the scene shown here
of the Fall of Man, as told in the Book of Genesis.
Expelled from Paradise and flung into history by
God, a distraught Adam and Eve stumble naked and
shamed towards the east end of the chapel. Adam
buries his downcast face in his hands, while Eve's

head is flung back, ensuring that her sorrow is entirely
visible. Although her seemingly chaste pose is based
upon the antique model of the *Venus Pudica* (Venus
of Modesty), Eve's gesture here is one of shame and
misery. Masaccio has modelled her facial features
as would a sculptor in a crude first attempt, gouging
hollows for mouth and eyes in order to ensure that her
distortive screams are almost palpable. The work is an
unequalled image of pain and exclusion.

Early Renaissance

c. **1430**
Germany

The Word at the Centre of the Jewish World, Attributed to Israel ben Meir
Pigments on vellum, 35.2 x 25.6 cm / 1 ft 2 in x 10 in,
Hessisches Landes-und-Hochschulbibliothek, Darmstadt

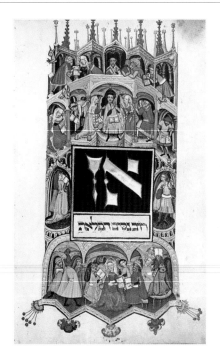

Visual imagery is less prevalent in Jewish culture than its Christian counterpart, and this Ashkenazi Haggadah from the Rhineland is exceptional for the richness of its illuminations. The Haggadah is used for private devotion, recited during the Seder, the ceremonial dinner on the eve of Passover.

This miniature adapts the Christian medieval conventionsof the International Gothic style for the purposes of illustrating the importance of study and discussion in the celebration of the Seder. Christian illumination decorates the initial capital letter of a text, but in Hebrew script, which has no upper case, the first word is decorated instead – here with the word *az*, which begins the Passover prayer, 'How

many wonders have you wrought'. The fanciful Gothic architectural setting is populated by fashionably dressed men and women; all of them hold or point to books, presumably Haggadot, and discuss the Exodus from Egypt. The woman in blue seated in the bottom arcade, who may be the book's owner, looks out at the viewer as if talking us through the Haggadah.

The scribe, Israel ben Meir of Heidelberg, may also have been responsible for the illumination, although it is also possible that it was carried out by a Christian master of an Upper Rhenish workshop.

Cloisonné Jar, Artist unknown
Cloisonné enamel on bronze, H: 62 cm / 2 ft ½ in, British Museum, London

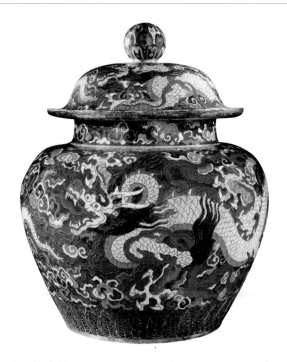

The shape of this splendid lidded jar, dated to c.1426–1435, recalls that of earlier ceramic vessels, and its decoration of dragons diving through the clouds and waves to fill the space around the bulging sides is also reminiscent of past motifs; this pair of creatures is of the five-clawed, imperial type. Nevertheless, in terms of cultural form the piece represents comparative novelty. The complicated and labour-intensive craft of making *cloisonné* had been introduced into China by the Mongols during the Yuan period (1279–1368), but in competition with the burgeoning porcelain industry it was slow to gain acceptance, and even from the fifteenth century authenticated examples of *cloisonné* work are not very common.

According to an inscription on the neck of the jar it was made in the Xuande reign period (1426–1435) of the Ming dynasty, although some of its decorative features suggest that it may date to a few decades later. Either way, it corroborates the impression given by contemporary painting that fifteenth-century Chinese taste favoured bold, bright colouring in the arts. Turquoise, lapis lazuli blue, dark green, red, yellow and white – all used on this jar – were characteristic of cloisonné from this date. The enamel is no more than 6.3 millimetres (¼ inch) thick, and has been built up on a bronze base. The wires separating the cloisons are also of bronze.

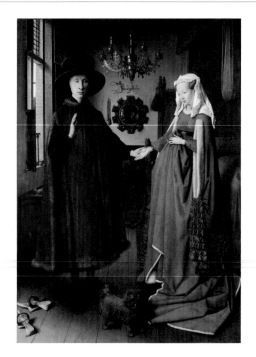

This innovative full-length double portrait by Jan van Eyck (c.1395–1441) shows an Italian merchant from Lucca and his wife, in a sumptuously appointed room. Early twentieth-century interpretations argued that the man's gesture of oath-taking indicates that this couple are being married on sacred ground – hence the discarded shoes. They are witnessed by two men reflected in the mirror, which is surrounded by roundels representing the Passion and Resurrection of Christ. One of these men may be the artist, as suggested by the signature above the mirror: *Johannes de eyck fuit hic 1434* ('Jan van Eyck was here 1434').

The objects within the room – the bed, fruit and faithful dog – elaborate the theme of marriage; the

woman's pose may have been expressive of fecundity. All these interpretations have, however, been disputed, as has the identity of the man as Giovanni Arnolfini, and the painting may simply represent a fashionable couple surrounded by their luxurious possessions, the man's hand raised in greeting.

Inarguable, however, is van Eyck's mastery of the medium of oil painting, which enabled him to reproduce light, reflections and modelling with an unprecedented degree of realism. This technique was enthusiastically adopted by numerous Netherlandish followers and was influential in Spain and Italy, notably in the art of Giovanni Bellini (see *St Francis in Ecstasy*, p.308).

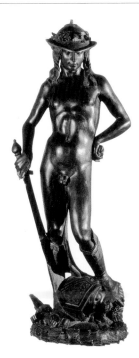

The bronze *David* by Donatello (c.1386–1466) was probably commissioned by Cosimo de' Medici between 1420 and 1460. It was the first life-size nude cast since antiquity, and the financial implications of its creation suggest the involvement of Florence's ruling family. It stood in the centre of the courtyard of the Medici Palace along with Donatello's sculpture of *Judith and Holofernes* from at least 1469 until 1495 – the year after the Medici family were expelled from the city. Its precise date is undocumented.

Unusually, Donatello chose to present the youthful David, not the mature figure of warrior and king as was customary at the time. His statue has many Classical attributes, including the hat covered with laurel, a plant symbolic of the poet and of fame. The large, unwieldy sword carried by the boy refers to the Biblical narrative: David is holding Goliath's weapon and clutching his own, a stone. His nakedness accents his vulnerability; he is not yet mature, thus his success in battle is testament not to brute force but to a belief in God. It is the realization of the consequences of his own actions that will pave the way to manhood.

Donatello was the most versatile sculptor of the early Renaissance, combining his study of ancient Roman sculpture with an acute observation of daily life. Later versions of *David* by Andrea del Verrocchio and Michelangelo were almost certainly inspired by Donatello's bronze shepherd boy.

Battle of San Romano, Paolo Uccello
Tempera and oil on panel, 182 x 320 cm / 5 ft 11½ in x 10 ft 5¾ in, National Gallery, London

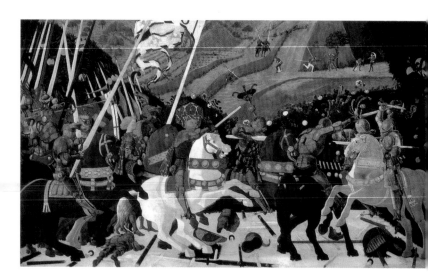

Although the event was probably rather less significant than this heroic image suggests, Paolo Uccello's depiction of the *Battle of San Romano* (c.1438–1440) shows the Florentine victory over the Sienese on 1 June 1432 under the leadership of Niccolò da Tolentino, a friend and ally of the Medici family. The painting is one of a series of three works installed in the palace of Lorenzo de' Medici that described the battle. When hung together, the panels' individual settings form a continuous backdrop promoting the military triumph of Florence. The works are now separately located in London, Florence and Paris.

Uccello (1396/7–1475) was a trained mosaicist and goldsmith as well as a painter, and was said by the biographer Giorgio Vasari to be fascinated with the laws of perspective, although his approach remained both traditional and fashionable. While his contemporaries Fillippo Brunelleschi and Leon Battista Alberti advocated the modelling of artistic compositions according to single-point perspective, Uccello preferred also to employ natural perspective, which was derived from the medieval approach to optics. Thus he could apply a different vanishing point to each of his subject groups in a single composition. It is this combined use of single-point perspective in the foreground and the more traditional use of natural perspective in the background that charges these battle scenes with power and intensity.

Descent from the Cross, Rogier van der Weyden
Oil on panel, 220 x 262 cm / 7 ft 2½ in x 8 ft 7 in, Museo del Prado, Madrid

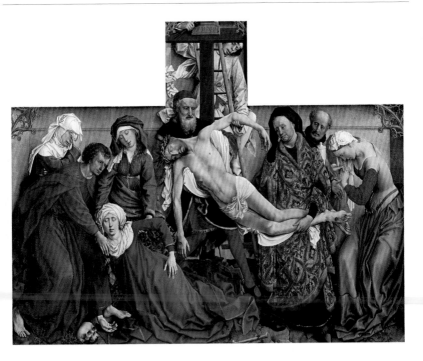

The Flemish artist Rogier van der Weyden (c.1399–1464) succeeded Jan van Eyck as court painter to Philip the Good, Duke of Burgundy (1396–1467). In this *Descent from the Cross*, dated between 1435 and 1443, he retains van Eyck's minute attention to realistic details, fusing this with a powerful emotional intensity achieved through anguished expressions and exaggerated postures.

In this monumental work, commissioned by the Confraternity of Archers for their chapel in Leuven, the figures are crowded into an impossibly shallow space with a gilded background, imitating earlier reliquary shrines and carved altarpieces. The effect is to highlight the volume of the bodies and to push

them closer to the picture plane and to the viewer. Christ's body is lowered from the Cross by the bearded Joseph of Arimathaea and by Nicodemus. To the right, Mary Magdalene is contorted with grief, and to the left, the deathly pale Virgin swoons, supported by St John the Evangelist. Mary's pose echoes that of the dead Christ, emphasizing her compassionate suffering with him and her role as co-redeemer of humankind. The empathy demanded of the viewer accords with the practice of the influential Modern Devotion movement, in which images were tools for bringing to life and engaging with the objects of prayer.

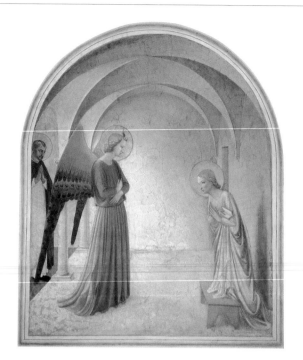

From 1437, the church and convent of San Marco was patronized by Cosimo de' Medici, at that time ruler of the city of Florence in all but name. Fra Angelico (c.1395–1455) was trained as a painter and later became a Dominican friar. With the help of assistants, he executed a series of paintings in the dormitories and corridors of the convent of San Marco from around 1439 to 1443.

Fra Angelico painted several versions of the *Annunciation*. This one, from an individual cell, was intended for the private contemplation and meditation of the friars. To the extreme left of the piece, St Peter Martyr serves as a witness and mediator for the divine miracle, which appears to take place in a bare vaulted

cloister, not entirely dissimilar to that in which it is frescoed. There is little need for ornament or further narrative here, and Fra Angelico employs a restrained language that is pertinent to his commission. The composition exudes simplicity in both form and colour, as the Virgin, kneeling at her *predieu* (prayer table), is greeted by the voice of Gabriel. In a break with tradition, Fra Angelico has chosen not to represent the descending dove of the Holy Spirit, but rather to illuminate the fictive cloister with divine light as Mary receives the news that she is to bear the Son of God.

1455
Armenia

Armenian Gospels, Priest Khach'atur
Tempera and black ink on paper, 27.5 x 18 cm / 10½ in x 7 in (each folio),
Walters Art Museum, Baltimore, Maryland

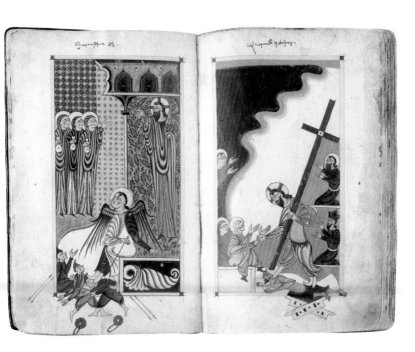

These stunning illuminations from the Armenian
Gospels (ms. W. 453, fols. 10v–11r) depict two episodes
in the story of Christ's Passion: the three Marys at
the tomb and the *Anastasis*, or Resurrection of Christ.
The artist, the priest Khach'atur, used highly stylized
figures, bedecked in brilliant undulating clothes
and set against elaborately patterned backgrounds.
On the left-hand leaf, Christ stands on the right
pointing to the three standing Marys, while below,
the angel who is guarding the tomb sits and points
to the empty shroud. The facing leaf depicts Christ,
dressed in yellow boots and holding a strident red
cross, stamping on the devil as he raises Adam and
Eve from Hades.

The manuscript (written by the scribe Yohannes, also a
priest) was made at Khizan, just south of Lake Van in
modern Turkey, at a time when it was part of greater
Armenia. The illuminations show the influence of
Islamic design, which had been popularized in the
thirteenth century, as well as the Turkic and Persian
influences of the local Timurids (a Muslim dynasty,
founders of the Mughal empire in India), combined
with elements of traditional Christian iconography.

The Flagellation of Christ, Piero della Francesca
Tempera on wood, 58 x 81.5 cm / 1 ft 11¼ in x 2 ft 8½ in, Galleria Nazionale
delle Marche, Palazzo Ducale, Urbino

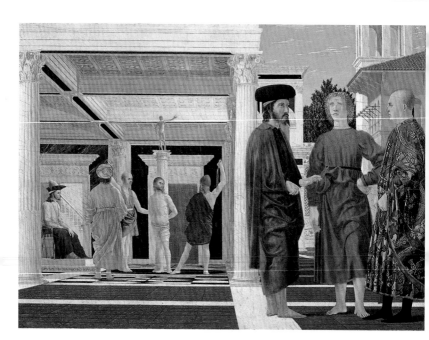

The composition of *The Flagellation of Christ* is divided sharply into two approximately equal sections by a single white column, and is a perfect example of single-point perspective. In the left background, Christ is subjected to the flagellation, while in the right foreground, three standing figures interact only with each other – seemingly oblivious to the torture being played out behind them. The minute detail in the fabric and drapery of the luxurious clothes worn by the three foreground figures anticipates the Venetian works of artists such as Giovanni Bellini (see *St Frances in Ecstasy*, p.308).

The painting by Piero della Francesca (c.1410/1420–1492) has attracted considerable attention for its

uneasy subject matter, but while there continues to be speculation over its specific meaning, it now seems likely that the commission was an attempt to promote a reconciliation between the Eastern and Western Christian churches at a time when the Turks were poised to attack Constantinople.

Piero was born away from the artistic centres of the Italian Renaissance in the small town of Borgo San Sepolcro, and he chose to maintain a degree of distance from Florence for most of his working life. His ability to combine the rigidity of accurate perspective characteristic of the Florentine school with the fluidity and grace more common in contemporary Netherlandish art was unequalled.

c. 1463
Italy

Lamentation over the Dead Christ, Niccolò dell'Arca
Painted terracotta, H: c.150 cm / 4 ft 11 in, In situ, Santa Maria della Vita, Bologna

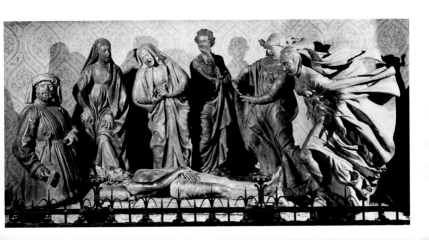

With his first known work, *Lamentation over the Dead Christ*, completed in 1463 for the church of Santa Maria della Vita, Niccolò dell'Arca emerged as one of the most original and unique sculptors of his generation. The terracotta six-figure group, arranged around the recumbent body of Christ, functioned as a sacred representation. The extraordinary expressivity of the figures has few parallels in fifteenth-century Italian sculpture. Although his style draws upon elements and motifs of the sculpture of the Flemish school and of Italians such as Donatello, Andrea del Verrocchio and Jacopo della Quercia, Niccolò creates in this unique work a dramatic pathos and style that is entirely his own.

Nothing concrete is known of Niccolò dell'Arca (also known as Niccolò d'Antonio d'Apulia, Niccolò di Bari or Niccolò da Ragusa) prior to his appearance in Bologna in 1462. He was probably born in Apulia in southeast Italy, and it has been speculated that he trained under a Dalmatian sculptor and that he worked in Naples. From these experiences or via a subsequent trip to France, he may have absorbed elements of Burgundian sculpture and could have encountered the work of Claus Sluter (see the Well of Moses, p.282). Niccolò was said to be a stubborn, difficult man, with no pupils, but he was nevertheless influential upon the development of sculpture in both northern Italy and Spain.

Early Renaissance

1464
Belgium

Last Supper, Dieric Bouts
Oil on panel, 180 x 150 cm / 5 ft 10¾ in x 4 ft 11½ in, In situ, St Peter's Church, Leuven

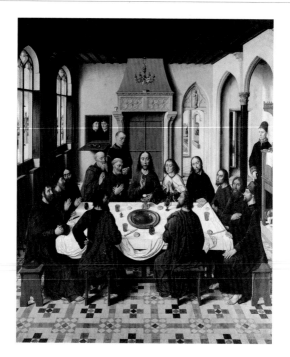

Dieric Bouts's *Last Supper* (1464–1467), the central panel of the Altarpiece of the Holy Sacrament, is distinguished for being one of the first paintings in the Netherlands to employ systematically the rules of linear perspective. The orthogonals (illusionistic lines running perpendicular to the picture plane and meeting at a vanishing point) of the main room converge just above Christ's head; the little room to the right of the main scene has its own perspective.

The painting is also thought to be the first representation of the Last Supper in northern art, and it is unusual in representing Christ as a priest celebrating the consecration of the Eucharistic wafer, the central rite of the Christian Church.

This underscores the institution of that ritual at the actual Last Supper, and reflects the interests of the Confraternity of the Holy Sacrament in Leuven, who commissioned the work. In common with earlier works by Netherlandish painters, the relevance of the Biblical event to the present is emphasized by the contemporary setting of the room and the landscape beyond. Two servants witnessing the scene through a hatch are likely to be portraits of members of the Confraternity, and the figure to the right may be that of Bouts (c.1415–1475) himself.

1470
Italy

Madonna and Child between Two Angels, Andrea della Robbia
Glazed terracotta, Diam: 100 cm / 3 ft 3¼ in, Museo Nazionale del Bargello, Florence

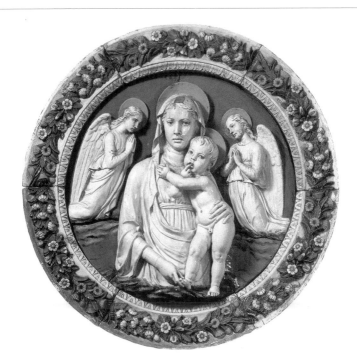

Andrea della Robbia (c.1435–1525) succeeded his uncle, Luca della Robbia, as head of the family business, a sculpture workshop established in 1440. Much of the family fame rested on Luca's rediscovery of the ancient techniques for painting and glazing terracotta and his invention of tin-glazed terracotta sculpture.

Andrea's compositions were inspired more by painting than by sculpture, and were both more complex and more highly coloured than the simple blue and white schemes favoured by Luca. Nevertheless, Andrea's early palette followed his uncle's conservative example, as in this tondo dated 1470–1471, made at the time Andrea took over the running of the workshop. (The piece has been variously attributed to both uncle and nephew, but it is generally accepted now as an early work by Andrea della Robbia.) The figures remain a sharp white set on a blue background, but the artist employs yellow-gold to accentuate the haloes of each of the figures and to enliven the naturalistic green of the garland that encircles the central image, presaging the polychrome glazing that would characterizes his later work. The figure of the standing Christ child, with his left arm reaching across the body of the Virgin and the index finger of his right hand lifted to his mouth, is a direct quotation from Luca's own *Madonna of the Apple* (1450), now in Berlin.

Pheasants and Hibiscus, Lu Ji
Ink and colours on silk, 172 x 108 cm / 5 ft 7¾ in x 3 ft 6½ in, Yunnan Provincial Museum, Kunming

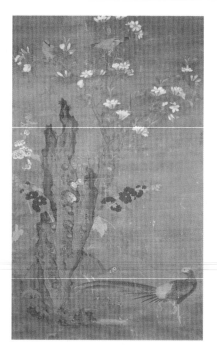

Lu Ji (fl. late fifteenth to early sixteenth century), decorated the court of the Hongzhi Emperor (reigned 1488–1505) with large flower-and-bird paintings such as this. He was expert at colour shading and grading, and depicted plumage and petals in realistic detail. Pheasants were his favourite motif, their gorgeous colours and strutting manner symbolic of the privileges of richly robed officials, with their education and literary refinement. In this picture (c.1439–1504), a pair of pheasants moves alongside a white hibiscus (indicative of honour and riches), pink gardenia, and an artfully eroded rock. Two orioles look down from the hibiscus. They, like pheasants, appeared on textiles as insignia of official rank.

The Yuan and Ming courts no longer perpetuated the Imperial Painting Academy that had been established during the Song dynasty (AD 960–1279). Nevertheless, the bifurcation into 'schools', which had been associated with the Academy's stress on technical formality on the one hand and scholars' personal painting styles on the other, continued. In the Ming period (1368–1644) they were known as the Zhe[jiang] and Wu[xian] schools respectively, named after the cities in which they flourished. Lu Ji is a typical example of the former; for the latter, see *Quiet Boats on an Autumn River*, p.317. Although he retained some of the atmospheric qualities associated with the Southern Song, his work is grand, not subtle.

c. 1475
Italy

Ginevra de' Benci, Leonardo da Vinci
Oil on panel, 38 x 37 cm / 1 ft 3¼ in x 1 ft 2½ in, National Gallery of Art, Washington, DC

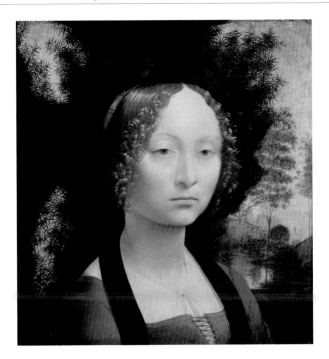

This is the earliest portrait by Leonardo da Vinci (1452–1519), produced while he was apprenticed to Andrea del Verrocchio. Although it is an early (1475–1480) experiment in oils, the young Leonardo already demonstrates a mastery of the medium. There is a striking naturalism in the handling of the curls and the delicate *sfumato* (using subtle shades of colour) of the flesh, which he softened further by pressing his fingers into the wet paint; the browning leaves were originally bright green. The panel has been cut down, for the work once included the sitter's arms and hands.

The portrait of Ginevra de' Benci, daughter of a rich Florentine banker, was commissioned by the poet and humanist Bernardo Bembo, the Venetian ambassador to Florence. Ginevra poses against a juniper bush (*ginepro* in Italian), punning on her name and symbolizing chastity in accordance with her modest dress and the motto 'Beauty adorns Virtue'. On the reverse of the panel is a depiction of a sprig of juniper on porphyry with a wreath of bay leaves and a palm branch, Bembo's personal device. The purity of the ambassador's Platonic friendship with the famed beauty, herself a poet, was celebrated in Medici court circles, where Neo-platonic ideals were in vogue.

Leonardo is the archetypal Renaissance man, his inquisitive mind occupied by all manner of investigation. Despite his unparalleled reputation as an artist, however, he finished few works.

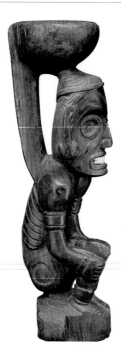

The tropical climate of the Greater Antilles, within which the Taino, or Arawak people lived, was not favourable to the preservation of the perishable products of their rich culture. This wooden figure with shell inlay is one of the very few examples of the human-figure type of zemi (ritual objects) to have survived, and the only one known that is not carved in stone. Many ritual objects were individually made and owned, although larger communal examples may have been made from wood.

The rich detail seen on this lone survivor, dated to c.1450–1500, reveals how many of the details of this complex culture have been lost to us. The fertility functions of zemis were paramount, and aspects of growth and renewal on this impressive carving are suggested by the channels for the flow of tears from the eyes, representing rainfall, as well as other details of the carving. Balanced on the head of the figure is a plate-like knob. Its surface is thought to have been used in the preparation and inhalation of a hallucinogenic snuff, called *cohoba*, prepared from the seeds of the *Anadenanthera peregrina* tree.

c. **1475**
Italy

Virgin Annunciate, Antonello da Messina
Oil and tempera on panel, 45 x 34.5 cm / 1 ft 5¾ in x 1 ft 1½ in, Galleria Regionale
della Sicilia, Palazzo Abatellis, Palermo

The Sicilian artist Antonello da Messina (c.1430–1479) probably only left southern Italy once, to visit Venice, where he is thought to have painted this arresting portrait of the Virgin c.1475–1476. She is portrayed fractionally turned from the viewer, distracted from her reading by the arrival of God's messenger. The pages of her book are caught by a divine breeze, and she reaches out beyond the picture plane. The composition is entirely novel. Normally, the Annunciate Virgin was depicted along with the archangel, but here the viewer takes Gabriel's place and is intimately drawn into the narrative.

The colour, luminosity and realism of the scene could only be achieved using oils. This new medium, first mastered in the Netherlands in the mid-fifteenth century, was highly appreciated in Renaissance Italy and had created a great market for Flemish art. Antonello is credited with introducing oil painting to Italy, and though his master Colantonio had used the technique, it was his pupil who first rivalled the artists of Northern Europe. Antonello's style is also close to that of the Provençal artist Enguerrand Quarton, and he may have become acquainted with works from Provence and the Netherlands in the art collection of Alfonso V in the court of Naples.

c. **1478**
Italy

Madonna and Child with Eight Angels, Sandro Botticelli
Tempera on panel, Diam: 135 cm / 4 ft 5 in, Staatliche Museen zu Berlin,
Gemäldegalerie, Berlin

The tondo (circular painting) emerged as a popular format during the second half of the fifteenth century, and Sandro Botticelli's painting is an early example. His palette here is dominated by complementary shades of blue with carefully accentuated highlights picked out in a bright white to illuminate fabric and skin. The work is a testament to his ability to portray the most serene of Madonnas. The entire composition displays an unforced symmetry in the attendant angels who surround the central Madonna; each one holds a lily in bloom, a traditional symbol of the Virgin's purity. In the centre is the Christ Child, who assumes a realistic, intimate pose as his chubby fingers struggle to open the folds in his mother's tunic.

Largely forgotten by the time of his death in 1510, the enigmatic works of Alessandro di Mariano Filipepi (1444–1510), known as Botticelli ('Little Barrel'), were only fully rediscovered in the nineteenth century by the English critic Walter Pater. There are few known biographical details on the artist, but we do know that he became a favourite of Lorenzo de' Medici in Florence, and was given several commissions, including the famous *Primavera* (1478) and the *Birth of Venus* (1486). In 1481 Botticelli was summoned by Pope Sixtus IV to fresco the lower walls of the Sistine Chapel in Rome, along with the leading artists of the day – Ghirlandaio, Perugino, Signorelli and Rosselli.

c. **1480**
Mexico

Eagle Warrior, Artist unknown
Painted earthenware and plaster, H: 200 cm / 6 ft 3 in, Museo de Templo Mayor,
Mexico City

This life-sized statue is one of a pair of similar
sculptures portraying Mexica (Aztec) eagle warriors.
Remarkable among all surviving monumental
sculpture of the Mexica, these are marvellous
expressions of military power and, simultaneously, the
celebration of the human form.

This impressive monument and its twin once
adorned the entrance to the private dwellings in
the Warriors' Precinct located next to the Templo
Mayor, the most sacred sector of the Mexica imperial
capital of Tenochtitlán. They oversaw the gathering
of the Cuaucuauhtin, the Order of the Eagle and
the Jaguar warriors, in the large vestibule fronting
the dwellings; these two majestic predatory animals

symbolized the strength and prowess of the members
of the military orders. The naturalistic modelling of
this eagle warrior attests to the technical expertise,
accomplished naturalism and aesthetic sensitivity
mastered by Mexica artists by the time of the arrival
of the Spanish in the early sixteenth century, and
forms a stark contrast to the massive public sculptures
adorning the Templo Mayor precinct, for which the
Mexica are famous. Unlike the naturalistic forms
of the eagle warriors, those stone monuments are
characterized by schematic shapes emblazoned with
iconic symbols.

c. **1480**
Italy

St Francis in Ecstasy, Giovanni Bellini
Oil and tempera on panel, 124 x 142 cm / 4 ft ¾ in x 4 ft 8 in, Frick Collection, New York

Giovanni Bellini's father, Jacopo, was a successful artist, as was his elder brother, Gentile, and Giovanni (c.1431–1516) continued in the family business, creating a workshop that dominated the Venetian art scene at the end of the fifteenth century. This personal devotional panel, made of poplar wood, was probably commissioned by Zuan Michiel, a respected secretary to the Venetian Council of Ten. Such works were admired by contemporaries as much for their aesthetic as their religious qualities.

The figure of St Francis receives the stigmata from God. The iconography is far from clear, however, as the normal rays from a vision of a crucified seraph are absent. Rather than the explicit visual aspects of

divinity, the artist concentrates on the natural beauty of the landscape suffused with golden dawn light. This luminosity was made possible by Bellini's mastery of the oil medium, still largely the preserve of the Flemish, although it seems he had received instruction from the Sicilian Antonello da Messina (see the *Virgin Annunciate*, p.305) during his stay in Venice. Flemish influence can also be seen in the landscape details.

Bellini's career spanned many decades, and he was enormously influential, spreading the fame of the Venetian school internationally and providing training for such future masters as Giorgione (see the *Three Philosophers*, p.321) and Titian (*The Rape of Europa*, p.339).

c. **1485**
Mexico

Tezcatlipoca Mask, Artist unknown
Human skull, turquoise, lignite, pyrite, shell and leather, 19.5 x 12.5 cm / 7¾ in x 5 in,
British Museum, London

This striking mask is made from a halved human skull lined with leather. The front of the skull is covered with alternate bands of tiny turquoise and lignite mosaic that replicate the characteristic facial features of the Mexica (Aztec) deity Tezcatlipoca, a creator god associated with warriors, rulers and sorcerers. The inlaid eye orbits seemingly preclude this mask having been worn by the living, although the leather ties suggest that it was intended to be worn or hung in some way. Mexica tribute lists from the early sixteenth century note that each year the Mixtec of Oaxaca were required to supply the Mexica emperor Motecuhzoma II with ten turquoise mosaic masks made by skilled artisans. Only a few such masks have survived, and

this is one of the finest examples, dating to between around 1450 and 1520.

The materials for the mask came from distant sources, their geographic origins indicating the extent of economic networks and political power of the Mexica state. The turquoise came from northern Mexico or the American southwest, the shell originated in either the Pacific Ocean or the Gulf of Mexico, and the lignite was probably found in Guerrero, in southwest Mexico.

c. **1488**
Bolivia

Llama, Artist unknown
Silver, gold and cinnabar, H: c.9 cm / 3½ in, American Museum of Natural History,
New York

Small llama effigies were frequently the featured
object in Inca dedications and other ritual caches.
Most have not survived because the Spanish melted
down all the precious metal objects they could find
during the early years of their conquest of Peru. This
silver example, which comes from the Island of the
Sun in Lake Titicaca and is dated to 1438–1534, may
portray the special white llama kept by the Inca
emperor as a mascot or pet. It is the only one of the
surviving examples that retains the blanket on its
back, a typical element of llama gear. The piece is an
especially fine example, with its uncommon details
of toenails, flaring nostrils and the decorative trim of
the blanket.

The small size of this llama sculpure belies its intricate
construction. Rather than a single casting, the body
is fashioned from several pieces of hammered sheet
metal carefully formed and soldered together. The
blanket is made of inlaid cinnabar; the diamond
shapes may originally have contained turquoise.

Llamas were the most important animal in any
Andean culture. They served as a prime source of
wool for clothing and myriad utilitarian items, as
pack animals, and as a source of meat for food and
blood for sacred rites. Their centrality to Andean life
made them the second most precious sacrificial votive
(after humans), and this effigy would have served as a
surrogate offering.

1488
Netherlands

High Altar of St Nicholas, Arnt von Zwolle, Jan van Halderen, Ludwig Jupan, Jan Joest
Painted and gilded wood, H: c.320 cm / 10 ft 6 in, In situ, St Nicholas Church, Kalkar, Germany

In 1488, the Brotherhood of the Virgin in the Church of St Nicholas commissioned the Netherlandish sculptor Master Arnt to produce this spectacular high altar. Although he died in 1492, Arnt was responsible for the overall design of the altar and began carving the principal figural groups. Either a lack of funds or changing tastes may account for unadorned state of the sculpture, since many of Arnt's other works were painted. The components were transported to Kalkar and completed after 1498 by Arnt's assistant, Jan van Halderen, and by Ludwig Jupan; the painted panels are by Jan Joest. The altar was probably dedicated in 1509. The incredibly detailed scenes tell the story of Christ's Passion, crowned by the Crucifixion.

Arnt was initially established in Kalkar, but had moved his workshop to Zwolle in 1484 and thereafter came to be known as Arnt von Zwolle. His work demonstrates the close relationship between painting and sculpture, for Arnt, like many contemporary sculptors, was strongly influenced by the work of Rogier van der Weyden (see *Descent from the Cross*, p.295). Arnt's figures are sensitively modelled and possess an elegant movement, the articulation of the body clear beneath the drapery. His technical brilliance is particularly evident in the exactitude of the detailing: the handling of the hair, the precise folds with their almost painterly quality, and the individual physiognomy of every figure.

Lamentation over the Dead Christ, Andrea Mantegna
Distemper on canvas, 68 x 81 cm / 1 ft 2¾ in x 2 ft 8 in, Pinacoteca di Brera, Milan

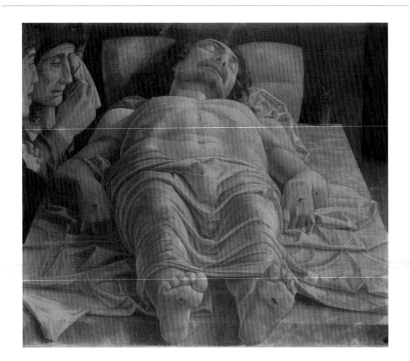

Andrea Mantegna (c.1431–1506) was renowned among contemporary artists for his antiquarian passion for Classical motifs and his development of innovative, complex foreshortening. The canvas support, favoured by Mantegna, was also unusual at this date, and he painted in distemper (pigment mixed with animal glue), producing the matt, fresco-like finish characteristic of this work.

This startling image of the dead Christ was among the works found in the artist's studio after his death and as a result, its date is disputed. Mantegna has deliberately reduced the size of Christ's feet and increased the size of his head to create a more readable, decorous composition. The body of Jesus has a sickly pallor, and the gaping nail holes in his hands and feet are faithfully rendered. On the left are the distraught St John wringing his hands, the wizened face of the Virgin Mary wiping away her tears and a barely visible Mary Magdalen. The red marbling of the funeray slab, or unction stone, is perfectly handled, and its unusual prominence may reflect the loss of this popular relic to pilgrims when Constantinople was overrun by the Turks in 1453. The stark realism and direct proximity of the viewer to Christ's body provoke a profound feeling of empathy for the suffering and sacrifice of the man.

St George and the Dragon, Attributed to Bernt Notke
Painted oak, gilding, elk antlers, hair and leather, H (total): 467 cm / 15 ft 4 in,
In situ, Church of St Nicholas, Stockholm

Bernt Notke (c.1440–1509) was the foremost late fifteenth-century painter and sculptor in the Baltic region. The Pomeranian-born artist of Estonian parentage was based in Lübeck, and this monument in the church of St Nicholas in Stockholm has been attributed to him on stylistic grounds. The sculptural group, composed of wood, bristling elk antlers, real hair and jewels and coins on the armour and bridle, is a highly expressive variant of Late Gothic art.

The reassembled structure once stood 6 metres (20 ft) high, straddling the nave on a chapel-like structure. Panels with scenes from St George's martyrdom adorn the plinth, and beneath the saint's steed are the bones of the dragon's victims and the beast's brood. A companion sculpture of the Libyan town of Selena, seen here on the left, holds a princess and a lamb, awaiting their fate. Sten Sture, the regent of Sweden, commissioned the work as a funerary monument for himself and his wife and incorporated an altar dedicated to St George, whose relics are housed in the saint's chest cavity. A papal nuncio, in Sweden to raise funds for a crusade, consecrated the still incomplete altar in 1489, and the saint's struggle could be viewed as an allegory of the Christian battle against the infidel.

1489
Belgium

Shrine of St Ursula, Hans Memling
Oil and gilt on wood, 87 x 33 x 91 cm / 2 ft 9½ in x 1 ft 9½ in x 2 ft 11¾ in,
Memling Museum, St John's Hospital, Bruges

Hans Memling's shrine is a reliquary casket designed to hold the relics of St Ursula and, like much of his work, it was commissioned by the Hospital of St John in Bruges. It replaced an earlier reliquary and is made entirely of wood, gilded to imitate those produced from precious metal in previous centuries.

The shrine lacks the elaborate ornamentation of precious stones so often found on reliquaries, but the real jewels are Memling's exquisite paintings. They tell the story, in six arched panels, of St Ursula's pilgrimage to Rome with 11,000 virgins and her eventual martyrdom in Cologne, Germany. One end of the shrine depicts Ursula sheltering 10 virgins under her cloak while on the other two sisters of the hospital

pray to the Virgin and Child. This panel in particular demonstrates the humanity of Memling's rendering of sacred subjects, as well as his skills as a portraitist.

Although Memling (c.1440–1494) often adapted compositions and figures found in the paintings of Rogier van der Weyden (see *Descent from the Cross*, p.295), with whom he may have studied, the scenes from the life of St Ursula are entirely original. They show considerable invention and wit in the arrangement of a huge number of figures into a legible composition on a relatively small scale.

Borgia Codex, Artist unknown

Deer skin, stucco and paint, 27 x 27 cm / 10½ in x 10½ in, Biblioteca Apostolica
Vaticana, Rome

The Borgia Codex, dated to c.1457–1520, is among the finest painted manuscripts of highland Mexico, its 39 panels created by a highly accomplished artist-scholar of the Mixtec-Puebla tradition. Only a few dozen tomes in this format survive, each containing a wealth of historical, astronomical and religious data, including calculation tables for planetary and lunar cycles, historical accounts of royal dynasties, and religious documents chronicling divine narratives, esoteric knowledge and the ritual calendar that ruled the universe. The Codex was used by priests to divine the future and to ensure that human events occured on propitious days and followed proper behaviour. It is particularly significant for its details concerning

Mexico's gods and the ritual divinatory nature of the *tonalpohualli*, the 260-day calendrical cycle.

This is one of three pages (22–24) that feature the 20 day names of the divinatory calendar. Read in serpentine fashion, bottom to top, each square contains the day name in the upper left or right corner and a large image of a deity, a priest of a specific deity, or an object symbolic of the deity. For example, the centre square features the day Reed and the sun god Tonatiuh, here cutting his throat in a symbolic act of self-sacrifice. Although these individual vignettes can be described, the manner in which a calendar priest would have used the images, and their underlying relational meanings, remains obscure.

c. **1500**
Netherlands

Unicorn in Captivity, Artist unknown
Wool, silk, silver and gilt, 368 x 252 cm / 12 ft 1 in x 8 ft 3¼ in, Metropolitan Museum of Art, New York

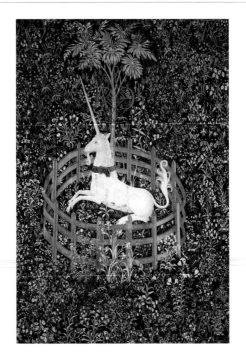

Tapestries were the most highly prized and expensive form of decoration in the Middle Ages. A panel like this would have taken a team of four to six male weavers at least a year to complete. Although produced in the southern Netherlands, the series of seven Unicorn Tapestries, dated to c.1495–1505, was probably based upon Parisian designs. They depict the hunt for the elusive unicorn, but the narrative can be allegorically interpreted as both the story of Christ and a tale of courtly love.

The symbolism suggests that the tapestries were intended to celebrate the marriage of a noble lady, whose initials A E are entwined in the tree seen here. This final scene, following the capture and killing of

the mythical beast, shows the reanimated unicorn chained and fenced in a superabundant meadow. The noble beast symbolizes both the resurrection of Christ and the capture of the lover-bridegroom. The pomegranate fruit, which drips blood-like juice on the unicorn's side, reiterates the resurrection but also represents the unity of the Church and refers to chastity. There are over 100 plant species depicted in the cycle, and this panel contains at least 20, alluding to love, fidelity, marriage and fertility.

Quiet Boats on an Autumn River, Tang Yin
Ink and colour on silk, 29 x 351 cm / 11½ x 11 ft 6¼ in,
National Palace Museum, Taipei

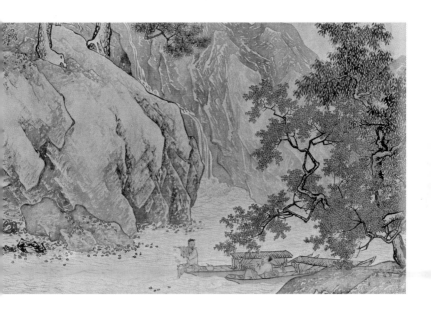

Tang Yin (1470–1523), one of the Four Masters of the Ming dynasty, was a specialist at conjuring up the mood of mountains. His massive, lowering ranges are reminiscent of the Northern Song style (compare, for example, Guo Xi's *Early Spring*, p.214). Here, although our attention is drawn to the detail concentrated to the right of the diagonal running from top right to bottom left, it is really the heavy cliff face of the background that sets the tone. The rocks are built up with forceful, axe-cut brush-strokes and swathes of colour, in contrast to the precise, brush-tip lines used to convey the serenity of the autumnal foliage and the two men in their boats. One is playing a flute and paddling his feet in the water; the other

sits back, clapping his hands in time with the melody. Theirs is a mood of calm while the stream foams against the rocks behind them. The painting is typical of the individualistic Wu school of painting (see *Pheasants and Hibiscus*, p.302).

Perhaps the picture is a metaphor for what Tang longed for in his own life. After losing his official career and social reputation as the result of an examination scandal, he sought peace in mountain temples and Suzhou brothels.

c. **1500**
Japan

Egrets in a Snowy Landscape, Attributed to Sesshu Toyo
Ink and colour on paper, 180 x 380 cm / 5 ft 10 in x 12 ft 4 in (each screen),
Freer Gallery, Smithsonian Institution, Washington, DC

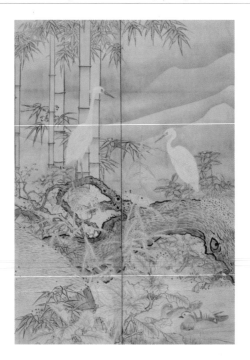

This winter vignette appears at the far left of two six-panel screens dating from c.1475 to 1525, depicting birds and flowers of the four seasons. The seasons progress from right to left, beginning with spring and concluding with winter. Here two egrets perch on a fallen trunk and scan a stream for fish. To the left, two chickadees find shelter in the branches of a bamboo grove, while below to the right, two mandarin ducks enjoy the protection of scrub oak laden with acorns. The informal composition conveys the atmosphere of secluded woodlands.

The textured brushwork and energetic outlines are characteristic of Sesshu Toyo's (1420–1506) highly influential style. He is regarded as one of Japan's greatest painters, principally for his ink landscapes, but he also produced Chinese-inspired 'bird-and-flower' (*kacho-ga*) paintings. From 1467 to 1469 he travelled through eastern China and was perhaps the first Japanese artist to make the journey specifically to hone his craft. He soon established an impressive reputation, and was even highly thought of at the Chinese imperial court. Upon returning to Japan, he set about producing some of the most advanced work of the time. The bird-and-flower screens attributed to him have in common a marshy landscape, a focus on native birds rendered in precise detail, large rocks and trees in the foreground, and a progression from right to left through the four seasons.

Holy Blood Altarpiece, Tilman Riemenschneider
Lime and pine wood, H: c.280 cm / 9 ft, In situ, St Jacob's Church,
Rothenburg ob der Tauber

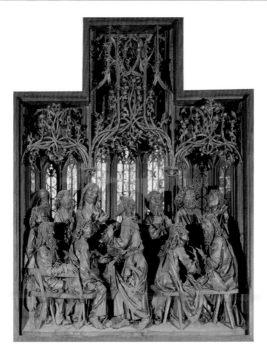

Tilman Riemenschneider (c.1460–1531) was the last great representative of German Gothic sculpture and ran one of the most successful workshops in southern Germany. He produced works in both wood and stone, and is credited with the aesthetic innovation of leaving limewood sculptures unpainted, simply applying coloured varnish and highlights to the lips and eyes. One unappreciative patron is recorded as having subsequently painted and gilded an altarpiece created by Riemenschneider.

The Holy Blood Altarpiece (1501–1505), as a monumental reliquary for a precious drop of Christ's blood, appropriately recounts the institution of the Eucharist during the Last Supper. Riemenschneider's limewood figures have calm features and make delicate gestures, their bodies defined by animated draperies broken into sharp, uneven folds. The apostles are caught in the most varied postures, with attention singularly centred on the figure of Judas.

Riemenschneider often used engravings as inspiration, especially those of Martin Schongauer (c.1448–1491), and would have been responsible for the overall conception and the finish of key elements within large-scale workshop commissions. Such life-size ensembles, once common in churches across Europe, served as a particularly dramatic and realistic Bible for the illiterate masses during the performance of the liturgy.

c. **1502**
Netherlands

Garden of Earthly Delights, Hieronymus Bosch
Oil on panel, 220 x 389 cm / 7 ft 2½ in x 12 ft 9 in, Museo del Prado, Madrid

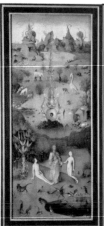
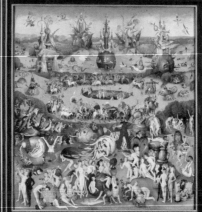

On the evidence of works such as this, Hieronymus Bosch (c.1450–1516) was labelled in the early twentieth century as a libertine, heretic, reformist and even the first surrealist. All indications, however, are that Bosch was an upstanding citizen whose clients included the nobility and the Church, and that he was a conventional Catholic, albeit with a pessimistic view of the goodness of humanity.

The *Garden of Earthly Delights* (c.1500–1505) is his most enigmatic work, in particular the central panel with its many naked, cavorting couples and gigantic birds and fruit. Conceived in a triptych format, commonly the preserve of altarpieces, the work is a moral reflection on the nature of sin and sensual pleasure, contextualized by the beginning of the world and its end. The outer wings represent the creation of the world, opening to reveal a continuous landscape with, from left to right, the creation of Eve, the joyless indulgence of base desire, and Hell.

Bizarre though Bosch's imagery may seem, it has precedents in the hybrid monsters of the margins of illuminated manuscripts. The conservatively Catholic Philip II of Spain (reigned 1556–1598) avidly collected his work, and among his many imitators was, most notably, Pieter Bruegel the Elder (see the *Census at Bethlehem*, p.342).

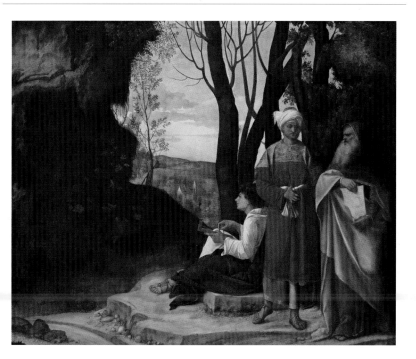

As with nearly all Giorgione's works, the meaning of this canvas (1508–1509; completed by Sebastiano del Piombo) has been much debated. The figures have been interpreted as the three stages of man's life, the three Magi, three philosophical schools or even the three monotheistic religions. The artist's small-scale domestic works embraced fresh subject matter, in which mood took precedence over figural content, and Giorgione also initiated the Venetian primacy of colour over line. He largely dispensed with preparatory drawings, building up the picture in oils directly on the canvas, not simply through the methodical application of thin, luminous layers, but more spontaneously, with pure strokes of colour. The

very process of painting dictated the final outcome. He produced startling *sfumato* effects using subtle shades of colour, and caught elusive qualities of light and shade. His innovations gave a new prominence to landscape, and his atmospheric techniques were adopted by Titian (see *The Rape of Europa*, p.339).

Giorgione (1477/1478–1510; also known as Giorgio Barbarelli or Giorgio da Castelfranco) died of the plague aged 30, and there are few paintings firmly attributed to him. Nevertheless, his work attracted the unbridled admiration of his contemporaries. He was one of the first artists to cater to a new clientele of connoisseurs, such as the wealthy merchant Taddeo Contarini, who first owned this canvas.

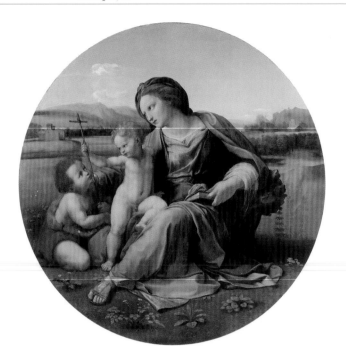

Raphael (Raffaello Santi or Sanzio; 1483–1520), one of the most successful of Renaissance artists, may have painted this panel for his first biographer, Paolo Giovio. Mary is seated on the ground in a composition referred to as the Madonna of Humility. In her lap, Jesus takes a reed cross from the child John the Baptist, symbolizing Christ's acceptance of his fate. This quintessential work of the High Renaissance combines Raphael's own creative genius with lessons learnt from Leonardo da Vinci and Michelangelo.

The handling of the idealized landscape and the minutiae of nature owe much to Leonardo (see *Ginevra de' Benci*, p.303), as do the complex poses. The composition possesses an effortless balance and

harmony, each figure in the pyramidal structure lending dynamism to the whole and anchoring it within the circular frame. Nude figure studies were the basis of the Renaissance artist's working method, and Raphael sketched a boy model, probably one of his apprentices, to judge the hang of the Madonna's garments and to model her angelic face and hair. After he moved to Rome in 1508, the influence of Michelangelo became more apparent in his work: the figures dominate the picture space and possess a powerful monumental quality that may also reflect Raphael's fascination with Roman antiquity. Interestingly, the Alba Madonna is the first Virgin th artist clothed in Classical robes.

Seated Painter, Artist unknown
Opaque watercolour and gold on paper, 18.9 x 12.8 cm / 7½ x 5 in, Freer Gallery, Smithsonian Institution, Washington, DC

This Iranian painting is thought to have been based on the work of a Venetian artist, Gentile Bellini (c.1429–1507). Following the conquest of Constantinople (modern Istanbul) in 1453, the Ottoman sultan Mehmet II (reigned 1451–1481) set out to make his new capital a centre of artistic production. He invited several Italian artists to his court, including Bellini. One of the works attributed to Bellini at the Ottoman court is the portrait of a seated scribe, now in the Isabella Stewart Gardner Museum in Boston, Massachusetts, USA. In the late fifteenth century, the Bellini painting was sent to the Aqqoyunlu court at Tabriz, in eastern Iran, where it was incorporated into an album, providing a model for at least two copies made for the Safavid rulers of Iran in the first quarter of the sixteenth century. Both copies show the same figure of the seated artist in profile, but some details are altered. The decoration on the figure's robe has been changed from the original into a cloud collar pattern, and the small drawing he is making on his lap has been changed into a painting in Safavid style.

This copy, which shows the scribe in the same position as the original, probably provided the model for the second copy (now located in Kuwait), which shows the seated artist in mirror reverse.

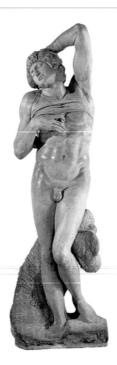

Michelangelo Buonarroti (1475–1564) considered himself primarily a sculptor, and the project to complete the tomb of Pope Julius II would preoccupy him for almost 40 years. Initially conceived as an enormous mausoleum, the scope of the monument was reduced after the death of Julius in 1513, and again in 1516, but even this smaller project was never completed. The so-called *Dying Slave* (1513–1515) was one of six figures to be installed on the cornice of the second version; Michelangelo's *Moses* and the *Rebellious Slave* were also made as part of this design.

The nearly completed statue features the raised arm that was employed to great effect in Michelangelo's figures for the Sistine Chapel ceiling. Here, however,

the treatment is less forced and the line more languid. The attitude of the *Dying Slave* is one of complete submission to the event; death is as sweet as it is victorious. The form has a gentility and sensuousness unusual in the male nude in Western art, but characteristic of Michelangelo's early sculptural style.

As sculptor, painter, poet, architect and engineer, Michelangelo remains one of the most influential artists in history, as well as being the most significantly documented artist of the sixteenth century. His output was immense, and his highly charged style gave rise, in the generations that followed the High Renaissance, to the next major artistic movement in the West: Mannerism.

Melencolia I, Albrecht Dürer

Engraving, H: 23.9 x 18.9 cm / 9½ in x 7½ in, Various locations

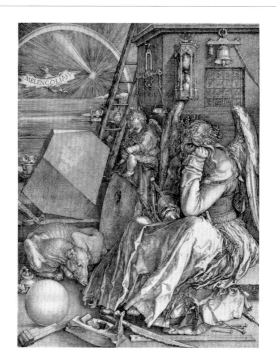

Albrecht Dürer (1471–1528) was an outstanding painter, draftsman and writer, but it was his printmaking that spread his fame. He was the first artist to establish his own printing business, on a par with his painter's workshop, and he revolutionized the techniques of woodcut printing and engraving. In this masterwork, Dürer used a burin (a fine steel tool) to etch his design onto a copper plate, achieving a remarkable degree of expressivity and detail of line, combined with an unprecedented depth of total range through elaborate cross-hatching and tiny incisions that create a smooth transition of grey tones. The complexity and drama of Dürer's subject matter endowed the humble medium with a new legitimacy.

This engraving has become the epitome of the Renaissance print, and its meaning has provoked much debate. The winged figure in a contemplative pose has been seen as a self-portrait of Dürer in the grip of the first of the three types of melancholy, *melencholia imaginativa*. The magic square on the wall alludes to a possible motive for the artist's melancholy – the death of his mother on 5 May 1514 – and various details refer to the four humours, which since antiquity had been held responsible for a person's individual disposition. At the time of the Renaissance, melancholy was associated with genius and creativity, and the engraving may be interpreted as a highly complex allegory of the struggles of the artist.

The Isenheim Altarpiece, Matthias Grünewald
Oil on panel, 269 x 590 cm / 8 ft 9¾ in x 19 ft 4¼ in (wings open),
Musée d'Unterlinden, Colmar

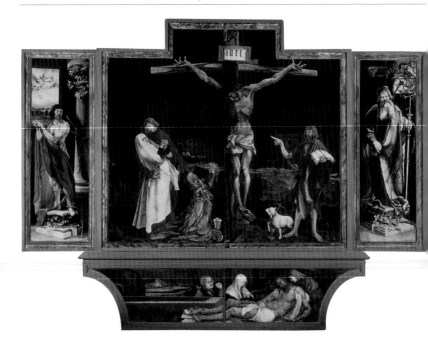

The Isenheim Altarpiece is a masterpiece of symbolic expression and emotion, revealed through gesture and colour. Painted for the Hospital Order of St Anthony in German Alsace (now France), the imagery of this elaborate polyptych (a painting with four or more panels) reflects its function of offering succour and hope to the sick and the dispossessed.

With the wings closed (shown here), it shows a bleak and darkly brooding landscape, within which an oversized, hideously wounded and broken, crucified Christ is the focus of piteous lamentation. St John the Baptist offers comfort with the words 'we must diminish so that he may increase'. St Anthony (right), protector against ergotism (poisoning by eating bread

made of grain diseased with ergot) and St Sebastian (left), protector against plague, flank the scene.

With the wings open (not shown), a joyful burst of riotous colour pervades scenes of hope – the Annunciation, a charmingly tender Virgin and Child serenaded by an angelic concert, and the resurrected Christ, his tortured body now restored to an immaculate, radiant purity. These panels open to access a further level, with an older, sculpted altarpiece at the centre and scenes from the life of St Anthony, also by Grünewald (c.1475–1528), on the wings. The Temptation of St Anthony, in which the saint is tormented by grotesque monsters, is particularly threatening.

The Carrying to the Grave, Jacopo Pontormo
Oil on panel, 313 x 192 cm / 10 ft 3¼ in x 6 ft 3½ in, Cappella Capponi, Santa Felicità, Florence

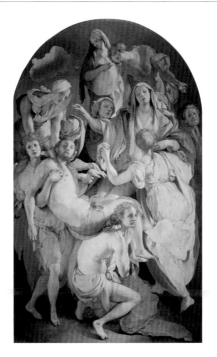

Jacopo Pontormo (1494–1557) was something of an eccentric, reclusive artist, and he took three years (1525–1528) to complete this startling painting. The composition fuses various scenes in the Passion of Christ in an entirely novel manner. Here, the Deposition, the Placing at the Grave and the Pietà (the Virgin holding the dead Christ) form a single narrative, which the spectator has the impression of interrupting. On the right in the background is a self-portrait of Pontormo in the guise of Nicodemus, traditionally depicted as an artisan in a turban. The artist invites us to participate in the event, just as he does. The unusual iconography may be an allusion to recently formulated Counter-Reformation doctrines

of Divine Love, which were embodied in the mystery of the Eucharist.

Michelangelo was a primary influence upon Pontormo, shown both by the vivid colours reminiscent of the Sistine Chapel ceiling and by the pose of various figures that echo the *Pietà* in St Peter's and other works by the master. Artists of the High Renaissance felt they had perfected the portrayal of reality, and Mannerists sought counter-realist forms of expression. Pontormo's bright, almost fluorescent palette and his elongated figures in complex postures are characteristic of the new style.

Anne Cresacre, Thomas More's Daughter-in-Law, Hans Holbein the Younger
Black and coloured chalks on paper, 37.3 x 26.7 cm / 1 ft 2¾ in x 10½ in,
Royal Library, Windsor Castle, Windsor

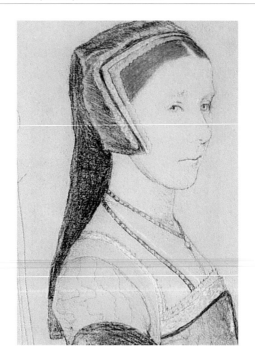

Hans Holbein's (c.1498–1543) expressive portrait drawings are rightly considered masterpieces in their own right, although most were intended as studies for paintings. In this portrait, dated to between 1526 and 1528, the slight turn of the woman's head and her direct and frank glance towards the viewer impart vivacity and a sense of personality, and his use of coloured chalk produces a lively effect.

Holbein journeyed to England with a letter of recommendation from the Dutch scholar Erasmus. There he found particular success with his portraits of statesmen, aristocrats and royalty, notably Henry VIII, and he became close to Henry's chancellor and friend of Erasmus, Sir Thomas More. This portrait of

More's daughter-in-law is a preliminary study for a large group portrait of More and his family, lost in a fire but recorded in a full-size sketch (Kunstmuseum, Basel). Had that painting survived, it probably would have ranked with Holbein's *Ambassadors* (National Gallery, London) as one of the defining images of the Northern Renaissance.

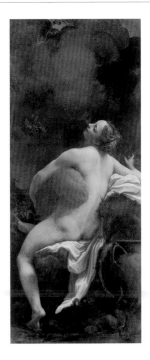

The northern Italian artist Correggio (Antonio Allegri; c.1489–1534) is particularly well known for his painting of allegorical and mythological subjects that catered for a refined courtly taste and showed novel iconographic solutions to somewhat *recherché* subject matter. This work is from the artist's last series of mythological paintings, unfinished at his death; commissioned by Federico II Gonzaga, duke of Mantua, they were to decorate the Room of Ovid designed by Giulio Romano in the Palazzo del Te at Mantua (see also Romano's *Hall of the Giants*, p.331).

The large canvas depicts the princess Io being ravished by the god Jupiter in the form of a nebulous cloud from which his hand and face barely emerge.

The subtle eroticism of the soft white flesh of Io's languorous body fusing with the dark storm clouds of the god would have pleased the worldly Federico and would have made a fitting decoration for a room assigned to his mistress, Isabella Boschetti. Nevertheless, Renaissance paintings often had complex multiple readings. For example, the deer drinking from the spring in the foreground symbolized a longing for God, adding an appropriate moral veneer to the provocative subject. The clear delight in the sensual nature of the female form and the light, playful mood have been seen as foreshadowing the Rococo style.

Court of Gayumars, Sultan Muhammad
Opaque pigments, gold and ink on paper, 34.2 x 23.1 cm / 1 ft 1 in x 9 in,
Private Collection

This painting by Sultan Muhammad (fl.1505–1550) of the court of Gayumars from the monumental copy of the *Shahnama* (Book of Kings) was made for the Safavid shah Tahmasp (reigned 1524–1576). Dated to 1525–1535, it is often reckoned to be the masterpiece of Persian painting. The painter Dust Muhammad (1490–c.1565), who himself added a painting to this manuscript, described Sultan Muhammad as the 'zenith of his age', whose depiction of a scene of people clothed in leopard skins 'made all other painters quail and hang their heads in shame'.

Gayumars, the legendary first king of Iran, is said to have ruled from a mountain top. Under his tutelage, humankind learned the arts of dress and food. This scene depicts the king gazing down at his young son (who will soon be killed in battle against the Black Demon), surrounded by courtiers dressed in leopard skins. The extraordinarily vibrant palette and the exquisite detail, including small faces hidden in the rocks, lush vegetation and lavish use of gold for sky and marginal flecks, make this a *tour de force* worthy of a king.

1532
Italy

Hall of the Giants, Giulio Romano
Fresco, H: c.105 cm / 3 ft 6 in (central figure in clouds), In situ, Palazzo del Te, Mantua

Giulio Romano (c.1499–1546) trained in Rome under Raphael but moved in 1524 to Mantua, where he worked as court artist for the Dukes of Gonzaga. His inventive distortions of the Classical rules of architecture and the Renaissance canons epitomize Mannerist art. In 1524 he began work on the Palazzo del Te for Federico II Gonzaga. The plans became ever more ambitious and culminated in the celebrated Hall of the Giants (1532–1535), a detail of which is seen here.

The *Metamorphoses*, by the Roman poet Ovid, recounts how the rebellious giants, who tried to scale the heights of Mount Olympus and challenge the gods, were struck by the lightning bolts of Jupiter and fell back to earth. The fresco is a tour de force of illusionism, in which the very fabric of the walls seems to tumble down upon the terrified and delighted spectator. With no visible ornamental separation of wall and ceiling, the frescos form one uninterrupted fictive spherical space in which even the pebble floor once merged with the *trompe l'oeil* of the lower walls. The ambitious Federico had recently been made a Duke by Emperor Charles V, and the victory of the Olympians may flatteringly allude to the imperial defeat of Francis I of France.

Salome with the Head of John the Baptist, Lucas Cranach the Elder
Oil on panel, 87 x 58 cm / 2 ft 10¼ in x 1 ft 11 in, Museum of Fine Arts, Budapest

There are many variations in Renaissance painting on the themes of Salome with the head of John the Baptist, and Judith and Holofernes, in which the lady in question is invariably dressed in the height of fashion, with opulent jewels and elaborate headgear. It seems that these purported mythological or Biblical scenes were, in fact, portraits of noble ladies of the court. The choice of Judith or Salome as a hidden portrait seems to have begun in Italy, perhaps originally to portray courtesans. It has been suggested that the message here is more one of courtly love, with the viewer accepting the allusion as a morbid joke, the noble ladies identifying themselves with the winner and the noblemen with the victim of love's games.

Lucas Cranach (1472–1553), who took his name from his native Kronach in Franconia, learned the art of painting from his father, Hals. After 1505, he worked in Wittenberg as court artist to Frederick the Wise, Elector of Saxony and protector of the religious reformer Martin Luther. Sometimes referred to as the chief artist of the Reformation, Cranach developed a softer, more ornamental style of courtly work than that of his father, ranging from staid portraits of black-clad electors to naked beauties in the respectable guise of Venus.

c. **1539**
Iran

Ardabil Carpet, Maqsud of Kashan
Wool and silk, 10.5 x 5.3 m / 34 ft 5 in x 17 ft 6 in, Victoria and Albert Museum, London

This enormous carpet is the most famous example to survive from the early sixteenth century. It is one of a matched pair made for the dynastic shrine of the sufi shaykh Safi al-Din at Ardabil in northwestern Iran. (The other, cut down in order to repair this one, is in the Los Angeles County Museum of Art, California.) Knotted in 10 colours of wool on a silk foundation, each carpet shows a central sunburst surrounded by 16 pendants, with a mosque lamp hanging at either end. The corners are filled by one-quarter of the central design. A small cartouche at the top contains a couplet by the lyric poet Hafiz, followed by the signature of the court servant Maqsud of Kashan and the date 946 AH (1539–1540). As it is inconceivable that a single

person could have tied the 25 million knots in each of these carpets, Maqsud must have designed the paper cartoon from which the carpets were woven.

Knotted carpets are so commonly associated with the Islamic lands that the traditional heartland of Islam, from Spain to Central Asia, is sometimes called the 'rug belt'. Under the Safavid rulers of Iran (reigned 1501–1765), production was transformed from a craft of nomads and villagers into a state industry carried out in urban factories.

Wagtails, Pine and Waterfall, Kano Motonobu
Ink and colour on paper, 180 x 140 cm / 5 ft 10 in x 4 ft 8 in, Daisen-in,
Daitoku-ji Temple, Kyoto

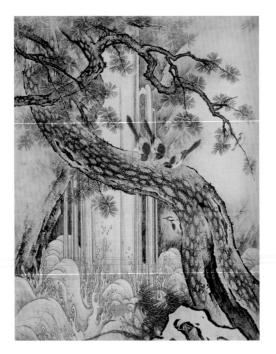

The decline of centralized warrior rule in Kyoto during the late Muromachi period (1333-1573) opened new opportunities for both the energetic samurai and the enterprising artist. The Kano family of painters took advantage of the situation and, under the leadership of Kano Motonobu (1476–1559), secured a dominant position in the painting world, which they retained for 300 years. In addition to screens and hanging scrolls, the Kano artists painted the sliding wall panels (*fusuma-e*) of rooms in elite settings, co-ordinating the decoration in elegant thematic programmes. This sliding wall panel, from a set of 16 now remounted as hanging scrolls and dated to the first half of the sixteenth century, formerly appeared on the north wall of the Patron's Room at Daisen-in, a sub-temple in the Daitoku-ji temple complex in Kyoto. It was the focal point of a cycle of Ming Chinese (1368–1644) inspired bird-and-flower paintings in the temple.

The aged pine in the foreground follows a tortuous upward path, suggesting growth through difficult seasons. In bold counterpoint, a waterfall plunges behind and strikes the stream below with such force that it sends up a large splash and turbulent waves. Japanese wagtails and other birds pause to take in the spectacle. The scene combines vitality with permanence and grandeur – qualities that became synonymous with Kano school imagery.

Benvenuto Cellini (1500–1571) was one of the foremost sculptors, medallists and goldsmiths of his age. He created this exquisite saltcellar between 1540 and 1543 for Francis I of France (reigned 1515–1547). Prevalent Mannerist tastes greatly appreciated abundance and ingenuity, and this precious piece is a *tour de force* of inventive detail. The legs of the goddess Ceres (or earth, the source of pepper) and Neptune (or the sea, the source of salt) intertwine suggestively, just as the real sea penetrates the coastline. In his picaresque autobiography, Cellini explained how Ceres 'had a richly decorated temple … intended to receive the pepper. In her other hand I put a cornucopia overflowing with all the natural treasures I could

think of.' Neptune grasps a trident and gazes at a ship sculpted to hold a quantity of salt.

The niches of the base contain figures of Morning, Day, Evening and Night, the four winds, and emblems of human activity. Many of the sculptural elements are based on models of the Fontainebleau school, one of the major artistic centres of Mannerism, and the times of day are modelled after Michelangelo. Nevertheless, Cellini's personal genius pervades all, creating a rich, sensuous piece of tableware.

This large, footed basin shows how Ottoman potters working at Iznik in western Anatolia (modern Turkey) in the sixteenth century extended the possibilities of both palette and shape in decorated ceramics. To the original cobalt blue they first added turquoise. By the 1530s, they had extended the palette in the so-called Damascus style to include pale purple and greyish green as well as a chromium black line that imitated the black ink used by calligraphers.

The decoration was equally skilful. The outside of the basin is painted with composite blossoms and serrated leaves typical of the *saz* style, which was associated with the court arts produced for Sultan Süleyman the Magnificent (reigned 1520–1566). The

inside shows sprays of blue hyacinths set between cartouches with black cloud bands.

The basin, dated c.1545–1550, belongs to a series that may have been used for washing the sultan's feet: a court inventory of the Ottoman treasury made in 1505 mentions 'foot basins', either basins for washing the feet or basins mounted on a circular foot. In either case, they are a *tour de force* of the potter's art.

Tughra for Sultan Süleyman, Artist unknown
Opaque pigments and gold on paper, 52.1 x 64.5 cm / 20 x 25 in, Metropolitan Museum of Art, New York

Edicts issued by the Ottoman chancery in Istanbul were written on a scroll and validated at the top with the sultan's official emblem, or *tughra*, which was designed at his accession. The Ottoman *tughra* always included several vertical strokes with S-shaped flourishes juxtaposed to several wide loops. It reached its classical form, shown here, under Sultan Süleyman (reigned 1520–1566).

The text, piled up at the bottom right of the *tughra*, contains the sultan's genealogy (Süleyman Shah ibn Selim Shah Khan), followed by a benediction ('may his victory endure') in fine gold calligraphy that ends to the left. The text is written in an extremely stylized form that is meant to be recognized as much

as actually read. Drawn up by a master calligrapher, it was decorated by a master illuminator, who painted the letters in blue, outlined them in gold and filled the interstices with spirals, flowers and feathery leaves typical of the *saz* style perfected under Süleyman's reign (see also the Ottoman Basin, opposite).

1551
Belgium

The Butcher's Stall, Pieter Aertsen
Oil on panel, 123 x 167 cm / 4 ft 4¼ in x 5 ft 5½ in,
Uppsala University Art Collections, Uppsala

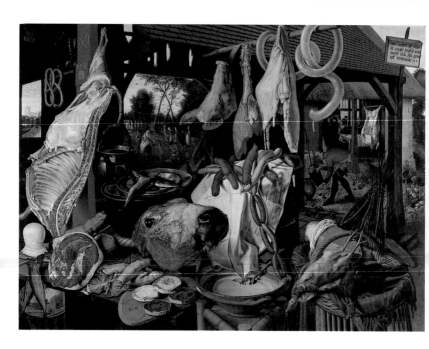

Pieter Aertsen (c.1508–1575) pioneered and popularized large-scale still life and genre scenes, specializing in market and kitchen views in which a small, barely visible religious scene adds a moral and spiritual dimension. In *The Butcher's Stall*, the rich variety of meats and their products, and the carousing company to the right, make a stark contrast to the background scene of the Holy Family distributing alms. On the stall, the Lenten fare of herrings, arranged as a cross, and the plain pretzels reinforce the message that we must learn to see beyond material comfort for the sake of bodily and spiritual wellbeing. The plaque on the right advertises the land behind it for sale – a legacy perhaps of the dissipation beyond.

Most arresting is the bull's head. The bull has been sacred to many cultures (see, for example, the Kneeling Bull with Vessel, p.22, and the Bull Standard, p.27), and in medieval Bibles, the image of the Prodigal Son's fatted and slaughtered calf was compared to the Crucifixion of Christ, both signifying redemption from sin. In the Netherlands during the seventeenth century, *vanitas* still lifes – featuring objects such as skulls to symbolize the brevity of human life – reprised the message of death, and Aertsen's abundance of foodstuffs found a legacy in still lifes such as those by Jan de Heem.

1559
Italy

The Rape of Europa, Titian
Oil on canvas, 185 x 205 cm / 6 ft ¾ in x 6 ft 8¾ in, Isabella Stewart Gardner Museum,
Boston, Massachusetts

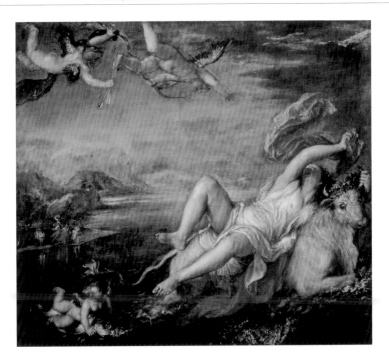

When Tiziano Vecellio (c.1490–1576), known as Titian, painted *The Rape of Europa* (1559–1562) for Philip II of Spain, he was in his seventies. He was internationally renowned, and had already painted a number of large pictures of sacred and profane subjects for the young monarch in return for a generous pension. Among the most distinctive was a series derived from Ovid's *Metamorphoses* that Titian termed *poesie* ('poetries'). All represent erotic themes charged with tragic overtones that were chosen by Titian himself, not his patron.

In Greek mythology, Europa was the daughter of Agenor, king of the Phoenicians. She was playing with her attendants on the shore when she was spotted (and desired) by Zeus. He assumed the guise of a white bull that charmed Europa with its beauty and docility, but the instant she climbed on his back he charged into the sea, abducting her. Titian shows the moment that Europa discovers her plight, distant from the security of the shore and her companions. At the same time he also suggests love, personified by Eros, anticipating the time when, on faraway Crete, Europa will give birth to Zeus's son Minos. In a sunset that reflects her mood, Europa writhes, stripped of all modesty by paradoxical emotions of terror and ecstasy. Her psychological state is echoed by Titian's swirling brushstrokes and vibrant use of colour.

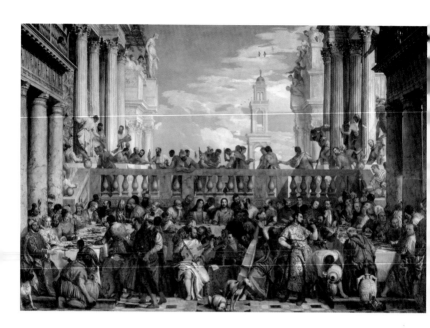

This immense canvas was executed in 1562–1563 for the Benedictine monks of San Giorgio Maggiore in Venice to cover an end wall of their refectory. The magnificent backdrop of sweeping Classical colonnades reflects the Palladian structure of the recently constructed monastery and provides a truly theatrical backdrop reminiscent of sixteenth-century stages. While the subject of Christ performing his first miracle, turning water into wine at a wedding feast in Cana in Galilee, was entirely appropriate for a refectory, the opulent, colourful event as it appears here has in it more of the profane than the sacred. The saints are dressed in the height of Venetian fashion, and there are various distinguished contemporaries

in the throng; these supposedly include Veronese (Paolo Caliari; 1528–1588) himself, in white with a viola da gamba (centre left), who sits opposite his contemporary Titian, dressed in red (centre right).

With Titian (see *The Rape of Europa*, p.339) and Tintoretto, Veronese came to dominate the Venetian art scene. His use of colour, however, differed from that of other painters of the Venetian school, and hints of his training in Verona can be seen in his distinctive yet harmonious colouring. This commission made Veronese's name in Venice, and countless monasteries petitioned him for similar works, despite the fact that there were those who viewed his excessively decorative settings as tantamount to sacrilege.

Winter, Giuseppe Arcimboldo
Oil on panel, 67 x 50.8 cm / 2 ft 2½ in x 1 ft 8 in, Gemäldegalerie,
Kunsthistorischesmuseum, Vienna

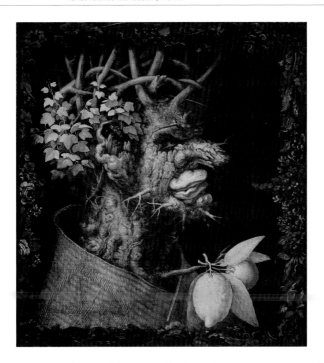

The Milanese artist Guiseppe Arcimboldo (c.1527–1593) was called to the Habsburg imperial court in 1562 as a portraitist and organizer of court festivities. His fame, however, was cemented by the fantastical, allegorical heads composed of depictions of natural objects, which he created for a series of Habsburg emperors. Despite their fanciful appearance, they allude to a complex system of natural philosophy. The heads of the Seasons and the Elements were created specifically to adorn the imperial Kunstkammer 'cabinet of curiosities'. As the Holy Roman Emperor dominated the body politic and the world of men, so he ruled over the elements and seasons. The harmony of all the elements reflects that of Habsburg rule.

This figure of *Winter* is wrapped in a mantle bearing a poker symbol from the royal insignia and the strokes of the letter M for Arcimboldo's patron Maximilian II of Bavaria. The ancient Romans began the year with winter, as do we, and this head could be seen as an allegory of the new emperor himself.

Arcimboldo's oeuvre spawned a whole new genre, and copies of his works with different hidden symbols were sent to allied European rulers. Centuries later, his unique vision was to have a profound effect upon the Surrealist movement.

Mannerism

Census at Bethlehem, Pieter Bruegel the Elder
Oil on panel, 115 x 163 cm / 3 ft 9¼ in x 5 ft 4 in,
Musée Royaux des Beaux-Arts, Brussels

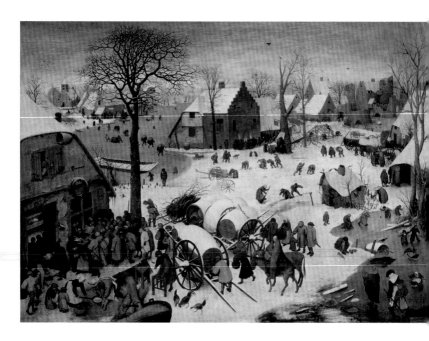

Bruegel's atmospheric and carefully observed painting of a sixteenth-century Flemish village in the snow beautifully captures the activities of its inhabitants at work and at play. However, in the middle foreground we see the Virgin Mary in her blue cloak on a donkey, being led by Joseph towards a crowded inn housing the offices of the imperial census and tax office. This device, of placing Biblical events in contemporary settings, was common to sixteenth-century Flemish painters and emphasized the relevance of the past event to the present day, imparting a moral as well as spiritual message.

Bruegel's paintings were avidly collected by a sophisticated Antwerp intelligentsia. They would have understood his sophisticated wit, and the *Census at Bethlehem* must be viewed in the context of political events. At the time, the Netherlands were under the control of Spain, whose king, Philip II, imposed punitive taxes and enforced Catholic orthodoxy on a populace increasingly sympathetic to the Protestant cause, leading to revolt that would eventually split the Netherlands. Bruegel (c.1528?–1569) made it clear that Philip's draconian measures were to be compared with those of Caesar in one small detail of the painting: the poster at the census office, just above the crowd, displays the double-headed eagle – symbol of ancient Rome and later the Hapsburg dynasty.

Pine Forest, Hasegawa Tohaku
Ink on paper, 170 x 350 cm / 5 ft 1 in x 11 ft 5 in, National Museum, Tokyo

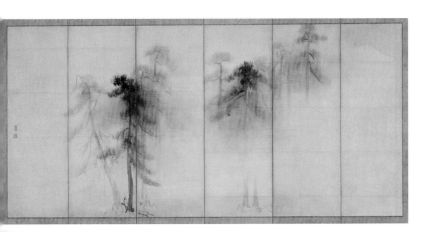

Few artists have handled India ink with more subtlely than Hasegawa Tohaku (1539–1610) in this evocation of pine trees through the mist, dated to the second half of the sixteenth century. He indicated the massed branches of the trees in the foreground by means of dark ink applied with dense brushstrokes; then he developed the trunks and needles of the distant trees with such pale washes and minimal detail that they almost dissolve into air. Graded ink washes elsewhere suggest that in the thinnest areas, the mist is filled with light. The space around the trees becomes an active atmosphere that moves through and unites the landscape. The scenes stretches across a pair of six-panel screens; this is the right-hand one of the pair.

Tohaku may have learned these painterly techniques, and the effect of natural elements seeming to melt together, from the ink landscapes of the Southern Song (1127–1279) Chinese artist Muqi, which he could have studied in contemporary collections. However, Chinese painting seems to possess no exact stylistic match for his work. It took a creative leap to expand a single motif from traditional Southern Song landscapes into the principal subject of two folding screens, and a second leap to present the subject entirely in ink, without the gold found in most other paintings from the Momoyama period (1573–1615).

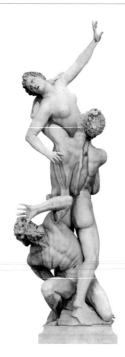

This sculptural group is signed by the Flemish-born Giambologna (1529–1608) and comprises three figures carved from a single block between 1581 and 1583: a man crouching with a raised arm at the base and a standing young male figure in the centre, who lifts an anguished female figure in his arms. The contemporary writer Raffaello Borghini explains in his *Riposo* of 1584 that the sculpture was initially an exercise in self-publicity, intended to demonstrate that the artist could produce the most complex of figures on an imposing scale. The Grand Duke of Tuscany, Francesco de' Medici, placed the statue in the Loggia dei Lanci in Florence's Piazza della Signoria, at which point it was given the name by which it is known

today. Legend had it that in order to increase the population of his city, Romulus, the founder of Rome, invited his neighbouring Sabines to a festival at which the nubile Sabine women were abducted and raped.

A perfect example of Mannerist form, the tightly arranged figures twist upwards in a strong vertical spiral that demonstrates the *figura serpentina*, a composition that ensured that the statue could be viewed from all angles, with no single vantage point. In both composition and form the statue looks forward to the later Baroque work of Lorenzo Bernini (see the *Ecstasy of St Teresa*, p.364).

Hindola Raga, Artist unknown
Opaque watercolour and gold on paper, 23.8 x 18.3 cm / 9¼ x 7¼ in,
National Museum, New Delhi

Artists of the South Asian painting tradition were fascinated by the topic of the *Ragamala* (literally 'garland of musical modes'). The 36 different musical modes offered artists various ways to represent the topic of love or heroic behaviour. In this watercolour, dated to c.1580–1590, we see a Deccani artist's approach to the musical mode *Hindola raga*, in which is represented a young prince seated on a *hindola*, or swing, which is surrounded by three beautiful ladies. This *raga* was originally part of a *Ragamala* series that is now dispersed.

In the late sixteenth century, on the Deccan plateau of central India, there were two rival Muslim dynasties, the Nizam Shahis in the city of Ahmadnagar and the Adil Shahis in Bijapur. Both groups sponsored local artists, and their stylistic trademarks – such as the depictions of figures with elongated forms and sharp facial features – overlapped, making it difficult to assign a specific region for this work. It has been suggested that Sultan Adil Shah II (reigned 1580–1627) of Bijapur was the likely patron for this painting, as he had an extreme fondness for music. However, the Sanskrit inscription above the image, which provides details about the specific musical mode, alludes to the fact that the patron was not a Muslim but rather a Hindu prince who lived in the region.

1586
Spain

Burial of the Count of Orgaz, El Greco
Oil on canvas, 480 x 360 cm / 15 ft ¾ in x 11 ft 9¾ in, Church of Santo Tomé, Toledo

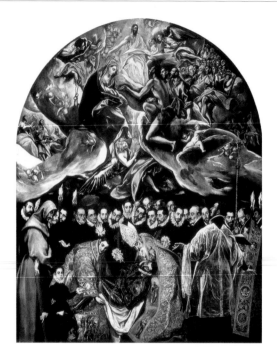

Eccentric and isolated, Domenikos Theotokopoulos, called El Greco (1540/41–1614), had been living in Spain for nearly nine years when he was commissioned by the Church of Santo Tomé in Toledo to paint a commemorative work celebrating the burial of Don Gonzalo Ruiz of Toledo, Lord of Orgaz. According to the records of this event, which occurred in 1312, the congregation had experienced a vision in which St Augustine and St Stephen descended from heaven to place the body in its tomb.

El Greco worked on the painting between 1586 and 1588. He represented the scene as described in the ancient source but transformed it into a vision of heaven and earth, with the Virgin and John the

Baptist, who interceded with Christ, surrounded by saints and angels. In this intermingling of temporal and divine powers, the Mannerist tradition of painting is brought to a disturbing climax.

Some of the figures painted here are thought to be portraits, and according to some accounts, El Greco even included a portrait of himself (in the background row of figures, sixth from the left, looking out) and his son (bottom left). The artist's signature appears on the handkerchief in his son's pocket and bears the boy's birth date, 1578, thus uniting contrasting references to birth and death.

Young Man among Roses, Nicholas Hilliard
Watercolour on vellum, 13.5 x 7.3 cm / 5¼ in x 3 in,
Victoria and Albert Museum, London

This full-length portrait, made by Nicholas Hilliard (c.1547–1619) between 1585 and 1595, is the embodiment of the romantic Elizabethan age. The sitter may be Robert Devereux, the second Earl of Essex, the queen's favourite at the time. He leans against a tree, an emblem of steadfastness, surrounded by eglantine roses, a personal device of the queen. He also wears the queen's colours, black and white, symbolizing chastity and constancy. Such miniatures were often worn as declarations of love and functioned as *imprese*, a complex personal combination of word and symbolic image that served as a form of Renaissance puzzle.

Nicholas Hilliard was originally apprenticed as a goldsmith and appears to have been largely self-taught. In his treatise *The Arte of Limning* (c.1600, but not published until 1912) he advises the careful copying of Dürer engravings and declares that 'Holbein's manner of limning [painting] I have ever imitated, and hold it for the best.' He effectively founded the English school of miniature painting. His figures possess a two-dimensional aesthetic that is seen throughout Elizabethan painting – linear, with a uniform light that flattens the scene and eliminates *chiaroscuro* (the contrast of light and dark). His figures also represent a personal interpretation of the Mannerist models of the Fontainbleau court, at which Hilliard spent part of his career.

The Calling of St Matthew, Michelangelo Merisi da Caravaggio

Oil on canvas, 322 x 340 cm / 10 ft 6¾ in x 11 ft 1¾ in, In situ, Contarelli Chapel, San Luigi dei Francesi, Rome

Together with its pendant work, *The Martyrdom of St Matthew*, *The Calling of St Matthew* (1599–1600) was the first major commission for the precocious Caravaggio (1573–1610), who began both works when he was only 26 years old.

Here, the figure of Christ is cast in deep shadow to the extreme right of the painting and is partially obscured by the attendant St Peter. Behind them, a beam of divine light cuts across the upper part of the wall, splitting Christ's halo and falling upon the bearded man seated at the centre of the table. Most interpretations see in his questioning gesture and prominent position the figure of Levi the tax collector, as Matthew was known before his conversion. An

alternative reading sees the bearded man as paying dues to the younger figure seated at the end of the table – this is Levi. In this view, Caravaggio's narrative is incomplete, and the work marks a dramatic break with convention: Matthew is still absorbed in his sinful life and has yet to hear the call.

The vertical triangle of the figures at the right and the horizontal block of those at the left divides the composition into two parts, the profane and the holy. The contrast is reinforced by the void between the two groups and the Antique cloaks of Christ and the apostle, as opposed to the contemporary costumes worn by Levi (whichever figure he is) and his companions.

Male Seated on Quadruped, Artist unknown

Steatite, H: 19 cm / 7½ in, National Museum of African Art, Smithsonian Institution, Washington, DC

Works in this style date from as early as the fifteenth century to the eighteenth and are found throughout Sierra Leone and Guinea; which country this sculpture comes from is unknown. It is attributed to the Sapi people, whose modern descendants are the Baga, Temne and Bullum. Its original significance is also unclear, for over the last century these steatite (soapstone) figures, called *nomoli*, have been adapted for different ritual uses by people who have discovered them on their land. They may have been intended as commemorative works that celebrated the regenerative forces attributed to prominent people.

Sapi sculptors typically embraced an exaggerated stylization in which the body is condensed. In this classic example the figure is seated with his elbows resting on his knees, hands held to his chin. The head is dominant, and its facial features are given bold definition in the treatment of the prominent triangular ears and flaring nostrils. The twisted band that encircles the head may resemble those worn by modern chiefs at their installations.

Most striking, however, is the diminutive animal on which the figure sits. This symbolic mount may be an elephant or a leopard, both associated with royalty in Temne society. The elephant is identified with the strength a leader may derive from his people, while the leopard represents unbridled power.

Still Life with Quince, Cabbage, Melon and Cucumber, Juan Sánchez Cotán
Oil on canvas, 69 x 84.5 cm / 2 ft 2¾ in x 2 ft 11 in, San Diego Museum of Art,
San Diego, California

Although well loved in antiquity (see also Still Life, p.136), the modern still life emerged as an autonomous subject for artists only at the end of the sixteenth century, when it flourished in southern Europe. Studies of fruit, other food and precious objects were produced by a number of outstanding masters, many of them little known today.

The paintings by Juan Sánchez Cotán (1560–1627) are all about austerity and self denial, with the elevation of simple vegetables and fruits to heroic proportions, each in its space, the blank darkness of background suggesting a meditation on infinity. This painting, one of the first European still lifes since the Roman period, dates to c.1602–1603 and shows

how the artist places his quince, cabbage, melon and cucumber so cunningly that the imagery seems to move beyond the physical, inviting the spectator to share in a melancholy and austere train of thought.

The pain of human existence and shadow of death were often present even in the most abundant and richly endowed still lifes of this period. They were intended to point out that the beauties and pleasures of the world are transient, and that tragedy is inherent to the human condition – a line of meditation this artist continued to follow after entering a Carthusian monastery in 1603.

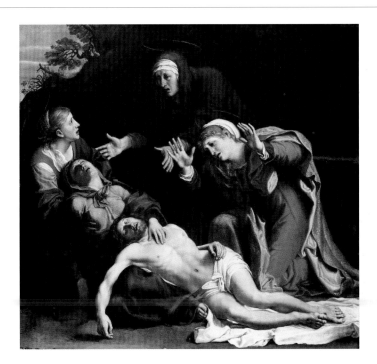

Annibale Carracci (1560–1609) was the most influential member of the Carracci family of artists, based in Bologna. He laid great importance on a renewed study of nature and the preparatory drawing process and drew early inspiration from fellow northern Italian artists, particularly Titian, Veronese and Correggio. After moving to Rome in 1595, he fell under the direct influence of the remains of Classical antiquity he saw there, as well as the works of Raphael and Michelangelo.

This Lamentation scene shows Christ on the Virgin's lap, surrounded by Mary, mother of James, Mary Magdalene and Mary Salome. Caracci created a number of variations on this theme, inspired by a painting by Correggio in Parma. In this work, Correggio's model is still discernible, but there is a new clarity of composition and precision of gesture. It is the influence of Raphael that appears uppermost in this late style (see the *Alba Madonna*, p.322) and earned him the nickname 'the new Raphael'. This clarity does not detract from an emotional force that eschews all Classical decorum and places the canvas squarely in the vanguard of seventeenth-century Baroque art. Rejecting Mannerist artificiality, Carracci's *oeuvre* embodies Counter-Reformation sentiments, fusing Roman idealism with an emotional vigour and a naturalism that connected directly with the viewer.

c. **1610**
Japan

Cranes, Tawaraya Sotatsu and Hon'ami Koetsu
Ink, silver and gold pigment on paper, 34 x 136 cm / 1 ft 1 in x 44 ft 5 in,
Kyoto National Museum, Kyoto

Along the shore of a golden sea, a group of silver cranes pauses to feed and contemplate their onward journey. Further on in this handscroll, the entire flock appears soaring over ocean waves. Cranes have an auspicious connotation in East Asian culture (see *Auspicious Cranes*, p.222), a subtext that may have been the initial motivation for the design. The painter Tawaraya Sotatsu (d. c.1643), however, went far beyond convention when he produced this virtuoso narrative depiction of a single natural motif. He radically simplified the forms of the birds so that they appear nearly identical, but then arranged them in such a way that they generate a lively and ever-varying pictorial rhythm. Before beginning to paint, he also

sized the paper with powdered shell, a non-absorbent material that caused the gold and silver inks to pool at random, thereby naturally differentiating the birds.

The cranes, moreover, were only the start of a remarkable collaboration, for over Sotatsu's design the calligrapher Hon'ami Koetsu (1558–1637) transcribed poems by Japan's 36 most renowned classical poets. Sotatsu's artistry found a match in Koetsu's robust and fluent calligraphic style, and the two artists collaborated on other projects similarly influenced by the courtly aesthetics of the Heian period (AD 794–1185). They are recognized as the spiritual founders of the Rinpa school of artists, who favoured themes drawn from indigenous Japanese literature and nature.

Picnickers, Reza 'Abbasi
Opaque pigments on paper, 26 x 16.7 cm / 10 x 6 in,
State Hermitage Museum, St Petersburg

From the middle of the sixteenth century in Iran, illustrations in manuscripts increasingly gave way to single-page works suitable for mounting in albums. The most famous artist associated with these drawings and paintings was Reza (c.1565–1635), whose epithet Abbasi shows that he worked for the Safavid shah Abbas (reigned 1588–1629) in Isfahan. After a mid-life crisis, during which Reza is said to have taken up with wrestlers and low-lifes and created scenes of dissolutes and dervishes, he reverted in about 1610 to courtly subject matter and the calligraphic use of line.

This scene of picnickers is the right side of a double-page painting. It is signed and dated Monday 1 Dhu'l Qa'da 1020 (5 January 1612) and exemplifies

Reza's mature style, in which his figures are ponderous and often set in elaborate landscapes of the type known from manuscript paintings. The palette of primary colours is extended with an array of secondary colours, including mauve, saffron, pink, pumpkin red, aquamarine and purple, to depict clothes and landscape. Such paintings show Reza's continued preoccupation with drapery, notably in the oversize turbans and the fluttering ends of the sashes.

1613
Italy

Judith Beheading Holofernes, Artemisia Gentileschi
Oil on canvas, 200 x 163 cm / 6 ft 6¾ in x 5 ft 4 in, Galleria degli Uffizi, Florence

It seems ironic that the most famous female artist of the Italian Baroque period (c.1600–1750) is perhaps equally renowned for her traumatic personal history. Allegedly raped at 19, Artemisia Gentileschi (1593–1652) was physically tortured during the trial that followed the incident in 1612. She subsequently moved from Rome to Florence, where she found favour with the Medici family and became the first female member of the city's Academy of Drawing.

Symbolic of the triumph of virtue over vice, the Old Testament figure of Judith was a popular subject for Gentileschi. A rich widow, Judith charmed her way into the camp of the Assyrian general Holofernes, whose armies were besieging her city. Having plied

the general with wine, Judith used his own sword to decapitate him, and with the help of her maidservant Abra returned to her home with the severed head.

This commission (1613–1614), which was probably for the Medici grand duke Cosimo II, who became Artemisia's principal patron in Florence, shows Abra actively assisting her mistress as she hacks at the general's head with a cruciform sword. As Holofernes struggles, blood spurts forth from the wound, drenching the fabric below him and cascading outwards in an arc that reaches as far as Judith's arm. The gritty realism of the whole owes much to Caravaggio's version of the same subject.

The Dying Inayat Khan, Attributed to Govardhan
Opaque watercolour and gold on paper, 12.5 x 15.3 cm / 5 in x 6 in, Bodleian Library,
University of Oxford, Oxford

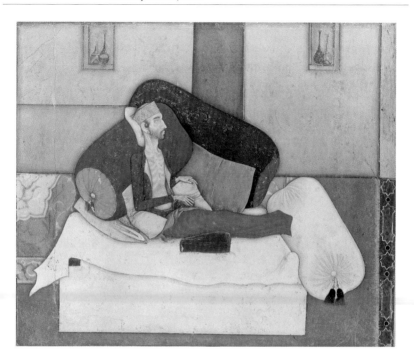

The Dying Inayat Khan is an extraordinary portrait of a Mughal courtier who suffered from an addiction to opium and wine. The Mughal emperor Jahangir (reigned 1605–1627), who was closely acquainted with the dying man, asked the court doctor to administer a cure and his artists to produce an exact likeness.

Jahangir's enthusiasm for the Mughal tradition of painting, similar to his father Akbar's, led him to establish formal workshops in the cities of Allahabad (1599–1604) and Agra (1605–1627) as part of a court-sponsored tradition of painting initiated in the sixteenth century by the emperor Humayun. Under Jahangir's influence, artists were challenged to shift from generic representations of individuals to realistic

likenesses that captured their true physiognomy and gave an impression of their character.

While this fine portrait of Inayat Khan is attributed to the artist Govardhan (fl. first half of the seventeenth century), it is believed that a similar study of the dying man was produced by one of his contemporaries, the artist Hashim. Hashim's version (Museum of Fine Arts, Boston) is unfinished but evokes a powerful emotional response from the courtier's gaunt features and skeletal body.

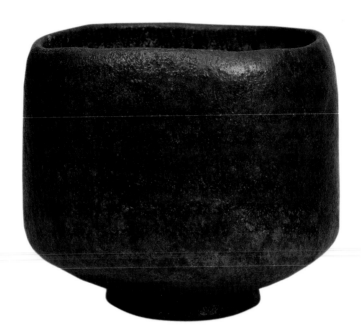

Raku ceramic vessels were originally developed for the Japanese tea ceremony, in particular the quiet style of tea drinking called *wabi-cha*, which emerged at the end of the sixteenth century. The rugged forms and monochrome low-fired glazes of Raku fit the spartan settings favoured for *wabi-cha* gatherings. The most celebrated examples are the raku teabowls hand-shaped by Hon'ami Koetsu (1558–1637), the early seventeenth-century sword expert, master calligrapher and amateur tea enthusiast.

This black raku teabowl, called 'Seven Leagues' (*Shichiri*) after the name of a former owner, exhibits the understatement and formal strength that have given Koetsu's work its special importance in the

history of tea. The low foot supports a wide horizontal base that angles sharply at the hip, leading to sheer walls that flare towards a subtly uneven rim. In certain areas, Koetsu created visual and tactile surface variations by scraping the glaze to bare clay. This innovative approach to glazing raku was partly inspired by Oribe ceramics, an intricately decorated late sixteenth-century style. Seven Leagues ranks among the so-called Koetsu Seven, considered the artist's most representative teabowls.

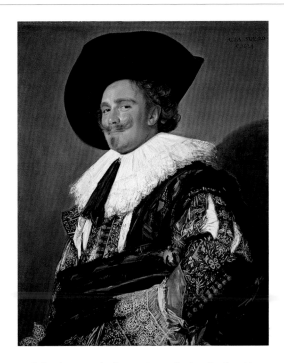

The Laughing Cavalier is the best known work of Franz Hals (1582/83–1666) and is much loved for its virtuosity and character. It conveys the personality of the sitter as a raffish roué who is looking directly at the viewer with a roguish grin, his hand assertively on hip. His exceptionally sumptuous clothing is delicately painted, but with such a bravura of brushstroke that when viewed at a distance, it optically resolves into focus without losing any sense of liveliness.

It is possible that *The Laughing Cavalier* may not have been intended as a portrait of an individual, despite the alleged age of the sitter – 26 – inscribed in the top right corner. Hals's reputation as a portrait painter in the seventeenth-century Low Countries

is second only to Rembrandt's, yet as with many of Rembrandt's pictures of his own family (see *Portrait of an Old Man in Red*, p.366), Hals's *Cavalier* may have been sold as a *tronie* – literally, 'fancy head' – a type of simulated portrait in which models were dressed in exotic garments. The embroidery on the sleeve, consisting of such love symbols as Cupid's bow and arrow, flaming cornucopia (horns of plenty) and lovers' knots, is probably an invention of the artist.

c. **1637**
Japan

The Matsushima Screens, Tawaraya Sotatsu
Colour and gold on paper, 150 x 360 cm / 5 ft x 11 ft 8 in (each screen), Freer Gallery,
Smithsonian Institution, Washington, DC

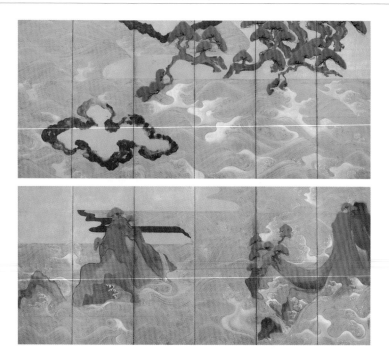

Tawaraya Sotatsu (d. c.1643) began his career painting fans and other speciality items, but eventually won large commissions to paint interiors and screens for members of the Edo-period (1615–1868) warrior elite and the imperial family. This magnificent pair of six-panel screens, dated to c.1600–1643 and depicting pine-covered islands in a rolling sea, may have been a similarly important commission.

Using a technique found in classical handscrolls, Sotatsu defined the waves with closely spaced lines of alternating black and gold ink, but he avoided strict patterning in favour of a natural variety that expresses the movement and counter-movement of a wind-driven ocean as it meets the shore (see also Cranes, p.352). The cloud-form in the top screen has a loosely painted border of silver ink (now oxidized). The mottled appearance is an intentional effect called *tarashikomi*, in which the artist brushes ink on to a painted area that is still wet. Sotatsu's workshop and followers adopted this as a signature brush method.

Beautiful as they are, the exact subject of these screens remains elusive. According to some scholars, they depict Matsushima, a famous place (*meisho*) on Japan's northeast coast often described in classical Japanese poetry. Others have suggested that the meandering line of the beaches recalls traditional depictions of the shore along Sumiyoshi, located near present-day Osaka.

Early Edo Period, Rinpa School

Equestrian Portrait of Charles I, Anthony van Dyck
Oil on canvas, 367 x 292 cm / 12 ft ½ in x 9 ft 7 in, National Gallery, London

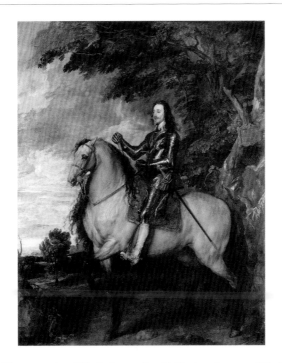

Anthony van Dyck's representation of Charles I of England (reigned 1625–1649) on horseback is the most imposing and monumental of the artist's many portraits of members of the Stuart court. The diminutive king is given stature and grandeur through the artist's mastery of a powerful warhorse, bred for carrying heavy suits of armour. By portraying Charles with the ability to hold such a horse in an elegant pose, van Dyck (1599–1641) projects the image of a highly skilled horseman and, by implication, a king whose hands firmly control the reins of State, ready to defend the realm in battle.

Such propagandistic images had a venerable tradition, notably in the equestrian portraits of the Spanish Hapsburg dynasty – of Charles V and Philip II by Titian and of Philip IV by van Dyck's own master, Rubens. By thus aligning himself with the rulers of England's arch-rivals, Charles I wanted to demonstrate his superiority to them, and van Dyck wanted to prove his work worthy of comparison with that of the two masters. His debt to them is evident in the loosely handled yet controlled brushstrokes of the work, which dates to c.1637–1638, but his ability to impart an elegant dignity to his aristocratic subjects is his own and was profoundly influential on later British portraitists such as Gainsborough.

The Horrors of War, Peter Paul Rubens
Oil on canvas, 206 x 342 cm / 6 ft 9 in x 11 ft 2¾ in, Galleria Palatina,
Palazzo Pitti, Florence

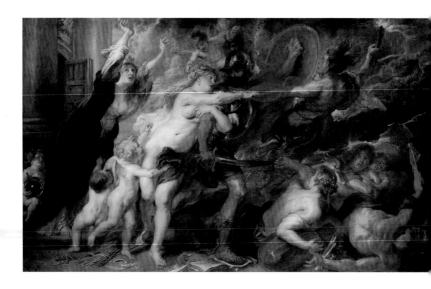

Painted for Ferdinand II de' Medici, Grand Duke of Tuscany, *The Horrors of War* (1637–1638; also known as *The Consequences of War*) is an allegorical response to the Thirty Years' War (1618–1648) that was devastating Europe at the time. A diplomat and scholar as well as an artist, Peter Paul Rubens (1577–1640) was compelled to describe the complex imagery of the painting in a letter to his friend Justus Sustermans, from which we learn that Mars, God of War, has left open the temple of Janus – which is closed in peacetime – and heedless of Venus, Goddess of Love, is dragged by the Fury Alekto into mayhem, accompanied by the monsters Pestilence and Fury. Cast aside and trampled underfoot are those benefits

of peace that are destroyed by war: architecture, harmony, the arts, letters and procreation, the latter represented by a mother and child. The grief-stricken woman dressed in black, robbed of all her jewels, personifies Europe.

The exuberance of Rubens's composition and his rich handling of paint are indebted to his youthful years in Italy, where he studied and copied the works of such masters as Titian. *The Horrors of War* is the antithesis of his *War and Peace* (National Gallery, London), painted several years earlier and presented to Charles I of England as a gift.

c. 1638
France

A Dance to the Music of Time, Nicolas Poussin
Oil on canvas, 85 x 108 cm / 2 ft 9½ in x 3 ft 6½ in, Wallace Collection, London

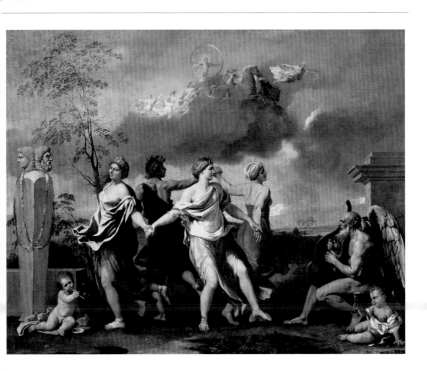

Nicolas Poussin (1594–1665) spent a large part of his artistic career in Rome, where he was deeply influenced by ancient sculpture and Italian Renaissance art, particularly the work of Raphael. His works possess a harmony and focused equilibrium of composition that together assuage the excesses of dramatic narrative and the expressive passions of the players. In this way the artist tried to reconcile the opposing tendencies of Classicism and Baroque art.

Poussin rarely employed assistants, preferring to handle every aspect of painting production himself. He created his compositions with small, nude wax figures, on a stage in a shadow box, and then progressed to larger draped figurines. In *A Dance to the Music of Time*, dated to between 1634 and 1640, the frieze-like foreground figures are caught in dramatic *chiaroscuro* (contrast of light and dark), their robes betraying the artist's earlier fascination with the rich colouration of Venetian painting. The four allegorical figures of Poverty, Industry, Riches and Pleasure perform a dance to the lyre of Father Time, which symbolizes the human condition.

The painting was commissioned by Giulio Respigliosi, later Pope Clement IX. An erudite poet and librettist, he provided a subject that may reflect early opera's theoretical concerns with the music of the ancients and its harmonious union with poetry and dance. This union could be seen as opera or painting.

Interior of the Buurkerk, Utrecht, Pieter Jansz Saenredam
Oil on panel, 58.1 x 50.8 cm / 1 ft 11 in x 1 ft 10 in, Kimbell Art Museum,
Fort Worth, Texas

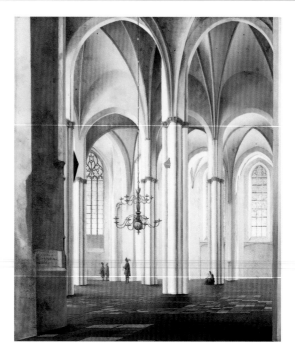

The works of Pieter Jansz Saenredam (1597–1665) are not without political overtones. This painting was executed not long after the Buurkerk had been cleansed of its Catholic finery. Altarpieces and statues were removed and wall paintings whitewashed over. At times, Saenredam even removed from his works any remaining popish elements and toned down Gothic arches. As such, his painting testifies to the Protestant Reformation in the Netherlands. At the same time, however, there is an ineffable poetry to his airy interiors, achieved through a simplicity and semi-abstract formalism that appeals to modern tastes.

Saenredam specialized in highly accurate representations of architectural interiors. His methodical approach was unlike that of any other Dutch contemporary. First, he produced detailed freehand sketches with annotated measurements, using pencil, pen and chalk with light washes to add texture and colour. Next, he prepared construction drawings that confronted the design problems of the on-site sketches and were then traced directly onto the final panel. The resulting painting is not a faithful rendering of reality. Saenredam's interiors encompass a wider view than that of the naked eye, though at the same time the artist subtly removed any of the inherent distortions of such a wide-angle vision. He often deliberately omitted people from the scene, concentrating on the soaring church interiors.

Seaport with the Embarkation of the Queen of Sheba, Claude Lorrain
Oil on canvas, 149 x 197 cm / 4 ft 10¾ in x 6 ft 5½ in, National Gallery, London

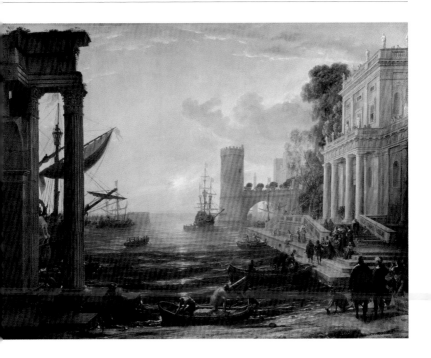

Claude Lorrain (Claude Gelée; 1600–1682) was born in Lorraine but spent his adult life in Rome. He went as a pastry chef but quickly became apprenticed as a landscape painter in Naples, and eventually established himself as the supreme seventeenth-century artist of ideal landscapes. Although he was strongly influenced by northern European landscape artists, by the point in his career when this work was made his paintings had become distinctively Classical in their allusions, with an air of gravity and grandeur. The contemporary architecture is increasingly replaced, as here, with imposing ancient ruins.

Over many years, Claude Lorrain made oil sketches and drawings from nature, but his final canvases are idealized compositions imbued with harmony and order. He was famed for his innovative handling of sunlight, caught with great realism and serving as a true light source for the whole scene. This large seascape and its pendant, the *Landscape with the Marriage of Isaac and Rebecca*, never reached their original patron, Cardinal Camillo Pamphili, nephew of Pope Innocent X, who fled Rome to marry Olimpia Aldobrandini. While the Old Testament theme of the *Marriage* could symbolize Christ's union with the church, the story of love and travel implicit in *Seaport with the Embarkation of the Queen of Sheba* may have alluded to the cardinal's illicit love for his mistress.

c. **1649**
Italy

Ecstasy of St Teresa, Gianlorenzo Bernini
Marble, H: 350 cm / 11 ft 5¾ in, In situ, Santa Maria della Vittoria, Rome

The sculptor Gianlorenzo Bernini (1598–1680) designed all the elements of the Cornaro Chapel in Santa Maria della Vittoria, Rome (1647–1652), and it constitutes one of his most sensuous and exaggerated works, combining gilt metal and rich marbles in a consummate union of form and content. A harsh self-critic, Bernini considered this work his 'least bad'.

The sixteenth-century Spanish Carmelite saint Teresa was famous for experiencing mystic visions, and here she is depicted floating on a cloud in spiritual rapture, overcome by her love of God. As she recounted in her own writings, the angel pierced her heart repeatedly with a golden spear, puncturing her entrails and seemingly drawing them out. The

ensemble is dramatically lit by a hidden window, and despite the physical weight of the marble the sculptural group seems to float in the air, enveloped in billowing folds of drapery. This chapel is the perfect example of what would become known as the High Baroque: the virtuoso handling of the stone, the feeling of dramatic movement and heightened emotion, and the exuberant decorative quality exemplify Italian Baroque sculpture.

This mortuary chapel housed the body of cardinal Federigo Cornaro and commemorated his family. In this context, St Teresa as intercessor and symbol of eucharistic sacrifice serves as an example of the promise of salvation.

Portrait of an Official, Artist unknown

Ink and colour on silk, 178 x 104 cm / 5 ft 10 in x 3 ft 5 in, National Museum of Korea, Seoul

Most examples of Korean portraits date from the Choson period (1392–1910), when the rising emphasis on ancestor worship and genealogical records enhanced their value (though the genre is known to have been practised in Korea from the fourth century AD). In particular, the achievements and moral qualities of lineage ancestors were seen to shine forth as an example to their descendants. Cho Malsaeng, who may be depicted on this hanging scroll, had been defended by King Sejong (reigned 1418–1450) after having had the temerity to criticize his prime minister, Hwang Hui.

Korean artists usually posed their sitters looking to the right, unlike Chinese subjects, who faced straight ahead. They concentrated mostly on the face, trying to convey both appearance and character through the use of line and colour wash. They also highlighted an official's *hyungbae,* the badge of rank worn on the front and back of his robe. Beautifully embroidered in silk and sometimes padded for extra effect, designs incorporated two cranes for civil dignitaries of upper third grade and above, and two tigers for correspondingly senior military officers. But *hyungbae,* and the 'winged' hat, were not introduced until the seventeenth century, so their inclusion in what may be a portrait of a fifteenth-century official is an anachronism.

1652
Netherlands

Portrait of an Old Man in Red, Rembrandt van Rijn
Oil on canvas, 108 x 86 cm / 3 ft 6½ in x 2 ft 9¾ in, State Hermitage Museum, St Petersburg

Rembrandt's pupil Samuel van Hoogstraten, in his 1678 treatise on painting, praised his master for his rendering of 'soul'. In this contemplative study of an old man, this is expressed through the use of *chiaroscuro* (bold contrast between light and dark). Here, Rembrandt (1606–1669) uses the technique to illuminate the man's face and hands, engaging us with the process of meditation. As is the case with Rembrandt's late style, the paint is broad and impasted yet refined, mimicking the wrinkles and furrows of old age.

Although we sense here the presence of a real person, and although a real person doubtless was the model, it is likely that this painting was not intended as an actual portrait but as a *tronie* ('fancy head'), a genre in which models were dressed in glamorous garments (see also *The Laughing Cavalier*, p.357). Rembrandt's many self-portraits and pictures of his family were probably intended for sale as *tronies*, and as with the *Portrait of an Old Man in Red* (1652–1654), their psychological intensity recalls their ancestry in iconic representations of the saints, such as those by Titian and El Greco. Rembrandt used his own face to represent the apostle St Paul (National Gallery, London), and his studies of old age, such as *Rembrandt's Mother as the Prophetess Hannah* (Rijksmuseum, Amsterdam), have been interpreted as Old Testament personages.

Jade (nephrite) was the most prized hardstone in the Islamic lands, appreciated not only for its hardness and colour, but also because it was believed to prevent poisoning, cure digestive complaints and ensure victory. Imported from Khotan in Central Asia, it was limited to royalty, who used it for everyday objects in place of pottery and glass.

This white jade wine cup (seen here from below) was made in 1656–1657 for the emperor Shah Jahan (reigned 1628–1658), the greatest Mughal patron of architecture, whose most famous project was the Taj Mahal. The idea of an imperial jade cup is derived from the Timurids (reigned 1370–1506), the Mughals' ancestors in Central Asia. The Mughals avidly collected Timurid jades, often adding their own names on them to reaffirm their legitimacy as Mongol rulers of India.

The artistic sources of this cup derive from the international repertory of designs available at the Mughal court. The form of a halved gourd is borrowed from the Chinese, while such features as the scroll handle ending in a goat's head, the acanthus leaf decoration and the prominent foot are European in origin. The flowering lotus blossom at the base derives from Hindu art.

1656
Spain

Las Meninas, Diego Rodríguez de Silva y Velázquez
Oil on canvas, 318 x 276 cm / 10 ft 4¾ in x 9 ft ½ in, Museo del Prado, Madrid

The Infanta Margarita of Spain stands between her two maids of honour, Doña Isabel de Velasco and Doña María Augustina Sarmiento, who curtsies to the little princess as she offers her a beaker of water. On the right stand two dwarfs, Mari-Bárbola and Nicolás de Pertusato, the latter of whom gently pushes a sleeping bull mastiff with his foot so that the dog will attend his master and mistress, Philip IV of Spain and Queen Mariana. The king and queen are reflected in a mirror at the back of the room as they stand under a red curtain and pose for the court artist, Velázquez (1599–1660) himself.

One of the most famous and controversial artworks of all time, *Las Meninas* (*The Maids of Honour*) is regarded as a dialogue between artist and viewer, with its double mirror imagery and sketchy brushwork that brings every figure and object in the room to life. Painters as diverse as Goya, Manet, Sargent and Picasso have been inspired to create copies and adaptations after Velázquez's masterpiece. In the eighteenth century the work was valued as the most precious painting in the Spanish royal collection, despite having been damaged by fire in 1734. Originally called *The Family of Philip IV*, its present title comes from the 1843 catalogue of the Museo del Prado.

The Milkmaid is an image of calm, still concentration on an everyday task, which gains grandeur from the servant's rapt, almost religious intensity. Bathed in cool light from a basement window, the surfaces and materials are pictured with a precise realism, and the milk has been rendered in viscous paint that appears to pour continuously. The complementary blue and yellow pigments lend an abstract harmony to the scene. The blue is probably ultramarine, created from the semi-precious stone lapis lazuli; being the most expensive of all pigments, it was reserved in previous centuries for elements such as the Virgin's robe. This 'milkmaid' could be interpreted as an embodiment of Charity, because the presence of bread and milk

suggests she is making a sop – food for invalids and small children. The box on the floor, near a tile representing Cupid, is a footstool designed to take a crock of glowing coals for warming the bed.

The pinpoints of light on the bread are suggestive of those produced by optical devices such as the *camera obscura*. This was the progenitor of the modern camera, comprising a box with a tiny hole, later a lens, in one wall. Light emitted through the hole produced an upside-down image of the world outside on the opposite wall, which an artist could trace accurately. Vermeer (1632–1675), following the example of Delft artists such as Carel Fabritius, possibly used this as an aid to developing his compositions.

c. **1670**
Japan

Spring Cherry with Poem Slips, Tosa Mitsuoki
Ink, colour, gold leaf and gold powder on silk, 140 x 290 cm / 4 ft 8 in x 9 ft 5 in,
Art Institute of Chicago, Chicago, Illinois

The court aristocracy of seventeenth-century Japan sponsored a revival of the culture of the Heian period (AD 794–1185), including traditional customs such as seasonal poetry meetings. Cherry blossoms in spring and the transient colours of maple leaves in autumn were considered particularly conducive to lyrical expression. The participants at a poetry meeting would inscribe verses on narrow poem slips (*tanzaku*), which they would tie to the branches of a flowering tree, almost in the form of an offering.

The screen shown is the right-hand one of a pair that the imperial consort Tofukumon-in (1607–1678) either commissioned or received as a gift in the third quarter of the seventeenth century. The white flowering cherry is decked with poem slips, each inscribed with a verse celebrating the cherry and spring. The left-hand screen (not shown) depicts poem slips on an autumn maple. The verses were brushed onto the screens by court calligraphers. The court artist Tosa Mitsuoki (1617–1691) positioned the delicately painted trees at the outer end of each screen, leaving an open central area to be filled with clouds of gold dust and cut gold squares, a sumptuous and timeless setting for a poetry meeting at court.

The Tosa school specialized in colourful *yamato-e*, a native Japanese painting style often contrasted with the monochrome Chinese ink styles favoured by the Kano School (see *Wagtails, Pine and Waterfall*, p.334).

View across Streams and Mountains, Wang Hui
Ink and colour on silk, 0.51 x 12.12 m / 1 ft 7¾ in x 39 ft 9 in, National Museum, Tokyo

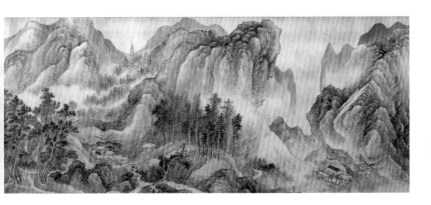

Wang Hui (1632–1717) is classed as one of the Four Wangs (the others being Wang Shimin, Wang Jian and Wang Yuanqi) and one of the Six Masters of the early Qing dynasty (1644–1911), thus underlining his reputation as a prolific and successful landscape painter. Scholar-artists of this period drew their inspiration from earlier masters rather than from nature itself, and Wang modelled himself on the great Dong Qichang (1555–1636), who had urged his own students to learn from famous artists of the past. If this apparent promotion of conservatism discouraged originality, it nevertheless brought forth top-class work, and the mature Wang Hui developed an outstanding style of his own.

Wang's use of the horizontal hand scroll to reveal the unfolding scenery of mountain valleys and streams shows his love of subjects popular in the Song and Yuan periods (AD 960–1368), and his admiration for Huang Gongwang (1269–1354) is clear from his densely packed mountains and trees. In the section seen here, he places two scholars in 'orthodox' situations, one seated in a viewing pavilion close to a small footbridge, the other, carrying a zither, leaving a traveller's refuge accompanied by his servant. In the far distance a pagoda soars above a mountain temple, another familiar device to indicate human presence amid the vast enormity of nature.

c. **1685**
Mongolia

Sitasamvara, Undur Gegeen Zanabazar
Bronze and gold leaf, 54.5 x 33.8 cm / 1 ft 9½ in x 1 ft 1¼ in, Choijin Lama Museum, Ulaan Baatar

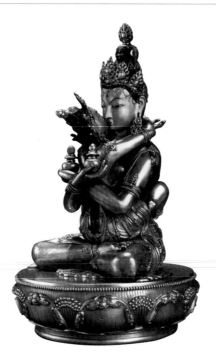

The motif of the coupling of the 'mother' (Tib.: *yum*) and 'father' (Tib.: *yab*), representing the union of wisdom with the means aimed at attaining nirvana, is embodied by Sitasamvara (or White Samvara) and his consort Vajravarahi. With pots of elixir in them, Sitasamvara's hands cross in the gesture of the highest energy (*vajrahumkara*) behind the back of his consort, and she repeats the action behind his neck. Such representations of coupling from the world of northern Buddhism are often memorable not only for the drama of iconography but also for the tender and emotive form and spirit of the images. In this sculpture, the deities embrace with a sensuality and delicacy that is immediate and compelling in its

appeal. The composition appears to have arrested a moment in the intimacy of the gods, and as their faces almost touch they appear passionate, vital and alive.

The ability to achieve symmetry and precision of detailing while bequeathing his subjects with life is characteristic of the work of Undur Gegeen Zanabazar (1635–1723). In a culture in which it was rare for artists to be personalities, the Mongolian monk and sculptor was recognized and adulated for his skilled craftsmanship and distinctive forms. This sculpture is also remarkable for the impression it gives of a continuous, composite whole; in reality it was cast in multiple parts that were then joined.

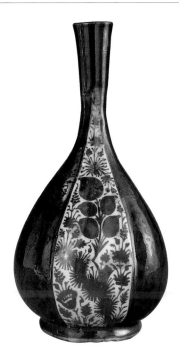

Pear-shaped bottles with long necks were popular in Iran under the Safavids (reigned 1501–1765) as wine jugs carried by courtiers on picnics. The ultimate source for the form is Chinese porcelain, but Iranian potters decorated their imitations in a variety of local techniques and styles. The finest and most expensive was overglaze painting in lustre, a technique that had been used in medieval times (see the Lustre Mihrab, p.250) but which apparently lay dormant for three centuries until it was revived sometime in the seventeenth century.

To decorate this moulded bottle, dated to c.1675–1700, the potter painted the fine stonepaste (fritware) body with a slip (a thin layer of coloured clay),

alternating around the bottle between a white slip and one stained blue. He next covered the vessel with a brilliant and close-fitting transparent glaze before firing. Then he painted designs of flowering plants over the glaze in a metallic oxide and re-fired the bottle in a reducing (oxygen-poor) kiln. The expense of the materials and the difficulty of controlling all the variables made lustreware expensive, and Safavid examples are limited to a small group of diminutive vessels. The contrasting colours and exquisite painting make this bottle a stunning example of its type.

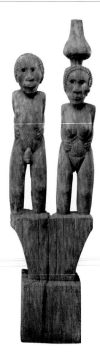

This work, dated to the late seventeenth or early eighteenth century, was created on the island of Madagascar, the cosmopolitan cultural heritage of which represents a synthesis of African and Asian elements. Although its weathered surface and design make it clear that it was originally the finial of an exterior monument, its specific function is unclear. This couple may have surmounted a post that was paired with a nearly identical one now at the Louvre in Paris, both of these positioned at the centre of a village as the site of important rites and offerings.

The idea of the fundamental complementarity of man and woman so eloquently depicted in this work is an important theme in Malagasy spiritual life. The male and female figures stand side-by-side in identical stances. Their bodies are closely symmetrical with the man only slightly taller; the woman balances a vessel upon her head. The immediacy of the representation lies in the intense facial expressions, confronting the viewer with their deeply recessed eyes.

There is a deceptive simplicity to this arrangement of unadorned vertical figures, for exacting care has been applied to their rendering as mirror images of one another and to the delicacy of the asymmetry of their relative height. The extent of the composition's calculated precision is apparent in the column of negative space between the figures echoed by that between their legs.

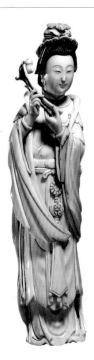

Careful design work and unusually deep cutting distinguish this stylish, almost enticing female from other Chinese ivory carvings. Like many other ivory figures, the piece refers gently to the characteristic curve of the elephant tusk, tastefully replicating it in the sweep of the queen's sleeves and the sceptre (*hu*) and peach spray she carries. The detail of her fingers, dress, and the jade pendant hanging from her belt are particularly fine, and much of the colouring on her coiffured hair and phoenix headdress remains.

The centre of the Chinese ivory carving industry was in Fujian Province, though workshops in cities further afield also produced high-quality pieces. By the seventeenth century elephant ivory was no longer available from native sources and was mostly supplied by Spanish merchants from their base in Manila, in the Philippines. Female figures made popular subjects for ivory- and stone-carving in the Ming and Qing periods (1368–1911), with the female bodhisattva Guanyin and the Christian Virgin Mary prominent.

It has been suggested that this figure was carved in Guangzhou for the export market, but if so, it is unlikely that a foreign purchaser would have recognized the subject – the Mother Queen of the West, Xiwangmu. Widely revered since the Han dynasty (206 BC–AD 220), she was often seen with magic peaches, a symbol of immortality.

c. **1710**
Japan

Flowering Irises, Ogata Korin
Colour and gold on paper, 150 x 360 cm / 5 ft x 11 ft 10 in, Nezu Institute
of Fine Arts, Tokyo

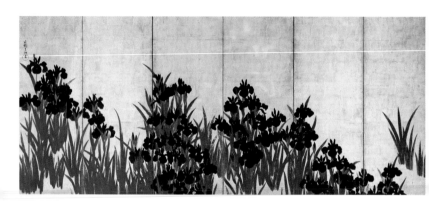

Using only three colours – ultramarine, copper blue and malachite– Ogata Korin (1658–1716) created two six-panel screens (one of which is pictured here) arranged with clusters of flowering irises that appear to flourish in a golden marsh. The blossoms share the same basic shape, but the colouration of the petals and the placement of the leaves received such individual treatment that the screens could almost be taken for a nature study. Korin learned this compositional method from Tawaraya Sotatsu, the early seventeenth-century Japanese master whose work he so admired (see also the Matsushima Screens, p.358).

At one level the screens, from the first quarter of the eighteenth century, can be enjoyed purely for

their visual interest; but at another level they almost certainly allude to Episode Nine in the tenth-century Japanese classic *Tales of Ise*. The episode tells of a courtier travelling in exile, who stops beside an iris pond and composes a poem expressing his longing for his wife, left behind in the capital. In other paintings, Korin depicted the courtier, his travelling companions and even the plank bridges across the marsh mentioned in the episode. Supplementary motifs were not needed here, however, since the screens were most likely intended for a patron already well versed in the classic story.

Path Through a Bamboo Grove, Gao Qipei

Ink and light colour on paper, 36.2 x 57.8 cm / 1 ft 2¼ in x 1 ft 10¾ in,
Nelson-Atkins Museum of Art, Kansas City, Missouri

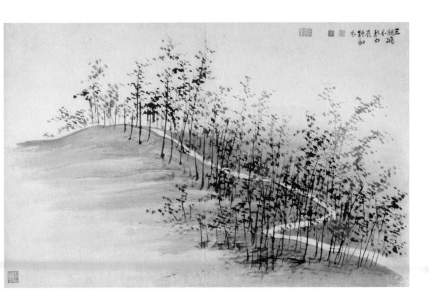

The appeal of this unpretentious finger painting lies in its simplicity, mood and balance. It comprises only three elements depicted against a heavy sky – waste hillside, wandering path and patchy bamboo – and conveys all too well a sense of gathering winter chill. It has been elegantly planned, with an unostentatious inscription in the upper right corner and a single small seal in the bottom left, acting as almost unnoticeable counterweights to the strong diagonal of the path.

Scratchy bamboo stems and splashed leaves may seem no more than an appropriate border for a path that appears to be going nowhere, but they also represent the particular response by Gao Qipei (1672–1734), a high Manchu official under the Kangxi

and Yongzheng emperors, to the contemporary demand for novelty in art. Some ingenious artists had discovered how to paint scenes on the inside of glass bottles, others developed the decoration of snuff bottles. Finger painting was not unprecedented in Chinese art history, but following an idea that came to him in a dream, Gao broadened the technique by using his whole hands, painting larger areas of colour with his palms and fingers and finer lines with his fingernails, which he wore long in the upper-class fashion; he found his thumbnails particularly useful for quick strokes. Although some regarded him as an eccentric, Gao was one of the few Manchu to earn the respect of Chinese artists.

c. **1728**
Italy

Venice: Campo San Vidal and Santa Maria della Carità, Canaletto
Oil on canvas, 124 x 165 cm / 4 ft 7¼ in x 5 ft 2¾ in, National Gallery, London

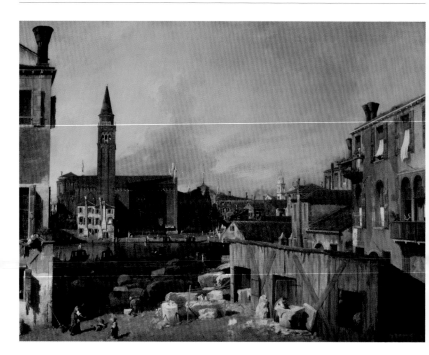

From 1726 to 1730, Canaletto (Giovani Antonio Canal; 1697–1768), the greatest eighteenth-century painter of *vedute* (urban views), developed his skill in portraying the Venetian landscape and waterways. His later scenes of Rome and Georgian London made him internationally famous, and his success was assured by the patronage of Joseph Smith, British consul in Venice. For Smith, as for the artist's many other British admirers, Canaletto became the supreme visualizer of Venetian life, with its inimitable dazzling façades and untroubled blue skies.

This work, also known as *The Stonemason's Yard*, is regarded as Canaletto's most monumental achievement from the early period of his life

when, with his breathtaking vistas and textures, he established himself among the international visitors to Venice as a unique painter of local scenes. The focus in this painting is on details of shutters, brickwork, boulders, woodwork and cloth. Figures play a subordinate role yet add scale and spatial reality to the view, maintaining the impression of bustle and liveliness. The colours are cunningly controlled, limited to sepia, chestnut and brick red, which bring out the warmth of the sun in the foreground and contrast with the dark green of the canal and shadowy façade of the distant church.

c. 1733
UK

The Orgy, from A Rake's Progress (III), William Hogarth
Oil on canvas, 62.5 x 75 cm / 2 ft ½ in x 2 ft 5½ in, Sir John Soane's Museum, London

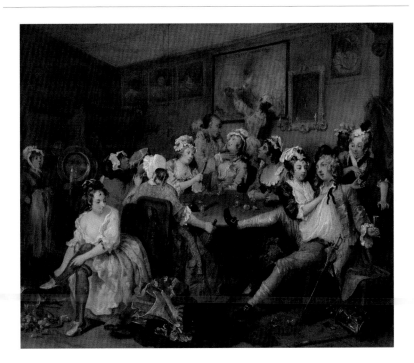

The complex reputation of William Hogarth (1697–1764) makes him appear an artistic rebel as well as an inspiration for continental artists of the Romantic period (conventionally 1798–1832) and Victorian social realists. Principally, he sought to express in his art a case for moderation between the ideological and aesthetic extremes of his own society. The 'Modern Moral Subjects', as he called them, told tales of social outcasts and personal disasters in cycles of paintings, like an early strip cartoon.

Set in Drury Lane's Rose Tavern, this scene (from the series completed in 1733–1734) shows the pathetic rake, Tom, so fuddled with drink that the tart who fondles him also steals his watch. This is the sordid end to a night of brutal saturnalia with disgusting details of thieving, spitting, the emptying of a chamber pot on to food and lurid sexual excesses. Hogarth's morality encompasses both the satirical and horrific: after a period of pointless extravagance, the rake ends in the London madhouse, Bedlam.

Hogarth's paintings were popularized through engraving, and prints after the works became accessible to all classes. With his knowledge of London and his sensitivity to visual variety within compositions, as described in his seminal treatise *The Analysis of Beauty* (1753), the artist achieved a striking level of graphic realism.

Self-portrait Shading the Eyes, Joshua Reynolds
Oil on canvas, 63 x 74 cm / 2 ft ¾ in x 2 ft 4¾ in, National Portrait Gallery, London

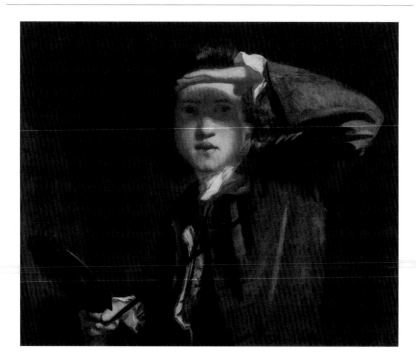

The greatest portraitist in Georgian London, Joshua Reynolds (1723–1792) here depicts himself as a working artist. He holds palette, mahlstick (a wrist support for use when painting small details) and brushes as he turns towards the spectator. At the same time he is keen to show how he moves in the highest society, presenting himself dressed in the height of fashion, wearing the most up-to-date brown coat with a velvet collar and a blue silk waistcoat unbuttoned to the chest, both the colours and cut especially popular in the 1740s.

The portrait, dated to 1748–1749, presents the artist as an intellectual rather than a craftsman: he adopts the pose best suited to the creative personality

of the Enlightenment, drawing attention to the processes of perception and cogitation, working in his studio, adjusting his eyes to artificial light as he ponders the next move and works out his artistic strategy. Although the tones and brushwork are here reminiscent of the artist's favourite model, Rembrandt, the planes of the face, jaw line and mouth also reveal a knowledge of Antique sculpture.

Carceri d'Invenzione, Giovanni Battista Piranesi

Etching and sulphur tint, 55.3 x 41.9 cm / 1 ft 9½ in x 1 ft 4½ in, Various locations

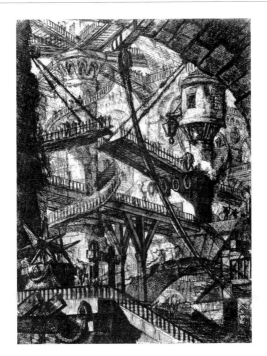

Etcher, architect, historian and archaeologist, Giovanni Battista Piranesi (1720–1778) produced in Rome 14 plates showing invented prisons, scenes that were probably too advanced for the taste of his own day. These fantasy interiors include lost prisoners, instruments of torture, and illusionistic, architecturally ambiguous spaces; this is plate VII from the series *Carceri d'Invenzione* ('Imaginary Prisons') produced in 1749–1750. The compositions are tightly controlled, revealling the artist's early professional training as a designer of stage scenery.

Known for his popular views of ancient Roman buildings, Piranesi converted his knowledge of the Antique into a more personal artistic motivation when he fashioned these interiors into a rhetorical language, expressing his dissatisfaction with contemporary modes of design and producing these fantasies, which rejected the architectural ideas of the French academy that were much in vogue at the time.

The *Carceri d'Invenzione* engravings remain some of the most striking images to have emerged from the eighteenth-century artistic repertoire, and many later artists, from Goya to Munch to the Surrealists to Mervyn Peake and even Frank Brangwyn, have been inspired by their originality. They also influenced set designs of German Expressionist films, as well as Fellini's *Roma* (1972) and Ridley Scott's *Alien* (1979).

Neoclassicism / Proto-Romanticism

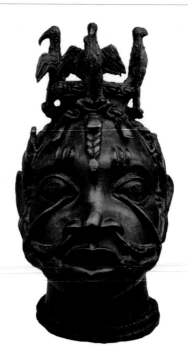

Each king of Benin invokes his predecessors before royal altars that honour their memory by means of sculpted heads such as this. It is through the living intermediary of the royal line that the state may be afforded protection from evil. This representation of the head of a Benin sovereign is dominated by creatures identified with the mystical qualities of his office, which were given prominent artistic emphasis from the eighteenth century onwards. These creatures take the form of slithering serpents that emanate from the eyes, nose and mouth, and a trio of birds with wings extended at the summit of the head.

Descriptions of the palace in Benin City provided by European visitors during this period mention snake and bird imagery as dramatically prominent elements of its exterior decoration. The 'bird of prophecy' is a motif originally associated with the sixteenth-century leader Esigie. It is said to have appeared on the eve of a battle against a formidable enemy. Although the bird was seen as a portent of defeat, Esigie defiantly ordered it to be killed; he subsequently prevailed and adopted the bird as an emblem of his triumph. The surreal combination here of the two motifs of bird and snake at once gives expression to the dynasty's power to decimate its rivals and its potential to anticipate and shield its domain from harm.

Daruma in Red, Hakuin Ekaku

Ink and colour on paper, 190 x 110 cm / 6 ft 4 in x 3 ft 8 in, Manju-ji Temple, Oita

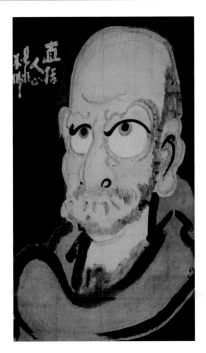

Looming out of black depths, Bodhidharma, called Daruma in Japan, the first patriarch of Zen Buddhism, stares at an injunction that appears to have materialized in the air before him: 'Aim straight for the human heart: to see your true nature is to achieve Buddhahood.' These words constitute the essence of the patriarch's teachings. They may be found inscribed on countless other images by Hakuin Ekaku (1685–1769), the priest who single-handedly revived the Rinzai sect of Zen Buddhism in Japan during the middle decades of the Edo period (1615–1868).

Decades earlier, the Rinzai Zen establishment had submitted to serving as an administrative branch of the warrior government in Edo (modern Tokyo).

Religious and spiritual training almost became a secondary priority. Hakuin's forceful teachings and determined character redirected those who would listen back to the basics of Zen practice. He is known not only for his sermons, but also for conceiving the famous Zen thought-problem, or *koan*, 'Hear the sound of one hand clapping' (see also *Catching a Catfish with a Gourd*, p.285).

This is one of Hakuin's largest and most impressive portraits of Daruma, with animated lines and stubbed marks of ink that coalesce into a towering image. The prominent eyes are characteristic of Bodhidharma portraits: according to legend, the patriarch cut off his eyelids in anger after falling asleep during meditation.

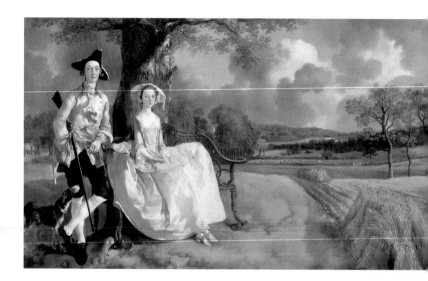

The double portrait is one of the most celebrated paintings by Thomas Gainsborough (1727–1788). It is often interpreted as a 'marriage portrait' and shows Robert Andrews and his wife Frances on their estate near Sudbury in Suffolk, two years after their wedding. It celebrates both their union and the extensive property reunited through their marriage.

The unusual details of a normally generalized landscape draw attention to the good husbandry of Robert Andrews, who was a keen agriculturist. Here the tradition of the 'conversation piece' – an informal family portrait or grouping of friends engaged in some favourite occupation in a private setting – is transmuted by the artist. Both the landscape and the

sitters are of equal interest, and if Robert Andrews seems well suited to his element, nonchalantly holding a gun, the same cannot be said of Frances Andrews – aged only 18 at the time, she is sitting upright, looking slightly uncomfortable and decidedly less confident. Notably, there is a patch of unfinished painting on her lap, leading to the disputable speculation that it was reserved for a cock pheasant shot by her husband.

Painted with elegance and virtuosity, this work stands as a powerful image of the British countryside. Gainsborough, trained by the French engraver Hubert François Gravelot and the painter Francis Hayman, proved here that he was one of the most significant artists of his generation.

Asia, from Apollo and the Continents, Giambattista Tiepolo
Fresco, 18 x 32 m / 59 ft x 105 ft (complete ceiling), In situ, Würzburg Palace, Würzburg

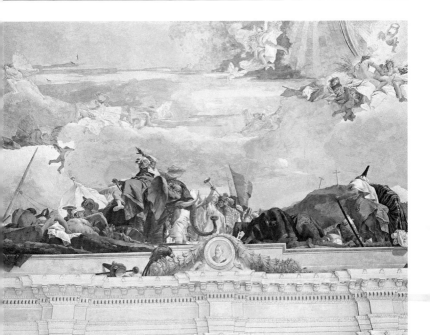

The last of the great fresco painters from Italy, Giambattista Tiepolo (1696–1770) brought traditional methods of wall painting to a triumphant climax around 1750, when he was commissioned to decorate the grand staircase of the Royal Palace in Würzburg. The completed fresco, showing allegorical figures representing the four continents, was intended to glorify the Catholic Church and, specifically, the Catholic prince-bishop of Würzburg, Karl Philipp von Greiffenklau, whose portrait dominates the allegorical imagery of Europe. In an age of Enlightenment, scepticism and early industrialization, the certainties of Catholicism were here portrayed with glorious verve and dramatic

perspective by Tiepolo, his son Giandomenico and their Swiss-born stuccoist Antonio Bossi, who designed the monochrome figures. The whole undertaking took some three years, the painting taking place in 1752–1753; the artist first made detailed *modelli* for most of the figures he would later paint.

This section portrays Asia as a woman wearing a turban and sitting on the back of an elephant that drags a captive. A European merchant oversees goods intended for shipment to Europe, and a tiger hunt is underway. The intermingling of contemporary and allegorical figures together with exotic costumes, plants and animals displays the artist's enormous range of expression and attention to detail.

Ship Cloth, Artist unknown
Cotton, beads, fibre and nassa shells, L: 411 cm / 13 ft 13 in, Metropolitan Museum of Art, New York

Indonesian *palepai*, or 'ship cloths', are among the most spectacular and technically accomplished textiles in the world. Produced exclusively by the Paminggir people of Lampung Province in southernmost Sumatra, ship cloths were woven to lengths of more than 4 metres (13 ft). Used as ceremonial banners for important rites of passage such as marriages, circumcisions and funerals, they were among the most prized possessions of the aristocratic families of Paminggir.

One of the finest surviving examples of a ship cloth, this unique beaded textile illustrates three long-hulled ships with curved sterns and prows. To the left, a ship is set against the backdrop of the night sky and bears a pyramidal shrine that may represent a sacred mountain or tree. To the right is depicted a ship set against the dawn sky. It carries what may be a *pepadon*, a Sumatran type of throne. In the centre, the third ship is shown bearing a sacred mountain. It has been suggested that the imagery of ship cloths represents the souls of the dead being borne off across the sea to the afterlife.

Lord Grosvenor's Arabian with a Groom, George Stubbs
Oil on canvas, 99.3 x 83.5 cm / 3 ft 3 in x 2 ft 8 in, Kimbell Art Gallery,
Fort Worth, Texas

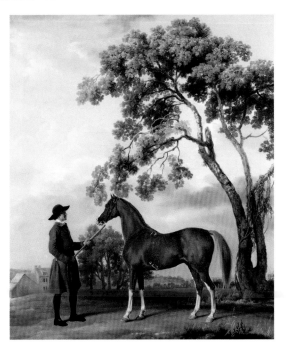

The eighteenth century was the golden age of British horse breeding and racing, when members of the aristocracy such as Lord Grosvenor, one of the richest men in England and George Stubbs's most important patron, commissioned portraits of their favourite animals. The self-taught son of a currier (leather-worker), Stubbs (1724–1806) became an unsurpassed sporting artist, whose study of anatomy allowed him to paint animals, and especially horses, with admirable accuracy and a great sense of beauty and harmony, as can be seen here. The brown coat of the Arabian is luminous, glistening as if he has just been running, and contrasts with the grey sky and green background. It is a graceful and dynamic composition,

and although the groom is secondary in the portrait, Stubbs does not condescend to him. By the time Stubbs made this portrait, he had developed skills in painting not only horses but also landscapes and figures, and was exhibiting regularly and successfully in London with the Society of Artists. A 1771 engraving by Peter Mazell shows the same scene, with a landscape on the left.

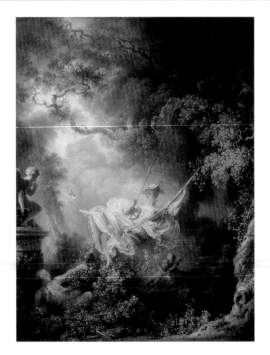

Jean-Honoré Fragonard (1732–1806) had his work praised by the greatest art critic of the day, Denis Diderot, and was successful until his fortunes declined in the 1770s and 1780s. With his individual techniques in oil, often compared to those of Impressionism, he was revered in the twentieth century as a rare technician whose unorthodox impasto attracted colourists as diverse as Claude Monet and Chaim Soutine. In his own day, his art was associated with a sexual explicitness bordering on pornography.

After winning the Prix de Rome in 1752 (an art prize that included an extended visit to Italy), Fragonard travelled to Rome in 1756, where he quickly rebelled against the academic teaching he had received in France, turning instead to the portrayal of life in the Italian countryside. His pastels and oils of beautiful young men and women in opulent interiors, southern landscapes and Mediterranean formal gardens, as here, dotted with cypresses, orange groves and statues, made him the supreme exponent of later Rococo painting.

Having built a reputation for the rapidity of his sketches, a skill implied by the swansdown and nipple-pink floss of the exuberantly naughty *Swing*, the artist further experimented with loose brushwork and the use of such colours as saffron, turquoise, vermilion, rose and snuff brown, which are particularly well rendered here.

Brook Watson and the Shark, John Singleton Copley
Oil on canvas, 182 x 229 cm / 5 ft 10¾ in x 7 ft 6 in, National Gallery of Art, Washington, DC

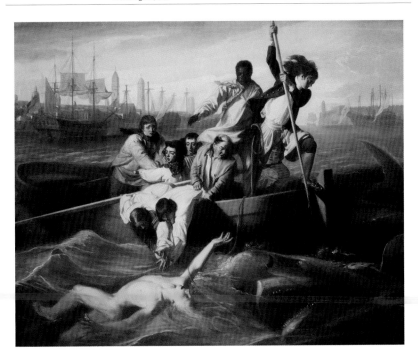

After establishing himself as a leading portraitist in Boston, Massachusetts, John Singleton Copley (1738–1815) exhibited at the Royal Academy in London to great acclaim and finally moved to England, settling there in 1775. This, his first major history painting, was a controversial work. The subject, an actual event that took place in Havana harbour in Cuba, set the tone for modern history painting and was to become immensely famous as an artistic inspiration, especially in France. Two smaller versions of the work also exist.

Although the heroically nude male victim (who, in fact, survived the horrendous accident, despite losing a leg) appears to assume the pose and colouring of an Antique statue (possibly the Borghese Gladiator), the

viewer's attention is also riveted by the harpoonist and his crew, whose grace and dexterity create a new style of hero in contrast to the Neoclassical style of the victim. Whether this symbolism deliberately asserts the coming modernity in European history painting, which would result in the supplanting of the Neoclassical style, it is hard to say, but the work is still regarded as a turning point in the history of art. Copley himself was arguably the most strikingly original American painter of the eighteenth century.

Voltaire, Jean-Antoine Houdon
Marble, H: 138 cm / 4 ft 4 in, Bibliothèque de la Comédie-Française, Paris

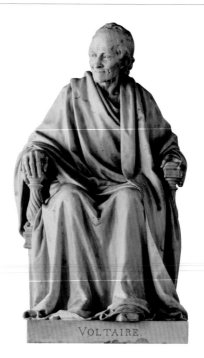

This statue of the French philosopher Voltaire is one of the greatest masterpieces Jean-Antoine Houdon (1741–1828). There exist several versions of this sculpture, including the original plaster at the Bibliothèque Nationale, in Paris. Another marble version was commissioned by Catherine II of Russia, a keen student of the philosopher.

Voltaire is seated here in a Louis XVI-style armchair, dressed in Classical robes, thus being explicitly linked to the great philosophers of antiquity. His head is wigless but adorned with a philosopher's headband, and the face has a wry expression emphasized by his sharp eyes. Inspired by the Italian architect and sculptor Gian Lorenzo Bernini, Houdon

experimented with a new way of treating eyes: by drilling deep holes and leaving a tiny circle of marble, he created a realistic impression of light reflecting from the iris.

Houdon began sculpting at the age of nine, and by the time he presented this statue of Voltaire he was the most important sculptor of his day, receiving commissions from the USA as well as from Europe. He famously made a monumental statue of George Washington for the Capitol at Richmond, Virginia, as well as busts of Napoleon, Molière and Rousseau.

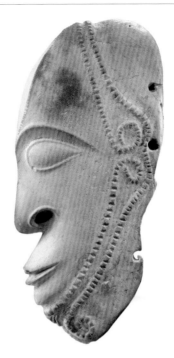

Amulets such as this one, from Metamli in northern Ambrym Island, Vanuatu, are typically carved from a soft, easily worked tufa (a volcanic stone). Stone sculpture is rare on Ambrym Island and throughout Vanuatu, and this example is particularly fine, with its elegantly delineated features and notched detailing. These amulets often represent squatting figures or, as here, human faces, sometimes singly and sometimes in janus-form (with two faces looking in opposite directions). They probably depict ancestral figures whose help is sought by the amulet's owner. One nineteenth-century missionary to Ambrym Island noted that an amulet's 'powers were remarkable. If carried in the hand it would jump when danger is near,

although nothing could be seen. At night it would whistle, to give warning.'

Amulets like this one are typically called *müyü ne bu*, or 'pig magic stone', possibly referring to the use of these stones to facilitate the accumulation or trading of pigs. Traditionally, pigs were the foundation of wealth and political power in Vanuatu, and it was impossible for a man to achieve a high rank in society without sacrificing many of the creatures.

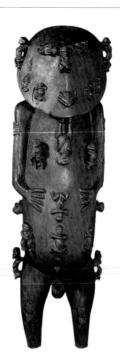

In eastern Polynesia, the use of small subsidiary figures incorporated into larger ones is a characteristic motif, of which this extraordinary sculpture is perhaps the most famous example. From Rurutu in the Austral Islands, the figure's body is covered with 30 smaller figures, some of which mark his facial features, nipples and navel. At one time, a small cavity in the back of the figure contained 24 small wooden figures carved in the round (now destroyed). The figure may depict A'a, the ancestor who first populated Rurutu; the subsidiary figures symbolize his generative power, and the subsequent generations to which he gave rise.

Members of the London Missionary Society who visited the Austral Islands to convert the islanders collected this figure in the early nineteenth century as a 'trophy of a bloodless conquest'. The missionaries sent the figure back to England, where it was widely exhibited to raise money for their work and later inspired many modern artists, including Henry Moore and Pablo Picasso, who kept a cast of it in his studio. The British poet William Empson paid ambiguous tribute to the figure in 'Homage to the British Museum' (1929–1930):

There is a supreme God in the ethnological section;
a hollow toad shape, faced with a blank shield.
He needs his belly to include the Pantheon,
which is inserted through a hole behind.

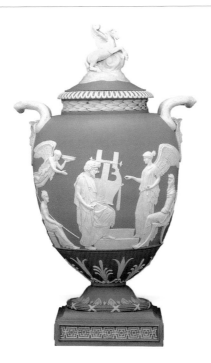

When, in 1786, Josiah Wedgwood (1750–1795) presented this vase to the British Museum, he described it as 'the finest and most perfect I have ever made'. A skilled potter and chemist, Wedgwood learned his craft at a time when techniques of ceramic manufacture were rapidly advancing, and he has remained a household name, his work synonymous with high-quality products. Having transformed his Staffordshire potteries from craft manufactures into major industries, he experimented with black basalt, white terracotta stoneware, cream-coloured earthenware and jasper ware, the last said to be the most important development in ceramics in the eighteenth century.

Part of Wedgwood's success lay in his employment of major artists as designers. The solid blue jasper ware vase was considerably enhanced by the white relief modelling of John Flaxman, the foremost British sculptor of the day, whose design derives from a relief on an ancient Roman vessel then in the collection of Sir William Hamilton. Flaxman modelled the design in wax and sent it to Wedgwood, who took a plaster cast. This was transferred to biscuit relief (i.e. of the same clay as the pot) that, when fired, shrank the figures to the required size. The frieze shows the Greek poet Homer mounting a plinth to have immortality bestowed upon him, attended by allegorical acolytes and the muse of epic poetry.

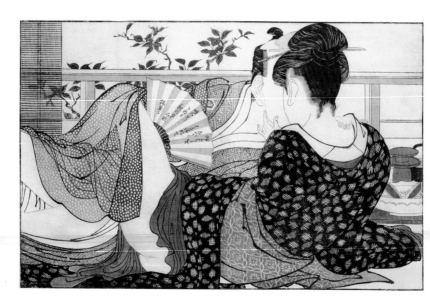

The *Poem of the Pillow* is among the finest Japanese erotic albums. Its 12 colour woodblock prints include some of the best designs by Kitagawa Utamaro (1753–1806), Japan's leading artist of passion and refined sensuality. Here, in the tenth print from the set, Utamaro depicts a rendezvous between a guest and a waitress on the second floor of a restaurant. The scene is tender, with the man amorously studying his lover while she gently caresses his cheek, her kimono loosened to allow full view of the nape of her neck – a Japanese erogenous zone. The man's folding fan is inscribed with a parody of a classical Japanese poem.

Along with beautiful women and kabuki actors, erotica (*shunga*) formed a major subject of Japanese

woodblock prints throughout the early modern period. But this book stands far above the norm, and not only for the superbly conceived images. Every refinement went into the printing, with warm red outlines for the figures instead of the standard black, and precision in the carving of details, especially the hair and the patterns of the robes. The publisher is not named, but the quality of the volume marks it as a product of Tsutaya Juzaburo, the publisher who discovered Utamaro, encouraged his work in different areas and eventually produced some of his most famous prints.

1795
UK

God Creating Adam, William Blake
Colour print, pen and watercolour on paper, 42.1 x 53.6 cm / 1 ft 4½ in x 1 ft 9 in,
Tate, London

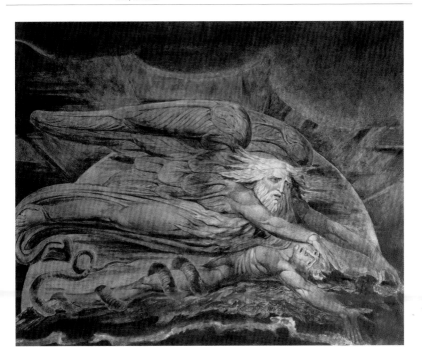

In this print, William Blake (1757–1827) depicts the creation of Man in a negative light: Adam lies enslaved within the material world, his body already trapped by the serpent, his face tormented by the powerful winged being hovering above him. The scene is set below dark storm clouds and shafts of lightning. As an artist and poet, Blake interpreted biblical and literary subjects according to his personal vision; here God is given the Hebrew name Elohim, a frightening entity based on the vengeful and unforgiving Old Testament deity.

On 3 March 1806, Blake delivered this print to his patron, Thomas Butts, who also bought a further eight from the series. As the culmination of the artist's experimental methods, the composition is highly unusual for its date: antique source material is designed inside a two-dimensional patterning of forms and vividly embellished by unnaturalistic colours and light sources, a style that Blake had developed in the 1780s and 1790s. This wilful distortion of anatomy and perspective anticipates the abstracted forms of such nineteenth-century modern movements in art as late Pre-Raphaelitism and Art Nouveau.

Napoleon Crossing the Alps, Jacques-Louis David
Oil on canvas, 259 x 221 cm / 8 ft 6 in x 7 ft 3 in, Musée National du Château
de Malmaison, Rueil-Malmaison

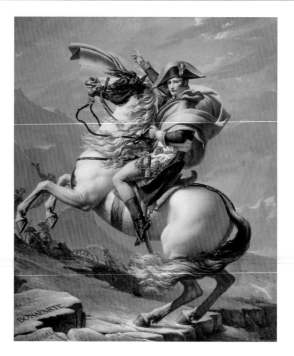

Napoleon was only 31 years old and already a formidable general, having defeated the Austrians in Italy for the second time in five years, when Jacques-Louis David (1748–1825) painted this image. Charles IV of Spain commissioned the work. Napoleon refused to sit for the portrait but sent the uniform he had worn at the Battle of Marengo. He wanted to be painted 'calm on a fiery steed' rather than with a sword, as originally suggested by David. In the remarkable propaganda painting that resulted, Napoleon is associated with Hannibal and Charlemagne, who also crossed the Alps, and is portrayed as a Romantic hero on a rearing horse, wearing flamboyant attire; in reality he travelled on a

donkey wearing a grey coat. The diagonal composition suggests how Napoleon directed his army onwards and upwards.

When David painted this portrait, he was the most important and influential painter of the Neoclassical movement in France. After the French Revolution he followed Napoleon without hesitation, fascinated by his aura of heroism and glorifying him in his painting. This original work, in which the general wears a yellow cloak, was repainted several times on Napoleon's order, with different coloured coats.

Fath 'Ali Shah, Mihr 'Ali

Oil on canvas, 253 x 124 cm / 8 ft 3 in x 4 ft 8 in, State Hermitage Museum, St Petersburg

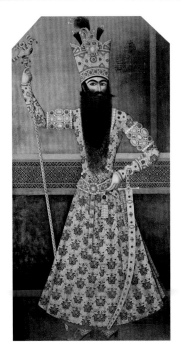

The coming of Europeans to the Islamic lands beginning in the sixteenth century led to the introduction of different techniques and styles. The most notable new medium was painting with oil pigments on canvas, and under the Qajar rulers of Iran (r.1779–1924), a distinct style of painting evolved that merged Persian and European modes of representation. Fath 'Ali Shah (reigned 1779–1834), the first major ruler in the Qajar line, appreciated the importance of art in creating a regal image and commissioned the court artist Mihr 'Ali (fl. c.1795–1830) to paint at least 10 full-length portraits of him.

In this painting of 1809–1810 the ruler is shown holding a sceptre topped by a hoopoe, the bird of King Solomon mentioned in the Koran. The painting shows off Fath 'Ali Shah's luxurious black beard, rich robes and gem-studded regalia, which form the basis of the crown jewels of Iran. The Qajar monarch's swaggering pose is modelled on contemporary portraits of Napoleon in his coronation robes, holding the sceptre of Charles V. Napoleon may well have sent such a portrait to Persia as part of General Gardane's mission there in 1807, and the Persians in turn presented portraits of Fath 'Ali Shah to European courts. Several of these large portraits still belong to European state museums.

c. **1809**
Germany

Monk on the Seashore, Caspar David Friedrich
Oil on canvas, 110 x 172 cm / 3 ft 7¼ in x 5 ft 7¼ in, Nationalgalerie,
Staatliche Museen, Berlin

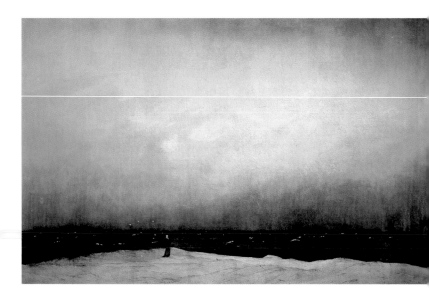

Exhibited at the Prussian Royal Academy in 1810, where it was identified in the catalogue without comment simply as a landscape, this picture bewildered even the German author Goethe. He was so surprised by the huge expanse of sky and the horizontal sand dunes and waves that he wrote that it could just as well be looked at upside-down.

In spite of this criticism, it was on the strength of this startling composition that Caspar David Friedrich (1774–1840) was elected a member of the Academy in the following year, and the Crown Prince of Saxony persuaded his father, Frederick William III, to buy the work so that the painter's future was assured. The tiny vertical figure of the monk, who is

so dwarfed by nature, is thought to be a self-portrait, and the symbolism of this beautiful, almost abstract painting concerns the artist's sense of loss and apprehension of the human condition, confronting mortality in the face of eternal nature.

c. **1810**
New Zealand

Maori Carved Centre-post, Artist unknown
Wood, H: 96.8 cm / 3 ft 2 in, Museum of New Zealand Te Papa Tongarewa, Wellington

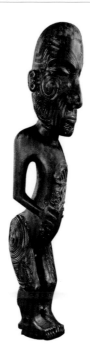

Maori ceremonial buildings were richly carved inside and out. This figure, from Ngati Pikiao (Te Arawa), the Bay of Plenty, functioned as part of the *pou tokomanawa* (carved centre-post) that supported the ridgepole of a large ancestral house or tribal council house; these posts usually have a carved representation of a significant tribal ancestor at their base. The post dates to the beginning of the Te Huringa I period (The Turning), from 1800 to the present.

The traditional Maori wood-carver acted as a conduit for the gods to express themselves in material form, and work such as this was imbued with spiritual power. The process of carving was sacred to the Maori, since it was a gift from the sea god, Tangaroa. This freestanding figure, sawn off the main pole, is sculpted in a particularly naturalistic fashion and covered with geometric designs of tattoos characteristic of all of Maori figural art. The *ta moko* (facial tattoos) denoted rank, status and virility, and the wearer's position in society could thus be instantly recognized. The figure's hands and feet have five digits instead of the customary three, and the right hand holds a carved *wahaika* (short club), indicating his chieftain status.

Numbered among the most famous works by Antonio Canova (1757–1822), this marble group, sculpted from c.1813 to 1816, was originally made for Napoleon's wife, Empress Josephine; she died in 1814 before it was completed, and it was eventually bought by her son. A second version was made for the Duke of Bedford. The work epitomizes the beauties of Neoclassical sculpture, with its erotic, curvaceous nudes and highly polished finish.

In fact, Canova here departed from the archaeologically correct ideals of Neoclassicism. He changed the traditional practice of depicting the Graces with the central figure facing the other two, and dispensed entirely with the goddesses' identifying attributes. An adventurous work that breaks some of the doctrinaire rules of the movement, it was universally admired, and it inspired poems by Ugo Foscolo and Ludwig I of Bavaria.

In his lifetime, Canova achieved wide reputation as the greatest of living sculptors. He received orders of knighthood from the Pope, the king of England and the emperor of Austria, and commissions from Catherine the Great of Russia, the Bonaparte family and the British aristocracy. He was instrumental in helping the Duke of Wellington restore works of art looted by Napoleon's armies to their rightful collections in Italy, and in England he was acclaimed as a unique artist and statesman.

Third of May 1808, Francisco de Goya
Oil on canvas, 266 x 345 cm / 8 ft 8¾ in x 11 ft 3½ in, Museo del Prado, Madrid

After Napoleon invaded Spain in 1808, the citizens of Madrid organized a hopeless attack against the French, after which many were rounded up and shot. It was not until 1814 that the invaders were driven from Spain, and that was when Goya, aged 68, profoundly deaf and in poor health, petitioned the Spanish government: 'It is my ardent wish to perpetuate by means of my brush the most notable and heroic actions and scenes of our most glorious insurrection against the tyrant of Europe.' He spent three months on a paid commission to complete two magisterial paintings.

With this work and its companion piece, the *Second of May 1808*, Francisco de Goya (1746–1828) transformed war art, breaking the tradition of portraying kings, generals and statesmen as heroes. In the *Third of May* he elevates the common man to a heroic, quasi-divine level, and the anonymous firing squad becomes the instrument of brutal repression. After the restoration of Fernando VII as king of Spain in 1814, both works were stored in the Prado palace reserve. Possibly intended for a triumphal arch to celebrate Fernando's return, the *Third of May* became famous as the first major image of urban warfare in the nineteenth century and influenced later artists from Edouard Manet to Pablo Picasso.

c. **1815**
Chile

Barkcloth Figure, Artist unknown
Reeds, barkcloth, wood and paint, H: 40 cm / 1 ft 3¾ in, Peabody Museum
of Archaeology and Ethnology, Harvard University, Cambridge, Massachusetts

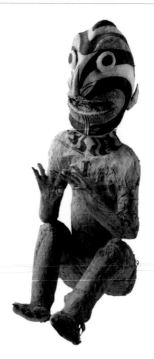

This striking barkcloth figure from Rapa Nui (Easter Island) is one of only three that survive in museums worldwide; all of them were collected during the first half of the nineteenth century. The large, skull-like head emphasizes the importance of that part of the body as the locus of *mana*, or spiritual power, and evokes an ancestral quality. The red, black and white design motif derives from tattoos and body painting.

Despite the compelling visual quality of its art, little is known about the religion of Easter Island. Barkcloth figures such as this may represent ancestral figures, for large barkcloth-covered wooden figures, about 3 meters (10 ft) tall, were used in the *paina* feasts that commemorated important men who had

died. The figure would be set up near the *ahu* platform where the deceased's bones were buried; according to some sources, the dead man's son would speak through the mouth of the figure. In 1770, Spanish explorers saw one of the large figures and compared it to the figures of Judas burned in Spain during Holy Week. Whether smaller figures such as the one shown here are related to these larger figures – perhaps as smaller memorials of the occasion – is unclear.

1819
France

The Raft of the Medusa, Théodore Géricault
Oil on canvas, 491 x 716 cm / 16 ft 2¼ in x 23 ft 4¾ in, Musée du Louvre, Paris

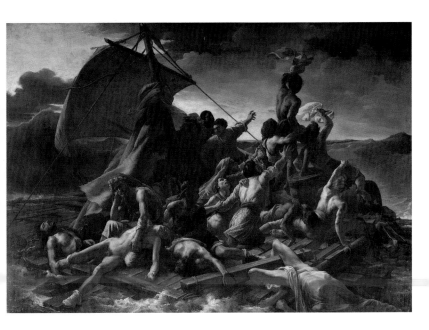

Inspired by a disaster that took place in July 1816 off the west coast of Africa, this painting was both an indictment of corruption in the French navy and a profound reworking of the traditional French historical exhibition piece. Théodore Géricault (1791–1824) studied the original incident in great detail: a French frigate, the *Medusa*, was transporting a new governor, soldiers and colonists to Senegal when it foundered in a storm. Some 150 passengers were forced onto a life raft while the captain and officers took the only available lifeboats and abandoned the raft. After 13 days of terrible suffering, 15 survivors were rescued, two of whom, the ship's surgeon and a geographer, published an account of the shipwreck.

When first exhibited at the Paris Salon (annual exhibition) in 1819, the work (formerly called *Scene of a Shipwreck*) attracted very little attention, probably because it had been hung above a door. A re-hanging brought the full vigour of the artist's powerful brushwork and livid colouring to public attention, and the painting became a political rallying point for liberals, as well as heralding a new era in French history painting. Although he never sold a single work of art in his lifetime, Géricault became a source of inspiration for later painters from Eugène Delacroix to Paul Cézanne.

One of the most magnificent portrait drawings Jean-Auguste-Dominique Ingres (1780–1867) ever produced, this image expresses the power of the artist's meticulously detailed sense of design. Ingres was among the first major artists to use graphite pencil as an important medium for portraiture, and he became renowned for his sketched likenesses of friends and society figures, mainly produced in Italy.

A fine violinist himself, Ingres admired the great Paganini, although he deplored the performer's more eccentric playing. Unlike his artistic rival Eugène Delacroix, who painted Paganini in the throes of a violent performance, possibly playing his renowned 'Devil's Trill', Ingres here portrays the musician as

a fine gentleman in an immaculate cravat and double-breasted frock coat trimmed with artfully fashionable buttons. Ingres's classical training and dedication to line drawing and the Antique is demonstrated here by the clarity of each pencil stroke, the internal rhythmic patterning of the hair and the refined expressive eyes, which suggest that the sitter is about to speak.

Salisbury Cathedral from Lower Marsh Close, John Constable
Oil on canvas, 73 x 91 cm / 2 ft 4¾ x 3 ft, National Gallery, Washington, DC

The famous Gothic spire of Salisbury Cathedral is one of the limited number of sites John Constable (1776–1837) worked on single-mindedly throughout his career, and the daring, free brushwork of this canvas was painted spontaneously *in situ*. This style stemmed from his desire to capture the vagaries of the weather in oils, a process he referred to as 'skying', though it could equally well apply to the splashes of yellow sunshine on the lawn. As early as 1814, Constable was producing canvases directly from nature, developing a unique manner of oil sketching from life.

Constable and J.M.W. Turner are the twin giants of early nineteenth-century British landscape painting, both of them seeking to position that genre on a par with history painting. Constable was initially inspired by the landscapes of Thomas Gainsborough and seventeenth-century Dutch masters, but most particularly by Claude Lorrain.

Constable's paintings were far more popular in France than in his native England. Eugène Delacroix reworked the background of his *Massacre at Chios* after seeing one of Constable's works at the Paris Salon of 1824. Constable's loose, dappled brushstroke, *in situ* painting, and emphasis on atmospheric effects have been seen by many as an inspiration for later Impressionist painters.

Ukiyo-e, literally 'pictures of the floating world', is a genre of Japanese woodblock prints and painting that developed in the urban centres of Edo (Tokyo), Osaka and Kyoto from the seventeenth to the twentieth century. *Ukiyo-e* prints were mass-produced, usually on single sheets of paper, and enjoyed great popularity. Keisai Eisen (c.1790–1848), a man of many talents, was a gifted and prolific producer of *ukiyo-e* prints, best known for his images of courtesans such as this.

In his portrayal of women, Eisen combines straight lines of varying thickness, sharp angular strokes, and fine details. A high-ranking courtesan fills the frame of this panel of a vertical diptych designed to emulate the hanging-scroll format common for

Japanese paintings. A dragon swirls over her robes, and bristling tortoiseshell hairpins and combs radiate from her elaborate coiffure. Her face reflects the hard-edged beauty favoured among *ukiyo-e* artists, and the resulting image conveys a sense of a very strong-minded woman.

Ukiyo-e had a powerful influence on Post-Impressionist artists, and this print featured on the cover of *Paris illustré* in 1886, directly inspiring Vincent van Gogh's *Courtesan* of 1887.

Death of Sardanapalus, Ferdinand Victor Eugène Delacroix
Oil on canvas, 392 x 496 cm / 12 ft 10¼ in x 16 ft 3¼ in, Musée du Louvre, Paris

Although the *oeuvre* of Eugène Delacroix (1798–1863) cannot be confined to paradigms of a single school or movement, this work may be seen as the culmination of his early, most Romantic phase. He was influenced by the colour and sensuality of Rubens, as well as by John Constable and the work of other artists encountered on his visit to England in 1825. His technique was constantly in flux, and in this work he abandons the polished finish of Neoclassicism in favour of a more open, loose brushwork.

The monumental canvas was exhibited at the Paris Salon of 1827 and provoked a barrage of criticism, languishing in the artist's studio until 1846. The tangled bodies, frieze-like foreground and raked perspective were considered an attack on the rational compositions of Neoclassical Academicism. The subject is loosely based on Byron's 'Sardanapalus' (1821) and depicts the legendary last king of Assyria on a funeral pyre surrounded by objects of luxury. The death of the decadent and cowardly ruler is not shown, but that of two of his attendants is depicted. The representation of royal downfall, shortly after the death of King Louis XVIII, has been seen as a Romantic rebellion against the Bourbon Restoration.

c. **1830**
Japan

Kajikazawa in Kai Province, from Thirty-six Views of Mount Fuji, Katsushika Hokusai
Woodblock print, c.26 x 38 cm / 10 in x 1 ft 3 in, Various locations

Katsushika Hokusai (1760–1849) already had nearly 50 years' experience as a painter and print designer behind him when he produced the series for which he is best known: *Thirty-six Views of Mount Fuji*. The series was originally planned at 36 woodblock prints, but its popularity led to the production of another 10 folios. Contemporary advertising notices and Hokusai's rate of design suggest that the series first appeared and was completed around 1830–1833.

This is one of the noblest images in the series. It depicts an elderly fisherman balanced on a rocky promontory, patiently holding fishing lines while his young assistant – perhaps his son – rests nearby. The man's bent figure – closely observed down to the thin

arm and the stretched grip of the hand – exemplifies Hokusai's superb draughtsmanship. The triangular form of the promontory, fisherman and fishing lines harmoniously echoes the shape of Mount Fuji rising through high clouds in the distance. The frothing waves and the silent currents of water that sweep across the middle ground are Hokusai's emblematic way to indicate Kajikazawa's setting on the Fuji River, one of the three widest and fastest rivers in Japan.

Mass-produced *ukiyo-e* woodblock prints were popular throughout the Edo period (1615–1868), especially in metropolitan Edo (modern Tokyo). Landscape emerged as an independent subject during the early nineteenth century.

View from Mount Holyoke after a Thunderstorm (The Oxbow), Thomas Cole

Oil on canvas, 131 x 193 cm / 4 ft 3½ in x 6 ft 4 in, Metropolitan Museum of Art, New York

Thomas Cole (1801–1848) is considered the founder and leading light of the Hudson River school, a group of artists who drew their inspiration from the untouched natural landscape of America, particularly New England. On a trip to Europe between 1829 and 1832, Cole made a tracing of this view from Basil Hall's *Forty Etchings Made with the Camera Lucida in North America in 1827 and 1828* (1829). This evidence, alongside Hall's criticism of Americans' disregard for their own scenery, explain the genesis of the work.

Cole was loath to paint the style of realistic views popular with patrons. In this magnificent canvas, the full title of which is *View from Mount Holyoke, Northamptonshire, Massachusetts, after a Thunderstorm*

(The Oxbow), he overcame these misgivings by imbuing the landscape with the same high-principled, intellectual content found in his religious and allegorical works, charging his composition with high moral significance. With consummate skill and virtuosity, he juxtaposes the tempestuous untamed wilderness of the heights with the soft verdant pastures below, tamed by man and bathed in golden sunlight. He alludes to the bright prospects for the American nation, rooted in the richness of their land, and places himself squarely within this continuum: the artist himself appears perched on a promontory in the foreground, in the act of painting the scene.

Man-bear Mask, Artist unknown
Wood, teeth, abalone shell and metal, H: 19.7 cm / 7¾ in, Peabody Museum
of Archaeology and Ethnology, Harvard University, Cambridge, Massachusetts

While totem poles are the most well known of Northwest Indian artefacts, dance masks display the greatest variety, vigour and aesthetic inventiveness. This remarkably expressive Alaskan mask was created using a wide variety of natural materials. The resplendent mother-of-pearl and metal inlay and the rare and costly blue-green pigment, obtained from copper-bearing clay, suggest that this mask was particularly highly prized. The mystical importance of the mask is made clear by the fact that the artisans who carved such sacred objects traditionally could not be watched while at work, and a finished mask, imbued with spiritual power, could not be brought into the house.

This mask, dated to c.1800–1867, depicts a bear with human features. The tribes of the Northwest Coast believed that supernatural beings or spirits could only take animal form in the world of men. The bear was the lord of the forest, an emblematic animal that had lived in a mythical era, and as such one of the most revered shamanic beasts. The mask was probably worn by a shaman during the potlatch, a traditional festival of the Northwest Coast Indians held at times of transition such as births, deaths and marriages. During ritual ceremonies the shaman was transformed into the animal portrayed and took on the magical powers associated with it.

Tlingit / Haida Culture

Snow Storm: Steamboat off a Harbour's Mouth, Joseph Mallord William Turner
Oil on canvas, 91 x 122 cm / 3 ft x 4 ft, Tate, London

In his *Modern Painters* (1843), the art critic John Ruskin declared J.M.W. Turner (1775–1851) 'the father of modern art' and lauded the *Snow Storm* as the grandest ever statement of sea motion, mist and light. Turner's work was ahead of its time and often misunderstood, however, and the press lampooned the painting as 'a mass of soap-suds and whitewash'. Turner originally entitled it *Snow Storm: Steam-boat of a Harbour's Mouth Making Signals in Shallow Water, and Going by the Lead. The Author Was in his Storm on the Night the Ariel Left Harwich*, thus creating a deliberately absurd disparity between this almost abstract, individualistic vision and a title that reads like a historical report, and at the same time parodying the establishment preference for history painting over personal inventiveness.

Turner claimed he was lashed to the mast of the steamship for four hours in order to paint the scene, but the result is far from authentic. He was not aiming for verisimilitude or naturalism but to encapsulate the experience of a storm at sea. The composition swirls round in a frenzied vortex, and bravura brushwork heightens the disorienting effect, the surface of the canvas emulating the violent waves.

c. **1854**
UK

The Blind Girl, John Everett Millais
Oil on canvas, 80.8 x 53.4 cm / 2 ft 7¾ in x 1 ft 9 in, Birmingham Museum
and Art Gallery, Birmingham

The sentimental themes of Sir John Everett Millais (1829–1896), often featuring children or beautiful women, were popular with the British public during the Victorian era. Millais, already a talented artist of great technical virtuosity, was one of the founders, in 1848, of the Pre-Raphaelite Brotherhood, the professed aim of which was to imbue British art with the vitality found in Italian painting before Raphael.

The minute detail in the foreground of this picture was painted with very fine brushes, every blade of grass individually handled. The painting's glowing luminosity was achieved through the application of translucent colours over a wet white ground. Superficially, the work depicts a blind girl forced

to play the concertina for money, set against a lush open field with a town in the distance. The painting also contains layers of religious symbolism and social commentary. The composition echoes that of the Virgin and Child, and the butterfly on the girl's shawl is an emblem of the soul. She is unable to appreciate the beauty of her surroundings or the double rainbow asserting the hope of a better world, but the message is that Christ will endow the blind girl with new and better vision, as in his Biblical miracle.

The Gleaners, Jean-François Millet
Oil on canvas, 83.5 x 111 cm / 2 ft 7 in x 3 ft 7 in, Musée d'Orsay, Paris

'Peasant subjects suit my temperament best' said Jean-François Millet (1814–1875) when referring to paintings such as *The Gleaners*, executed in the village of Barbizon near Fontainebleau. His depiction of poor country women led to him being accused of being a 'socialist revolutionary', but his major concern was not with revolution but with the dignity and fatalism exhibited by common agricultural labourers. Millet's art, which was rooted in his native Normandy, was also influenced by wide-ranging themes from Biblical stories and Classical art and literature: the figures in this painting, for example, have been said to evoke the writings of Homer and Virgil, as well as being reminiscent of the Parthenon frieze.

Millet was a remarkable draughtsman and a master of light and dark, favouring a palette of earth tones and greens. Although generally associated with the Barbizon school of artists, which in reaction to the Romantic style of the time pursued a more realistic manner of painting, Millet was the least typical of the group, being less concerned with landscapes than with figure painting. Influenced by such Old Masters as Nicolas Poussin, Millet's work in turn influenced both Impressionists and Post-Impressionists, notably Camille Pissarro and Vincent van Gogh.

The greatest exponent of the American Sublime school of landscape painting, Frederic Church (1826–1900) travelled in Ecuador and painted this volcano on several occasions. Called Cotopaxi, it is regarded as the most beautiful, terrifying and unpredictable of South American volcanoes. Generally covered with snow, which can be seen to the left of the eruption in Church's picture, the mountain became for the artist a dramatic terrestrial symbol of cosmic unrest.

One of the few major landscape artists of the nineteenth century to tackle the difficulties of infusing such subjects with accuracy as well as a sense of tragedy and impending cataclysm, Church was originally influenced by such British artists

as J.M.W. Turner (see *Snow Storm: Steamboat off a Harbour's Month*, p.411). He developed new skills in depicting the extreme elements of the natural world by creating a unique sense of space and energy with vivid, carefully chosen colours and a pictorial instinct for achieving a striking, central motif. Critics have linked his depictions of this volcano to anxieties about social and national conflict, and one especially violent view of Cotopaxi was completed during the American Civil War (1860–1865). Admirers on both sides of the Atlantic acclaimed this painting as a masterpiece of the American Sublime when it was exhibited in New York and London in 1865.

Lunch in the Studio, Edouard Manet
Oil on canvas, 118 x 154 cm / 3 ft 10½ in x 5 ft 2¼ in, Neue Pinakothek, Munich

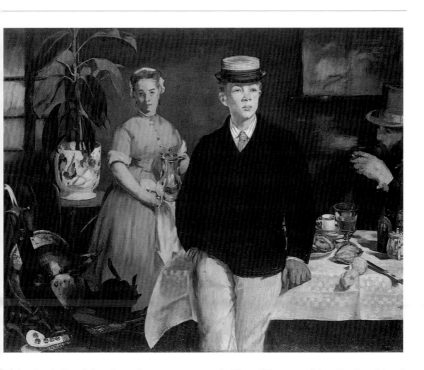

Exhibited at the Paris Salon of 1869, this picture provoked conflicting commentaries from Parisian critics. The still life elements of lemon, oysters, tablecloth and the suit of armour in the corner were all seen as remarkably true to life. Only the figures puzzled spectators and critics, because they were regarded as awkward, even inspiring a few caricatures and gentle jokes from humorous periodicals.

In fact, with this work Edouard Manet (1832–1883) had developed a truly modern realist style, depicting a group of contemporary figures unimpeded by narrative or allegory. Only the freshness of the artist's colouring and piercing clarity of detail express the true meaning. While deriving ultimately from the work of Diego Velázquez and from Dutch art, Manet's technique has here found an individual vision: a moment in the day, a family meal coming to an end, portraits of sitters who adopt no stiff poses or stylized gestures, and a subtle atmosphere of well-being and relaxation, which was at the time unprecedented in French painting. An early example of the movement that would later be called Impressionism, it presages the casual settings and attention to light and movement that were typical of the style.

1871
USA

Max Schmitt in a Single Scull, Thomas Cowperthwait Eakins
Oil on canvas, 82 x 118 cm / 2 ft 8¼ in x 3 ft 10¼ in, Metropolitan Museum of Art,
New York

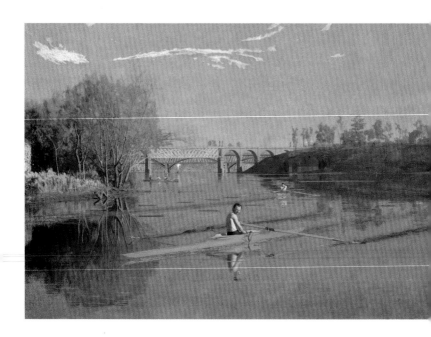

Dedicated to an active outdoor life as well as art, Thomas Eakins (1844–1916) painted many studies of sportsmen on his return to the United States in 1870, after three years of study in France and a visit to Spain. In his native Philadelphia, where rowing on the Schuylkill River was a favourite activity, the artist became a member of an exclusive rowing club and painted a number of river scenes set north of the Falls of Schuylkill Bridge, where there was a wide, smooth stretch of water.

This work (also known as *The Champion Single Sculls*), Eakins's first outdoor painting executed in the United States, has a precision of detail and atmosphere unchallenged in American naturalistic painting at

this time and reflects his European training in Realist painting styles. Set during a late summer afternoon, the work reveals a tranquil, almost melancholy quality as the principal figure – Max Schmitt, Eakins's childhood friend – rows across the broad passage of water before the distant Girard Avenue Bridge. Eakins himself is depicted the red boat in the distance. Part of the artist's effect is achieved through his powerful colour control, revealed by sky blues and pearly clouds above the orange and terracotta shades of the trees, complementing the statuesque rower, who pauses momentarily in the midst of his efforts.

1873
Russia

Barge-haulers on the Volga, Il'ya Yefimovich Repin
Oil on canvas, 132 x 281 cm / 4 ft 3½ in x 9 ft 2½ in, State Russian Museum,
St Petersburg

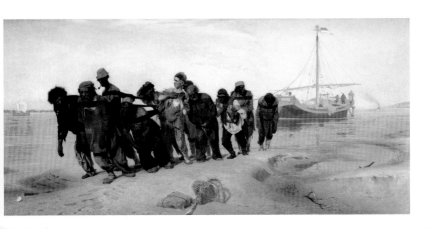

This famous work, which inspired several generations of Russian Socialist Realist painters, sends out mixed messages. As a group of peasants hauls a barge upstream against the current, having probably loaded it with goods and no doubt responsible for unloading them at their destination, are we asked to admire the strength and endurance of the Russian working man, or is this an indictment of a cruel system?

Having just completed his training at the Russian Academy in St Petersburg, Il'ya Repin (1844–1930) had obviously been taught to draw after ancient sculpture. The line of figures is reminiscent of a Classical frieze, but one brought up to date in the tradition of modern heroism. Hailed as a masterpiece, this work, with its luminous colouring, fascinated many of the artist's fellow countrymen. Dostoevski wrote of the painting: 'the artist deserved the greatest praise. Good, familiar figures … by no means are they thinking about their social conditions.' Nevertheless, the last and most distant figure in the group is almost on the point of collapse, and the imagery has inevitably been interpreted as a sympathetic commentary on the plight of the oppressed.

Realism

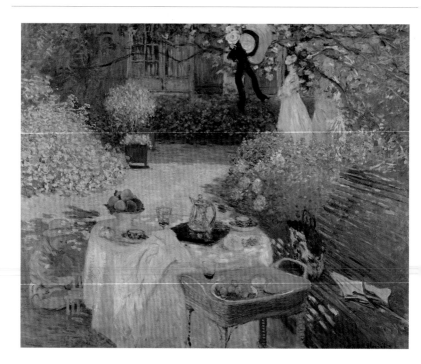

The largest work that Claude Monet (1840–1926) attempted after his return from London, where he lived in 1870–1871 to avoid the Franco-Prussian War, this painting celebrates the good things of life: flowers, snowy tablecloth and golden, light, crisp bread rolls, fruit, wine, the wicker table and an abandoned napkin thrown down after the meal. The summer afternoon follows a lunch eaten outdoors in the well-kept garden, seen through the eyes of the child playing with his toys to the left of the table.

The simplicity of details, the clean textures and brilliant sunshine enhancing ordinary pleasures are all characteristic of Impressionist painting. The work itself is far from simple: each object is carefully

placed and contributes to the idea of time passing, suggested by the ending of the luncheon, the absence of diners and the long shadows. Replete with a sense of well-being, the sunny atmosphere and the women strolling in the distance evoke contentment, but shadows promise the onset of evening. The child pausing in his play and his shaded presence are cunning arrangements expressing the fleeting nature of happiness. Monet himself described this work as 'decorative'. The patterns of light slightly flatten the perspective and heighten each colour, thus achieving a masterpiece in the artist's early development of Impressionism.

c. 1875
Papua New Guinea

Malaggan Mask, Artist unknown
Wood, pigment, opercula shells and bone, H: 72 cm / 28½ in,
Museum der Kulturen, Basel

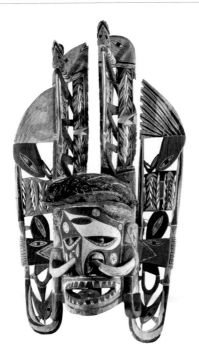

Elaborately carved Melanesian masks such as this one, which bristles with animal imagery, represent *wanis*, or nature spirits. From New Ireland in Papua New Guinea, the face is essentially human, although boar tusks protrude from the nose. The dramatic ear pieces include images of snakes and birds. The asymmetrical painting of the face enhances the mask's wild appearance, and the overall impression is one of movement, transformation and ambiguity. The Surrealists were drawn to the art of New Ireland, seeing in these works a connection to the visual puns and unconscious imagery that marked their own.

The *malaggan* ceremonial cycle, a mortuary ritual that could take years to complete, included many dance performances; masks such as this sometimes appeared at the end of a ceremony, to suspend the social restrictions that had been in place during the funerary cycle. Unlike the carved figures that also featured, but which were sometimes discarded after the *malaggan* display, masks such as this one were meant to be worn repeatedly.

Chokwe Face Mask, Artist unknown
Wood, plant fibre, pigment and copper alloy, H: 39.1 cm / 1 ft 3½ in, National Museum of African Art, Washington, DC

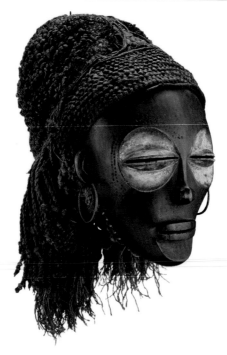

The original Chokwe name for this type of mask, *pwo*, referred to a mature woman who had given birth; the more recent name, *mwana pwo*, emphasizes youthful feminine beauty and probably indicates European influence. This mask, dated to the late nineteenth or early twentieth century, represents a beautiful young woman adorned with scarification, earrings and an elaborate coiffure, and was one of the most popular dancing masks among the artistically sophisticated Chokwe people, who live in southwest Congo, Angola and Zambia. Within their matrilineal society, the *pwo* dance honoured the founding female ancestor of the tribe, but the dancers were males dressed as women in costumes of braided fibre that concealed their identity.

The mask was carved from local alstonia wood; red clay and oil were applied to the face and have aged to a rich reddish-brown patina. Since *pwo* was envisioned as an mature female ancestor, the narrow slit-eyes in large, concave sockets covered with white clay may evoke those of a deceased person. The non-naturalistic style of African masks like this one played an important role in the evolution of late nineteenth- and early twentieth-century Western art. Their perceived primitivism inspired artists such as Paul Gauguin and Pablo Picasso to break with traditional canons.

Nocturne in Black and Gold: The Falling Rocket, James McNeill Whistler
Oil on panel, 60.3 x 46.6 cm / 1 ft 11½ in x 1 ft 6¼ in, Detroit Institute of Arts,
Detroit, Michigan

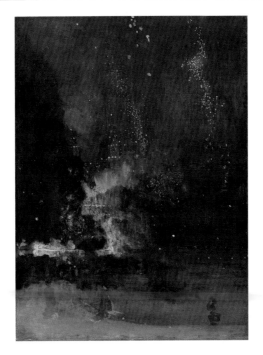

The American-born James Whistler (1834–1903) left the USA aged 21 to work in Paris and London, where he lived for the rest of his life. His art mediated between French and English styles, especially in the portrayal of urban scenes. Whistler matched his palette to the colours of London fogs ('pea-soupers'), dwelling with great intensity on gaunt, shabby terraces of houses and flats around Chelsea and producing unique images of the city. This painting depicts the nightly fireworks display over Cremorne Gardens, a confection of gold and scarlet flecks over ultramarine, ebony, browns and greens. Whistler regarded his translucent oils as analogous with music, hence his musical titles.

The British art critic John Ruskin, whose magisterial, five-volume *Modern Painters* was dedicated to the principle of artists representing nature faithfully, published a hostile analysis of Whistler's picture, characterizing the American as a trickster who charged 200 guineas for 'flinging a pot of paint in the public's face'. In the resulting libel case, Whistler defended the painting, declaring it was the result of a lifetime's artistic knowledge. Although he won, the case ruined him financially; it nevertheless resulted in his becoming an artistic hero, dominating the Aesthetic movement in England and much admired by French Impressionists.

Ball at the Moulin de la Galette, Pierre-Auguste Renoir
Oil on canvas, 131 x 175 cm / 4 ft 3½ in x 8¾ in, Musée d'Orsay, Paris

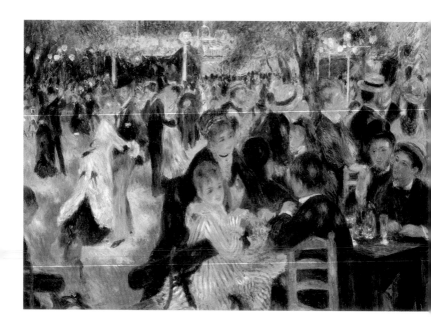

Two years after the first public exhibition of what came to be called Impressionist paintings, Auguste Renoir (1841–1919) completed this highly ambitious work, of which there are two further versions. This popular pleasure garden in Montmartre, Paris, was a venue for dancing and enjoyment, although it also retained a louche reputation as a pick-up place for prostitutes. No hint of such a seedy atmosphere disturbs Renoir's image of an idyllic summer afternoon, where the late sun filters down through the trees in cunningly placed, luminous patches while lamps are lit, parents and children in their best clothes chat together, and young lovers dance and flirt in the middle distance.

Shown in 1877 at the third Impressionist exhibition, the picture is a celebration of happiness and prosperity. It has become the image of high Impressionism, idealizing Parisian life, portraying many of the artist's friends and models and paying artistic tribute to French fashions and standards of entertainment. It demonstrates Renoir's interest in French Rococo painting of the eighteenth century and articulates the artist's superb skill as a colourist.

c. 1878
France

Singer with a Glove, Edgar Degas
Pastel on canvas, 52.9 x 41.1 cm / 1 ft 8¾ in x 1 ft 4 in, Fogg Art Museum,
Harvard University, Cambridge, Massachusetts

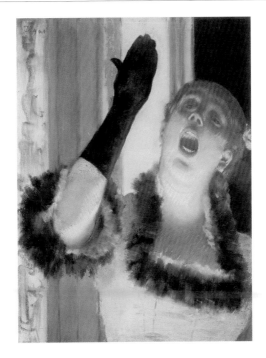

'Revolutionaries? We are *tradition*,' wrote Edgar Degas (1834–1917) about his work and that of his Impressionist colleagues. He had steeped himself in studies after Renaissance and Classical art, and made copious drawings after eighteenth-century British Neoclassical masters such as John Flaxman and nineteenth-century French artists such as Jean-Auguste-Dominique Ingres. His intention was to develop a style as solid as the Old Masters but to use it for representations of laundresses, milliners, ballerinas and tarts as well as smart boulevardiers at the racetrack and drunken patrons in Parisian bars.

This pastel comes from a series portraying leading artistes of the café concerts, each work combining the grandeur of Renaissance figures with the bold contours of contemporary fashion plates. Identifying himself with modernity, the artist used daring methods to achieve a new style for the contemporary heroine: the singer's left arm is cut by the composition's edge; her gloved hand floats like a separate entity and imparts a mysterious portentousness to the high moment of her performance. The portrait of this *demi-mondaine*, thought to be the singer Mlle Desgranges, assumes the monumentality of Antique sculpture coloured by artificial stage lighting.

The Daughters of Edward Darley Boit, John Singer Sargent

Oil on canvas, 221 x 221 cm / 7 ft 3 in x 7 ft 3 in, Museum of Fine Arts,
Boston, Massachusetts

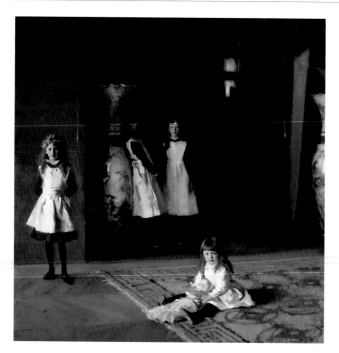

Although briefly influenced by French Impressionism, John Singer Sargent (1856–1925) remained on the margins of late nineteenth-century artistic modernism. After working in Paris, he travelled to Madrid in 1879 to study works by Diego Velázquez, and to Haarlem in the Netherlands to study the paintings of Franz Hals. It was after these two formative journeys that he produced his best portraits.

The artist was a close friend of the Boit family, and Edward Darley Boit, also a painter, was (like Sargent at the time) an American living in Paris, where this portrait was painted. The Boits were obsessive travellers, and the four daughters – Maria-Louisa, Florence, Jane and Julia – posed for the artist in their Parisian apartment. Their itinerant family life is symbolized by the Japanese porcelain vases and a composition based openly on the greatest of Spanish group portraits, Velázquez's *Las Meninas* (p.368).

The cosmopolitan flavour of the portrait, the placing of the two eldest girls in shadow, the similarity of their dress and pinafores, and their juxtaposition with the costly but fragile vases have raised questions about the work's symbolism, indicating perhaps the fleeting character of childhood. Sargent's colour sense, skill at depicting children and wonderfully suggestive brushwork have here combined to create a major composition in the tradition of the Old Masters.

c. 1884
France

The Burghers of Calais, François-Auguste-René Rodin
Bronze, H: 200 cm / 6 ft 6 in, In situ, Victoria Tower Gardens, London

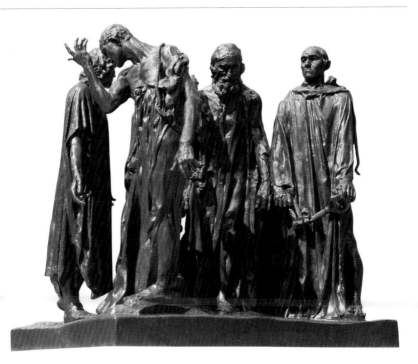

In 1884, Auguste Rodin (1840–1917) was approached by the mayor and municipality of the city of Calais to design a statue of Eustache de St Pierre and his companions, who were famous for having saved the citizens of Calais from starvation in a siege during the Hundred Years War. Chronicled by Froissart, the events took place in 1347, when six hostages left the relative safety of the city walls and walked to surrender themselves to the victorious English king, Edward III. Rodin studied Froissart's account before making the work, insisting that he should portray all six of the hostages as part of an over-life-size group. Each figure was modelled in clay from live models, and in the preliminary plaster model (Musée Rodin,

Paris) he shows the men in flimsy garments with ropes around their necks.

Some 12 bronzes, including the one shown here, were cast from the completed group in 1884–1885, and it became one of the sculptor's most controversial and well-known works. At first, few people liked the theme of the piece; the burghers were thought to look like convicts, criminals or destitute beggars, such was the degree of unorthodox realism in their figures and faces. The artist later made a robust defence of his work, commenting: 'I only ask to be allowed to make a masterpiece … for me the question of art takes precedence over anything else.'

Models, Georges Seurat
Oil on canvas, 200 x 250 cm / 6 ft 6 in x 8 ft 2½ in, The Barnes Foundation,
Merion Station, Pennsylvania

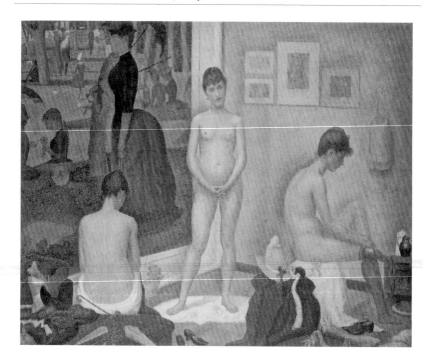

Having rejected the naturalism of the Impressionists, Seurat (1859–1891) developed his painting methods in tune with a modernized idealism, involving himself with the Symbolist avant-garde as well as making scientific enquiries into the nature of colour. His aim, he wrote, was to establish 'a kind of painting that was my own'. His obsession with originality and use of pointillism – painting in dots of unmixed colour, a technique that he invented – gave his imagery a static quality. He portrayed contemporary scenes with sculptural figures like images on an antique frieze, combining this with a pure tone and robust realism.

The models in this composition, dated to between 1886 and 1888, may be a single model seen from several angles or three different girls posing at the same time. A section of Seurat's earlier masterpiece *Sunday Afternoon on the Island of the Grande Jatte* is visible in the background, as if the artist is drawing attention to the separate realities of art and life.

After Seurat's death at the age of 32, works such as this were hailed by his followers and admirers, notably the Neo-Impressionist painter Paul Signac, and Seurat has remained one of the most influential late nineteenth-century French artists.

Roses of Heliogabalus, Lawrence Alma-Tadema
Oil on canvas, 132 x 213 cm / 4 ft 4 in x 6 ft 11¾ in, Private Collection

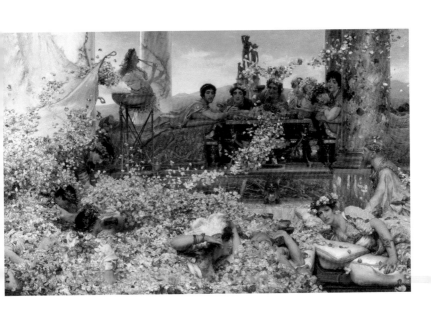

In 1866 the Pre-Raphaelite Simeon Solomon created a watercolour of the Roman emperor Heliogabalus. Languorous, sensuous and effete, Heliogabalus was murdered by his own Praetorian guards, but not before indulging in sexual excess, extravagance and mass murder. Holding a huge banquet and orgy, he was said to have arranged for tonnes of flowers to pour down on his drunken guests, smothering them to death. In the late nineteenth century, writers and artists saw such anti-heroes from Roman history as personifying a decadent extreme.

Exhibited in London in 1888, this painting by Lawrence Alma-Tadema (1836–1912) expresses the aesthetics rather than the cruelty of Heliogabalus

and in this way signals a profound change in British art. The victims appear to die easily and the emperor reclines on his couch, unmoved by the scene. Enjoyment is signified by the elegant female flute-player facing away from the slaughter and looking out at a mountainous Italian landscape.

With the falling flowers, the artist creates a piquant, pictorial juxtaposition of rose petals and death. In the original story, from Gibbon's *Decline and Fall of the Roman Empire*, the emperor murdered his guests with violets and other flowers, but Alma-Tadema chose to depict roses, which signified lust in the Victorian lexicon of flower symbolism.

1889
Netherlands

Trabuc, Attendant at Saint-Paul's Hospital, Vincent van Gogh
Oil on canvas, 61 x 46 cm / 2 ft x 1 ft 6 in, Kunstmuseum, Solothurn, Switzerland

In his comparatively short painting career, Vincent van Gogh (1853–1890) produced a number of portraits, all of them significant in the way they use colour and composition to evoke a strong sense of presence.

In 1889, while a patient at the Saint-Paul hospital at Saint-Rémy, van Gogh painted portraits of the hospital attendant Trabuc and his wife. The man himself particularly fascinated the painter. 'A very interesting face', he wrote to his brother, Theo. The rough, unidealized technique of the paint is laid on in such a way as to hint at emotion, even suffering, in the attendant's cross-veined and lined face. But there is also a debonair quality, as in many of van Gogh's best portraits, signalled by the tight necktie and yellow

button that fastens the jacket. Van Gogh was so taken with this portrait that he made a copy of it, which he sent to his brother, and it is this version that is known today; the original, which the artist gave to the sitter, has long since disappeared.

1893
Norway

The Scream, Edvard Munch
Oil, casein and pastel on cardboard, 91 x 74 cm / 2 ft 11¾ in x 2 ft 5 in,
National Gallery, Oslo

'The terror of life has pursued me ever since I first began to think … I was very tired, leaning on a railing overlooking a fiord, alone, trembling with fear, and I experienced nature's great scream.' This was how the Norwegian painter and printmaker Edvard Munch (1863–1944) described this, his most famous work, and it has remained an icon of man's alienation and fear of nature ever since. It is also a powerful symbol of the artist's own terror in confronting an increasingly alien modern world. By expressing his own feelings and personality, Munch became widely recognized as one of the first truly Expressionist artists, and this painting has influenced many twentieth-century art movements, from Expressionism to Surrealism.

Having left Norway to study in France, Munch became dissatisfied with the lyrical realities of French Impressionism, his first artistic love. He returned in 1890 to an increasingly desperate and tragic life, including familial sickness, insanity and early death. His attempts to achieve acceptance as an artist met with little success at first. Invited to exhibit in Berlin in 1892, he caused a furore with his strange paintings, which were seen as decadent and amateurish, partly because of his method of reducing extraneous detail to a minimum, and partly because of his semi-autobiographical, mysterious subjects. He nevertheless inspired numerous admirers in northern Europe and has been widely imitated.

The immense looming presence of this nineteenth-century mask, with its massive domed forehead, was intended to intimidate as well as inspire awe. The apparition evoked is an immaterial one, apparent through its ghostly pallor, the wispy lines that minimally define the brows, and the radical tapering of the head. Its massive spectral manifestation was intended to suggest an abstract spiritual force rather than an overtly human subject.

The mask was worn in performances related to rites of *ngi* (*ngil*), a Fang anti-witchcraft association that transcended clan interests to regulate village life and protect individuals against mystical aggression. *Ngi* was credited with the ability to reveal hidden

dangers, and villages adopted *ngi* ceremonies as they experienced a need to combat crises attributed to witchcraft by detecting and punishing sorcerers. *Ngi* members gathered in small groups with an emblematic mask, both to investigate foul play and to expose and bring the perpetrators to justice. The presence of the fearsome masked and armed representative served to enforce punishment of criminal behaviour and pre-empt potential foul play.

Apples and Oranges, Paul Cézanne
Oil on canvas, 73 x 92 cm / 2 ft 4¾ in x 3 ft, Musée d'Orsay, Paris

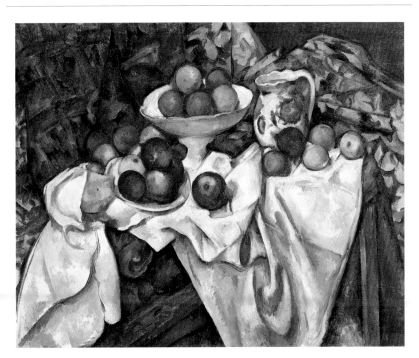

Probably the most monumental and experimental among a series of still lifes from this period, this work, dated to between 1895 and 1900, employs a basic range of details – jug, bowl, fruit, cloth, carpet – that Paul Cézanne (1839–1906) used in several similar canvases. The series became ever more experimental as the artist explored composition and perspective, attempting to depict the physical presence of the objects without recreating real space. This still life has a number of viewpoints, the perspective switches from one angle to another, each object has its own lighting, and only the artist's hard outlines and disciplined choice of colour, by which he achieved a sense of depth without sacrificing the brightness of his palette, keep the

composition from disintegration. Against the more subdued tones of drapes, the rich, pure reds and oranges of the fruit stand out as powerful forms.

One of the most daring still lifes in the history of art, the image shifts from detail of substances to shadows to fabric, setting its own rules, an entirely autonomous object with a flat surface. The loose brushwork, colour control and, especially, fragmentation and abstraction of the forms, herald later Cubist still life paintings.

1898
Russia

Lilies of the Valley Egg, Peter Carl Fabergé
Gold, enamel, diamond, ruby, velvet, rock crystal and platinum,
H (open): 20 cm / 5 x 7 in, Private Collection

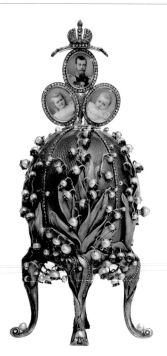

The *Lilies of the Valley Egg* is one of only two eggs executed by Fabergé (1846–1920) in the Art Nouveau style. Its rose pink *guilloché* (interlace pattern) is surmounted by a diamond and ruby-set imperial crown and is covered with green enamelled leaves, lily-of-the-valley pearls and rose-cut diamonds. A pearl knob activates a mechanism that reveals the miniature portraits of Tsar Nicholas II and his two eldest daughters, Olga and Tatiana, framed in rose-cut diamonds. It was one of the empress's favourite objects by the Russian jeweller, kept in her private apartments in the Winter Palace, St Petersburg.

The rich variety of stones from Siberia, the Caucasus and the Urals provided ample sources for attractive compositions, and Fabergé experimented with an astounding 140 shades of colours while making 56 eggs for the Russian imperial family from 1884 to 1917. The Fabergé Moscow workshops, which mainly produced items in the medieval Russian and Italian Renaissance styles, were also influenced by contemporary French designs. The *Lilies of the Valley Egg* was displayed at the 1900 World Fair in Paris, at the height of the Art Nouveau movement.

Gulf Stream, Winslow Homer
Oil on canvas, 72 x 124 cm / 2 ft 4¼ in x 4 ft 8¼ in, Metropolitan Museum of Art,
New York

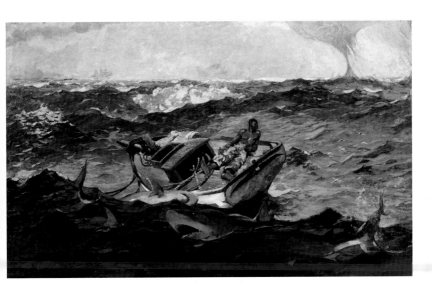

Having begun his career as an illustrator, Winslow
Homer (1836–1910) generally produced paintings
with a narrative or allegorical subtext. Although he
regarded his watercolours as his supreme achievement,
it was his studies in oil, chiefly made during two
winter visits to the Bahamas in 1884–1885 and 1898–
1899, that established him as the major American
marine artist of the late nineteenth century.

 This work reveals a moral that even the artist's
admirers found disturbing: the man adrift in his
dismasted sloop tries to maintain his grip on the
frail craft although threatened by an approaching
waterspout and several encircling sharks, thus
symbolizing heroism in the face of extinction.

Exhibited at the Pennsylvania Academy of Fine
Arts in 1900, the painting became the centre of
critical debate, and the artist reworked it on several
occasions. Priced at a then astronomical $4000, it
was thought to be impossible to sell, but it has since
achieved international fame as a classic work in the
European tradition of shipwreck scenes. J.M.W.
Turner (*The Slave Ship*, 1840) and Théodore Géricault
(*Raft of the Medusa*, p.403) formed artistic reference
points, and Homer evidently decided to challenge
these masterpieces. The energy and freshness of the
turquoise sea and pinkish sky are personal reworkings
of a subject achieved with great panache.

Naturalism

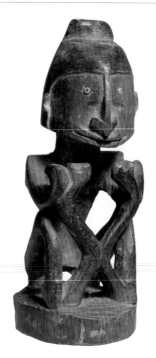

Korwar figures from Irian Jaya, the western half of the island of New Guinea, enabled communication between the living and the dead. The word means 'soul of the dead', for the spirit of the deceased was thought to enter the image. The figures were often made to appease the souls of people who had met unnatural or untimely ends – women in childbirth or victims of violence, for example – as well as the members of elite families. *Korwar* figures were typically kept in sacred locations such as caves, along with the bones of the deceased person.

Certain individuals, men who also had spiritual gifts, specialized in carving *korwar* figures. As priests or shamans – *mon* – these carvers served as intermediaries between this world and the next. Once the *mon* had drawn the deceased's soul into the *korwar*, the living could ask it for protection, good health or predictions about the future.

This *korwar* figure, collected from Cenderawasih (Geelvink) Bay and dated to the late nineteenth or early twentieth century, is seated with its knees drawn up in reference to the typical burial position. The use of glass beads, which were traded into the area, for the eyes was not only luxurious but also gives the figure a penetrating, otherworldly gaze.

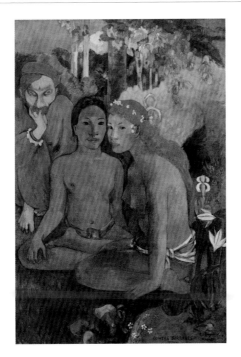

Paul Gauguin (1848–1903) painted *Savage Tales* (*Contes Barbares*) at the end of his life, during his second sojourn in French Polynesia. Discouraged and disgusted by what he perceived as the slick cleverness of European civilization and its art, Gauguin had embarked on a quest to discover supposedly noble 'savages', sensual 'otherness' and an emotionally intense existence at the far edge of the world.

In *Savage Tales*, two Polynesian women sit calmly amid an Edenic oasis. The woman on the left sits in the lotus position, recalling Gauguin's fascination with the Buddha. Behind crouches a demonic-looking European man – modelled on Gauguin's friend Meyer de Haan – who seems to symbolize the antithesis

of the womens' innocence. Flattened, simplified forms reinforce an exotic combination of blues, red-browns, pink and other unusual colours, which blend together like notes of music. The results go beyond the naturalism of Impressionist painting to suggest a realm of mystery, symbolism and inward thoughts.

Despite the fact that his work dismayed even his closest friends when it was first shown in Europe, Gauguin's style wielded enormous influence on the early twentieth-century *avant-garde*, and his unswerving belief in the visionary purity of painting served as a source of inspiration to many followers.

Yoruba Palace Doors, Areogun of Osi Ilorin
Wood, H: 182 cm / 5 ft 11½ in, Fowler Museum of Cultural History, University of California, Los Angeles

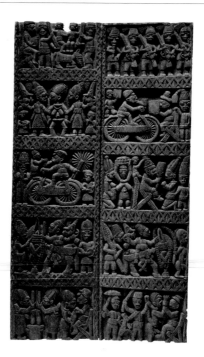

Wealthy Yoruba patrons traditionally commissioned impressive relief sculptures to enhance the doors of palaces, shrines and residences. In the Ekiti region of Nigeria, the format is typically two vertical panels subdivided into rectangular registers and filled with imagery carved in low relief. While not designed to be read sequentially as any kind of narrative, the most important scenes were always centrally positioned.

This grandiose creation for the entrance of the palace at Osi Ilorin is by Areogun (1880–1954), who ranks among the most influential Yoruba masters for his prolific sculptural output and his role as mentor to an extensive group of followers. The principal scene is found in the right-hand panel (three registers down from the top). The crowned king is depicted in profile, seated and holding a flywhisk. The space around him is filled with female attendants who show him deference. The miniature figure positioned at the back of the king's seat gesturing toward his crown may portray Eshu, the trickster and messenger god, his presence possibly alluding to the capricious nature of a leader's claim to power. Eshu is also apparent in the scene directly above, as a cyclist smoking a pipe. The individual seated before him holding a book and wearing a pith helmet may portray a government official with his code of laws. The depiction of figures and forms in flat relief, with finely detailed pierced and openwork areas, is typical of Yoruba carving.

The Kiss, Gustav Klimt
Oil, silver and gold on canvas, 180 x 180 cm / 70.9 x 70.9 in, Österreichische Galerie Belvedere, Vienna

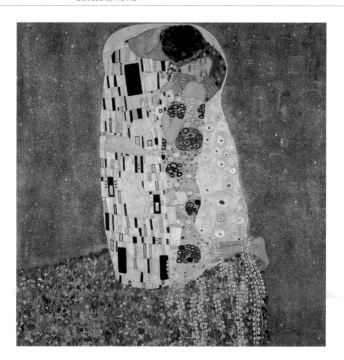

Gustav Klimt (1862–1918) was the president of the Vienna Secession, a radical group of Austrian *avant-garde* artists who were active during the late nineteenth and early twentieth centuries. His paintings, murals and graphics exemplify the sinuous, refined and dazzlingly patterned stylizations of Jugendstil ('youth style'), the Art Nouveau of the German-speaking world. Using this exquisite approach, Klimt addressed a heady symbolism of love, death, transcendence and nature.

The Kiss (1907–1908) is an iconic statement of Klimt's mature gold leaf-encrusted painting technique, influenced by the Byzantine mosaics of Ravenna (see Empress Theodora and Her Attendants,

p.162). A couple embraces on a bed of flowers, surrounded by a glowing starscape. The woman kneels next to the man, possibly implying a ritual with erotic overtones. Their robes are covered in golden circles and panels, intermixed with geometric shapes in casein colours. The painting's mostly abstract planes surround the human faces and flesh, which, by contrast, are rendered in a highly realistic fashion, attesting to Klimt's virtuosity as a portraitist.

Mukudj Dance Mask, Artist unknown
Wood, pigment and kaolin, H: 34.3 cm / 1 ft 1 in, Metropolitan Museum of Art, New York

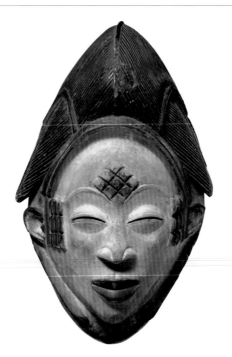

Mukudj masks of Gabon have been celebrated for their delicate beauty since they first began to be collected in the early twentieth century. The mask is worn as part of the complex mukudj stilt-dances executed by male acrobats, which have become symbolic of Punu cultural identity. The dances are performed to mark important occasions within the community, and the exceptionally athletic dancers are thought to draw on spiritual powers in order to carry out the extraordinary choreography.

Like all mukudj masks, this one, which dates from the nineteenth or twentieth century, was fashioned as a stylized portrait of a particularly beautiful female member of the community. The Punu ideals

of feminine beauty are evident: a broad, rounded forehead, arched brows and almond-shaped eyes, a narrow face, small chin and elaborate coiffeur combining a prominent central lobe with two stylized curls on either cheek, typical of nineteenth-century styles in the region. White kaolin clay was applied to the surface to represent both beauty and spirituality, associated with the whiteness of the ancestral spirit world. The lozenge-shaped scarification between the brows is a sign of sensuality, and its nine-fold division represents the mystical healing power of the number nine. These spiritual powers are believed to imbue the dancer with the skill and protection needed to perform the difficult dance.

1907
Spain

Les Demoiselles d'Avignon, Pablo Picasso
Oil on canvas, 244 x 235 cm / 8 ft x 7 ft 8 in, Museum of Modern Art, New York

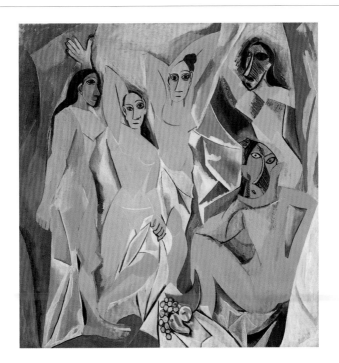

Les Demoiselles d'Avignon is considered a cornerstone of modern art and the seminal work of Cubism. Pablo Picasso (1881–1973) unveiled the canvas at the Bateau-Lavoir, the legendary Parisian *avant-garde* artists' studios, where his friends were shocked by its brutality and its revolutionary rendering of the human figure with sharp planes and disjointed volumes. The painting was not publicly exhibited until 1916.

The contemporary art critic André Salmon gave the work its present title, which alludes to the women's profession: Avinyó ('Avignon') was the street in which stood an infamous Barcelona brothel. The original composition had included male figures, but in the final painting five female prostitutes with violently

jagged bodies simply face the viewer head-on, two of them pushing aside curtains, the others in erotic poses. The mixture of approaches in the painting – the facets of the figures and their ambient space, the faces influenced by African masks and stylizations taken from Iberian art and El Greco (see p.346) – marks a transitional phase in the evolution of Picasso's art, towards the complex geometries of full Cubism.

As a painter, sculptor, ceramicist, draughtsman and printmaker, Picasso was arguably the single most influential artist of the twentieth century, playing a major role in its artistic development. Even those artists not directly influenced by his work could not avoid its manifold implications.

Conversation, Henri Matisse
Oil on canvas, 177 x 217 cm / 5 ft 9½ in x 7 ft 1½ in, State Hermitage Museum, St Petersburg

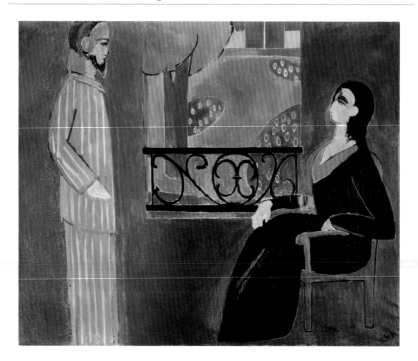

A man in his pyjamas and a woman in a black robe confront each other before a garden. Despite the title, very little conversation seems to be taking place, and the emphasis of the painting is on colour and pattern rather than narrative. There is little or no depth: is the garden scene a view through a window or a picture on the wall? Henri Matisse (1869–1954) made no attempt to show the contours of the man's figure (probably a self-portrait), the white stripes on his blue pyjamas painted as if on a wall, not on a human body. The chair merges into the acutely coloured space.

While Pablo Picasso and Georges Braque paved the way for changes to form and shape in twentieth-century art, Matisse pioneered the early twentieth-

century revolution in colour. Having launched Fauvism in the late nineteenth century, Matisse and his associates rejected the harmonies of Impressionism and embraced the bright colours and linear patterns of van Gogh and Gauguin to create a fresh reality. In their compositions and decorative arrangements of pure colour the Fauvists aimed to express feelings rather than facts. In his 1908 manifesto Matisse wrote that 'expression and decoration are one and the same'.

Begun in the winter of 1908–1909 at the artist's country house and probably not completed until 1912, this painting is apparently simple, but it exemplifies a turning point in art history, demonstrating Matisse's command of pattern and his reinvention of colour.

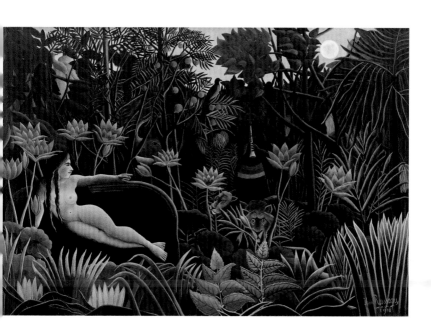

The self-taught artist Henri Rousseau (1844–1910) is famous for his jungle paintings, and *The Dream*, one of his last works, perfectly exemplifies the flat, colourful, childlike style he developed. Rousseau probably never left France, instead using travel brochures and children's picture books as sources for jungle scenes such as this one.

Despite *The Dream's* humour and its naïve quality, it has an undercurrent of eroticism and imminent threat. The lion's face in the centre of the painting is comically deadpan, yet stares disconcertingly at the viewer. The flowers and leaves are larger than the woman's head, and the birds are ominously large. André Breton, the founder of Surrealism, praised

Rousseau's painting for its fusion of the exotic (wild animals and tropical vegetation) with the quotidian (an incongruous velvet sofa on the jungle floor).

Rousseau and his brand of Naïve art inspired countless twentieth-century artists and movements, including Surrealism, with its dreamlike, fantastical scenes. At first ridiculed, Rousseau eventually came to be seen by his young contemporaries as the epitome of the 'primitive' visionary: Pablo Picasso held a banquet in his honour in 1908, cementing his heroic status among the younger generation of Parisian Modernists, who saw in him proof that academic art training could prove a hindrance in the quest for simplicity, purity and the imaginative in painting.

1910
Germany

Self-portrait with Model, Ernst Ludwig Kirchner
Oil on canvas, 150 x 100 cm / 4 ft 11¼ in x 3 ft 3¼ in, Hamburger Kunsthalle, Hamburg

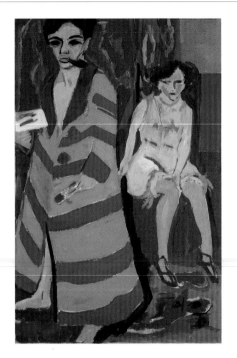

Four architecture students – Fritz Bleyl, Erich Heckel, Karl Schmidt-Rotluff and Ernst Kirchner (1880–1938) – formed the German Expressionist group Die Brücke ('The Bridge') in Dresden in 1905 with the goal of creating a 'bridge' to a better, more perfect future. The group rejected the then current styles of academicism, realism and Impressionism. Instead, they looked to such Post-Impressionists as Vincent van Gogh and Paul Gauguin, the German middle ages and the Renaissance, primitive art and Art Nouveau, with the aim of creating a new, expressionistic art.

Kirchner's work contains echoes of the agitated state of Europe on the brink of World War I. His figures are often tense and distorted, as if to convey disquieting moods. In *Self-portrait with Model*, the artist depicts himself confronting the viewer with his female sitter posed to the right, in livid colours and reduced, angular forms that disrupt ordinary perspective, filling the composition with their smouldering intensity. This approach is typical of Expressionism, in which raw, subjective feelings seem to overwhelm objective observation. The mask-like faces heighten the psychological drama.

Kirchner had been traumatized by World War I, and the rise of Nazism and increasing ill health exacerbated his sense of insecurity until, in 1938, he committed suicide.

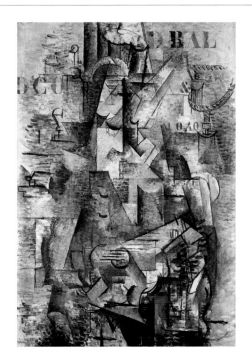

Along with other Cubist works, *Le Portugais* (1911–1912) by Georges Braque (1882–1963) heralded an entirely new method of making and understanding art, shattering perspective and questioning the entire Western tradition of illusionistic representation. Its subject is a man playing an instrument in a bar. The stencilled lettering on the wall adds atmosphere and plays with Cubist notions of plane and surface: the letters suggest posters hanging in the bar, but they exist on the flat surface of the painting, thus demonstrating the nature of a picture as an object, not just the representation of an object. However daring, Braque and his fellow Cubists favoured traditional themes and visual hints, seen here in the traces of

the man's stringed instrument; the subject matter is all but unrecognizable, although the image is not yet completely abstract.

Braque was born to a family of decorators and used techniques such as combing and graining throughout his career. Two events in 1907 radically shaped his art: the Paul Cézanne retrospective at the Salon d'Automne, where he saw the still lifes that were to be hugely influential on his own art (see *Apples and Oranges*, p.431), and his first encounter with Pablo Picasso's *Les Demoiselles d'Avignon* (p.439). Together Braque and Picasso created Cubism, which relied on the shattering and flattening of form and, initially, on a rigorously subdued palette such as in this work.

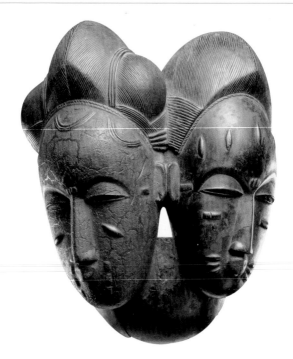

In Baule communities of West Africa, masks such as this are seen in performances of an operatic public entertainment known as *Mblo*, consisting of a series of skits that feature masked dancers who impersonate socially familiar subjects, ranging from animals to human caricatures. The succession of dances escalates in complexity and importance, ultimately culminating in performances that pay tribute to a community's most admired member. Individuals honoured in this way are depicted by a mask that is conceived as their artistic 'double' or 'namesake'.

In the context of *Mblo* masquerades, a mask that generically refers to twins – who are credited with bringing fortune to their families and are considered to share a single soul – may appear midway through the sequence of social types portrayed, or at the culmination of the entertainment to honour specific individuals. This twin mask, dating from the late nineteenth century to the first half of the twentieth, displays distinctions that underscore physical contrasts between the paired faces: differences in scale, facial markings, coiffures and colours, which refer to the essential dissimilarities exhibited by male and female twins.

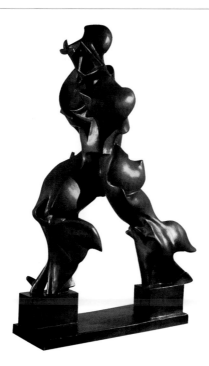

Previously working only with paint, Umberto Boccioni (1882–1916) began to sculpt in 1912. This work, created a year later, was originally produced in plaster, then bronze; this version was cast in 1931. It explores the human figure in motion, manipulating the body's forms and simulating the movement of space around the striding figure; the influence of Cubism can be seen in the angular nature of the piece.

The body exudes confidence and power and suggests the Futurists' ideals of boldly striding towards discovery and technology. In his 1909 Futurist manifesto, Filippo Tommaso Marinetti claimed 'a roaring motorcar, which runs like a machine-gun, is more beautiful than the *Victory*

of Samothrace'. Yet Boccioni's work shares a likeness with this second-century BC Hellenistic sculpture (p.118), both sculptures draped in billowing spirals of fabric, suggesting speed and motion.

Boccioni was a leading member of the Futurists, who spurned the traditions of art history and were inspired by technology and mechanical dynamism. His work explored volume and space, and he claimed that to portray an object, an artist had to 'render the whole of its surrounding atmosphere'. The Futurists' belief in technology's ability to improve society was mirrored by the Russian Constructivists, who strove to break down barriers between art and technology (see Naum Gabo, *Linear Construction No. 2*, p.474).

Composition VII, Vasily Kandinsky
Oil on canvas, 200 x 300 cm / 6 ft 6½ in x 9 ft 10 in, Tretyakov Gallery, Moscow

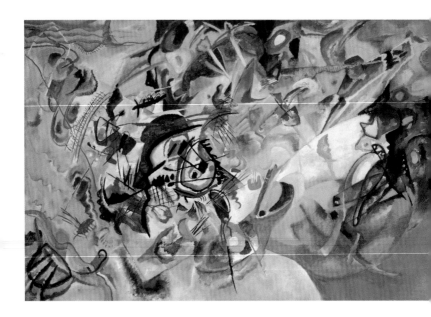

Vasily Kandinsky (1866–1944) is generally acknowledged as the first exponent of abstract art. At the age of 30 he left a career teaching law and economics in Moscow and enrolled at the Academy of Fine Arts in Munich. He was a leading member of Die Blaue Reiter ('The Blue Rider'), a group of German Expressionists concerned with unveiling the spiritual nature of the world through art. His early representational work included themes such as horses and riders, boats and churches; by the early 1900s, Kandinsky started to attenuate his forms and transform his motifs into schematic ideograms or pictorial shorthand in a concerted move towards artistic abstraction.

In 1909 he developed three types of paintings that heralded a distinct shift in his style: the *Improvisations*, the *Impressions* and the *Compositions*. One of the most complex, *Composition VII* is the result of over 30 preparatory drawings, watercolours and oil studies. These works chart Kandinsky's rigorous process of planning, developing and testing his ideas to evolve a carefully drafted, yet altogether abstract painting. The final version was painted in four days and evokes such apocalyptic themes as the Last Judgement, Resurrection, Deluge and the Garden of Love. The work projects his fundamental convictions: art's mystical ability to regenerate the world and the power of colour to provoke a psychological response.

The Mystery and Melancholy of a Street, Giorgio de Chirico
Oil on canvas, 87 x 71.4 cm / 2 ft 10¼ in x 2 ft 4 in, Private Collection

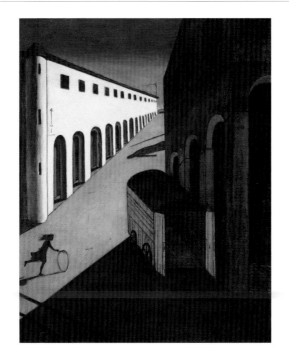

Giorgio de Chirico (1888–1978) was one of the originators of the movement Metaphysical Painting, or La Pittura Metafisica. De Chirico's dreamlike, mysterious and often ghostly paintings, which frequently depicted solitary figures, uninhabited cities and out-of-place objects, combined with Classical statues, were heavily influenced by the Symbolist work of Arnold Böcklin and the philosophy of Nietzsche. In contrast to Futurism (see *Unique Forms of Continuity in Space*, p.445), Metaphysical Painting strove to draw on, rather than reject, history.

In this painting, a little girl runs with a hoop through a desolate town, an ominous shadow looming towards her. Arches extend into the distance in sharp perspective, and the darkened, high-walled building in the foreground cuts into an already claustrophobic space. The influence of this painting can be seen in such Surrealist works as Ernst's *Two Children Are Threatened by a Nightingale* (p.454), Magritte's *The Human Condition* (p.460) and Dalí's *Persistence of Memory* (p.459).

De Chirico was born to Italian parents in the Greek town of Volos, the site of the Argonauts' departure on their mythical quest for the Golden Fleece. As children, Giorgio and his brother Andrea Savinio imagined that they were Castor and Pollux, the celestial twins also known as the Gemini; Classical mythology and art inspired both brothers.

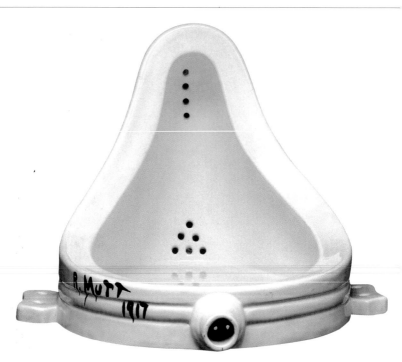

In his early work the painter, sculptor and writer Marcel Duchamp (1887–1968) experimented with Post-Impressionism, Fauvism and Cubism. He quickly grew impatient of styles and approaches he understood and sought more radical forms of art.

In 1917 he became president of the Society of Independent Artists, an association that held annual exhibitions to offer progressive American and European artists the chance to show their work. In the same year Duchamp submitted *Fountain*, under the pseudonym R. Mutt. The work was a factory-made urinal that he displayed on its side and on a plinth. The piece was rejected by the jury and Duchamp resigned. (The original was soon lost, but Duchamp commissioned a number of reproductions years later; this version dates to 1964.)

Fountain was one of many ready-mades that Duchamp placed in a gallery context in order to question not just the beauty and value of art, but its entire concept. As such his art was known as anti-art, or Dada. Duchamp became a legend in his own lifetime, and countless contemporary artists have acknowledged a deep debt to him. His conceptual form of art inspired numerous twentieth-century movements, including Pop Art, Minimalism, Op Art and Conceptual Art. His work exists in a space between painting, sculpture and installation and asks the questions, 'Who is an artist?' and 'What is art?'

1917
Germany

Dedication To Oskar Panizza, George Grosz
Oil on canvas, 140 x 110 cm / 4 ft 7 in x 3 ft 7½ in, Staatsgalerie Stuttgart, Stuttgart

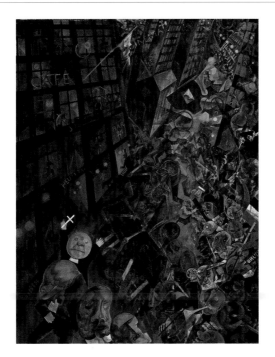

Following six months of military service in 1914, George Grosz (1893–1959) was conscripted again in 1917 and finally discharged after a stay in a mental hospital. His early drawings and paintings were apolitical, but after his war experience his work changed fundamentally: the German army, politics in general, the aristocracy, commerce and religion became the targets of his virulently satirical art. In his misanthropy he came to hate Germans, particularly Berliners; he anglicized his name, hoping to use his stridently moral art to become the German Hogarth (see *The Orgy*, from *A Rake's Progress*, p.379).

Dedication To Oskar Panizza (1917–1918) depicts Grosz's distopian vision of a hell-like, post-war metropolis (Panizza was a disgraced German writer extremely critical of society). A moon-faced priest marches at the head of a chaotic procession, followed by Death, who sits atop a coffin drinking schnapps from a bottle. The sharp perspective of the road makes the jumbled angles of the skyscrapers all the more precarious; the bloodthirsty and anarchic crowd seems oblivious to the towers about to tumble down.

Grosz joined the Berlin Dada movement in 1918, embracing its anti-war, anti-bourgeois, anti-aesthetic protest even after returning to a more realistic style of painting in the 1920s. His modernist caricatures, overt criticism of German society and rejection of Nazism forced his emigration to the United States in 1933.

**1918
Russia**

Suprematist Composition: White on White, Kazimir Malevich
Oil on canvas, 79.4 x 79.4 cm / 2 ft 7¼ in x 2 ft 7¼ in, Museum of Modern Art,
New York

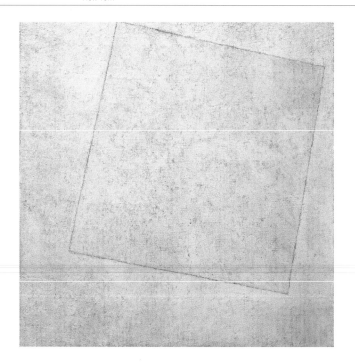

The 1915 '0.10' exhibition in Petrograd (St Petersburg) was so named because each of its ten participants were attempting to define the 'zero degree', or the absolute minimal essence to which it was possible to reduce a painting. Kazimir Malevich (1878–1935) exhibited *Black Square*, now acknowledged as the first exemplar of Suprematism, an aesthetic theory based on geometric abstraction, messianism and the purging of all representation and narrative. The Russian intelligentsia hoped that the 1917 October Revolution would usher in a utopian society; Malevich believed that non-representational art would pave its way.

Suprematist Composition: White on White was the most daring painting of its time and a complement

to *Black Square*. A white square floats against an off-white background, suggesting transcendence, an ascent towards the ether and perhaps some metaphysical fourth dimension. Yet the artist's hand is apparent in both the surface of the painting and the slight asymmetry of the square. To Malevich, Suprematism was concerned with pure form and hue, exemplified in the square and the colour white.

After the *White on White* series, Malevich felt he could achieve no more radical form of non-objectivity and devoted himself to teaching. His work and theories paved the way for Constructivism (see *Linear Construction No. 2*, p.474) and Minimalism (see Donald Judd's *Untitled (1982–1986)*, p.496).

Golden Bird, Constantin Brancusi

Bronze, stone and wood, H: 218 cm / 7 ft 1¾ in (with base), Art Institute of Chicago, Chicago, Illinois

Constantin Brancusi (1876–1957) was unusual among early twentieth-century artists for his interest in sculpting animals with a mixture of primitivism and extreme sophistication. His series of birds began with *Maiastra* in 1910, depicting the mythical Romanian firebird; he refined each subsequent version. *Golden Bird* (1919–1920) has an elegant, attenuated body set on a roughly hewn wooden base; its simplified beak and claws are merely suggested. These avian sculptures eventually developed into Brancusi's *Birds in Space* series, one of which was so unconventional for its period that a United States customs official, refusing to accept such a work as art, taxed it as raw metal. By contrast, Brancusi associated his subject with freedom

and exaltation, remarking 'le vol, quel bonheur!' ('flight – what joy!').

Brancusi was apprenticed to Auguste Rodin in 1906, but soon left to explore his own methods. Within a year he was experimenting with bold simplification, and he devoted his career to reducing form to its most uncompromising essence. Unlike his *avant-garde* friend Marcel Duchamp (see *Fountain*, p.448), Brancusi was not inspired by the machine but rather looked to the artisanal traditions and crafts of his native Romania. He aimed to achieve a balance between the sculpted figure and the characteristics of the original slab of stone, and especially favoured sleek ovoids and highly polished surfaces.

1919
Germany

The Worker Picture, Kurt Schwitters
Paper, wood and metal on board, 125 x 91 cm / 4 ft 1¼ 2 ft 11¾ in,
Moderna Museet, Stockholm

Kurt Schwitters (1887–1948) abandoned both his early Impressionistic and his Expressionistic painting style after being exposed to the German Dada movement in 1918. Striving to make something new and whole after the shattering effects of World War I, he began to collect refuse from the streets of Hanover for collages. He named them *Merzbilder* (said to derive from discarded letterhead of the Kommerz- und Privatbank), and the word came to encapsulate his philosophy – the creation of new art from the rubbish of German culture.

The Worker Picture (Das Arbeiterbild) is typical of Schwitters' assemblages and owes a debt to Russian Constructivism (see *Linear Construction No. 2*, p.474)

and the theories of the Dutch art magazine *De Stijl*, which advocated pure abstraction and a reduction of art to horizontals and verticals and primary colours (see *Broadway Boogie Woogie*, p.467). Schwitters nailed and glued his found objects, creating visual puzzles and formalist compositions to achieve 'the union of art and non-art in the *Merz* total world view'.

In 1940 Schwitters was interned on the Isle of Man after emigrating to the UK. He continued to create his found-object collages, but his fellow German internees saw them as an obsolete ideology. His Dadaist assemblages – existing between painting and sculpture – nevertheless provided inspiration to later artists (see, for example, *Monogram*, p.481).

The Hunter (Catalan Landscape), Joan Miró
Oil on canvas, 65 x 100 cm / 2 ft 1½ in x 3 ft 3½ in, Museum of Modern Art, New York

While an art student in Barcelona, the Catalan painter Joan Miró (1893–1983) was blindfolded and told to touch objects before drawing them, in order to understand form. Miró discovered constant sources of inspiration at his family home in rural Montroig, including its medieval frescoes. Flora, fauna and other natural phenomena – as simple as plants and as cosmic as the sun and stars – often featured in his paintings and sculptures, characteristically depicted with bright colours and sinuous yet incisive draughtsmanship.

The Hunter (*Catalan Landscape*) dates from 1923–1924, when Miró began to abandon magic realism for abstraction. Motifs – apparently spontaneous but actually meticulously organized – float through the humorous composition, most of them imaginary and connoting either droll creatures, microscopic organisms or sexual organs. Whimsical letters are inscribed across the lower right of the scene, a device employed by the Cubists to amplify the nature of a painting as a flat sign (see *Le Portugais*, p.443).

Miró is associated most closely with Surrealism – its revolutionary spirit grew from Dada's anti-art stance during World War I and exploited dream-like juxtapositions and freedom from the strictures of rational thought. Yet he was never an official member of the movement, preferring his own experimental path. His vibrant imagery influenced such artists as Alexander Calder (*Arc of Petals*, p.466).

1924
Germany

Two Children Are Threatened by a Nightingale, Max Ernst
Oil on panel with painted wood elements and frame, 69.8 x 57.1 cm /
2 ft 3½ in x 1 ft 10½ in, Museum of Modern Art, New York

The experience of World War I left the German artist Max Ernst (1891–1976) shattered and alienated, no longer able to accept traditional European moral codes, and he found solace in the growing Dada movement (see, for example, *Dedication To Oskar Panizza*, p.449). As Dada, with its complete rejection of categories and bourgeois labels, gave way to Surrealism, in which ordinary ideas were considered important as a means of liberating the imagination, Ernst joined such artists as Henri Magritte, Salvador Dalí and Joan Miró in using art to represent dreams.

In 1922 Ernst began to work on a series of works that dealt with his childhood dreams and nightmares. *Two Children Are Threatened by a Nightingale* is not strictly a collage but, like all Ernst's paintings from 1918 until 1924, is based on that method. Ernst believed that 'he who speaks of collage, speaks of the irrational'; so, in this work, he has added a three-dimensional gate, a hut and a doorknob to the painted surface. The painted elements make art historical references: the children recall idealized Old Master figures, and the background consists of a Classical dome and arch. The title is ironic – fear of a small bird seems absurd – yet Ernst's painting fosters a sense of hallucinatory foreboding and predatory sexuality. Birds were a recurring theme in Ernst's work and something of a personal obsession – the artist adopted an avian persona as his alter-ego, called 'Loplop'.

1924
Russia

Lenin in Red Square, Isaak Brodsky
Oil on canvas , 207 x 135 cm / 6 ft 9 in x 4 ft 5 in, State Historical Museum, Moscow

Isaak Brodsky (1884–1939) was one of the most influential members of the Association of Artists of Revolutionary Russia (AKhRR), one of a number of groups of Soviet artists active in the 1920s. AKhRR's doctrine was conservative, and its members helped to establish the framework for the Socialist Realism style. Famed for his realistically depicted scenes of heroic post-Revolution life, Brodsky painted political figures and peasants alike, and specialized in portraits of Vladimir Lenin, such as this.

Brodsky's preparatory process was extensive, and he produced countless sketches before embarking on his final paintings. This portrait of Lenin portrays the Soviet leader in a humanizing, sympathetic light,

not as a monumentalized figure of revolution. As the 1930s wore on and Stalin replaced Lenin as the Soviet leader, the state's grip on artistic freedom grew tighter. Socialist Realism soon became the mandated state artistic style; abstraction – and with it Constructivism (see *Linear Construction No. 2*, p.474) and Suprematism (see *Suprematist Composition: White on White*, p.450) – was emphatically excluded from the art establishment. Brodsky's representational paintings, with their art historical roots in the nineteenth century, came to be viewed as illustrations of Communism's agenda and its drive to create a utopian society.

Paul Klee (1879–1940) believed that colour and line had the ability to transport a viewer beyond the quotidian world, as music might enrapture a listener. He was a violinist who frequently attended the opera; music remained a profound influence on his painting, and colour an intrinsic element.

As a teacher at the Bauhaus in the 1920s, Klee lectured on design, and his ideas provide an insight into his logically drafted compositions. He painted *Highroads and Byroads* after a revelatory stay in Egypt. An earlier trip to Tunisia had inspired him to abandon his monochrome palette for vivid colour; the Egyptian landscape inspired this grid-like composition, which illustrates Klee's notions of 'individual' and 'dividual'

framework. 'Dividual' refers to the structure as a whole, which is composed here of parallel strata. The 'individual' structures comprise small units of colour within parallel channels that fluctuate between warm and cool hues. Cubist design had at first strongly impressed Klee, but the geometry of *Highroads and Byroads* is looser and evokes musical notation, while containing imperfections and variations that reflect his belief that a composition should almost form itself rather than follow any rigid programme. Klee's vibrant, poetic and often amusing paintings were a beacon for countless modern artists, in particular Joan Miró (see *The Hunter (Catalan Landscape)*, p.453), the Surrealists and the Abstract Expressionists.

1930
USA

Early Sunday Morning, Edward Hopper
Oil on canvas, 89 x 153 cm / 2 ft 6½ in x 5 ft, Whitney Museum of American Art,
New York

Early Sunday Morning exemplifies the desolate scenes of American life painted by Edward Hopper (1882–1967). Hopper's universe is often devoid of people, and when figures do appear, they rarely interact. The long shadows in this painting suggest time passing, and the empty street and half-drawn blinds convey loneliness and melancholy, notwithstanding the strong red and yellow tones of the houses and pavement. Although the scene is ostensibly a specific row of buildings in Manhattan, the curious frontality and formality impose an almost abstract cast to the whole.

Hopper was dubbed the leading twentieth-century American Realist, and sometimes compared to his predecessor Thomas Eakins (see *Max Schmitt in a Single Scull*, p.416); born in New York, he worked as a commercial illustrator before studying painting. While visiting Paris in 1906, Hopper painted open-air scenes with a breezy, Impressionist feel. French literature, particularly Symbolist poetry, and Edgar Degas' work remained inspirational throughout his life. Hopper sold his first painting at the Armory Show in 1913, but full success only arrived a decade later, after he began using watercolours. Hopper's realism became unfashionable with the rise of Abstract Expressionism. Nevertheless, his sparse, disquieting imagination has exerted its influence as far afield as the arts of the cinema, literature and music.

American Gothic, Grant Wood
Oil on beaverboard, 78 x 65.3 cm / 2 ft 6½ in x 2 ft 1¾ in, Art Institute of Chicago,
Chicago, Illinois

Grant Wood (1891–1942) was the acknowledged leader of the American Regionalists, a group that championed the depiction of local Midwestern imagery. Born into a conservative farming family in Iowa, Wood spent his twenties travelling and studying art. He was influenced by the English Arts and Crafts Movement, and his early landscape painting had an Impressionistic quality. However, in 1928 on a visit to Munich, Wood encountered the precisely detailed and strongly coloured paintings of the fifteenth-century Netherlandish masters, and his style changed irrevocably.

American Gothic epitomizes Wood's newfound realism. It depicts a dour Midwestern farmer,

pitchfork clasped firmly in hand, and his unmarried daughter. Their elongated necks and oval faces are almost caricatural in style, perharps recalling the work of the fifteenth-century Flemish painter Dieric Bouts (see *Last Supper*, p.300). Certainly the precision of the painting's realistic rendering is indebted to the northern Renaissance masters. The farmer's extreme seriousness is a satirical comment on the society of Wood's upbringing. The 'Carpenter's Gothic' architecture of the farmhouse implies the steeple and cross of a church, signifying the Puritan ethics and values of the rural Midwest. Today this painting is one of the most iconic images in the United States, appropriated by countless advertisers and designers.

Persistence of Memory, Salvador Dalí

Oil on canvas, 24.1 x 33 cm / 9.5 x 1 ft 1 in, Museum of Modern Art, New York

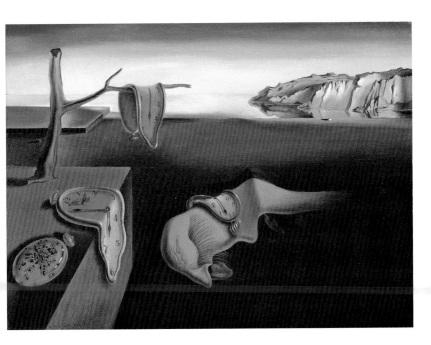

The *Persistence of Memory* is a classic instance of the hallucinatory vision of the Surrealist painter Salvador Dalí (1904–1989), who emulated the thought processes of the mentally disturbed to invent shocking, strange dream scenes in paint. A number of Dalí's leitmotifs inhabit this bleak landscape: melting clocks warp the stability of time; ants swarm over metal as if it were decaying flesh; and a monstrous, mask-like thing, a hybrid of a head and a horse, lies limp and abandoned. The creature's profile resembles the artist's, making it at once alarmingly recognizable and alien. *Persistence of Memory* evinces the same detailed accuracy as Grant Wood's *American Gothic* (opposite), which was painted a year earlier, yet in place of an American moral tale

or rural scene it depicts a grotesque and macabre subconscious domain.

After being expelled from art school in Madrid in 1926, Dalí began to achieve public acclaim for his work, which revealed the influence of Giorgio de Chirico's Metaphysical Painting (see *The Mystery and Melancholy of a Street*, p.447). In 1929 Dalí collaborated with his former classmate Luis Buñuel on the iconoclastic film *Un Chien Andalou*. The film caught the attention of André Breton, leader of the Surrealists, and Dalí soon joined the movement. His eccentricity and pursuit of notoriety, alongside his artistic talents, made this artist Surrealism's best-known representative.

The Human Condition, René Magritte
Oil on canvas, 100 x 81 cm / 3 ft 2½ in x 2 ft 7¾ in, National Gallery of Art, Washington, DC

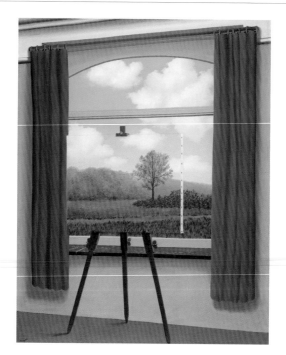

René Magritte (1898–1967) was profoundly influenced by the Italian metaphysical painter Giorgio de Chirico (see *The Mystery and Melancholy of a Street*, p.447) and was instrumental in the launch of the Belgian Surrealist group. Using visual puns and a smooth painting style devoid of gesture, Magritte played with the relationship between objects and the images that represented them.

In *The Human Condition* (*La Condition Humaine*) Magritte has painted three easel legs beneath a window that looks out onto a picturesque view, and in so doing has created a canvas within a canvas. The long, white vertical form standing in the grass resembles the edge of a canvas, stretched and stapled

over its frame, though it also could represent a tree. The idea of a picture within a picture relates to a long tradition of *trompe l'oeil* painting, images so verisitic that they trick the spectator into thinking they are real, prompting questions about illusion versus reality.

Magritte's style did not change dramatically from his early Surrealist paintings, but by the end of his life he nevertheless was considered Belgium's greatest twentieth-century artist, and he still holds that rank today. His ongoing influence can be seen in the strategies of both Pop and Conceptual artists.

Man Controller of the Universe, Diego Rivera
Fresco, 48.5 x 114.5 m / 15 ft 11 in x 37 ft 6¾ in, In situ, Palacio de Bellas Artes,
Mexico City

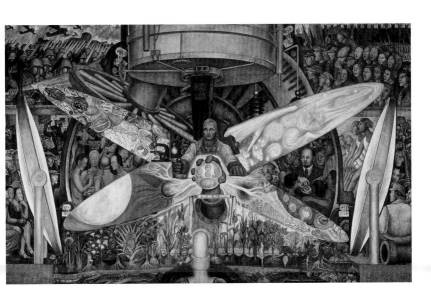

In the decades after the Mexican Revolution of 1910, Diego Rivera (1886–1957) helped establish an imagery that fulfilled the nationalist agenda of the new government. From the 1920s onwards, Rivera became Mexico's most internationally renowned artist, gaining important commissions in the United States, including this mural. Originally painted in 1933 for the Radion Corporation of America Building at the Rockefeller Centre in New York, *Man Controller of the Universe* was never finished because it included a portrayal of Lenin, which Rivera refused to omit. After a public scandal, Nelson Rockefeller ordered its destruction. Rivera re-painted the mural in Mexico City's Palacio de Bellas Artes, where it remains.

Rivera's distinctive style brought great technical prowess to bear on complex historical narratives. Unlike some of his contemporaries, such as José Clemente Orozco and David Alfaro Siqueiros, Rivera's outlook conveys hope and trust in the future. In this case the progressive force of industrial technology and science directs the universe, led by a blue-eyed figure representing progress in the United States. Technology may bring misfortune if used in pursuit of greed and domination (right) or freedom if used to better the working classes (left). The treatment of a utopian modernity, imbued with a socialist aesthetic, places this mural among Rivera's most typical and accomplished achievements.

1937
France

Nude in the Bath, Pierre Bonnard
Oil on canvas, 93 x 147 cm / 3 ft ½ in x 4 ft 10 in, Musée d'Art Moderne
de la Ville de Paris, Paris

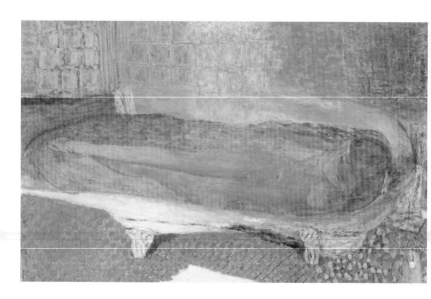

Pierre Bonnard (1867–1947) was one of several young Parisian artists who, greatly influenced by the bold colour and strong outlines of Paul Gauguin (see *Savage Tales*, p.435), formed a collaborative group called Les Nabis (The Prophets). He also found inspiration in Japanese woodblock prints, and was so attracted to their formal composition, simple modelling and pure colour that his friends – including fellow Nabi Edouard Vuillard – christened him 'the Japanese Nabi'.

In 1893, Bonnard met a young model named Marthe Boursin, later his wife. He painted Marthe for almost 50 years, but on canvas her body never aged. Although nearly 60 at the time of this intimate

painting, her figure appears youthful and lithe. *Nude in the Bath* (*Nu dans le Bain*) can be compared to Henri Matisse's *Conversation* (see p.440) for its rejection of depth to accentuate its bold colour and pattern. The curvilinear and fluid forms of Marthe's body, the water and the bath contrast with the geometric patterns on the floor and the wall, and the grid of the wall tiles continues through the window on the external wall, blurring the line between interior and exterior. Coupled with the abruptly cropped bathtub, this device creates a sense of both intimacy and claustrophobia. The warm and cool colours produce a shimmering, incandescent effect, which is further enhanced by the similarity of the colours' values.

The most influential British sculptor of the twentieth century, Henry Moore (1898–1986) was inspired by the artistic traditions of African, Cycladic and Pre-Columbian cultures. Exploring the human form, Moore sought to link his sculpture with the art of the past, while simultaneously eradicating 'the Greek spectacles from the eyes of the modern sculptor'.

Recumbent Figure bears comparison with the Modernist sculpture of Constantin Brancusi (see *Golden Bird*, p.451), both for its simplification of form and for Moore's practice of carving directly from stone. (Like many of his works, *Recumbent Figure* is carved of indigenous British stone, mined in Oxfordshire.) He claimed that his greatest source of

inspiration was the Mayan reclining sculpture type called *chac-mool* (see p.218), whose recumbent pose and aura of immense size is recalled here.

The English landscape tradition, with Constable and Turner at its helm, was also an intrinsic part of Moore's inherited artistic legacy. His biomorphic forms evoke both female figures and metaphorical landscapes: the sharp, raised knees and globular breasts of *Recumbent Figure* suggest mountains and hills, and the niches or hollows imply cliffs, caves, valleys and undulating slopes. Moore said of this favoured pose, 'the reclining figure gives the most freedom, compositionally and spatially… It is free and stable at the same time.'

White Crucifixion, Marc Chagall
Oil on canvas, 154 x 140 cm / 5 ft 7½ in x 4 ft 7 in, Art Institute of Chicago,
Chicago, Illinois

Marc Chagall (1887–1985) was born in Vitebsk (now Viciebsk, Belarus) to a tightly knit Hassidic Jewish family, the oldest of nine children. He considered himself a Russian painter, though he is now acknowledged as one of the most influential members of the École de Paris. His lyrical and vivacious Expressionist style, developed before World War I, changed little throughout his long career.

In 1935 Chagall travelled to Palestine, the Netherlands, Spain and Poland and was alarmed at the rise of Fascism and anti-Semitism that he witnessed. *White Crucifixion*, painted three years later, depicts his shock at the Nazis' campaign of terror against the Jews, a prophetic vision of the cataclysmic

events of World War II. The central figure in the painting, clearly Jewish and wearing a *tallit* (prayer shawl), hangs crucified amid scenes of persecution and war. A stripe of bright white bisects the image and bathes the tortured man in a shaft of divine light.

This work was a political statement, and in it Chagall rejected his normally expressive use of colour, asserting his identity as a Jewish artist and emphatically stating his horror at the persecution of his people. Despite its subject matter of murder and destruction, Chagall's *White Crucifixion* nonetheless resembles Henri Rousseau's Primitivist painting *The Dream* (see p.441) in its emulation of folk art and childlike vitality.

As the wife of Diego Rivera, Frida Kahlo (1907–1954) became an important figure in the artistic movement known as the Mexican Renaissance. Working alongside Rivera, she developed a style that combined cosmopolitan modernism with popular culture.

As a result of a near-fatal accident at the age of 18, Kahlo would endure many operations and chronic pain throughout her life. Her *oeuvre* is mainly autobiographical, using the self-portrait to express the complexity of her emotions and to reflect on the significance of religion, gender and identity. *The Two Fridas*, painted during her divorce from Rivera in 1939, encapsulates many of the personal and cultural aspects of her life. Sat against a tempestuous sky,

Kahlo portrayed her Fridas in European and Mexican dress to express the essence of *mestizaje* and the predicament of her own identity. As the daughter of a German father and a Mexican mother, Kahlo's bloodline was that of a *mestiza* – a colonial term referring to the children of Spaniards and *indígenas*. The open hearts symbolize her relationship with Rivera. In her left hand the Frida clad in Tehuana dress holds a small portrait of Rivera and represents the Frida that Diego loved. The Frida clothed in European dress sits with a broken heart and a severed vein that symbolize her marital separation. This duality is characteristic of Kahlo's unmistakeable style, which blends Symbolism and Surrealism.

Bronze had been the primary metal used in sculpture until the 1930s, when artists such as Alexander Calder (1898–1976) seized upon iron and steel as modern, dynamic materials. Calder used these new metals in hanging sculptures with moving parts, some motorized, others powered by currents of air. Calder's innovative genius produced a new type of art, and he is regarded as creating the first truly kinetic sculpture, whereby movement plays an integral part in the work. Marcel Duchamp christened them 'mobiles'.

This 1941 mobile is comprised of organic metal shapes that flutter on curved wire stems. The cascading sculpture seems to defy gravity and float in the air as a three-dimensional drawing.

Although asymmetric, it has an elegant sense of balance and even at rest seems to move. Calder twisted, cut and bent his metal components by hand; here he has painted every leaf but one, thus leaving the raw material partially visible. Calder was the first American artist to reference the Russian Constructivists (see *Linear Construction No. 2*, p.474), and his work inspired younger abstract sculptors such as David Smith (see *Hudson River Landscape*, p.476).

Calder gained a degree in mechanical engineering before embarking on his own art career. After moving to Paris, he was influenced by Miró (see p.453) and Klee (see p.456), and a visit to Mondrian's studio (see opposite) inspired him to explore abstraction.

Broadway Boogie Woogie, Piet Mondrian
Oil on canvas, 127 x 127 cm / 4 ft 2 in x 4 ft 2 in, Museum of Modern Art, New York

A leading member of the De Stijl movement and group, Piet Mondrian (1872–1944) coined the term Neo-Plasticism for his distinctive brand of abstraction, involving spartan geometry and a palette of red, yellow, blue, black, white and grey. He aimed to forge a unity between life and art, revealing the spiritual harmony of the world. He painstakingly planned his compositions with coloured tape, endlessly refining the placement of his horizontal and vertical bands and the relationships of his colours.

Mondrian heard boogie-woogie jazz on his first evening in Manhattan in 1940, falling in love with its syncopation and melodic improvisations. *Broadway Boogie Woogie* (1942–1943) stems from his fascination

with the architecture of New York and the freedom of jazz, which he compared to the 'dynamic rhythm' of his own aesthetic. Here Mondrian removed black from his gamut of hues and injected staccato dashes of red, blue, grey and white into the geometric yellow lines. These echo the stop-start movement of traffic along New York's grid system, seeming to blink like the lights of Broadway.

This was Mondrian's last completed painting but his first to suggest the presence of resurgent figurative elements within abstraction. Like Alexander Calder (opposite), he strove to create art that reflected universal laws, while nevertheless retaining a degree of intuitive spontaneity.

De Stijl / Neo-Plasticism

Sidney Nolan (1917–1992) remains Australia's most widely acclaimed artist. Self-taught as a painter, Nolan also worked as a set designer, illustrator and poet. In 1942 he was conscripted into the Australian army and stationed in northwestern Victoria. There the vast spaces and luminous tone of the bush resulted in a series of bold vistas that heralded a new direction for Australian landscape painting.

Nolan's *Ned Kelly* paintings are his best-known series; throughout his career, he revisited the subject. Influenced by Dada and the Surrealists, these seemingly naïve images were meant to shock. Kelly was a nineteenth-century Irish-Australian outlaw and folk hero; Nolan always pictured him in his trademark

square, black, homemade armour. Here, the dark geometric silhouette looms dramatically against the blue and yellow fields of brooding sky and scorched scrubland, implying both empathy for the anti-hero and human alienation from the land.

In the 1930s, Australian artists' sources grew to encompass European modernism, particularly German Expressionism and Surrealism. Nolan was among the many in Melbourne to follow these new directions. Yet ultimately Nolan never adopted a single idiom, instead exploring different moods and techniques to portray his themes of injustice, love, betrayal and the enduring Australian landscape.

Surrealism

Winter 1946, Andrew Wyeth

Tempera on composition board, 79 x 121 cm / 2 ft 7 in x 4 ft, North Carolina Museum of Art, Raleigh, North Carolina

The American painter Andrew Wyeth (b.1917) is known for his singular ability to paint with painstaking detail and accuracy, yet simultaneously to inject his work with intense personality and emotion. He was trained in the studio of his father, the illustrator N.C. Wyeth, and the elder Wyeth's tragic death in a car accident in 1945 marked a turning point in his artistic career. For the next 50 years his work was characterized by a subdued palette, extremely realistic, almost photographic renderings, and symbolic, emotionally charged compositions. Wyeth worked in dry-brush watercolour and egg tempera, difficult media in which the paint is applied in thin layers that cannot be blended on the canvas.

Winter 1946 is the first tempera painting that Wyeth made after his father's death. It depicts a landscape that the artist knew well, and was sparked by the sight of a boy dressed in an old World War II uniform running down a hill. Wyeth conveys the expanse of the outdoors with exceptional detail, but the emphasis on realism does not render the work impersonal: the boy appears isolated and alienated in the vast landscape, and the tilting hill and almost tumbling figure, set at conflicting diagonals, evokes lack of control and instability. The concentration on a single, nearby object, and the sloping horizon line are typical motifs of 1930s and 1940s Magic Realist art, which Wyeth used throughout his career.

Magic Realism 469

The works of Clyfford Still (1904–1980) are most closely associated with the Abstract Expressionist movement, although his style was acutely original and he always remained something of an outsider, both socially and artistically. Raised on the prairies of western Canada, his early paintings and drawings were landscapes and figure studies. As Still progressed to abstraction, his approach retained a visceral earthiness, combined with starkly elemental themes.

1947-R No. 2 is particularly violent in its effects. The black incidents recede, creating an illusion of glimpses into an abyss, while the ragged edges seem to move with a life of their own. The vividly advancing whites likewise heighten the spatial tensions. Still ground his pigments by hand and painted on unprimed canvas with a palette knife; this raw technique adds to the impact of the imposingly large-scale composition, as the ridges of impasto establish urgent visual rhythms. Many have compared Still's shifting patterns of light and dark to landscapes, but in *1947-R No. 2* the dramatic silhouettes, immediacy and bloody redness have distinctly corporeal overtones.

Clyfford Still produced some of the most graphically coruscating images of Abstract Expressionism, imbued with the vigour of his moral defiance of the decadence of modern society.

This striking tableau (1947–1948) by the sculptor Alberto Giacometti (1901–1966) depicts an urban scene, using its base to present a city plaza. Four male figures stride towards the centre of the space, but none appear aware of the others. A lone female stands erect and still, seemingly frozen or lost in thought. Giacometti's attenuated protagonists functioned the same way in his best-known post-war sculptures: the men are always in motion towards a set destination, while the women stand immobile and inaccessible.

Giacometti's creativity surged in the aftermath of World War II towards his final mature style. Following forays into Cubism and Surrealism in the 1920s and 1930s, he began to envision emaciated,

jittery human beings; some were alone and some were in groups, but all seemed to exist in a void at once both open-ended and oppressive, producing a sense of isolation and solitude. He once claimed to sculpt not the human figure, but the 'shadow that is cast' – the mere trace of presence. His friend Jean-Paul Sartre referred to Giacometti's sculpture as Existentialist art, and the art establishment of post-war Europe identified with his agitated figures, which struck a chord with both critics and collectors.

Prawns and Sagittaria, Qi Baishi
Ink on paper, 137 x 41 cm / 4 ft 6 in x 1 ft 4¼ in, National Museum, Beijing

Committed to the subjects of *guohua* (national art), and especially famous for his flowers, birds, insects and water creatures, Qi Baishi (1863–1957) aimed – as ancient masters had done – to convey their inner spirit. His style was spontaneous and individual and his compositions often simple. Critics scorned his preference for plain and unfashionable subjects, as they had done centuries before with the Chan (Jap: Zen) master Muqi, with whose mixture of precise and broad brushwork some similarities can be seen. No special significance attaches to the painting of *Prawns and Sagittaria* (also called arrowhead). Qi turned out thousands of such miniature masterpieces, and his detractors were refuted by the strength of public demand for them and the complimentary appearance of numerous fakes.

Qi is one of the best-known painters of an era when Chinese art was undergoing searching self-examination. His work remained free of either Western or Chinese communist ideological influence and was sometimes deemed unscholarly by traditional literati standards, though it is now praised for its vitality and innovative insight into the world of nature. Although born into humble rural circumstances, Qi Baishi achieved the post of Chairman of the Chinese Artists' Association in 1953 and was awarded the title Outstanding Artist of the Chinese People the same year.

Number 1, 1950 (Lavender Mist), Jackson Pollock
Oil, enamel and aluminium paint on canvas, 221 x 300 cm / 7 ft 3 in x 9 ft 10 in,
National Gallery of Art, Washington, DC

Jackson Pollock (1912–1956) was at the forefront of Abstract Expressionism, and a figure whose celebrity and critical acclaim have always focused upon his drip paintings of 1947–1950. In these revolutionary works Pollock poured and dribbled enamel house paints onto unstretched canvases laid on his studio floor. The visual effect was, as Pollock put it, a whirlwind of 'energy and motion made visible'. The critic Clement Greenberg named this work *Lavender Mist*; Pollock only titled his drip paintings with numbers and dates. Although the palette does not actually include the colour lavender, the mix of greys, umber and dusky rose create an ethereal tonality that suggests its aura. Pollock applied his handprints around the periphery of the composition, signifying his physical presence in the image and stress the flatness of the painting's surface. By contrast, the myriad skeins of pigment seem to convey limitless, even cosmic space and flux.

Critics dubbed Pollock's energetic working methods Action Painting, and his example influenced an entire generation of artists who adopted the painterly gesture as a primary means of expression. Even as the CIA co-opted Pollock and the Abstract Expressionists to fit their anti-Communist agenda, their art rapidly became a watershed and starting-point for subsequent *avant-garde* tendencies.

Linear Construction No. 2 (Variation No. 1), Naum Gabo
Perspex and nylon monofilament, H: 61 cm / 2 ft, Addison Gallery of American Art, Andover, Massachusetts

Naum Gabo (1890–1977) was a pioneer of Kinetic art and is most closely associated with Constructivism, a movement that originated in Russia after the 1917 October Revolution, specifically to create a new art to embody the new Communist order – using art as a tool for social purpose. Constructivism became an international movement during the 1920s, when Gabo became concerned with the need for art to express modernity – hence his use of contemporary materials and his creation of sculpture that appeared to diverge completely from the Western artistic tradition.

Linear Construction No. 2 is made from strings of nylon monofilament strung over a Perspex frame, and embodies Gabo's belief that space could be depicted

without having to represent mass. The strings create layers of impenetrable planes, producing, in Gabo's words, 'a living surface'. The work transcends its materials: the light playing on the strings, the spaces between them and the orientation of the viewer are as important as the sculpture's physical substance. In this piece Gabo uses space and time as construction elements within which the solid matter of the sculpture dissolves and reforms.

Gabo produced 26 versions of *Linear Construction*, with variations in scale and mode of orientation; this is the original. His techniques and use of modern materials such as plastics were adopted by many. He moved permanently to the United States in 1946.

Corps de Dame – Château d'Etoupe, Jean Dubuffet
Oil on canvas, 114 x 88 cm / 3 ft 9 in x 2 ft 10½ in, Allen Memorial Art Museum, Oberlin College, Oberlin, Ohio

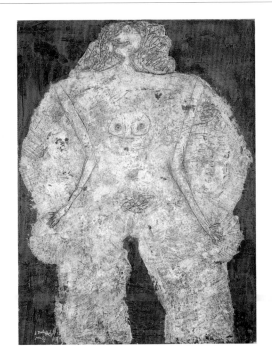

Corps de Dame – Château d'Etoupe by Jean Dubuffet (1901–1985) belongs to a series of female nudes painted with the coarsest impasto and a wilful crudity that defies all conventional parameters. These personages are more topographies than people. The woman's head and breasts are tiny compared to the massive bulk of her body, the encrusted surface of which is alive with myriad scratches and irregularities that reflect the artist's working process.

Dubuffet achieved fame for his staunchly anti-establishment and, indeed, anti-cultural, stance. His rebellion against hallowed academic canons and their notions of ideal beauty led first to notoriety and eventually to acclaim. Dubuffet only devoted himself

wholeheartedly to painting at the age of 41; previously he had felt ill at ease with the privileged status of the artist. He insisted that children's art had an emotional rawness and authenticity that rendered that done by professionals irrelevant. Dubuffet coined the term Art Brut (Fr: 'raw art') to describe expression that lay beyond bourgeois norms, whether by children or other outsiders such as prisoners and the mentally ill. Dubuffet himself sought to paint in 'perfect liberty', conjuring the most primitive graffiti-like appearances and incorporating harsh materials such as sand or plaster with his pigments. In 1948 he established with André Breton the magazine *Compagnie de l'Art Brut*, which championed the work of psychiatric patients.

Hudson River Landscape, David Smith
Welded painted steel and stainless steel, W: 187 cm / 6 ft 1½ in, Whitney Museum
of American Art, New York

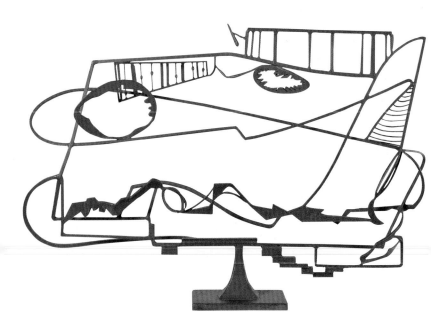

Hudson River Landscape epitomizes what David Smith (1906–1965) called his 'drawings-in-space' of the 1950s. Rather than define conventional volume in three dimensions, these sculptures instead tend to defy gravity, appearing to float and expand as a sequence of linear gestures and open planes. While travelling by train between Albany and Poughkeepsie, New York, Smith made various drawings from which *Hudson River Landscape* ultimately evolved. In this medley of half-recognizable ciphers and sweeping vectors, Smith expressed his fascination with the relationship between earth and sky, the vertical human agent and its wider ambience. Furthermore, the very notion of sculpting a landscape is pathbreaking.

Smith first worked with industrial materials as a welder in an Indiana automobile factory, and subsequently studied painting and drawing at the Art Students' League in New York. There he encountered European Modernist and abstract art. Over the ensuing two and a half decades, Smith single-handedly created a prodigious body of sculptures, transforming steel from an industrial material into the medium of high art. As such, his achievement inspired a variety of younger sculptors – including, perhaps most notably, Anthony Caro (see *Early One Morning*, p.485).

Onement VI, Barnett Newman
Oil on canvas, 259 x 304 cm / 8 ft 5 ¾ in x 9 ft 11 ¾ in, Private Collection

Onement VI is among the most commanding of Barnett Newman's self-termed 'zip' paintings, in which one or more verticals punctuate an expansive chromatic field. Here the luminous 'zip' communes with the deep blueness in which it hovers, the two forces intensifying each other. The large scale of the composition reinforces its impact, as the sheer volume of colour engulfs the viewer, embodying the concept of 'Onement' (that is, physical union or oneness).

Barnett Newman (1905–1970) believed that American and European art – Cubism, Surrealism, Regionalism and Realism – had run their course, and that an entirely new form of painting was needed. He destroyed much of his work made before 1940

and focused on his own style of mystical abstraction. Newman is often associated with so-called colour-field painting, a branch of Abstract Expressionism that exploited sustained chromatic continuums to engage the beholder. Hues and compositions were kept relatively simple to heighten the overall impact: what matters most is the sense of directness, uplift and awe. Such painting was extremely influential, in particular for Minimalism, with its austerity of expression and impersonal or even industrial production methods (see Judd, *Untitled (1982–1986)*, p.496). By comparison, Newman wanted viewers to empathize with his images, which he considered palpable bearers of emotion.

Study After Velázquez's Portrait of Pope Innocent X, Francis Bacon
Oil on canvas, 153 x 118 cm / 5 ft x 3 ft 10½ in, Des Moines Art Center,
Des Moines, Iowa

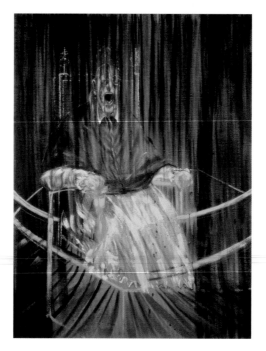

With no formal training as an artist, and minimal education, Francis Bacon (1909–1992) lived an edgy existence in Berlin and Paris before settling in London and undertaking a number of jobs, including interior decorating and running an illegal casino. Despite being an autodidact, Bacon's range of literary and artistic influences was wide, and included the ancient Greek playwright Aeschylus, the poet and critic T.S. Eliot, and the artists Fernand Léger, Pablo Picasso, Vincent van Gogh and Diego Velázquez, who inspired his *Screaming Pope* series of the early 1950s.

Bacon worked largely from photographs, even when painting portraits of his closest friends, and he often combined elements from different sources within a single work. While this riveting canvas emphatically appropriates Velázquez's portrait of Innocent X (c.1650), it also draws on Sergei Eisenstein's film *Battleship Potemkin*, in which a woman in close-up screams after being shot in the eye. Bacon's pope also cries out on his throne, enclosed in a frame that resembles a cage or instrument of torture. Bacon portrayed many of his grotesque figures within comparable frameworks, symbols of the human condition whose anguish finds an equivalent in the artist's dramatic handling of oil paint.

Although Bacon drew upon both Surrealism and Expressionism, he never joined any defined trends or modernist movements.

Expressionism

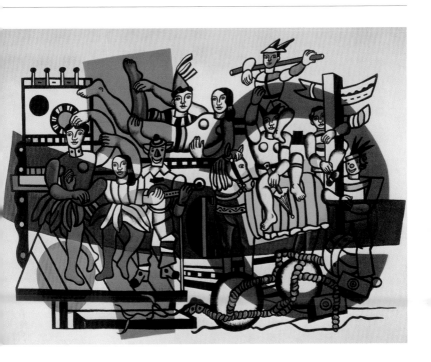

Clowns, trapeze artists, musicians and acrobats playfully cavort around *The Great Parade*'s framework of black and white structures and blue, green, orange and red shapes that echo the palette used by Piet Mondrian (see *Broadway Boogie Woogie*, p.467). In the trenches of World War I, Fernand Léger (1881–1955) met soldiers from all walks of life and began to conceive a need to create popular art for Everyman. He often used the circus as a motif, seeing it as a social leveller, enthralling people from all aspects of society.

Léger had been deeply affected by the 1907 Cézanne retrospective at the Salon d'Automne in Paris, which moved him to abandon his Fauvist-inspired style (see *Conversation*, p.440) and develop

a Cubist concern with volume. During his military service, Léger developed a fascination with machinery that aligned him with the Purism movement of the architect Le Corbusier, which celebrated order, precision and modern products. The figures in *The Great Parade* are surrounded by mass-produced objects and are constructed from simplified, geometric, machine-like shapes. Derived from over 100 preparatory drawings, some dating back to 1947, this final joyful version of *The Great Parade*, which Léger finished only a year before his death, is the climax of a lifelong search for an art form that could be enjoyed by a wide general public.

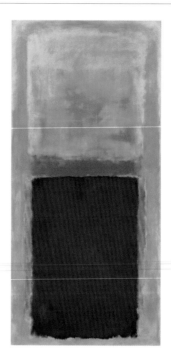

In the early 1940s, the Latvian-born Mark Rothko (1903–1970) saw Henri Matisse's *Red Studio* (1917) in New York's Museum of Modern Art; the work was one of many sources that contributed to a seismic shift in Rothko's painting style, which had previously focused on crudely Expressionistic scenes of everyday life. After the cataclysm of World War II, however, Rothko found himself unable to treat the human figure without mutilating it. *Homage to Matisse*, created at the end of 1954 in response to the death of the great French master, presents Rothko at the zenith of his classic idiom, which he had initiated in 1950.

Two fields of intense colour, respectively dusky gold and deep blue, hover upon a richly tinted ground.

The mottled application of paint, the hazy edging to the lower rectangle and the dialogue between the two primary hues causes the entire image to pulsate and dilate in the beholder's gaze. Rothko insisted that viewers stand close to his compositions so as to become immersed in their radiance, immediacy and enigmatic blankness. He was adamant that his canvases were neither abstract nor a mere manifestation of self-expression. Rather, Rothko aimed to plumb such universal emotions as tragedy, ecstasy and doom. Orchestrating ostensibly plain elements to cast a hypnotic pictorial spell over the spectator, *Homage to Matisse* fulfils Rothko's wish to convey 'the simple expression of the complex thought'.

Monogram, Robert Rauschenberg
Mixed media, 107 x 160 x 162 cm / 3 ft 6 in x 5 ft 3 in x 5 ft 3¼ in,
Moderna Museet, Stockholm

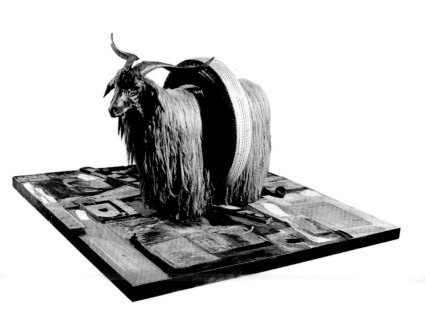

The works of Robert Rauschenberg (1925–2008) and his close friend Jasper Johns anticipated aspects of Pop Art, initiating a shift from the dominance of Abstract Expressionism on the American art scene of the mid-1950s. Rauschenberg first became interested in art after visiting an art gallery while serving as a neuro-psychiatric technician in the United States Navy. His approach owes a debt to the legacy of Marcel Duchamp and his ironic ready-mades (see *Fountain*, p.448), to the Surrealists and their absurdist use of found objects and, in particular, to the German artist Kurt Schwitters and his *Merz* collages made of collected refuse and mundane materials (see *The Worker Picture*, p.452).

In the mid-1950s, Rauschenberg began his 'combine paintings', so named because of their fusion of techniques. They are hybrids of sculptures, painting and photography, full of allusions to the 'gap' that Rauschenberg famously felt existed between art and life. *Monogram* (1955–1959) consists of a stuffed angora goat with a rubber tyre around its middle. It stands on roughly painted boards mounted on casters and is splattered with paint, a gesture suggestive of Action Painting. The piece is an example of Neo-Dada and a precursor to Pop Art, breaking barriers between the banal and high art, painting and object, art and life.

1956
UK

Just What Is It That Makes Today's Homes So Different, Richard Hamilton
Collage on paper, 26 x 25 cm / 10.2 x 9.8 in,
Kunsthalle Tübingen, Tübingen

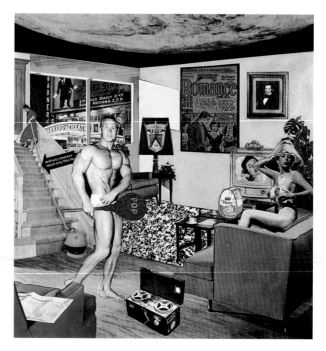

Considered the first Pop artwork, *Just What Is It That Makes Today's Homes So Different, So Appealing?* was exhibited at the entrance to the 1956 show *This Is Tomorrow* at the Whitechapel Gallery in London. The exhibition is now seen as the first show of British Pop Art, and Hamilton's work was its publicity illustration. In 1957, Richard Hamilton (b.1922) outlined the Pop Art movement in a letter: it is 'Popular (designed for a mass audience), Transient (short-term solution), Expendable (easily forgotten), Low Cost, Mass-produced, Young (aimed at youth), Witty, Sexy, Gimmicky, Glamourous, Big Business'.

In this collage of images, taken from magazines and advertisements, a semi-nude modern couple are depicted in their home, surrounded by the mass-produced accoutrements of post-war affluence. In lieu of artworks, a tinned ham and a comic strip take pride of place in their home; above them hovers a giant moon. The body-builder brandishes a lollipop with the word 'Pop', a testament perhaps to Pop Art's admiration for, yet wariness of the consumer artefact.

Hamilton's art studies were diverse: he attended Westminster Technical College, the Royal Academy Schools and the Slade School of Fine Art. He also worked as a commercial artist for the EMI record label. This mixture of the traditional and commercial contributed to his exploration of the distinctions between high and low art.

Made in a studio overlooking Lake Maggiore in southern Switzerland, this large work seems to merge a still life on a table with the view from a studio window. The simplified shapes of bottles, carafes and jugs, drawn in pencil, dance and float on a painted table with three white legs; the blue section towards the lower right feels like the water of the lake, and the brown background on the left hand side could be inspired by the hills beyond. In addition to paint and pencil, Ben Nicholson (1894–1982) scraped the surface of the hard masonite board to create a relief. The reduction of objects to simple shapes is reminiscent of Cubism (see pp.439 and 443), and the fluid, spare lines recall the work of Matisse (see *Conversation*, p.440).

One of several large still lifes of the late 1950s, the lyrical lines, strong shapes and subtle colours are musical in their composition. Exacting and precise, Nicholson titled all of his works specifically, although the actual place or name that he used may have had little or no relation to the painting, being merely a 'kind of label to identify luggage'. Argolis is a region in the Greek Peloponnese.

Son of a still life painter and portraitist, Nicholson was an important link between the art of continental Europe and Britain and helped to define English Modernism in the 1930s. From 1924 he was a leading representative of the St Ives School, establishing the Cornish town as a centre of Modernist painting.

Jasper Johns (b.1930) favoured depictions of recognizable emblems, such as the American flag and map, or a beer can, for their seemingly commonplace status. He claimed to be uninterested in their everyday meaning, but rather in complex new ways to represent them. Yet in the charged climate of the Cold War, such symbols as the flag and map of the United States were loaded with connotations and interpretations.

Map is conceived on an epic scale and realized in the primary colours, plus black and white. It occupies a puzzling hinterland between reality and the abstract. By definition, any map is an abstract sign of something else in the real world. Nevertheless, Johns insisted that this painting was itself a map and not a representation of one, thereby complicating its perceptual status and how we comprehend it.

Johns's debut exhibition in 1958 at the Leo Castelli Gallery in New York met with immediate success: every painting sold, four to the Museum of Modern Art. Johns's early triumph signalled the decline of Abstract Expressionism and the emergence of Pop Art. He was deeply indebted to Duchamp's ironic questioning of art itself (see *Fountain*, p.448), and he took this preoccupation of Dada into new territory, reviving the ancient medium of encaustic (see Funerary Portrait of a Roman Soldier, p.141) and mining a wealth of ideas, from sexual identity to metaphysical puzzles.

Anthony Caro (b.1924) is one of the world's foremost abstract sculptors. He studied at the British Royal Academy after training as an engineer at Cambridge University. His artistic education was conservative, but his work as an assistant to Henry Moore in the early 1950s and his teaching projects at the experimental St Martins' School of Art in London led him towards more innovative directions.

Early One Morning breaks away from Caro's early work (which is figurative and modelled from clay) and, indeed, from the tradition of early twentieth-century British sculpture, which was dominated by Moore's example (see *Recumbent Figure*, p.463). Composed of separate angular elements, bolted and welded together, the sculpture's horizontality may hint at a reclining nude, but it is otherwise resolutely non-representational. The single colour unifies the potentially disparate arrangement of shapes and, by disguising the metal, removes any industrial associations; nor is there any base or pedestal to mediate between the diverse planes and the spectator. Thus the relationship between the parts of this construction unfold, like an abstract fugue, in time and space as the viewer contemplates them from different angles. Caro felt that much traditional British art lacked such direct impact on the viewer and his breakthrough heralded a new way of thinking about sculpture.

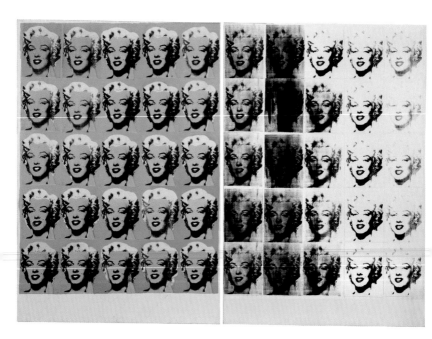

Andy Warhol (1928–1987) was a figurehead of Pop Art. Taking his subject matter from everyday culture – from commercial domestic products such as soup cans, to tragic disasters and celebrities such as Jacqueline Kennedy – he favoured mechanical processes that made his work impersonal. The *Marilyn Diptych* was made four months after Marilyn Monroe's death, using a publicity still from the film *Niagara* (1953). By repeating Monroe's face, Warhol alluded to the media's constant coverage of her image, yet simultaneously emptied it of meaning. The crude screen-printing process emulates the cheap mass-production methods of newspapers and magazines to create a mood of banality and alienation.

Jasper Johns (see p.484) and Robert Rauschenberg (see p.481) influenced Warhol's appropriation of popular icons and commonplace objects. His elimination of any sense of personal touch from the artistic process extended Duchamp's practice of exhibiting ready-mades (see *Fountain*, p.448).

Warhol had a vividly prescient vision of contemporary society and its obsession with celebrity. During his lifetime, he mingled with the famous and often incorporated their portraits into his art. A household name himself, he exerted a huge influence, ensuring that Pop Art became one of the major movements of the twentieth century and changing the ways that art itself was subsequently conceived.

'Monument' for V. Tatlin 1, Dan Flavin
Cool white fluorescent lights and metal fixtures, H: 243.8 cm / 8 ft 2 in,
Museum of Modern Art, New York

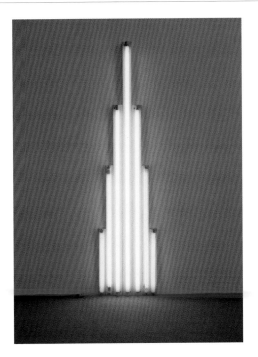

Dan Flavin (1933–1996) is best known for his Minimalist works made from commercially available fluorescent lights. He used varying tube lengths and combinations of colours to create physical compositions that also transform the space around them. He was the first artist to use this new medium. Like Marcel Duchamp (see *Fountain*, p.448), Flavin used everyday objects in his art, but in his case these materials are used to make new forms. When the light tubes burn out, they are replaced, thus subverting the concept of an original.

'*Monument' for V. Tatlin 1* is one of a series of works dedicated to the Russian Constructivist Vladimir Tatlin. Flavin admired Tatlin's fusing of technology and architectural form, particularly Tatlin's *Monument to the Third International* (1919–1920), a revolving spiral that was never built but was intended to be taller than the Eiffel Tower.

Despite their use of industrial materials and austere geometric forms, both signatures of Minimalist art, Flavin's works have a mesmerizing, almost spiritual quality. (Flavin's father wanted his son to become a priest, and he attended seminary school in Brooklyn before turning to art.) His sculpture is as much comprised of light and gallery space as of materials, and as such can be compared to such site-specific art as James Turrell's *Roden Crater* (p.503) and Donald Judd's *Untitled (1982–1986)* (p.496).

Minimalism

1967
Nigeria

The Lazy Hunters and the Poisonous Wrestlers, Twins Seven-Seven
Ink, paint and chalk on plywood, 87 x 125 cm / 2 ft 10¼ in x 4 ft 1¼ in,
National Museum of African Art, Lagos

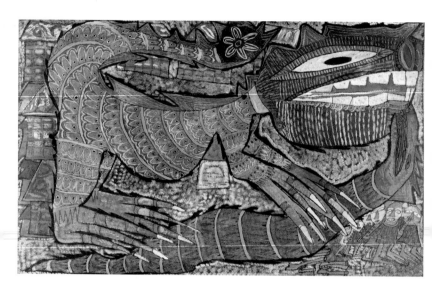

In 1962, in the Yoruba town of Oshogbo, the Mbasi-Mbayo artist's co-operative was established, and from it the Oshogbo school of Nigerian artists formed. Its members wanted to create a new art without jettisoning African artistic traditions. Although there is virtually no tradition of painting in Africa, save for prehistoric rock paintings and ecclesiastical Ethiopian paintings, the Oshogbu school aimed to retain the cultural sensibilities of the Yoruba people in the medium of painting, and in doing so, produced some of the most imaginative and original twentieth-century African works of art.

Twins Seven-Seven (b.1944) is the best known artist of the Oshogbo school. His work relates his own creation but also aims to recreate the intensity of traditional Yoruba storytellers. Twins is known for 'sculptural' painting, in which he creates a low relief on the surface of the work, as if to reconcile the medium of paint with the Yoruba sculptural tradition. In this piece, *The Lazy Hunters and the Poisonous Wrestlers, Lizard Ghost and the Cobra,* Twins uses no more than chalk, paint and ink, yet the black ink outline round the figures and the mosaic-like detail give the surface of the work a three-dimensional feel. The distorted figures, vivid colours and intricate detail create a fantastic mythological world that is Twins' own, though related to earlier traditions and the Oshogbo style.

1967
USA

Bouncing Two Balls Between the Floor and Ceiling, Bruce Nauman
16 mm black-and-white film and sound, 10 minutes, Various locations

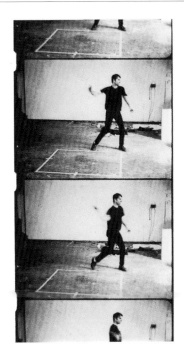

The work of Bruce Nauman (b.1941), which includes film, sculpture, photography, video and performance art, often features the artist as its subject. Using his own body, Nauman performed and recorded seemingly mindless tasks, and in so doing extended the boundaries of what constitutes art and what role an artist plays in his or her work. *Bouncing Two Balls Between the Floor and Ceiling with Changing Rhythms* (1967–1968) is an example of Conceptual art, in particular Process art, defined by the conceptual artist Robert Morris as an artistic movement 'involved in issues attendant to the body, random occurrences, improvization, and the liberating qualities of non-traditional materials'. In this film, Nauman bounces two balls into a square marked on the floor of his studio with tape. He tries to follow a pattern, but his throwing becomes erratic, and the balls bounce further out of control.

A former mathematics and physics student, Nauman studied art at the University of California in Davis at a time when the role of New York as epicentre of the art world had begun to dissipate and the Californian art scene was growing in influence. Much of his work explores the limitations of language using the manipulation of words. Finding himself questioning how to define his role as an artist, he theorized that as an artist must have a studio, whatever he did inside of his would necessarily be art.

Spiral Jetty, Robert Smithson
Basalt, earth and salt crystal, Diam: 457 cm / 15 ft, In situ, Rozel Point,
Great Salt Lake, Utah

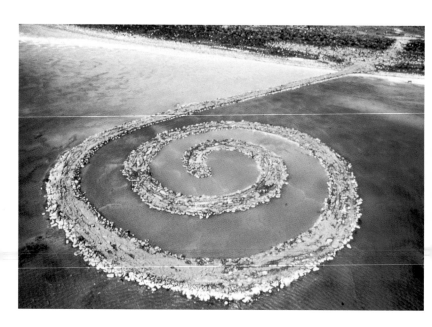

Spiral Jetty is one of the last of the enormous, site-specific, outdoor projects known as Earthworks created by Robert Smithson (1938–1973) before his death in an airplane crash. The giant spiral – seen here as it appeared in April 1970 – sits in the waters of Great Salt Lake and is only sometimes visible, depending on water levels. The work was created using dump trucks and bulldozers to dredge 6650 tonnes of earth and rock and deposit them in the lake, eventually forming this anti-clockwise coil, 457 metres (1500 ft) long and 457 centimetres (15 ft) wide. The Rozel Point site was chosen for the blood-red colour of its water (caused by salt-tolerant bacteria and algae), which was said to be indicative of the primeval sea.

Like all Land Art, Smithson's Earthworks make reference to the genre of landscape painting, but rather than representing nature, *Spiral Jetty* is the landscape itself. The monumentality and mythic quality of the work owes a debt to such ancient colossal works of architecture as the Egyptian pyramids, Stonehenge, and Native American ceremonial earth mounds.

By the time Land Art began to emerge in the 1970s – preceded by 1960s Pop Art, which had celebrated consumerism and industrialization – social debate was raging about the effects of pollution and the need to respect the Earth. Today a similar debate concerns the preservation of these works of art, which are made of natural materials and left to erode naturally.

1974
Germany

I Like America and America Likes Me, Joseph Beuys
Performance including coyote, felt, Wall Street Journal newspapers, walking stick,
hat and gloves, 23–25 May 1974, Rene Block Gallery, New York

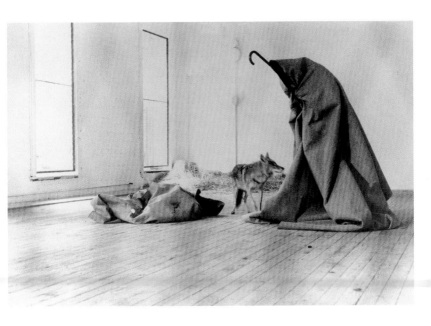

Early in his career, Joseph Beuys (1921–1986) claimed that in the winter of 1943, while serving as a Luftwaffe pilot, his airplane crashed in the Crimea and he was rescued by a group of Tatars. They wrapped him in animal fat and felt to keep him warm; he used both these materials in his sculpture and *Aktionen*, or performances, thus mythologizing his own history.

In May 1974 Beuys travelled from Germany to New York to stage *I Like America and America Likes Me*. He was wrapped in felt at the airport and transported to the Rene Block Gallery in an ambulance, never setting foot on American soil (he was deeply opposed to American involvement in Vietnam). He spent three days in the gallery with a coyote, which varied from aggressive to wary to friendly over the course of the performance. It urinated on the fifty copies of the *Wall Street Journal* that were delivered each day; Beuys never took his eyes from the animal. To Native Americans the coyote was a god, but to white settlers it was a pest. Beuys' art had undertones of shamanism, controlling and transforming nature, and he saw this *Aktion* as atonement for white America's wrongdoings.

A charismatic and unconventional personality, Beuys' definition of art included debate, discussion and teaching, as well as performance, installation and culture. His concept of 'social sculpture', how our actions shape the world around us, has been an important development in contemporary art.

Wind Combs, Eduardo Chillida
Steel, 216 x 177 x 186 cm / 7 ft 1¼ in x 5 ft 9½ in x 6 ft 1¼ in (each sculpture),
In situ, San Sebastián

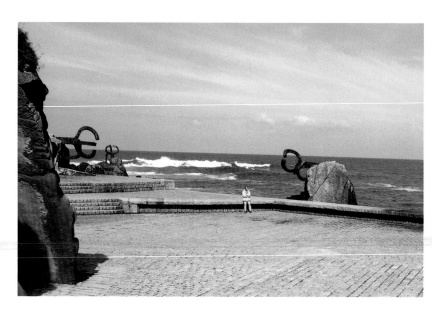

As a young child Eduardo Chillida (1924–2002) spent much time at this spot on the San Sebastián coast instead of going to school; he was fascinated by the interminable pounding of waves against the rocks. Although the intensity of each wave might have been different, to him they also appeared similar, hence the similarity of the three elements that make up this powerful site-specific work.

The three steel abstract figures weathered by the salt, wind and waves of their environment arise from the rocks as if they have been there as long as the stones themselves. Twisted and powerful, the combination of steel, water and earth is fixed by the single line of the unmovable horizon. Jutting out from the rocks, forming claw-like shapes that seem to comb the wind, their rusted surfaces resemble the mooring rings hammered into rocks for securing boats. The three structures relate in terms of scale; although each piece is large when viewed up close, it shrinks and recedes when viewed from the sites of the others.

Chillida was born and died in San Sebastián and could see his celebrated sculpture from the windows of his living room. He began using iron and steel after an apprenticeship with a metalsmith in the Basque village of Hernani. He learned to weld metal and cut iron and later introduced granite, alabaster and clay into his repertoire. His use of iron was also influenced by David Smith (see *Hudson River Landscape*, p.476).

Abstraction / Late Modernism 492

1977
Japan

Momo Taro, Isamu Noguchi
Granite, 274 x 105 x 658 cm / 9 ft x 34 ft 7 in x 21 ft 7 in, Storm King Art Center,
Mountainville, New York

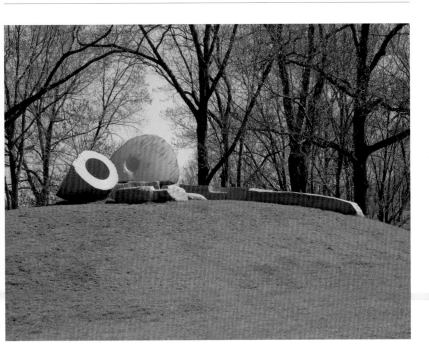

In 1971 the Japanese-American sculptor Isamu Noguchi (1904–1988) established a studio on the Japanese island of Shikoku. As the boulders on Shikoku were split to create the stones for a site-specific sculpture, Noguchi thought of Momo Taro, a Japanese folk hero who emerged from the centre of a peach, and so titled this work.

The sculpture, created in 1977–1978, weighs 40 tonnes and is situated on top of a hill at the Storm King Art Center in upstate New York, integrating itself with the landscape. It provides seating for visitors and expansive views of the grounds for which it was created. *Momo Taro*'s form mirrors the organic and biomorphic sculpture of Noguchi's former mentor Constantin Brancusi (see *Golden Bird*, p.451), and its function echoes James Turrell's *Roden Crater* (p.503) in its shaping of the visitor's view and experience. Stone lends the work a monumental and ancient quality.

Noguchi was born in Los Angeles to an American writer mother and Japanese poet father. Social interaction plays an intrinsic part in his artistry: he worked as a landscape architect, designing playgrounds and gardens and sculpted environments throughout his career; he created numerous theatrical set designs for Martha Graham, as well as furniture and lamps for mass-production. Above all, Noguchi's idiosyncratic attitude to materials and space fused the aesthetics of East and West.

1981
China

Panorama of Mount Lu, Zhang Daqian
Ink and colour on silk, 179 x 995 cm / 5 ft 10¼ in x 32 ft 7½ in (entire work),
National Palace Museum, Taipei

Zhang Daqian (1899–1983) learned by copying famous painters (and earned a reputation for forgery). He studied abroad, but he also travelled within China and was particularly inspired by the murals at Dunhuang. He painted from life but also drew on his imagination – as in this detail of a vast unfinished work on silk – for views that he had never seen. And he experimented and developed a grand, forceful style that incorporated techniques that in the past might have been regarded, at least within a single picture, as mutually exclusory.

Mount Lu (1981–1983) was Zhang's last and greatest work, an example of 'modern traditional' Chinese painting. The distinctive 'splashed colour' of the iridescent patch of mist swirling across from the mid-left of the silk represents his indebtedness both to the techniques of Tang (AD 618–907) and Song (AD 960–1279) painting and to the Abstract Expressionism he learned abroad. But the colour is also closely allied with the freehand strokes (*xieyi*) that build up the mountains in the background and the precise brushwork (*gongbi*) of the pine needles in the foreground. One seems to see here the vertical faces of Ma Yuan's cliffs (p.246), the drooping loneliness of one of Ni Zan's trees (p.279), and, in the background, the hint of a paternalistic peak by Guo Xi (p.214), each suggesting the inspiration as well as the individuality of Zhang's style.

Tilted Arc, Richard Serra
Steel, 3.67 x 36.58 m / 12 x 120 ft, Federal Plaza, New York; now destroyed

The 'Art in Architecture' programme of the US General Services Administration commissioned Richard Serra (b.1939) to create *Tilted Arc*, which was installed in New York's Federal Plaza in 1981. The monumental curved steel wall was self-supporting, its size and weight emphasizing the nature of its gently rusting mild steel. The sculpture bisected the plaza, forcing employees to walk around it to their offices, and the piece immediately triggered controversy: Judge Edward Re began a petition for its removal. A public trial was held in 1985 to determine its fate, at which Serra testified that *Tilted Arc* was site-specific and could not exist in another location. Although 122 people testified for the sculpture and 58 against it, the

jury decided upon its removal: it was cut into three pieces overnight on 15 March 1989 and sent to a scrap metal yard.

The fate of *Tilted Arc* raised a debate about public art and government funding that raged throughout the 1980s and 1990s. People questioned whether popularity equalled value and whether an artist had rights to a commissioned work. Serra's response was that 'art is not democratic. It is not for the people.' Not all Serra's works have received such hostility, and he remains highly influential. Although his pieces are objective and free of imagery, his interests lie in how people view the environment and react to such fundamental qualities as weight, scale and place.

Untitled (1982–1986), Donald Judd
52 works in milled aluminium, 104 x 129 x 182 cm / 3 ft 5 in x 4 ft 3 in x 6 ft (each),
In situ, North Artillery Shed, Chinati Foundation, Marfa, Texas

Donald Judd (1928–1994) was a principal exponent of the Minimalist movement that flourished in the United States during the 1960s. Although never a monolithic style, Minimalism sought to retain a sense of the art object as a whole, by removing distractions such as compositional effect or – in painting – perspective. In part a rejection of the gestural painting and high emotional content of the preceding Abstract Expressionist movement, Minimalist works are characterized by austerity, industrial materials and geometric forms. A critic and an artist, Judd in a sense created the climate in which he worked; his influential essay 'Specific Objects' (*Arts Magazine*, 1965) is regarded as a manifesto for the movement.

Between 1982 and 1986, Judd installed 100 aluminium boxes in two former military artillery sheds; the view here is of the northern shed. Each box has an open panel through which one can view the interior, which is divided by sheets of aluminium. Identical in size and material, the seriality of the work is disrupted because each box is unique, reflecting the external world, changing with the light and weather. The installation has many features typical of Judd's earlier works: regularity of form, symmetry and use of industrial materials. By this stage, however, the artist was interested in the effect of the space in which his works were shown, hence his creation of a work that is markedly affected by its surroundings.

1984
USA

Untitled No. 4, Agnes Martin
Acrylic, gesso and graphite on canvas, 183 x 183 cm / 6 ft 1¼ in x 6 ft 1¼ in,
Private Collection

A delicate grid of pencil lines floats above a white background prepared with gesso. Although something as strict as a grid might appear machine-like and impersonal, the abstract compositions of Agnes Martin (1912–2004) are imbued with beauty and spirituality. Unlike the work of her peers Donald Judd (opposite) and Dan Flavin (p.487), no machines or assistants were used to create Martin's paintings. Her work contains no narrative, no superfluous detail or repetitive forms, and so is considered Minimalist, but her aim was not to create intellectual exercises in abstraction, but emotions that could be experienced.

In 1976 she delivered a lecture at Yale University entitled 'We Are in the Midst of Reality Responding with Joy', in which she emphasized the emotional subtext of her work that links her strongly to the Abstract Expressionists. Ultimately, *Untitled No. 4* can be seen as her personal exploration of her own perceptions of truth and beauty.

Born on the western plains of Canada and brought up in Vancouver, Martin moved to the United States in 1932 and became a citizen in 1950. For many years she worked and lived at the centre of the New York art world, but in 1967 she moved to New Mexico and did not paint for seven years. After this hiatus she stayed away from the bustle of the city but returned to painting until her death, replacing neutral colourless tones with brighter colours.

Abstraction / Minimalism

1988
Australia

Aboriginal Memorial, Various artists
Wood and pigment, H (max): c.327 cm / 10 ft 9 in, National Gallery
of Australia, Canberra

The year 1988 marked the two hundredth anniversary of European settlement in Australia. While the nation officially celebrated, many Aboriginal Australians used the occasion to mark the tragedies of the past and the inequalities of the present. A group of artists from Ramingining in Central Arnhem Land, including Paddy Dhatangu, George Milpurrurru, Jimmy Wululu and David Malangi, among others, created a memorial to mark the past while also celebrating the resilience of Aboriginal people.

The memorial takes the form of 200 traditional coffins, *dupun*, made from hollowed logs – one to mark each year of European settlement in Australia. Each coffin is unique, decorated with clan designs

and images from the Dreamings of the artists. The red, yellow, black and white palette of Arnhem Land artists is composed of natural pigments made from ochre, kaolin and charcoal. The painting style of each coffin relates to the artist's social group and forms, in effect, his copyright or exclusive clan symbol. Designs of animals, birds and patterns are of ancient lineage.

Massed together, the 200 coffins create a museum space that is transformed and infused with Aboriginal spirit. It is a work that speaks both to Aboriginal people and to the world at large, to past and present, to tradition and innovation. Although made of coffins, the *Aboriginal Memorial* speaks powerfully of life.

Famous for his earlier luminous colour-field paintings, Brice Marden (b.1938) has been most closely associated with Minimalism for much of his career. His work, in which rectangular blocks of smooth, subtle colour are offset against each other, has many qualities of Minimalism: absence of representation and complex composition. Marden, however, has always felt an affinity with the high emotional content of the Abstract Expressionists. The flat planes of colour in his early work often have an expressive texture only revealed if one stands close to the canvas.

The *Cold Mountain* series, created between 1989 and 1991, embody a dramatic departure from Marden's early work and are the first of his now iconic paintings to be made in this style. The sensuous curves, loops and lyrical lines that seemingly glide and drip down this canvas find their source in the calligraphic poems of a nineteenth-century Chinese poet-hermit called Han Shan, or Cold Mountain. The gestural tangle of lines that seems to take the myriad webs of Jackson Pollock (see *Number 1, 1950 (Lavender Mist)*, p.473) to a different level gives the work a more direct expressive quality, while retaining the refined colouring and subtle handling of paint that characterized his early work. Marden is in this way singular in his ability to balance the expressive, emotional, painterly qualities of Abstract Expressionism and the restrained, formal qualities of Minimalism.

1992
USA

Puppy, Jeff Koons
Live flowers, earth, wood and steel, H: 11.5 m / 38 ft, Bad Arolsen, Germany;
now Guggenheim Museum, Bilbao, Spain

Puppy was originally created for a temporary exhibition in Bad Arolsen, Germany, but is now on permanent display in Bilbao; the original installation is shown here. The giant West Highland terrier is constructed of a steel framework that supports 25 tonnes of soil and 70,000 plants, including marigolds, impatiens and petunias; the fusion of flowers and a pet is a monument to the saccharine and the sentimental.

Jeff Koons (b.1955) supported himself as a Wall Street commodities broker before finding success as an artist in the 1980s. His desire to pursue celebrity status, combined with his talent for elevating common items into the contemporary art arena, prompted many critics to label his art as Neo-Pop. Like the Pop artists of the 1960s, his work celebrates – and criticizes – domestic products and the fundamental capitalism of American society. Koons focuses primarily on the relationship between high art and kitsch.

Koons has courted controversy, exhibiting, for example, basketballs in tanks of water, vacuum cleaners in Plexiglas, and polished porcelain replicas of popular culture items such as toys and the pop star Michael Jackson. His work references Duchamp's ready-mades and their appropriation of everyday items as high art objects (see *Fountain*, p.448), and his use of scale in this piece has echoes of Surrealism.

1993
Canada

A Sudden Gust of Wind (after Hokusai), Jeff Wall
Transparency in lightbox, 229 x 377 cm / 7 ft 5¼ in x 12 ft 4½ in, Tate, London

A Sudden Gust of Wind (after Hokusai) is based on a
nineteenth-century woodblock print by the Japanese
artist Hokusai (see p. 408), in which a group of
travellers loses a stack of papers to the wind. Jeff
Wall's (b.1946) tableau uses the same composition
but sets the group of figures in a modern, post-
industrialist landscape. The cinematic quality of the
work is indicative of Wall's construction of images
that resemble film stills. His entire process is, in fact,
informed by filmmaking: this can be documentary
in style, when the work doesn't involve some form of
collaboration, or 'cinematographic', as in this case,
when he hires actors, scouts locations and creates
digital special effects. Although the photograph

appears to be a snapshot capturing a moment in
time, in actuality Wall spent months composing
and perfecting its elements and details with digital
photographic tools.

Wall first began producing his lightbox-mounted
photographs in Vancouver after studying at the
Courtauld Institute in London; he was the first artist
to use this method. The effect resembles a cinema
or television screen, enhancing the unreality of the
scene. His research degree in art history provided a
basis for his exploration of contemporary life through
art historical references. This piece challenges the
documentary nature of photography, a characteristic
associated with the medium since its inception.

Curved Plane/Figure XI, Robert Mangold

Acrylic and pencil on canvas, 275 x 550 cm / 9 ft x 18 ft ½ in,
Collection Fundació la Caixa, Barcelona

The subtle, abstract paintings of Robert Mangold (b.1937) are most closely associated with Minimalism, although his work draws on influences as wide-ranging as early Classical pottery from Greece, Renaissance frescoes and Abstract Expressionism. Mangold's images, composed of reductive elements and showing a complete lack of depth and perspective, represent nothing more than their parts. It is the complex relationship between these that is key.

The *Curved Plane/Figure* series of 1994–1995 is a group of semi-circular paintings inspired by a sixteenth-century Jacopo Pontormo drawing in a lunette. *Curved Plane/Figure XI* is divided into four panels of colour, over which the artist has drawn three pencil ellipses. The brown of the second panel from the left combines the two colours on either side: the orange has been painted over the grey. The white segment on the right (the ground for the grey and orange) breaks the symmetry of the triad while completing the configuration of the lunette. The curiously harmonious combination of mismatched shapes is one of the most striking elements of Mangold's outlook. Although the shape of the painting is, in Mangold's words, 'the first element', he was also inspired by colour-field painting, in particular the work of Mark Rothko (see *Homage to Matisse*, p.480) and of Barnett Newman (see *Onement VI*, p.477).

James Turrell (b.1941) claims that one of his earliest memories is of his grandmother inviting him into a Quaker meeting 'to greet the light'. His media comprise sky, light and space, and his overtly spiritual artworks, often existing beyond the realm of galleries or museums, encourage viewers to 'touch with sight'.

Turrell discovered Roden Crater on the edges of the Painted Desert in 1974, and he bought the site in 1977; since that time he has been transforming the cinder of the extinct volcano into an interactive light environment and an observatory. Four underground chambers orientated to the cardinal directions will ultimately be linked to a central oval room, above which the sky will curve, seeming to attach itself to the rim of the crater. *Roden Crater*'s elliptical openings in the chambers' ceilings recall the Roman Pantheon, itself created as both a temple and a giant, man-made sundial. The sculptural use of light is combined with the raw physicality and spatial breadth of the desert to make specific references to the interior and exterior spaces of the volcano and its landscape.

Like Robert Smithson's *Spiral Jetty* (p.490), *Roden Crater* shares with ancient sites such as Stonehenge or the Egyptian pyramids a sense of mystery and monument. In addition to light and space, it uses time as an artistic element, suggesting the infinity of both astronomical and geological periods, and the ongoing, limitless aspect of human creativity.

Glossary

Cross-references within the glossary are **bold**.

'Abbasid Dynasty

Rulers in Baghdad between AD 749 and 1258, the 'Abbasids traced their descent from al-'Abbas, uncle of the prophet Muhammad. After moving their capital from Damascus to Baghdad in AD 762, they encouraged the absorption of artistic and cultural ideas from across the Islamic world, China, and some parts of Europe.

Abstract Expressionism

American painting movement that flourished in the 1940s and 1950s. Although their styles varied, abstract expressionists all used **abstraction** to externalize emotions, allowing the subconscious to express itself on the canvas. **Gesturalism**, sometimes called Action Painting, was one technique used by these painters.

Abstraction

An artistic concept denoting a lack of concern with accurate representation of the natural world, instead using colours and shapes to represent the essential elements of a subject. Abstraction can be seen across many cultures and all times, and includes abstract art, which, strictly applied, is a term relating to twentieth-century Western art that rejects representation and any relationship to the natural world.

Achaemenid Persian Empire

A Persian-led empire that stretched across western Asia, Egypt and into Europe from around 550 BC until its defeat by Alexander the Great in 330

BC. Achaemenid art and architecture was heavily influenced by preceding Assyrian (see **Neo-Assyrian Empire**) and contemporary Greek styles.

Aesthetic Movement

A movement of the 1870s and 1880s among creators of fine and decorative arts and architecture, first in the UK and subsequently in the USA. It emphasized the aesthetic experience of the viewer in a reaction against what was seen as philistinism in design and art. This view of 'art for art's sake' produced decorative works largely without narrative and with an emphasis on harmony of colour and composition.

Akkadian Empire

First empire of **Mesopotamia**, established in the later third millennium BC on the banks of the Euphrates near modern Baghdad; the site of the ancient capital remains undiscovered. Notable artistic achievements include carved stelae (see **Stele**) and bronzework; Akkadian cylinder seals are some of the best examples of the gem-cutters' art.

Aksumite Culture

Culture from the region of modern Ethiopia that flourished between the first and eighth centuries AD. The Aksum had close ties to the kingdom of Saba (see **Sabaean Kingdom**) in southern Arabia, and elements of this Arabic influence survive in their culture; the development of the kingdom's main port at Adulis also encouraged ties with the eastern Mediterranean.

Altarpiece

Screen-like structure, usually carved or painted, which stands behind and above the altar in a Christian church

or chapel. A focus for worship, the role of the altarpiece is to identify the dedication of the altar and reinforce its sacramental function.

American Sublime

Style of landscape painting practised most famously by members of the **Hudson River School**, which sought to convey a sense of the magnificence of the American landscape, in which human figures, if present at all, are dwarfed. Based on an aesthetic concept originating in Classical Greece, and much debated in eighteenth-century Europe, the concept of the Sublime re-emerged in the later twentieth century as a term for the graphic expression of social horrors such as the Holocaust.

Amphora

Form of ancient vessel with two handles and a narrow neck, used as a storage jar for liquids such as water or oil.

Amulet

An object believed to have religious or magical powers. Amulets, frequently in the form of jewellery, are often worn about the body to protect the wearer from danger or disease.

Angkor Wat

See under **Khmer Culture**.

Anglo-Saxon Style

Term generally applied to English art dating from the Germanic invasions of the later fifth century AD to the Norman Conquest of 1066. Upon settling in Britain, the pagan Saxons were exposed to the influence of **Celtic** art, the Romano-British artistic tradition, and the missionary activities of the Roman and Celtic Christian churches; as a result of the unique

usion of these varied influences, the sixth to ninth centuries AD are often termed the Insular period, referring to the artistic production of Britain and Ireland. The ornamental mixture of Germanic, Celtic and Pictish motifs was particularly marked in the Celtic areas of the north and west, the art of which is sometimes termed Hiberno-Saxon.

Aramaean Culture

Ancient Near Eastern culture prominent in the first millennium BC, made up of semi-nomadic tribes from the Syrian steppe who spoke a West Semitic language written in the Phoenician alphabet. Their art exhibits influences from the Neo-Hittite empire to the west and the **Neo-Assyrian Empire** to the east.

Archaic Period

In Greek art, period from c.700 to 480 BC. In both sculpture and painting, an early formulaic approach possibly based on Egyptian models engendered an increasing interest in anatomy that resulted by the end of the period in bold experimentation and mastery of form. Sophisticated metalworking and painting techniques developed, and themes and subject matter expanded, though any direct form of historical representation is rare. In North America, the term refers to the period ending around 800–600 BC, identified mostly through lithic technology.

Art Brut

The French for 'raw art', a term invented by Jean Dubuffet for a style of art that is purposefully outside the tradition of accepted fine art; also called Outsider Art. Dubuffet saw in the drawings of small children and the mentally ill an unprocessed spontaneity that came to identify the Art Brut movement.

Art Nouveau

A primarily architectural and decorative art style of late nineteenth- and early twentieth-century Europe and North America, which also influenced fine art. Rejecting what its proponents felt were austere **Classical** aesthetics, the movement sought a new style based on traditional crafts and the imitation of nature. Art Nouveau works were characterized by asymmetry and flowing organic forms.

Assemblage Art

Form of sculpture produced by arranging often disparate found objects and materials. First used by Cubists (see **Cubism**) and Dadaists (see **Dada**), the juxtapositions that could be created were also attractive to Surrealist artists (see **Surrealism**), and it remains a popular medium today.

Avant-Garde

From the French meaning 'advance guard', a term used to describe a movement or work that is experimental or that lies outside the predominant style of contemporary society.

Aztec

Generic label for the final period of Pre-Columbian central Mexican cultural history, popularized by the European explorer Alexander von Humboldt in the nineteenth century. The term has been used inconsistently to identify what were in reality several distinct peoples, and in this book the more specific **Mexica** culture is referred to.

Barbizon School

Group of French painters who lived near the village of Barbizon, near Paris, from around 1830 to 1870. The most famous members were Jean-François Millet and Théodore Rousseau. Focusing on landscape painting, they rejected **Classical** conventions and tried to represent realistically a rural world they felt was disappearing. They were a great influence on the Impressionists (see **Impressionism**).

Baroque

The principal European artistic style of the seventeenth century and the first half of the eighteenth. Beginning in Italy, it has been suggested that the Baroque style was born out of the Counter Reformation, and was at first a form of propaganda for the Catholic Church. Baroque art was intended to address the senses directly and to influence the intellect through emotion rather than through reason. Decorative and emotional excess, dramatic movement and spectacle characterize the style.

Bauhaus

School of art, design and architecture established in Weimar Germany in 1919 by the architect Walter Gropius. Its roots lay in nineteenth- and early twentieth-century attempts to re-establish the connection between design and manufacture, and it reinstituted the idea of workshop training in preference to academic studio education. Its disciplined, functional style widely influenced European architecture and design.

Benin, Kingdom of

Kingdom in southern Nigeria, with its capital at Benin City. The people of this region are known primarily

for their brass plaques, which are believed to represent great moments in their history.

Black-figure Style

Ancient Greek vase-painting technique in which figures and designs are painted in black silhouette, with details incised to reveal the colour of the background slip. See also **Red-figure Style.**

Blaue Reiter

German for 'blue rider', this loose group of expressionist (see **Expressionism**) artists in Munich was active from 1911 to the outbreak of World War I in 1914. The group had no unifying style, but its members were linked by the desire to explore their own emotions and consciousness and to promote the spiritual element of art. Members included Vasily Kandinsky and Paul Klee.

Block Printing

Technique in which a solid material, usually wood (rather than a metal plate), is engraved or cut and used to print a design onto cloth or paper.

Bodhisattva

In the Mahayana Buddhist tradition, an enlightened being who out of compassion has deliberately postponed the attainment of full nirvana in order to assist others towards enlightenment.

Bronze Age

Period in the development of civilization characterized by the use of bronze as the major metal for tools and weapons. In most cultures the Bronze Age followed the **Neolithic period**, when stone tools were prevalent, and was succeeded by the **Iron Age**, when techniques

for smelting iron ore for use in weapons and tools were developed.

Brücke, Die

Group of German Expressionist painters (see **Expressionism**) and printmakers formed in 1905 and influenced by **Post-Impressionism** and **Fauvism**. The name ('the bridge') indicated its members' desire to bridge the gap between art and the way life is lived, and represented a call for the complete rethinking of artistic practice.

Byzantine Style

Style prevalent under the Byzantine Empire, which succeeded and continued the Roman Empire in the east after the deposition of the last emperor in Rome in AD 476. The territories of Byzantium took in at various times Italy, Greece and the Balkans, modern Turkey, the eastern Mediterranean and North Africa. The highly representational language of Christian iconography that developed in the Byzantine period survives almost unchanged in the Orthodox Church.

Calligraphy

The art of decorative writing, usually in ink, using a brush or pen.

Cameo

A method of carving or a piece of jewellery in which a design is carved in raised **relief** on glass, ceramic or a gemstone.

Camera obscura

A device by means of which the likeness of an image or object can be copied accurately, used by artists from ancient times until the invention of the modern camera. A box, tent

or small room is supplied with a small hole in one side and an internal mirror, positioned so that the image of a subject outside the box is reflected onto a piece of paper on which the outline can be sketched.

Carolingian Renaissance

Term referring to art produced in western continental Europe in the ninth century AD under the Frankish empire, when it was ruled by Charlemagne and Louis the Pious. The period was one of intellectual revival that saw the emulation of Classical Roman culture, and was a time during which Carolingian artists combined the styles and subject matter of Early Christian art with ancient Mediterranean forms, creating a transformative medieval art that would lead to the **Romanesque style.**

Celtic Style

Style of European **Iron Age** art produced by the Celtic-speaking peoples of central and western Europe between the fifth century BC and the eighth century AD. Exuberant and complex decoration characterizes Celtic design, an essential element of which is rhythmic distortion and an almost unrecognizable **abstraction** of natural forms.

Chalcolithic Period

Also known as the Copper Age, this period falls between the **Neolithic period** and the **Bronze Age** in some parts of eastern Europe and the Near East, from roughly 4500 to 3500 BC. It is characterized by the appearance of the first metal tools, made of copper.

Champa Culture

The Champa kingdom of Southeast Asia was comprised of a variety

of small states along the coast of modern Vietnam and flourished from the late second century AD to the seventeenth century. It was heavily influenced by the art and culture of Hindu India.

Chancay Culture

Pre-Columbian culture of South America that flourished between c.1100 and 1470 in the Chancay valley of the central Peruvian coast. It came under Chimú domination in the fifteenth century.

Chavín Culture

Pre-Columbian artistic and cultural tradition that flourished during the Early Horizon period (c.900–250 BC) in the central Andes. Named after the site of Chavín de Huántar, it laid the foundations for all subsequent Pre-Columbian Peruvian cultures.

Chiaroscuro

Term used in drawing and painting to describe the utilization of light and dark shades of a colour to produce an illusion of depth. Literally translated as 'light-dark', the technique was developed during the Renaissance, and Italian and Dutch masters famously used it to create works full of exaggerated light and shadow.

Chola Dynasty

Tamil Hindu dynasty in southern India that flourished until the thirteenth century. Their lands extended to Sri Lanka and parts of Indonesia. The Chola are renowned for their carved stone temples and bronzes.

Choson Dynasty

Last and longest-lived Korean dynasty, which ruled the peninsula from 1392 to 1910. The conservative values of Confucianism dominated Korea's art and culture at this time, as support for Buddhism was withdrawn. Chinese painting styles were introduced via trading missions, but by the late seventeenth century distinctly Korean styles had developed.

Classical Period

In Greek art, the period from c.480 to 323 BC, following the Greek victory over the Persians and ending with the death of Alexander the Great. Classical Greek artists achieved an elegance of form and perfection of technique that has been emulated but seldom surpassed in Western art. The period is divided variously into the Early Classical (c.480-450 BC), High Classical (c.450-375) and Late Classical (c.375-323 BC) periods. The term is also used generally to describe the art and culture of ancient Greece and Rome.

Cloisonné

Enamelling technique in which a design is created with thin metal wire, forming partitions (Fr: cloisons) that act as colour dividers. The resulting cells are then filled in with coloured ceramic or glass paste, and the object is fired before the cooled surface is ground smooth.

Conceptual Art

Term applied to art produced from the mid-1960s in which an artist eliminates or radically reduces any emphasis on a particular object – sculpture or painting – in favour of the idea behind the work, thus elevating the conception of the piece above its execution. Conceptual art began as a criticism of traditional art and its political and economic systems, in which traditional artistic skill and knowledge were not valued.

Constructivism

Art movement that began in Russia in the early 1920s and spread to other parts of Europe, remaining important throughout that decade. Constructivists were inspired by the Bolshevik Revolution of 1917 to break free from artistic conventions, experimenting with new forms of sculpture and modern technology, including **kinetic art** and practical design. They were particularly interested in moving away from traditional art in three dimensions, to explore time as well.

Contrapposto

Term describing the position assumed by the human body when weight is borne on one leg while the other is relaxed (It: 'set against').

Cubism

Artistic movement based in France from the late 1900s to the early 1920s, developed by Georges Braque and Pablo Picasso. The style is characterized by the fracturing of images, the simplification of form to its essential elements, and the use of unnatural and multiple perspectives. Early works are sometimes referred to as examples of Proto-Cubism or Analytical Cubism, for the artists were studying subjects directly and dissecting their forms. Synthetic Cubism, more inventive and symbolic, developed after around 1912.

Cycladic Culture

Culture that flourished on the Cycladic islands of Greece during the **Bronze Age**. The culture is best known for its elegantly schematic marble figurines dating to the Early Bronze Age (third millennium BC). Although the Cyclades fell within the cultural orbit of **Minoan** Crete and **Mycenean** Greece, they

retained their own distinctive art and architecture.

Dada

Originally launched in Zurich in 1916, Dada was an anti-rational art movement formed in response to the horrors of World War I. Rejecting artistic conventions, the Dadaists used **performance art**, irony and humour to subvert societal norms and shock the establishment. Many independent Dada groups were later set up in European and American cities, and the movement was a strong force throughout the 1920s. Later art that shares the same sensibilities is often labelled Neo-Dada.

Delft School

Modern name for Dutch painters active in Delft in the second half of the seventeenth century who created either realistic architectural paintings or **genre** scenes. Well-known Delft school artists include Johannes Vermeer and Carel Fabritius.

Deva

Sanskrit term for 'god' or 'deity'. In Hindu lore the word may denote any spirit, demi-god, celestial being, angel, deity, or other supernatural being. In Buddhist tradition it refers to one of many different types of beings, invisible to the human eye, who are more powerful, long-living, and generally more content than the average human.

Diptych

Any two-leaved object joined by a hinge. In art, usually a painting or carving (often of ivory) used for devotional or display purposes.

Divisionism

See under **Pointillism**.

Djenne Culture

Culture of the people of the independent city-state of Djenne, which flourished from the second century BC until 1473 in the Niger Inland Delta of central Mali. Djenne was a major iron-working centre and trading crossroads; by the fourteenth century, gold, slaves and manuscripts were bought and sold here.

Dogon Culture

Culture of the Gur-speaking people of Mali, east of the confluence of the Niger and Bani rivers. The Dogon are renowned for their figurative sculpture, mask traditions and architecture.

Edo Period

Period from 1615 to 1868, during which Japan was ruled by the Tokugawa shogunate from its capital at Edo (modern Tokyo). A time of self-imposed near isolation from both Western and Chinese influences, it was also a period of internal stability, when Japanese arts such as haiku poetry, kabuki theatre and **ukiyo-e** woodblock prints all flourished.

Egypt, Ancient

Civilization that flourished for some three millennia along the River Nile, from around 3000 BC to the Roman period. Best known for its pyramids, carved temples and pharaonic tombs, Egyptian artistry is exhibited also in exquisite personal items such as cosmetic boxes, jewellery and pottery. Egyptian history is traditionally divided into dynasties that are grouped into the Old, Middle and New Kingdoms, divided by so-called Intermediate periods characterized by political and cultural upheaval. The country was ruled by a Hellenistic Greek dynasty, the Ptolemies, from 304 to 30 BC, after which it was annexed by Rome.

Elamite Culture

Elam was an ancient state that flourished intermittently from the fourth to the first millenium BC, in the region of modern Fars and Khuzistan in southwest Iran. At certain periods of their history the Elamites produced a lively and distinctive art that was transmitted eastwards along one of the great trade routes of antiquity as far as Afghanistan and the Indus valley area.

Electrum

A naturally occuring alloy of (primarily) gold and silver.

Enamel

A decorative medium made from coloured vitreous paste. The powdered glass is fused to the surface of an object, usually of metal, under intense heat. There are many types of enamelling, including **cloisonné**; champlevé; *basse-taille*, or translucent; *email-en-ronde-bosse* or encrusted; and painted. The technique is found in ancient Egypt, Greece, China and elsewhere, and was widely used under the Roman and Byzantine empires.

Encaustic

From the Greek meaning 'burning in', encaustic painting involves the use of pigments mixed with wax, usually on prepared wood, though sometimes on canvas. Most famously used in Roman-period funerary portraits from the Fayyum, in Egypt, the technique enjoyed a revival among some mid-twentieth-century American artists.

Engraving

Technique of intaglio (recessed) printmaking in which an image or pattern is incised into a metal plate,

usually copper. The plate is covered with ink, which fills the incisions, the surface is wiped clean, and then paper is pressed onto the plate and into the incisions, thus transfering the inked design as a mirror image. Multiple copies can be made from the same plate. The term is also used generally to refer to any incised decorative design.

Enlightenment, Age of

Period in Western history covering broadly the eighteenth century, during which reason, science and rationality were advocated; often linked with the Scientific Revolution. The belief that systematic thinking could be applied to all human activity profoundly influenced the individual, society and state. The period coincides roughly with the Neoclassical period of Western art (see **Neoclassicism**) and is generally agreed to have ended with the beginning of the Napoleonic Wars in 1804.

Etching

Type of print in which a design is drawn onto a metal plate, usually made of copper, using acid. The plate is first covered in an acid-resistant layer, traditionally wax, into which the design is incised, thus exposing the metal. Acid is then applied, corroding the exposed metal, a process called 'biting'. Ink is applied to the plate, the surface is wiped clean, and paper is applied under pressure to produce a mirror image of the design.

Etruscan Civilization

Civilization that flourished in central Italy and Tuscany from the ninth to the third century BC. Etruria carried on extensive trade with Greece during the **Archaic** and **Classical** periods

(seventh to fourth centuries BC), and many of the most well-known Greek vases came from Etruscan tombs at Cerveteri, Tarquinia and elsewhere. Etruscan tomb paintings also reveal much of what is known of ancient Greek painting styles. Despite this eastern influence, Etruscan art is nevertheless stylistically distinct, as well as aesthetically superb.

Existential Surrealism

A movement of Surrealist artists (see **Surrealism**) that had an existential philosophical bias. The work of Existential Surrealists reflected the belief that each person is solely responsible for creating meaning in his own life.

Expressionism

International art movement that flourished from around 1905 until the 1920s, particularly in Germany and Scandinavia; its practioners sought to move away from pure representation in a bid to externalize the human condition. Influenced by **Symbolism**, **Fauvism** and **Primitivism**, and reacting against **Impressionism**, expressionist artists used distortion, bold colours and abstract lines to convey spiritual and highly emotional messages.

Faience

Artificial material consisting of a core of ground quartz covered with an alkaline glaze that is, in effect, glass; in antiquity, the glaze was usually coloured blue or green with the addition of copper compounds. The material may have been invented in Mesopotamia and was widely used in Egypt and Bronze Age Greece. The term also refers to tin-glazed pottery such as Italian Majolica.

Fang Culture

West-central African culture that flourished in the late nineteenth and early twentieth centuries. The Fang are noted for their fine wooden sculpture and masks.

Fatimid Dynasty

Islamic dynasty that ruled in Ifriqiya (now Tunisia) from AD 909 to 972 and in Egypt from AD 910 to 1171. The Fatimids founded the city of Cairo as their new capital around AD 970.

Fauvism

French **avant-garde** movement of the early twentieth century that acted as a forerunner to **expressionism** and abstract art (see under **Abstraction**). Fauvism is characterized by the use of violent colours, often unmixed and laid on with broad, rough brushstrokes, and by loose, spontaneous compositions.

Figura serpentina

Mannerist device (see **Mannerism**) used in the creation of a spiralling sculptural composition, which ensured the statue could be viewed from all angles.

Fin de siècle

French for 'end of the century', this usually refers to the period from around 1890 until the beginning of World War I, a time of decadence in high society. Artistically, it relates to a loose movement of artists and writers in France and Belgium that worked at this time, many of whom were Symbolists (see **Symbolism**).

Five Dynasties Period

Period in Chinese history from AD 906 to 960, following the **Tang dynasty**. The Tang were succeeded in the

north by the Liao, but in the south the country disintegrated into a series of small kingdoms, referred to as the Five Dynasties.

Foreshortening

Effect used to give the illusion of depth to two-dimensional representations through the manipulation of scale, based on the fact that objects closer to the viewer appear larger than more distant ones.

Fresco

Wall painting technique first used by ancient Mediterranean artists, in which water-based pigments are applied to wet lime plaster (*buon fresco*) or in which pigments are combined with a binder such as egg white or glue and applied to dry plaster (*fresco secco*). Some of the most celebrated examples of fresco painting are from the buried Vesuvian cities such as Pompeii, and from Renaissance Italy.

Frieze

Any horizontal band decorated with mouldings, **relief** sculpture or painting.

Futurism

Italian-centred art movement that glorified the dynamism of the newly-mechanized world and rejected the veneration of past art, particularly the weighty tradition of Italian art. Futurist paintings and sculptures are often aggressive, representing machines and speed. The movement was launched in 1908 by Filippo Tommaso Marinetti and continued until the late 1920s.

Gandharan Style

Term applied to Buddhist art and architecture of the first to fifth century AD from the ancient region of Gandhara, now in Afghanistan, Pakistan and northwest India. Gandharan art exhibits a startling combination of Indian, Hellenistic Greek and Iranian influences, reflecting the presence of the armies of Alexander the Great in the region in the fourth and third centuries BC.

Genre

Term used to characterize art that takes everyday life as its subject matter. This limited use of the word only became established in the nineteenth century, following the broader, and still current, use of the term to include any specialized category of art, such as landscape or still life, that established an independent identity at around the end of the sixteenth century.

Geometric Period

Period in ancient Greece dating to c.900–700 BC. So called because the decoration of pottery at this time was distinctly geometric, made up of lines, triangles and circles, and largely non-narrative. Where figures do appear, they too are created of geometric shapes; three-dimensional sculpture is also schematic.

Gesturalism

A technique (also called Action Painting) used by abstract expressionists, in which paint was dripped, smeared and splashed on to canvas. The painting became an embodiment of the act of its creation. See also **Abstract Expressionism**.

Gilding

Decoration of works of art and architecture usually with gold, but also with silver or other metals. Traditionally, the term describes the application of thin sheets of metal to a surface by means of an adhesive. It is also possible to use the metal in powdered form.

Gothic Style

Term used to denote the art and architecture of medieval Europe from about 1120 to 1400 in central Italy, and until the late fifteenth century or well into the sixteenth century in northern Europe and the Iberian peninsula. It developed out of the **Romanesque style** in France and was used largely in religious contexts. Stylistic characterizations have traditionally applied mostly to architecture, and the term when used in respect to painting, sculpture and manuscript illumination is somewhat arbitrary. See also **International Gothic** Style.

Goths

East Germanic tribe that flourished from the third to the sixth century AD over a large area of eastern Europe. See **Visigothic Style**.

Guilloche

A curving interlace pattern commonly used as a decorative border.

Gupta Dynasty

Dynasty that ruled most of northern India from the mid-fourth century AD to the mid-sixth century, creating one of the world's largest political and military empires. The period is considered a golden age of Hindu and Buddhist art and culture, renowned for its architecture, paintings, sculpture and metalwork.

Haida Culture

Native American culture of the northwest coast of Canada, noted for finely carved totem poles and canoes.

Hallstatt Culture

Dominant culture of central Europe during the Bronze Age, dating from c.750–450 BC. Named after a large prehistoric cemetery near Hallstatt in Austria, where the culture was first identified.

Han Dynasty

Chinese dynasty dating to 206 BC–AD 220. The Han period was a golden age in China's history, during which the basic framework of Chinese civilization and culture was established. Under the Western Han dynasty (206 BC–AD 9) Chinese trade expanded via the inland **Silk Route** and by sea as far as India. From AD 9 to 25 the country was ruled by the interloper Wang Meng, but the Han dynasty (now called the Eastern Han) reasserted itself and reigned from AD 25 to 220. The Eastern Han period witnessed the first infiltration of Buddhism into China.

Heian Period

Period in Japanese history dating from AD 794 to 1185, the beginning of which coincided with the establishment of the imperial capital in Heian (modern Kyoto). The first century of the Heian era saw increasing cultural contacts with China, but this waned after AD 894, and for the next three centuries a truly native Japanese culture developed out of earlier Chinese cultural borrowings. The oldest *yamato-e* ('Japanese-style') paintings date to this period.

Helladic Culture

See **Mycenaean Civilization**.

Hellenistic Period

Beginning with the death of Alexander the Great in 323 BC and ending with the defeat of Cleopatra and Marcus Antonius by Octavian (later Augustus) in 27 BC, the Hellenistic period was a time when Greek art and culture expanded throughout the eastern Mediterranean and Near East. Alexander's generals divided up between them the conquered regions and established Greek political institutions, culture and art in lands from Egypt to Persia. The painting and sculpture of the period is characterized by increasing realism and exaggerated drama.

Hiberno-Saxon Style

See under **Anglo-Saxon Style**.

Hieroglyph

Character from a writing system in which each symbol represents an entire word or phrase. Used mainly in reference to ancient Egyptian inscriptions, but also for Pre-Columbian American writing systems.

Hittite Empire

Empire ruled by the Hittites of the central Anatolian plateau (in modern Turkey) from their capital at Hattusa; the empire covered parts of Syria, Palestine, Mesopotamia and Egypt from c.1380 to 1200 BC. The Hittites traded and carried on diplomacy with the **Mycenaean** Greeks to the west and the Assyrian empire and other states to the east. They were accomplished sculptors and metalworkers, and their art draws on influences from **Mesopotamia** as well as local culture.

Hohokam Culture

Referring to an agricultural group living in Arizona and New Mexico along the Gila and Salt rivers from around AD 700 to 1450. They produced a find red and brown decorated pottery.

Holocene Period

The current geological period, which began at the end of the last Ice Age around 8000 BC. Although humans had dispersed all over the world by the beginning of the Holocene, it is only after this point that agriculture and civilization began.

Hongshan Culture

Chinese **Neolithic** culture that occupied the area of modern Liaoning Province, the western part of Inner Mongolia, and northeast Hebei Province between around 4700 and 2900 BC.

Hopewell Culture

Native American culture that flourished in a large area of the northwest and mid-west United States around 200 BC–AD 400.

Huastec Culture

Mesoamerican culture located on the Gulf Coast of Mexico, characterized by distinctive free-standing sculpture, elaborately painted pottery and temples on pyramid mounds. The Huastec may date back to the tenth century BC, but their most productive period was the post-Classic period, c. AD 700–1300. Their descendents still live in the region today.

Hudson River School

American group of landscape painters active in the mid-nineteenth century, based in New York City. The name is somewhat misleading: the Hudson River valley was not the only area in which they worked, and their very loose organization cannot strictly

be considered a 'school'. See also **American Sublime**.

Icon

From the Greek term for 'image' or 'likeness', commonly used in the Orthodox Christian church to designate a panel painting representing Christ, the Virgin Mary, a saint or a religious narrative.

Igbo Ukwu Culture

Ancient culture of Nigeria that produced elaborate metalwork and ceramics, dated to the tenth century AD.

Ilkhanid Dynasty

Rulers from 1256 to 1353 of the Ilkhanate, one of the four provinces of the Mongol Empire and a region covering modern Iran, Iraq and Turkey. Succeeding that of the **'Abbasid dynasty**, the period was one of great religious tolerance, in which the Islamic arts of **calligraphy** and illumination (see **Illuminated Manuscript**) flourished.

Illuminated Manuscript

Handwritten books or scrolls with painted decoration and illustration. The term 'illuminate' to describe the painting of books derives from medieval usage.

Impasto

Term for paint that is thickly applied so that it stands in **relief** and retains the marks of the brush or palette knife. The technique was only really explored when **oil paint** was introduced during the Renaissance.

Impressionism

Term referring to a French art movement dating from around 1860 to 1900. The term was initially used derisively after the first exhibition of independent artists in Paris in 1874, when critics seized on a painting by Monet – Impression, Sunrise – as exemplifying the unfinished nature of the works; by 1877 the artists themselves adopted the term for their exhibition. Typical Impressionist paintings are landscapes or scenes of daily life, with special attention paid to the effects of light, atmosphere or movement. See also **Neo-Impressionism**, **Post-Impressionism**.

Inca Civilization

Pre-Columbian culture of the Central Andean area of South America, including at its height parts of modern Ecuador, Peru, Bolivia, Argentina, Chile and Colombia. The early Inca people are recognizable in the archaeological record from the twelfth century onwards, and the Inca empire flourished in the fifteenth and early sixteenth centuries. The culture is known for its architecture, painted pottery, metalworking and textiles.

Indus Valley Tradition

Civilization of the Indus and Ghaggar-Hakra river valleys in modern Pakistan, India, Afghanistan and Turkmenistan, which flourished from c.5000 to 1900 BC; its mature, urban phase dates from c.2600 to 1900 BC. The culture is best known from two **Bronze Age** cities, Mohenjo-daro and Harappa, which have produced elaborate houses and sophisticated cultural remains.

Insular Art

See under **Anglo-Saxon Style**.

Intarsia

A technique in which shaped pieces of wood veneer, stone or other materials are applied to a surface to produce a decorative effect.

International Gothic Style

Term denoting a late form of **Gothic** art, sometimes called the 'International Style', particularly practised from c.1380 to 1440 in France, Germany and Italy. Essentially a refined court style dependent on royal patronage, it featured an increased level of realism in the details of a work.

Intimisme

Term applied to painting that depicts everyday life in domestic interiors, often with a calm mood and muted colours. It is most commonly used to refer to the work of Pierre Bonnard and Edouard Vuillard from the 1890s onwards, but works that could be considered Intimist were also produced much earlier by artists such as Johannes Vermeer and Jean-Siméon Chardin.

Iron Age

In the traditional categorization of the human past, the Iron Age succeeded the **Bronze Age** and was characterized by the use of iron as the main metal used for weapons and tools.

Jomon Period

Early period of Japanese history, dating from c.10,500 to 300 BC. Japan's long and distinctive ceramic tradition had its origins in the Jomon period, and the name Jomon ('cord-mark design') relates to the type of surface pattern on surviving examples of Jomon pottery.

Kamakura Period

Period of Japanese history (1185–1333) that saw the establishment of

the first of the military governments that would rule Japan until 1868, although titular emperors still reigned. The capital was moved from the imperial city of Heian to the province of Kamakura, near Edo (modern Tokyo). Under the Kamakura shogunate, the values of the increasingly powerful warrior class began to supplant the aesthetic, courtly practices of the **Heian** nobility.

Khmer Culture

Relating to the people who now form approximately 90 per cent of the population of Cambodia, and who once ruled a vast empire in Southeast Asia. At its height in the eleventh and twelfth centuries, Khmer rule extended into modern Laos, Thailand and Vietnam. The old capital of Angkor, site of the magnificent temple of Angkor Wat, has lent its name to the prevailing style of the empire.

Kinetic Art

Any artwork that involves movement, either real or imagined, of light or other media. Starting in the early twentieth century, when modern technology allowed new materials and motors to be used, kinetic art played an important part in **Constructivism**. Op Art, which uses illusions or effects caused by the limits of human vision, is a related movement.

Kofun Period

Period of Japanese history between the third century AD and 710, named after the tomb mounds (*kofun*) erected for the nobility of the time. Wall paintings in tombs, primarily in Kyushu, are of particular significance, as they mark the earliest appearance of the pictorial painted image in Japanese art. Other tomb goods include armour and weapons, bronze mirrors and personal items, figurines and ceramics.

Koguryo

Situated in the north of the Korean peninsula, Koguryo was the largest state of the Three Kingdoms period (AD 57–668). Strongly influenced by **Han** China, it was the first state in Korea to receive Buddhism.

Kore

See under **Kouros**.

Koryo Dynasty

Korean dynasty that reigned from AD 918 to 1392 and included important patrons of Buddhist art. The Koryo kings were forced to accept Mongol annexation in 1258, after Kublai Khan invaded the peninsula, but the period was nonetheless one of immense cultural and artistic achievement. The world's first moveable metal type was used to print a book in Korea in 1234, and celadon-glazed stoneware was developed.

Kouros / Kore

Terms for freestanding statues from the Greek **Archaic period**, denoting nude male youths and clothed maidens, respectively. The sculptures stand upright with one foot in front of the other, their weight distributed evenly on both legs. Increasing naturalism is apparent as the figures develop over time, but a distinct individualism nevertheless exists.

Kurgan

Site in Uzbekistan, on the lower Kashka River, which flourished from the eighth century BC to the seventh century AD. Also refers to the culture that inhabited the area, and more generally, to a type of burial mound containing internal chambers, found across the Caucasian steppe and Central Asia.

Kushan Dynasty

Central Asian dynasty that ruled an area covering parts of modern Afghanistan and India during the first three centuries AD. Under the Kushans, northwest India and adjoining regions participated in both seagoing trade and commerce along the **Silk Road** to China. The melding of peoples produced an eclectic culture, vividly expressed in the visual arts produced during the period.

Lacquer

Substance used to give a shiny, durable surface to objects. It was first used in Japan and was traditionally produced from the sap of the *Rhus vernicifera* plant, although other saps or synthetic alternatives can be used. Pigment can be added, and once hardened, the material can be carved to produce intricate decoration.

Land Art

Art movement that began in the late 1960s as a reaction to the insularity of gallery-contained art and as a response to growing environmental concerns. Land artists have produced monumental works, often in remote locations and using natural materials, inspired by such ancient structures as Stonehenge.

Landscape Painting

Type of work in which natural scenery is the main subject. Many cultures have traditions of landscape painting, and it became an important and popular genre in European art from the sixteenth century.

Late Antique Period

Usually dated from c. AD 200 to 650, the Late Antique period begins with the decline of the Roman Empire in the third century and ends with the Islamic conquests of the Middle East and North Africa. Christianity became the religion of the Roman Empire at this time, and there was a transition from the realism of **Classical** art to the stylization of the Middle Ages.

La Tène Culture

Central and western European culture of the later **Iron Age**, named after a site at Lake Neuchâtel in Switzerland and dating from c.450 BC to the Roman conquests of the first century BC. La Tène developed from the earlier **Hallstatt culture** with influence from Greece and Etruria, and may have had connections with Celtic peoples.

Linear Perspective

Technique used to produce the effect of depth and space in two dimensional images. The composition is arranged to be viewed by a person standing at a designated point, and is based on the fact that parallel lines appear to converge and objects appear smaller as they move further away from the viewer. See also under **Foreshortening**.

Lintel

In architecture, a horizontal support placed above an opening, usually a window or door.

Lost-wax Casting

A method of metal-casting that dates back to ancient Egypt and Greece and can produce fine detail in the finished piece. A model is produced in clay, covered in wax and then another layer of clay, and fired. The melted wax is poured away, leaving a void into which molten metal is poured. When the outer clay casing is removed, the metal sculpture remains and can be further worked.

Magic Realism

Painting style that was influential in Europe and the USA from the 1920s to the 1940s. It is characterized by photorealistic detail, skewed perspectives and eerie subjects, producing a dream-like effect. **Metaphysical painting** and **Surrealism** are related movements.

Mahlstick

Long stick with a ball-shaped pad at one end used by artists as a hand rest and support when painting detail. The use of mahlsticks coincided with the development of oil painting in the fifteenth century, and fell out of favour as brushstrokes became broader in the nineteenth and twentieth century.

Malla Dynasty

Dynasty that ruled Nepal from the beginning of the thirteenth to the late eighteenth century. Lucrative trade with Tibet allowed the Malla kings to invest heavily in architecture and the arts.

Mamluk Dynasty

Name applied to two distinct lines of Islamic rulers, one in northern India from 1206 to 1290, and the other in Egypt and Syria from 1250 to 1517. The Arabic word means 'owned', and mamluks were converted slave soldiers who served the caliph or sultan. Thus, the founder of each of the Mamluk dynasties started life as a slave.

Mannerism

Name given to the period of Italian art between the High **Renaissance** and the **Baroque**, dating from c.1510/1520 to 1600; sometimes called the Late Renaissance. Mannerist artists rejected the **Classical** idealism of High Renaissance art and painted instead distorted, elongated forms, using bright colours, incorporating a sense of movement, and eschewing **linear perspective**.

Maori Culture

Culture of the Polynesian-speaking earliest inhabitants of New Zealand, who arrived c.AD 900. Polynesian influences are visible in Maori art, but a unique style developed once the newcomers settled in the islands.

Marlik Culture

Indo-Iranian culture of the late second and early first millennium BC, known from the site of a vast royal cemetery in northwest Iran that contained thousands of burial goods, many of gold. Marlik art exhibits a combination of local styles along with influences from Elam (see **Elamite Culture**) and the Iranian plateau.

Maya Civilization

Pre-Columbian culture that flourished over a wide area of Mexico and Central America from around 300 BC until the Spanish conquest of the early sixteenth century.

Meriotic Period

The Meriotic kingdom of Nubia (modern Sudan) flourished from around 900 BC to AD 360 and is named after its capital city, Meroë. The Meriotic kingdom was heavily influenced by the art, culture and religion of ancient Egypt.

Mesopotamia

Meaning 'between the rivers', the ancient name given to the region between the Tigris and Euphrates in modern Iraq, as well as to parts of modern Syria, Turkey and Iran.

Metaphysical Painting

Italian movement (*Pittura metafisica*) of the 1910s and 1920s founded by Giorgio De Chirico and Carlo Carrà. Inspired by psychoanalysis and Nietzsche's philosophy, these artists painted detailed and realistic nightmarish scenes in an attempt to break through the surface of the world to a deeper truth. The movement strongly influenced **Surrealism**.

Mexica Civilization

Civilization of the Nahuatl-speaking peoples of late Pre-Columbian central Mexico that flourished c.1400–1520, also known as **Aztec**.

Mexican Renaissance

Resurgent movement in Mexican art from around 1920 to 1950. Inspired by the Mexican Revolution of 1910 and its socialist-inspired ideas, artists developed a new nationalist style that included religious and Pre-Columbian iconography. Some of the most important works produced were murals commissioned by the government for public buildings, and their artists formed a distinct school.

Mihrab

Niche found in every mosque that indicates the direction of Mecca and acts as a focal point for prayer.

Ming Dynasty

Chinese dynasty that ruled from 1368 to 1644. The Ming dynasty is reknowned for the building of the Forbidden City and large parts of the Great Wall, and for its blue-and-white porcelain ceramics.

Minimalism

Art movement beginning in the 1960s that can be seen as an extreme form of abstract art (see under **Abstraction**). Works are made of simple geometric configurations with serial, repeating elements; sculptural pieces incorporate modern materials. Minimalist art projects an impersonal austerity, concerned mainly with perfection of form and the exploration of space and time.

Minoan Civilization

Bronze Age civilization of Crete, named for its legendary king, Minos. Minoan art and culture heavily influenced that of mainland Greece before being absorbed, probably militarily, by the **Mycenaeans**. The Minoans are renowned for their naturalistic wall paintings, exquisite metal- and stonework, and fine painted pottery.

Mixtec Culture

Pre-Columbian peoples who spoke the Mixtec language in the area that is now the state of Oaxaca in Mexico. Flourishing from around 1200 to 1521, they were allied with the Zapotecs (see **Zapotec Culture**) and were at least partly controlled by the **Mexica** people at the time of European colonization.

Modernism

Term used to denote an ethos shared by many nineteenth- and twentieth-century works of art, design and architecture; it is often considered to dominate the culture of this era. The social and psychological impact of industrialization is explored, celebrated or condemned in Modernist works. The term came into widespread usage in the 1960s to describe the prevailing style of twentieth-century abstract art.

Momoyama Period

Period from 1573 to 1615, when Japanese artistic values were revolutionized by patronage. The art of this period was characterized by a vigorous, opulent and vibrant style, with gold lavishly applied to architecture, furnishings, paintings, sculpture and garments. Simultaneously, the ruling military elite supported a counter-aesthetic of rustic plainness.

Mosaic

Decorative art using pebbles or small pieces (*tesserae*) of coloured glass, stone or other materials. Pebble mosaics were used to create decorated floors in ancient Greek buildings, whereas in Roman times square *tesserae* were common. In the **Byzantine** period, mosaics began to be used to decorate the walls and ceilings of churches, as well as floors, and the technique is also used on furniture and other surfaces. See also **Opus sectile**, **Tessera**.

Mughal Empire

Empire established by the Mongol prince Babur in 1526 (Mughal is the Persian word for Mongol). The Mughal empire ruled much of the Indian subcontinent until its deposition by the British in 1857. The early Mughal emperors (those who reigned before 1707) were prominent patrons of the arts, responsible for active state patronage of arts, crafts, architecture, literature and music.

Muromachi Period

Named after the Kyoto district in which its headquarters was located, the Muromachi period (1392–1573) saw renewed contacts with Ming dynasty China. Art of all kinds – literature, painting, Noh drama, gardening – flourished under the leadership of the Ashikaga shogunate.

Mycenaean Civilization

Culture that flourished during the late **Bronze Age** in central and southern mainland Greece, from c.1600 to 1050 BC; also called Late Helladic. Culturally and artistically influenced by the **Minoan** and **Cycladic** civilizations, by around 1450 BC the Mycenaeans dominated the whole of the Aegean. Mycenaean art and, by extension, culture, has been found as far away as Egypt, the shores of Anatolia and the Black Sea region.

Nabis, Les

Group of Parisian artists of the 1890s, who took their name from the Hebrew word for 'prophet'. Rejecting the naturalism of the Impressionists (see **Impressionism**), they worked with flat, pure colours and depicted mystical themes. They had close ties to the Symbolists (see **Symbolism**) and were influenced also by the English Arts and Crafts Movement.

Naïve Art

Art produced by self-taught, non-profressional artists. The term can be applied to works in a wide variety of different styles and media. See also under **Primitivism**.

Nara Period

Period in Japanese history (AD 710–794), during which the city of Nara was the national capital. Japan was largely agricultural during this period, with life centred on villages rather than cities. Shintoism was the dominant religion, but under Emperor Shomu (reigned AD 724–756) Buddhism was embraced.

Nasca Culture

Pre-Columbian culture of southern Peru, which flourished c.400 BC–AD 800. The Nasca are most well known for their fine painted pottery, and for the mysterious large-scale markings on the desert floor that produce pictures visible from the air.

Naturalism

Art that attempts to depict actual, rather than imagined subjects in a realistic way. Naturalistic paintings are often of everyday scenes and were particularly popular in the nineteenth century. **Realism** is a related movement.

Neo-Assyrian Empire

Mesopotamian empire dating from 911 to 612 BC. At its peak, the empire ruled the Near East from modern Iraq to the Mediterranean, including the states of the Levant, Egypt and eastern Anatolia. Neo-Assyrian artists excelled at **relief** sculpture, and evidence of their skill in metalworking and jewellery design comes from the royal tombs at Nimrud.

Neoclassicism

Predominant artistic style in Europe and North America between 1750 and 1830. The revival of **Classical** styles was based on a new and unprecedented understanding of the art and architecture of the ancient Roman world as a result of the discovery of Pompeii and Herculaneum in southern Italy. Neoclassical art emphasized calm simplicity and noble grandeur, in reaction to the preceeding **Rococo** artistic movement.

Neo-Impressionism

Term coined by the art critic Félix Fénéon and applied to a French **avant-guarde** art movement that was active from 1886 to 1906. Neo-Impressionism emphasized rules of colour contrast according to scientific principles, based on the way the brain determines colour. See also **Pointillism**.

Neolithic Period

A period of cultural and technological development beginning in the Near East around 8000 BC, characterized by settled agricultural societies using highly worked stone tools. Along with the domestication of plants and animals, populations began to produce pottery and woven cloth for the first time.

Neo-Plasticism

A term coined by Piet Mondrian to describe his own style of abstract painting, in which only black horizontal and vertical lines with areas of white, red, yellow and blue are used. Mondrian was a leading member of **De Stijl**.

Niello

Metallic alloy of copper and silver sulfides, used as an inlay material on engraved metal. Niello is melted and pressed into engraved designs on a metal surface, leaving a shiny metallic image when heated. The technique was popular in **Mycenaean** Greece and later during the Roman and medieval periods.

Nok Culture

Agricultural and iron-working civilization that lived in what is now central Nigeria from around 500 BC to AD 500. Most of the evidence for their culture comes from terracotta figurines, sculptures of humans and animals that use geometric forms to produce highly stylized facial features.

Northern Renaissance

Term used to describe the **Renaissance** in northern Europe or, more broadly, outside of Italy.

Oil Paint

Pigments mixed with the slow-drying and flexible medium of oil and applied to a primed wooden panel or stretched canvas strengthened with a mixture of glue and white pigment. Oil paint became a popular medium from the fifteenth century.

Olmec Culture

Early prehistoric Mesoamerican culture that occupied the tropical lowlands of Mexico, on the Gulf Coast. The Olmec originated the Mesoamerican ball game and are best known for their colossal stone heads and other sculptures, including works in jade. They are believed by many to be the progenitor of later Mesoamerican cultures such as that of the **Mixtec** and **Mexica** people.

Opus anglicanum

Term used to describe medieval English embroidery, valued at the time for its fine goldwork and intricacy, though few examples survive.

Opus sectile

Decorative medium first used by the Romans to produce patterns and pictures on floors and walls. Stone (commonly marble), mother of pearl or glass is cut into pieces that follow the lines of the image, and then arranged in a binding medium. In contrast to **mosaic**, where pieces are cut to a uniform size, in *opus sectile* ('cut work') the shape of the parts provides the form of the composition, rather than the grouping of them.

Opus vermiculatum

Type of **mosaic** using very small (1–2.5 mm) *tesserae* to create the finest of detail and shading. The term is translated 'worm-track work' in reference to the lines of tiny *tessarae* that snake around the figures in the work. See also **Tessera**.

Ottoman Empire

Islamic empire that existed from 1281 until 1924, ruled by a Turkish dynasty based in Istanbul. At its height in the sixteenth century, the empire included Greece and the Balkans, the Mediterranean littoral from Greece to Morocco, the coasts of the Red Sea and as far east as Mesopotamia. Best known artistically for their architecture, the Ottomans also produced beautiful ceramics, tiles and metalwork.

Ottonian Empire

The three Ottonian rulers, each called Otto, are regarded as the first dynasty of the Holy Roman Empire, sucessors to the Carolingian dynasty of Charlemagne. They reigned from AD 962 to the early eleventh century. Art of the period is characterized by its adaptation of **Byzantine**, **Carolingian**, and Antique styles.

Ozieri Culture

Neolithic culture of Sardinia dating from around 4000–3200 BC. Most surviving Ozieri artefacts, including bronzes and some wall paintings, come from rock-cut tombs.

Pallava Dynasty

South Indian dynasty that was the most important power in the region from around AD 275 to 925. Their greatest legacy is their monolithic temple and palatial architecture, richly decorated with sculpture.

Pediment

Triangular gable at the end of a building, formed by the pitch of the roof. In ancient Greece and Rome, and in Classical revival architecture since then, the pediment was often filled with sculpture.

Performance Art

Term used to describe 'live' presentations by artists. It was first coined in the early 1960s in the USA, and is closely linked with **conceptual art**.

Phoenecian Style

Style of art produced by a trading people of the Levantine coast in the first millennium BC, and in their colonies throughout the Mediterranean. The Phoenecians occupied the coasts of modern Syria and Lebanon, and established colonies and trading posts throughout the Mediterranean, most famously at Carthage, on Cyprus, Malta and Sicily, and in Spain.

Pittura metafisica

See **Metaphysical Painting**.

Pointillism

Neo-Impressionist style in which small dots of different pigments are used to build up overall colour. In Divisionism,

small strokes are used instead of dots. See also **Neo-Impressionism**.

Polyptych

A painting or carving, often an **altarpiece** or other devotional object, consisting of more than three sections joined together.

Pompeian Styles

Roman wall painting is usually distinguished by four periods, defined in the surviving paintings from Pompeii, Herculaneum and surrounding sites. In the Republican First style (c.200–90 BC), walls were painted to simulate the appearance of coloured marbles. The Second style (c.90–20 BC) is defined by **linear perspective**, in which artists created illusionistic space with realistically represented architectural elements. Architectural features also appear in the Third style (c.15 BC–AD 45), but in a lighter, more delicate and purely decorative form. The Fourth style (AD 40–90) made use of **trompe l'oeil** architectural decoration like Second style, and often included small landscapes or mythological scenes.

Pop Art

Abbreviation for 'popular art', term used to describe a movement which began in the late 1950s and flourished until the 1970s, independently but simultaneously, in Europe and the USA. It included artists working in a variety of different styles whose subject matter embraced and celebrated popular commercial culture, including advertising, photography, comics and the entertainment industry. Art that shared these sensibilities but was produced very early in the movement may be called Proto-Pop, and more

recent works that carry on the tradition are labelled Neo-Pop.

Post-Impressionism

Broad movement that includes artists with many different styles, all reacting against the **naturalism** of **Impressionism**. From the last Impressionist exhibition in 1886 until around 1905, when **Fauvism** appeared and the first moves toward **Cubism** were made, Post-Impressionist artists emphasized abstract qualities and symbolic subjects over the naturalistic depiction of light and colour.

Pre-Raphaelite Brotherhood

Group founded in 1848 by three young English painters, William Holman Hunt, John Everett Millais, and Dante Gabriel Rossetti. They rejected sterile and formulaic academicism in art, which they perceived as having been begun by the Bolognese followers of Raphael, and advocated a return to nature and earlier sources for inspiration. Pre-Raphaelite works are usually characterized by abundant detail, intense colours and complex compositions.

Primitivism

Term that originated in nineteenth-century France to refer to the imitation of primitive art. This narrow meaning partly persists, although the identity of the 'primitives' has changed at various times, to include pre-Renaissance Italian artists and most non-Western peoples, as well as the tribal African and Oceanic artefacts that are usually meant today.

Print

Work of art produced in multiple copies by means of the techniques of

engraving, etching, block printing or other methods.

Proto-Corinthian Style

Orientalizing style of Greek vase-painting centred on the city of Corinth c.720 to 640 BC. It is characterized by miniature vessels and complex animal and figural friezes.

Qajar Dynasty

Turkmen dynasty that ruled Iran from 1779 to 1924. The Qajar shahs were important patrons of the arts, and the elaborate life of the court was recorded in paintings of various media. Paintings from the period show a hybrid European-Persian style, combining techniques such as portraiture and perspective with rich colour and pattern.

Qin Dynasty

The first imperial Chinese dynasty, dating from 221 to 206 BC, under which China was unified for the first time. The tomb of the first emperor, Qin Shi Huangdi (reigned 221–210 BC) is famous for its terracotta army.

Qing Dynasty

The last imperial Chinese dynasty, dating from 1644 to 1911, when uprisings deposed the emperor and the Republic of China was formed. The Qing dynasty was a foreign one, founded by the Manchus of northeast China, but the Qing emperors quickly adopted Chinese culture and became patrons of all forms of Chinese art.

Realism

Art movement that began in the mid-nineteenth century and aimed to produce naturalistic works depicting everyday life, in contrast to Romantic subjectivity (see **Romanticism**). See also **Magic Realism**.

Red-figure Style

Ancient Greek vase-painting technique in which figures and designs are left reserved (without paint), the resulting blank silhouettes then completed with painted details. See also **Black-figure Style**.

Regionalism

American painting movement of the 1930s and 1940s that depicted everyday life, often in idyllic, rural scenes that were naturalistic and identifiably American, making them accessible to a wide audience.

Relief

From the Italian *rilevare* ('to raise'), term used in sculpture and architecture to describe a design or image that protrudes from a flat surface. The terms 'high relief' or 'low relief' are used to describe the amount of projection.

Reliquary

Container or structure designed to hold relics (objects associated with a person of religious significance).

Renaissance

Used generally to describe periods in which there is renewed artistic or cultural vigour, often inspired by past movements. More specifically, the period between the fourteenth and seventeenth centuries, beginning in Italy and spreading to the rest of Europe, during which there was a revival of learning based on Classical literary sources. The use of perspective and other techniques were developed in painting, and increasing realism was expressed in sculpture; the art of ancient Greece and Rome served as an inspiration. The Early Renaissance is usually considered to span the fifteenth century, and

so-called Proto-Renaissance works appear as early as the thirteenth century. The High Renaissance is dated to the first quarter of the sixteenth century and was confined mainly to Italy. The Late Renaissance followed after c.1525 and included **Mannerism**. See also **Carolingian Renaissance**, **Mexican Renaissance**, **Northern Renaissance** and **Venetian School**.

Repoussé

Term applied to a type of decorative metalwork, in which the sheet metal is hammered from the back to create a design in **relief**.

Rhyton

Ancient drinking or libation vessel with two openings: one into which liquid is poured, and another, smaller, from which it escapes.

Rococo

Ostentatious decorative style that became very popular in France, southern Germany and Austria in the eighteenth century. Rococo architecture, interiors, furniture and *objets d'art* are characterized by asymmetry and the playful use of organic forms. Motifs such as shells, leaves and cherubs were particularly prominent. Rococo was lighter in tone than both the more monumental **Baroque** style from which it stemmed, and the much more formal **Neoclassicism** that succeeded it.

Romanesque

Style characteristic of the art and architecture of western Europe in the period 1050–1200. Romanesque artists drew upon the arts of the past – the Roman, **Carolingian**, and **Ottonian** empires – but also absorbed the art of the contemporary **Byzantine**

and Islamic worlds to create a unified and original style. The Romanesque was followed by the **Gothic** period.

Romanticism

Broad literary and artistic movement of the late eighteenth and early nineteenth centuries that was a reaction to the rationalism of **Neoclassicism**, in which emotions, spontaneity and self-expression were valued above reason, producing colourful works in many styles. **Landscape painting** was a popular genre at this time, as were history painting and scenes of exotic places.

Sabaean Kingdom

A South Arabian kingdom located in the area of modern Yemen that flourished from around the ninth century to the first century BC. Archaeologically identified with the Biblical kingdom of Sheba, it played a major role in the caravan trade of the ancient Near East.

Safavid Dynasty

Dynasty that ruled Persia (modern Iran) from 1501 to 1765, bringing a period of stability to the region after the fall of the **Ilkhanid** and Timurid dynasties, and under whose rule an Iranian national identity was formed. Its principal artistic achievements were architectural, but the period is also known for other arts, including especially carpet-weaving.

Sarcophagus

A stone or terracotta coffin, often highly decorated.

Seljuq Dynasty

Turkish dynasty with branches that ruled Iran, Iraq and Syria from 1040 to 1157, and Anatolia (modern

Turkey) from 1081 to 1307. This was a period of strengthening of Islam in the region, and one of huge development in the visual arts, particularly in architecture but also in metalwork, ceramics and the arts of the book.

Sfumato

In oil painting, the technique of blending colour and tone very gradually so that the edges of objects are soft and blurred. First used by Leonardo da Vinci during the Italian **Renaissance**, the technique produces a 'smoky' and atmospheric effect.

Shang Dynasty

Chinese dynasty that reigned from c.1600 to 1045 BC, the first dynasty for which archaeological evidence survives. The Shang period is particularly known for its major developments in the technology of bronzeworking, and the earliest known Chinese glazed ceramics were produced at this time.

Silk Route

The name given to the network of trade routes linking China with Europe from around the second century BC to the fifteenth century. The land route crossed Central Asia and the Near East before reaching the eastern Mediterranean, while the maritime silk route skirted the coasts of Southeast Asia and India. As well as engendering trade in silk and other goods, the routes also allowed the exchange of cultural, religious and artistic knowledge.

Silla, Kingdom of

Founded around 57 BC in the southeast of the Korean peninsula, during the Three Kingdoms period, Silla defeated **Koguryo** and Paekche in AD 668 to create the Unified Silla Kingdom (AD 668–935).

Slip

Dilute mix of water and clay used to coat and decorate the surface of pottery.

Socialist Realism

Term used to describe a style of painting and sculpture in which the dictatorship of the proletariat is idealized and celebrated. It was made the official style of the USSR in 1934; artists who worked in other styles risked imprisonment until the death of Stalin in 1956. It later became the officially-sanctioned style in China under Mao.

Song Dynasty

Chinese dynasty that ruled from 960 to 1279, divided into the Northern Song (960–1127) dynasty and the Southern Song (1127–1279); the latter was established following barbarian incursions from the north. The Song period was a time of artistic invention and experimentation, which saw unprecedented achievements in painting, calligraphy and ceramics.

Stele / Stela

Upright stone used to record an event or mark a grave, common in many cultures throughout the world and throughout history. Stelae are often inscribed or decorated with carvings.

Stijl, De

Dutch Modernist movement (see **Modernism**) of the 1920s, made up of artists associated with the magazine De Stijl ('The Style'). A new aesthetic involving horizontal and vertical lines and using mostly primary colours was developed – a new consciousness to reflect the spirit of the times. The most prominent artist in the group was Piet Mondrian (see **Neo-Plasticism**).

Stucco

Slow-setting plaster that can be used to make a smooth finish on walls, or to produce decorative work on buildings or statues.

Stupa

Buddhist monument, usually domed. Stupas are common throughout the Buddhist world, with many distinct local styles. Probably evolving from funerary mounds, they often contain relics (see **Reliquary**).

Sui Dynasty

Chinese dynasty that ruled from AD 581 to 618 and reunified the country after almost four centuries of division.

Sumerian Culture

Ancient culture of southern **Mesopotamia** dating from c.3500 to 2000 BC. The royal cemetery at Ur contained a rich range of Sumerian art, including metalwork, some created using the **lost-wax** method, and carved sealstones. The Sumerians established the world's first city-state, a political unity comprising the city and its hinterland.

Suprematism

Art movement that took the reduction of form characteristic of **abstraction** and **Cubism** even further, using only simple geometric shapes to produce complete purity of form; the square was believed to best represent this. Founded by Kazimir Malevich in 1915, Suprematism was a mostly Russian movement that remained prominent throughout the 1920s and is still influential today.

Surrealism

Artistic and literary movement prominent from the 1920s until World War II, which sought to explore the unconscious mind to find a deeper truth; Surrealists produced fantastical, disturbing and sometimes amusing works of art. Many styles and methods were used, including **assemblage** of found objects and hyper-realistic painting of dreamscapes. See also under **Existential Surrealism**.

Symbolism

Literary and artistic movement of the 1880s and 1890s that aimed to explore the psyche, using objects symbolically to express underlying ideas and emotions. Reacting against the growing materialism of the age, and specifically the artistic dominance of **Impressionism** and **Realism**, Symbolists aimed to reconcile matter and spirit through a language of signs and hidden meanings.

Taino Culture

Group of seafaring agriculturalists of the Lesser Antilles who were the first indigenous people to meet Christopher Columbus and his men in the late fifteenth century.

Tairona Culture

Pre-Columbian culture of the Sierra Nevada de Santa Marta in Colombia, which flourished from the seventh or eighth century AD until the Spanish conquests of the sixteenth century. The Tairona are known for their metalwork.

Tang Dynasty

Chinese dynasty that ruled from AD 618 to 907. One of the most brilliant periods in Chinese history, it was marked by cultural prosperity, international contacts and patronage, which combined to create a golden age of painting, poetry and ceramics.

Te Huringa

Period in **Maori** history from 1800 to the present day, following the settlement of New Zealand by Europeans. Despite loss of land and the introduction of Christianity, Maori art continued to flourish and diversify.

Tempera

Paint made of ground colours and a binding medium, usually egg yolk.

Tessera

Small cube of glass, stone, ceramic or metal used in the creation of **mosaic**. Very small *tesserae* are used in the **opus vermiculatum** technique.

Tlingit Culture

Native American culture of the northwest coast of Canada and Alaska. Tlingit art is similar to that of the neighbouring **Haida** people.

Toltec Culture

Group of peoples from Pre-Columbian Mesoamerica that were dominant from AD 900 to 1200, succeeding the culture of Teotihuacán. The art and culture of the Toltecs influenced the later **Mexica** culture.

Tondo

A circular painting or **relief** carving. The format became popular in the fifteenth century, used mostly for religious subjects.

Triptych

Painting, **altarpiece** or other devotional object consisting of three associated sections.

Trompe l'oeil

French term ('trick the eye') describing a painting technique designed to create the illusion that depicted objects actually exist in three dimensions, rather than being merely two-dimensional representations.

Ukiyo-e

Translated as 'pictures of the floating world', this Japanese genre is primarily associated with colour woodblock prints of the **Edo period** (1615–1868), which depicted the decadent, pleasure-seeking society that had developed in urban areas of Japan. The works were never intended to be 'high art' but were unabashedly popular and commercial in intent.

Uruk

Important **Sumerian** city in modern Iraq, continuously occupied from the fifth millennium BC to the seventh century AD. During the Uruk period, dating to the fourth millennium BC, the city produced the first known written documents, along with imposing architecture, sculpture and other arts.

Valdivian Culture

Pre-Columbian culture that flourished between around 4000 BC and 1500 BC in Ecuador, famous for its terracotta female figurines.

Veduta Painting

From the Italian 'to view', a genre of painting in which a landscape or urban view is depicted. Veduta paintings were often produced as souvenirs for wealthy travellers, and were popular from the sixteenth century until the development of photography in the middle of the nineteenth century.

Venetian School

Group of Renaissance painters working in Venice from around 1450 to 1600, who developed a style based on the use of oil paint that focussed on light and colour. This was a period of great prosperity for the Venetian Republic, during which art was generously supported by the government of the day.

Verism

Ancient Roman portrait style that emphasized maturity, experience and gravitas over youthful idealism.

Viking Culture

Scandinavian culture that flourished from around AD 750 to 1150, spreading across northwest Europe as the Vikings founded coastal settlements. Viking art is highly decorative, commonly using stylized animal motifs.

Video Art

Term used to describe art that uses video as its medium and is shown on monitors and screens in galleries, sometimes making up only part of an installation. Video developed as a medium from the 1960s and is an element of **conceptual art**.

Vienna Secession

Diverse group of Austrian artists that formed in 1897 when they left the Künstlerhaus of Vienna in protest at the art school's conservative attitude. Gustav Klimt was the first president of the group and oversaw the building of its exhibition hall, which is still in use today.

Visigothic Style

Term describing the art of the Gothic peoples (see **Goths**) who migrated from south Russia via France to rule the Iberian peninsula from the fifth to the eighth century AD. Visigothic art represents a fusion between Germanic and **Classical** styles.

Wash

A thin layer of diluted colour used in some drawings to enhance the effect of shadow; also refers to a drawing made in this technique.

Watercolour Paint

Type of paint made from pigments bound with a fixing medium (usually gum arabic) and dissolved in water. Their effect is a soft **wash** of colour. Modern watercolours were developed in the eighteenth century and are popular for landscape painting.

Woodcut

Printing process in which the image to be printed is carved on wood in **relief**. Ink is then applied and the wood block pressed onto paper. The term is also used to describe a print made by this process.

Xia Dynasty

Traditional but archaeologically unverified first dynasty of China, supposedly dating from the early second millennium BC to the beginning of the **Shang dynasty**, around 1600 BC.

Yoruba Culture

Yoruba-speaking ethnic group of Nigeria, Benin, Ghana and Togo. The Yoruba have a rich artistic tradition and are most famous for their sculpture.

Yuan Dynasty

Mongol dynasty that ruled China from 1279 to 1368, reuniting the whole of China and incorporating it into the vast Mongol empire that stretched as far as eastern Europe. The Mongols were not great patrons of the arts, and their rule brought about the abdication of many artists and scholars from official government service, leaving these artists (literati) free to pursue individual styles of painting and calligraphy.

Zapotec Culture

Pre-Columbian culture of modern Oaxaca State in Mexico, which flourished between AD 900 and 1520. The Zapotec were contempories of the **Mixtec** people to their west.

Zhou Dynasty

Chinese dynasty that ruled from around 1045 to 256 BC, succeeding the **Shang dynasty**. The Zhou period is divided into the Western Zhou (c.1050–771 BC) and the Eastern Zhou (771–256 BC), based on the location of the imperial capital. The Eastern Zhou is further divided into the Spring and Autumn period and the Warring States period, a time of severe fragmentation. As in the Shang period, cast bronzes were the most important form of artistic expression.

Index

This index lists artists (where known), titles of works, countries, and style, dynasty, culture or period. Names beginning al-, da, de, della, van and van der are alphabetized under the next letter; titles of works beginning with A, The, Le, La or Les will also be found under the first letter of the next word.

Picture Credits

All works in copyright are © the artist.

Publisher's Note

The works of art in this book are arranged in chronological order. Where the precise date of an object is unknown, a rational mid-point within its possible range of dates has been chosen and indicated by the use of circa; in each case the full chronological span is cited in the main text. For works whose creation took place over more than one year, the initial year is used and the full dates are cited in the main text.

The place of origin for all works is given in the captions as the modern country name; where this is not possible, we have used its region. For works by known artists, the country name indicates their place of birth or greatest artistic influence.

Measurements are given as height x width; for three-dimensional works, the main dimension is shown. In instances where the correct measurements have been impossible to acquire due to the nature of the works or location, we have included approximate dimensions. All reasonable efforts have been made to standardize and ensure the accuracy of the information provided herein.

Acknowledgements

For their advice, consultancy and texts, the publishers are indebted to the following: Larry Ball, Marshall J. Becker, Evelyne Bell, Peter Bellwood, Sheila S. Blair, Crispin Branfoot, Fiona Buckee, John Carpenter, Yashaswini Chandra, Matthew Clear, Nicola Coldstream, Robin Coningham, Anne D'Alleva, Rachel Fentem, Andrew Fitzpatrick, Diane Fortenberry, Duncan Garrow, Madhuvanti Ghose, John Glass, Charles Gore, Alfred Haft, Cecily Hennessy, Alisa LaGamma, Lloyd Laing, James Lin, Jaromir Malek, Mark Manuel, Fabiola Rodriguez Martinez, Robert Morkot, Stephen Murphy, Kate Murray-Browne, Paul Pettitt, Deborah Povey, Keith Pratt, Dorie Reents-Budet, Malini Roy, Lindsay Rothwell, Michael Seymour, Peter Sharrock, Sabrina Shim, Mamtimyn Sunuodula, Sarah Symmons, Jeremy Tanner, Jean McIntosh Turfa, Lisa Wade and David Webster.

Phaidon Press Limited
Regent's Wharf
All Saints Street
London N1 9PA

Phaidon Press Inc.
180 Varick Street
New York, NY 10014

www.phaidon.com

First published as *30,000 Years of Art* 2007
This edition abridged and revised 2009
© 2007, 2009 Phaidon Press Limited

ISBN 978 0 7148 4969 0

A CIP catalogue record for this book is available from the British Library.

Jacket designed by Julia Hasting
Printed in China

31901046108207